ART
+
NYC

A COMPLETE GUIDE TO
NEW YORK CITY ART
AND ARTISTS

D0062131

© Museyon Inc. 2011

Published in the United States by:
Museyon, Inc.
20 E. 46th St., Ste. 1400
New York, NY 10017

Museyon is a registered trademark.
Visit us online at www.museyon.com

Cover: Jeff Koons, Rabbit, 1986. Stainless steel, 41 x 19 x 12 inches,
104.1 x 48.3 x 30.5 cm ©Jeff Koons

ISBN 978-0-9822320-8-8

102912

Printed in China

4

CONTENTS

MOVEMENTS

7 **ROOTS OF NEW YORK CITY ART**

10 **ABEX / THE NEW YORK SCHOOL**
13 Peggy Guggenheim

14 **NEO DADA/ASSEMBLAGE**
17 Black Mountain College
18 Fluxus

20 **POP ART**
23 Leo Castelli

24 **MINIMALISM**
27 Post-Painterly Abstraction

28 **CONCEPTUAL ART**

32 **PERFORMANCE ART**
35 Body Art
35 Ana Mendieta

36 **DOCUMENTARY PHOTOGRAPHY**
39 Documentary Photography
since "New Documents"

40 **POSTMODERNISM: APPROPRIATION
AND THE PICTURES GENERATION**
43 Neo Pop/Neo Geo

44 **NEO EXPRESSIONISM**
47 Graffiti
47 Mary Boone

48 **INSTALLATION ART**
51 Gordon Matta-Clark

52 **VIDEO ART**
55 New Media Art

ARTISTS

58 **MARK ROTHKO**
 65 Seagram Murals
 Go Global

66 **JACKSON POLLOCK**
 69 Lee Krasner

72 **ROBERT RAUSCHENBERG**

78 **YOKO ONO**

84 **ROY LICHTENSTEIN**

90 **ANDY WARHOL**

96 **DONALD JUDD**
 101 Marfa, Texas

102 **CINDY SHERMAN**

108 **JEFF KOONS**

LISTINGS

114 **DOWNTOWN**

122 **SOHO**

134 **BOWERY ARTS DISTRICT**
 141 Feature Inc

156 **GREENWICH VILLAGE**

168 **EAST VILLAGE**

180 **CHELSEA**
 185 Studio Visit

204 **MIDTOWN SOUTH**

210 **MIDTOWN**

228 **UPPER EAST SIDE**

248 **UPPER WEST SIDE**

254 **HARLEM & NORTH**

262 **QUEENS**

268 **BROOKLYN**
 280 Interview: Cleopatra's
 281 Studio Visit: Camel Art
 Space
 282 Studio Visit: 3rd Ward

286 **EXTENDED TRAVEL**
 286 The Hamptons
 290 Dia: Beacon
 292 Storm King Art Center

MOV

07 **ROOTS OF NEW YORK CITY ART**

10 **ABSTRACT EXPRESSIONISM**

14 **NEO DADA**

20 **POP ART**

24 **MINIMALISM**

28 **CONCEPTUAL ART**

32 **PERFORMANCE ART**

36 **DOCUMENTARY PHOTOGRAPHY**

40 **APPROPRIATION**

44 **NEO-EXPRESSIONISM**

48 **INSTALLATION**

52 **VIDEO ART**

THE ROOTS OF NEW YORK CITY ART

Up until the early 20th century, Paris was firmly established as the center of the artistic avant-garde — from the official exhibitions of the Salon to the renegade art of the Impressionists to the Surrealist circle of André Breton. The city's artistic energy beckoned writers like Ernest Hemingway and the other artists of the Lost Generation, who expatriated to Paris in the years following World War I.

While Europe's vanguard artists were breaking with realism and developing the hallmarks of what was to become Modern Art, New York's artists continued working in a realistic vein. In 1857, the Tenth Street Studio Building, the first modern studio in New York, opened in Greenwich Village. Designed by Richard Morris Hunt, the Tenth Street Studios were home to such pioneering American artists as Winslow Homer and the Hudson River School painters of romantic landscapes. In the early years of the 20th century, another scene emerged from the converted carriage houses of Greenwich Village. Artists of The Ashcan School, led by Robert Henri — teacher of George Bellows and Edward Hopper — painted grim depictions of the darker side of urban life. Sculptor Gertrude Vanderbilt Whitney was an early patron of their work,

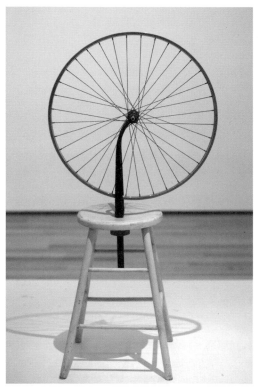

forming in Greenwich Village what would later become the Whitney Museum of American Art.

The dawn of World War II ended Paris' reign as the world's official cultural capital. The Nazi expansion had left Europe in shambles, forcing the artistic and intellectual community to scramble to the relative safety of the United States. New York offered a haven for artists like Mark Rothko, Willem de Kooning, Hans Hofmann and Louise Bourgeois, as well as influential dealers such as Leo Castelli and Ileana Sonnabend. Even the influential American-born collector Peggy Guggenheim returned from Europe in 1941, abandoning her plans for a museum of Abstract and Surrealist art. It was in New York City that she founded her Art of this Century Gallery in 1942, one of the leading forces in promoting a new, purely American form of art. It was called Abstract Expressionism, and it was completely unlike anything that had been seen before.

In a decade that witnessed the Holocaust, the atomic bomb and other unthinkable atrocities, artists such as Jackson Pollock, Lee Krasner, Mark Rothko, Franz Kline and others set out to deal with the dark aftermath of World War II in a deeply personal manner. Though they had little in common stylistically, each artist was interested in creating a wholly new form of art, inventing a new artistic language to deal with what seemed like the collapse of civilization. Along with Art of this Century, the new Museum of Modern Art was an early champion in supporting the New York School of artists, and had

been collecting Abstract Expressionist art as early as the mid 1940s. In 1945 the group show "A Problem for Critics" brought together a number of early Abstract Expressionists. As gallerist Howard Putzel remarked: "I believe we see real American painting beginning right now."

Outside of the Abstract Expressionists, perhaps the most influential artist on the New York art scene of the 20th century was born a generation earlier. The French artist Marcel Duchamp, who later emigrated from Paris to New York in 1915 after the outbreak of World War I, burst into the unsuspecting New York art world in 1913 with his painting *Nude Descending a Staircase No. 2*, first exhibited at the Armory Show. The work was an instant scandal to audiences not accustomed to such abstract work, and the artist continued to shock in his adopted city for years to come. Perhaps his most famous work, *Fountain* (1917) — a Readymade consisting of a store-bought urinal that the artist upended, signed and declared his own work of art — was flatly rejected when Duchamp tried to show it in New York at the Society of Independent Artists in 1917. However, such anti-art impulses would become the core of many of the most avant-garde movements of the 20th century — from the combines of Robert Rauschenberg to the conceptual work of Joseph Kosuth to the appropriation art of the 1980s.

From this small group of pioneering artists, New York's contemporary art scene has exploded into a big business, one with lasting international influence. It may be more difficult than ever to find (or afford) an artist's loft, but entire sections of the city are dedicated the buying, selling and exhibition of art, and mega-million dollar auction results are common front-page headlines. Though the art world has gone global in the 21st century, New York retains an ever-important role.

OPPOSITE: Marcel Duchamp, Bicycle Wheel, 1951, Museum of Modern Art. Originally created in 1913, Bicycle Wheel was the first of the artist's Readymades.
PREVIOUS SPREAD: Edward Hopper, Early Sunday Morning, 1930, on view at the Whitney Museum of American Art

ABSTRACT E

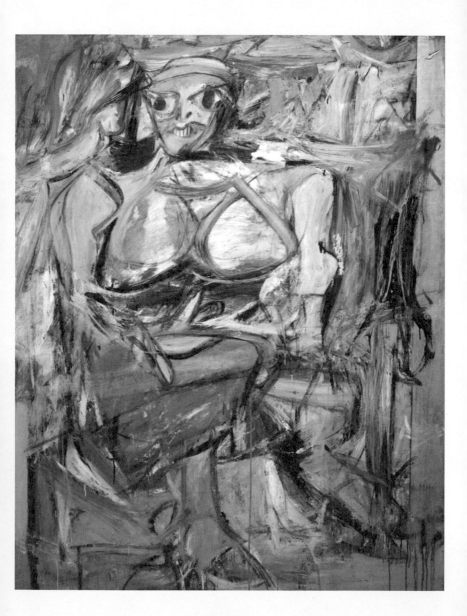

Willem de Kooning, <u>Woman I</u>, 1950-52

IN THE YEARS FOLLOWING WORLD WAR II, THE FIRST DISTINCTLY AMERICAN ART MOVEMENT EMERGED IN NEW YORK CITY: ABSTRACT EXPRESSIONISM. CALLED **THE NEW YORK SCHOOL**, THESE ARTISTS TURNED AWAY FROM THE SURREALIST MODE DOMINANT IN EUROPE, OPTING INSTEAD TO EXPLORE THE HUMAN CONDITION IN A NON-REPRESENTATIONAL WAY.

In the search for the underlying realism of Carl Jung's "collective unconsciousness," they broke painting down into its most elemental forms: gesture, texture, color and tone. Various styles flourished within the group. The Action Painters, such as Jackson Pollock and Willem de Kooning, used the canvas to document the performative act of creation, filling it with dramatic brushstrokes, scribbles, drips and daubs of paint. On the other hand, the Color Field painters explored the relationship between areas of color—whether in the thick impasto of Clyfford Still or in Mark Rothko's ethereal washes.

Though it may seem that these paintings have no subject, content and intent were of the utmost importance to the Abstract Expressionists. The artists had shared the experiences of the Great Depression and World War II and common themes in the work included life, death and the expression (rather than illustration) of basic human emotion.

Unlike many artistic movements that came later, the Abstract Expressionists were a distinct group, and were part of the Artists' Club. They exhibited their art together, often at Betty Parsons Gallery, and hung out in Greenwich Village, where they joined in heated debates at the Cedar Tavern on University Place. Likewise, the concept of "the artist" was central to Abstract Expressionism, seen as an essential and heroic figure who translated the complex inner world into the visual.

ABSTRACT E

UNDERSTAND / CONCEPTS

Emotion Over Narrative, Order and Color Express the Divine, Influence of Carl Jung and the Idea of "Collective Unconscious," "All-over" Composition: All Parts of the Canvas are Equal, The Artist as Heroic Figure

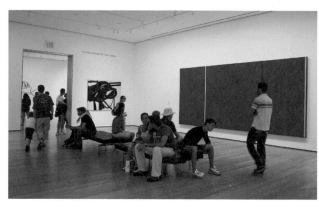

Franz Kline *Chief* (1950) and Barnett Newman's *Vir Heroicus Sublimis* (1951) at MoMA

UNDERSTAND / IMPORTANT FIGURES

Arshile Gorky (1904-1948) Described as a Surrealist by André Breton, Gorky was a pioneering figure in lyrical abstraction and a profound influence on the New York School.

Willem de Kooning (1904-1997) Dutch-born de Kooning abstracted the female form into violent explosions of brushstroke and color in his *Woman* series.

Jackson Pollock (1912-1956) The quintessential Action Painter, Pollock removed the canvas from the wall and placed it on the floor, splattering paint onto the surface and removing any recognizable subject matter.

Lee Krasner (1908-1984) Krasner studied under Hans Hofmann, where she developed her abstracted still-lifes and active, calligraphic canvases. The only female among the original New York School, she married Pollock in 1945. Like Pollock, she used liquid paint, as well as the brush and her hands.

Franz Kline (1910-1962) Kline's spontaneous compositions include thick swaths of strong, black-and-white brushstrokes.

Robert Motherwell (1915-1991) Expressive brushstrokes in black and white are the hallmarks of Motherwell's *Elegies*. Though one of the youngest of his

Robert Motherwell (1915-1991) Expressive brushstrokes in black and white are the hallmarks of Motherwell's *Elegies*. Though one of the youngest of his contemporaries, Motherwell was instrumental in promoting the work of the other artists of the New York School, a term he coined.

Clyfford Still (1904-1980) Still explored ideas of the human condition through the relationship between colors in jagged areas of thick, impasto paint.

Mark Rothko (1903-1970) Rothko used luminous registers of flat color—and the relationship between them—to seek a divine harmony on the canvas.

Barnett Newman (1905-1970) Newman's signature is the "zip," the thin vertical lines he used to separate fields of bold color on the canvas.

Ad Reinhardt (1913-1967) Reinhardt reduced paintings to its simplest forms, monochromatic black canvases that he called "the last paintings."

UNDERSTAND / KEY EXHIBITION

Ninth Street Show *May 21 – June 10, 1951*

In 1951 a group of artists put on a show in a vacant store that was about to be demolished. Sponsored by Leo Castelli, the exhibition included artists working in a non-representational style at a time when few galleries were open to the avant-garde. "An air of haphazard gaiety, confusion, punctuated by moments of achievement, reflects the organization of this mammoth show, which, according to one of the organizers, 'just grew,'" wrote *ArtNews* critic Thomas Hess. He singled out among the show's 61 artists the "authoritative statements" of Jackson Pollock, Robert Motherwell, Willem de Kooning and Ad Reinhardt.

PEGGY GUGGENHEIM

Peggy Guggenheim was an independent millionaire several times by the time she was 21. As a young woman, she lived throughout Europe, befriending avant-garde artists Marcel Duchamp and Man Ray. She built a private collection with intentions of starting a museum, and vowed to buy a painting a day. When World War II broke out, she returned to New York, where her uncle Solomon R. Guggenheim was building a museum of his own.

Back in her native city, she opened a gallery called Art of This Century in 1942. The gallery focused on European Surrealism, including the work of her husband, painter Max Ernst. It also showcased new American artists, including Mark Rothko and Jackson Pollock, who had his first solo show with the gallery. The gallery revolutionized the way that art was shown. Each of the four spaces within the mini-museum was tailored to the art on display: The Abstract Gallery had curved blue walls and paintings suspended from the ceiling, the Surrealist Gallery randomly illumined works with flashing light, and the Kinetic Gallery allowed viewers to interact with the work. Meanwhile, the Daylight Gallery was dedicated to temporary exhibitions including the work of Abstract Expressionists Robert Motherwell and Clyfford Still.

NE

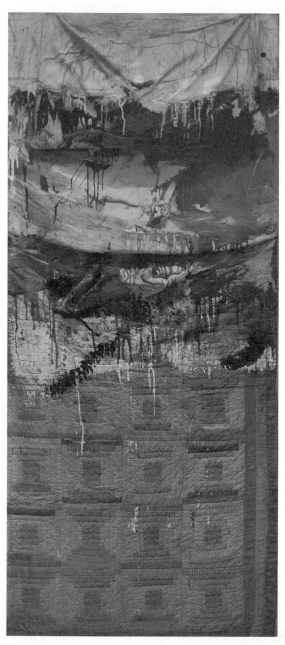

Robert Rauschenberg, <u>Bed</u>,

WHEN MARCEL **DUCHAMP** MOVED TO NEW YORK, THE **ART WORLD** AXIS SHIFTED, AND THROUGHOUT THE CENTURY MANY **U.S. ARTISTS** RETURNED TO THEMES FIRST PROPOSED BY DUCHAMP AND **DADA—** MOST NOTABLY, THE **GROUP** OF EXPERIMENTAL ARTISTS THAT BECAME KNOWN AS THE **NEO-DADAISTS**, WHO MINED DUCHAMP'S **LANGUAGE** OF **READYMADE OBJECTS** AND MULTI-MEDIA **COLLAGES** KNOWN AS **ASSEMBLAGE**.

These artists, christened Neo-Dadaists by critic Barbara Rose, reveled in the anything-goes philosophy of their Dada predecessors, looking outside of art for inspiration, and collaborating with a diverse cast of creative forces such as choreographer Merce Cunningham and composer John Cage.

The movement's most famous artists, Robert Rauschenberg and Jasper Johns, were outcasts in an art world filled with the larger-than-life Abstract Expressionists of the Cedar Tavern scene. Romantic partners and studio-mates, the pair opted for an art embedded in the everyday, rather than exploring the grand emotions set forth by their Abstract Expressionist predecessors—Johns in his hot-wax paintings of flags, targets and maps, and Rauschenberg in his combines, three-dimensional collages made of found objects, silkscreen and paint.

For his part, Duchamp disavowed his followers, declaring that they had turned his provocative Readymades into beautiful art objects. Nevertheless, the artists' use of found, pop culture imagery—such as Rauschenberg's silk screens of President John F. Kennedy and the moon landing—was the launching point for the Pop Art movement that followed. Some artists associated with the Neo-Dada movement, such as Claes Oldenburg, Larry Rivers

UNDERSTAND / CONCEPTS

Mixed Media, Use of Everyday Objects as Material or Theme, Appropriation of Pop Culture References, Collaboration

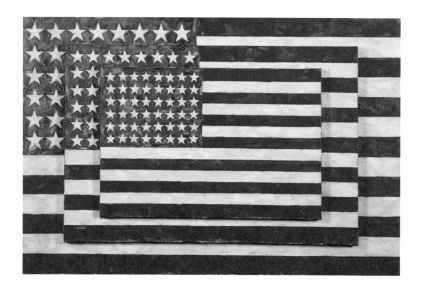

UNDERSTAND / KEY EXHIBITION

New Media, New Forms *Part One: June 6–24, 1960,*
Part Two: September 28–October 22, 1960; Martha Jackson Gallery

In 1960, gallerist Martha Jackson brought together artists from 20 galleries (including her own) for a two-part show called "New Media, New Forms." The quirky show puzzled and delighted critics, including John Canaday of *The New York Times* who called the show's first installment "wild and wacky," and gushed about "just about the gol' darnedest collection of seventy-two objects that you ever saw in your life." The artwork filled the gallery, extending even to the elevator, featuring Dada pioneers like Kurt Schwitters, as well as younger artists revisiting the anti-art energy of Dada and the psychological territory of Surrealism, including Robert Rauschenberg, Jasper Johns, Jim Dine and Bruce Conner.

UNDERSTAND/ IMPORTANT FIGURES

Jasper Johns (born 1930) Johns skyrocketed to art-world fame with his 1958 solo exhibition at Leo Castelli Gallery, where he first showed his flags — encaustic (hot wax) paintings over collaged newspaper. Now iconic works, these early images caused viewers to look at familiar objects with new eyes and left the interpretation open-ended.

Robert Rauschenberg (1925-2008) Rauschenberg's early mixed media collages, called "combines" by the artist, merged painting and found-object sculpture into a new form of art that transcended traditional modes of art making.

Claes Oldenburg (born 1929) Stockholm-born and Yale-educated, Oldenburg is best known for his oversized sculptures of everyday objects — clothespins, spoons and stamps — as well as his soft sculptures of hamburgers, pies and toilets.

Jim Dine (born 1935) Along with Claes Oldenburg, Dine forms a bridge between Neo-Dada and Pop Art. Dine was also a pioneer of multimedia proto-Performance Art "Happenings" with the likes of Red Grooms and Allan Kaprow.

Larry Rivers (1923-2002) Rivers was a painter who worked in a language of familiar objects, adding an all-over AbEx finish to such familiar images as cigarette packages and the iconic painting *Washington Crossing the Delaware*.

BLACK MOUNTAIN COLLEGE

In 1933, John A. Rice founded an alternative educational institution in a quiet Asheville, North Carolina. He named it Black Mountain College and in its brief, 24-year history it went on to become one of the most influential creative hubs of the 20th century.

At the core of Rice's beliefs was the idea that art-making is a crucial part of a well-rounded liberal arts education. He hired Abstract painter Josef Albers as the college's first art teacher and soon attracted the likes of Buckminster Fuller, Elaine de Kooning and Cy Twombly.

It was here that John Cage staged his first Happening, and where the experimental composer met his longtime collaborator in the choreographer Merce Cunningham. In 1948, Robert Rauschenberg, followed his then-girlfriend to the college, where he studied under Albers, rejecting his teacher's disciplined and anti-experimental approach.

Though the college closed its doors in 1957, the friendships forged at Black Mountain College continued in New York, influencing—and linking—a generation of the city's key artistic figures.

OPPOSITE: Jasper Johns, Three Flags, 1955

SMOKE PAINTING

Light canvas or any finished painting
with a cigarette at any time for any
length of time.
See the smoke movement.
The painting ends when the whole
canvas or painting is gone.

1961 summer

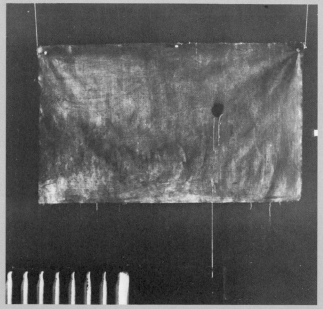

Yoko Ono,
Smoke Painting,
1961

FLUXUS

In 1963, an international group of artists wrote a manifesto urging artists to "purge the world of dead art, imitation, artificial art, abstract art, illusionistic art, mathematical art." Instead, they looked to revolutionize the world through "living art, anti-art and non-art reality," and bringing art into the everyday. They called themselves Fluxus, a term coined by artist George Maciunas in 1961 from the Latin word meaning "flow," as a reference to their "intermedia" work. These artists prized collaboration and experimentation, working in all media from performances and concerts to experimental poetry and mail art. More of an attitude than a movement, Fluxus combined political action and social critique with a D.I.Y. aesthetic and an absurdist edge.

ARTISTS ASSOCIATED WITH FLUXUS

George Maciunas (1931-1978) Inspired by experimental musician John Cage, Maciunas was the founder of Fluxus and its early home, AG Gallery. The artist organized influential concerts and performances including 1962's *Piano Activities*, in which a group of artists "played" a piano with saws and tools until it was destroyed.

Yoko Ono (born 1933) One of the first artists to experiment with Performance Art and Conceptualism, Ono's work has been prolific and wide-ranging. She played host to early Fluxus performances, while developing her own brand of work that encourages viewers to rethink the meaning of art.

Nam June Paik (1932-2006) Paik is credited as the founder of Video Art. His earliest work used magnets to distort televisions and combined music, performance and recorded imagery.

La Monte Young (born 1935) Pioneering minimalist composer Young was an early performer at Yoko Ono's 112 Chambers loft. His early work consisted of dreamy scores of haiku-like text.

George Brecht (1926-2008) Conceptual artist and composer Brecht was a close associate of George Maciunas. He studied with John Cage at the New School of Social Research, where he developed the event score. Brecht was an early proponent of participatory work that depended on audience interaction.

PO

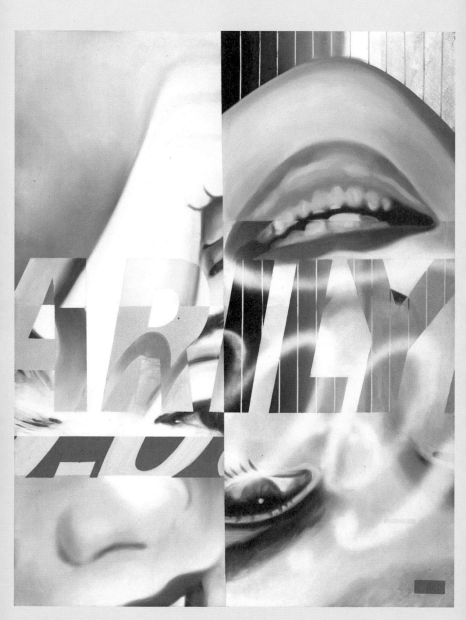

James Rosenquist, <u>Marilyn, I</u>, 1962

IN THE YEARS FOLLOWING WWII, THE PROLIFERATION OF MASS-PRODUCED MIDCENTURY POP CULTURE FOUND ITS WAY INTO ART. BEGINNING IN BRITAIN, ARTISTS SUCH AS RICHARD HAMILTON COMBINED COMICS, ADVERTISEMENTS AND IDEALIZED MAGAZINE SPREADS INTO COLLAGES THAT COMMENTED ON EVERYDAY LIFE.

By the time it reached New York, Pop Art was bigger than ever. As American artists mined advertising, movies and print media for source material,their works began to take on the cool gloss of commercial art. This new type of slick, satirical imagery was a direct reaction to the heroic figures of Abstract Expressionists. Instead of reflecting the artist's inner world, these paintings took on the guise of mass-produced imagery and reflected culture at large.

Among the most enduring images of Pop Art are Roy Lichtenstein's spotted canvases. In these thoughtful plays on print media, Lichtenstein exaggerated the printer's Ben-Day dots into an abstract pattern, pulling images from comics and reproducing everyday objects in his signature style. James Rosenquist pulled images from multiple sources, remixing them into his own compositions and building upon the found-image silkscreen collages of Robert Rauschenberg. Larger-than-life artist Andy Warhol marketed himself as a brand name — painting celebrities and creating so-called Superstars until he himself surpassed his fifteen minutes of fame.

UNDERSTAND / CONCEPTS

Mix of High and Low Culture, Commercialism and Mass Media, Kitsch, Irony

UNDERSTAND / IMPORTANT FIGURES

Andy Warhol (1928-1987)The king of Pop Art's life was as much a work of art as his famous silkscreen prints, paintings and films. Warhol began his career as a commercial artist, and burst onto the fine art scene in 1962 with his mass-produced images of icons of both culture and commerce: Marilyn Monroe, Campbell's soup cans and dollar bills.

Roy Lichtenstein (1923-1997) Lichtenstein brought comics to the gallery, blowing up kitsch cartoon images until the newsprint style Ben-Day dots — which he painstakingly created by hand — were visible.

James Rosenquist (born 1933) After training as a billboard painter, Pop Art pioneer Rosenquist continued making larger-than-life images, layering pop culture motifs in a deadpan style that echoed his commercial background. Unlike his Pop peers, Rosenquist dealt with politics head-on and reconstructed the source imagery he reproduced.

Marisol (born 1930) Marisol Escobar was born in Paris and studied at the Art Students League where she befriended the Abstract Expressionists of the Cedar Tavern scene. She went on to star in two Andy Warhol films, all the while creating her own brand of Pop: satirical paintings of contemporary culture and life-sized

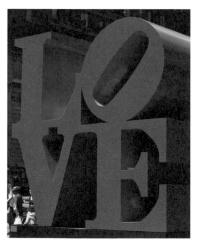

sculptures that blend pre-Colombian and Catholic traditions.

Tom Wesselmann (1931-2004) Wesselmann began his career as a cartoonist and continued using bold planes of primary color and found-art imagery in his mixed media collages.

Robert Indiana (born 1928) Commercial art is at the core of Indiana's text-based graphics and sculpture, including his iconic *LOVE* design.

Alex Katz (born 1927) Originally a commercial muralist, Katz became known for his simple, yet surprisingly

commercial muralist, Katz became known for his simple, yet surprisingly moving, portraits, including many of his wife and muse Ada. By reducing the figures to simple, flat forms and giving his work intentionally vague titles (an article of clothing, a date or a detail of the image), Katz allows the viewer to interpret the image.

George Segal (1924-2000) Segal's life-sized plaster figures are blank representations of urban archetypes.

UNDERSTAND/ KEY EXHIBITION

The New Realists
October 31–December 1, 1962
Sidney Janis Gallery

Pop Art hit the New York scene with "The New Realists," a group show of international artists at Sidney Janis Gallery. Among this international crowd, the Americans were the clear stars: Andy Warhol's paint-by-number landscapes and Tom Wesselmann's appropriated mix of art history and advertising, as well as work by James Rosenquist, Robert Indiana, Claes Oldenburg and George Segal. The show was a smash.

"The American products are the most interesting, mainly because they have a zany sprightliness, as wisecracking sophistication like a stand-up comic before a good audience," wrote Brian O'Doherty in his *New York Times Review*, "'Pop' Goes The New Art." "Techniques may not be particularly new here, but the brightly satiric content is."

Despite the positive critical response, the show was not entirely a success. As a result of the exhibition, Janis signed Dine, Oldenburg, Segal and Wesselmann, but lost Mark Rothko and most of his Abstract Expressionist stable in protest.

LEO CASTELLI

Few names are as important in 20th-century art as Leo Castelli, the influential dealer who championed the likes of Jackson Pollock, Robert Rauschenberg, Jasper Johns, Roy Lichtenstein, Andy Warhol and Frank Stella.

Aristocratic and influential, Castelli was born in Trieste, Italy, in 1907. He made his way to New York in 1941 after several years on the European art scene with his wife Ileana Sonnabend, who would also make her name as one of New York's leading gallerists.

In 1951, Castelli curated the ground-breaking Ninth Street Show, an exhibition that announced the arrival of Abstract Expressionism. Castelli became closely linked to the group, many of whom—including Jackson Pollock, Cy Twombly and Willem de Kooning—exhibited at his influential Upper East Side gallery when it opened in 1957.

The following year, Castelli discovered the work of Jasper Johns on a visit to the studio of Robert Rauschenberg. He shifted his interest to Pop and, later, to Minimalism and Conceptual art.

A consistent figure on the cutting edge, Castelli set up a gallery in the heart of the bourgeoning SoHo scene in the 1970s. There, he met a young dealer named Mary Boone, who convinced him to do a dual exhibition of the work of Julian Schnabel—the show that launched Neo-Expressionism and created the art boom of the 1980s.

Castelli died in 1999. His gallery remains a feature on the Upper East Side.

For more information visit castelligallery.com.

OPPOSITE: Robert Indiana, <u>LOVE</u>

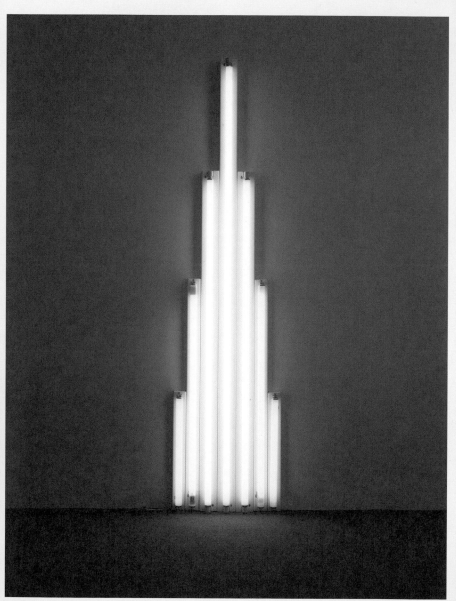

Dan Flavin, <u>Monument for V. Tatlin 1</u>, 1964

IN THE EARLY '60s, ABSTRACT ART REACHED ITS PUREST POSSIBLE FORM: THE GLOSSY BLACK CUBES AND STEEL PLANES OF MINIMALISM. THIS COOL, CALCULATED, CEREBRAL STYLE WAS A RESPONSE TO THE BOMBASTIC ART – AND ARTISTS – ASSOCIATED WITH ABSTRACT EXPRESSIONISM AND POP.

Mainly comprising sculpture, this new type of art first appeared in the early 1960s with the solo exhibitions of artists such as Donald Judd, Robert Morris, Dan Flavin and Carl Andre, all occurring between 1963 and 1965. Each of these early shows explored a different non-representational style, from Judd's flat planes and Morris' mirrored cubes to Flavin's explorations of fluorescent-lit space and Andre's stacked bricks. The one thing they had in common was the desire to remove all ornamentation.

Instead of projecting the inner life of the artist, these blank and anonymous works required the viewer to project her own meaning onto non-representational objects and the space around them. With self-expression removed, artists instead focused on the elemental ideas of form, color and value, much like the earlier Hard-Edge and Color Field painters working in two dimensions.

While Minimalism became one of the most iconic movements of the '60s, many well-known Minimalists rejected the title, deeming it derogatory — as well as alternatives such as ABC Art, Primary Structures and Cool Art. Judd preferred the term "specific objects" to describe his free-standing sculptures, and staunchly dismissed any idea that the style was even a movement, rather separate artists dealing with similar themes, independently, on their own terms.

UNDERSTAND / CONCEPTS

Form over Self-Expression, Clean Geometry, Mass Production, Repetition, Everyday Materials

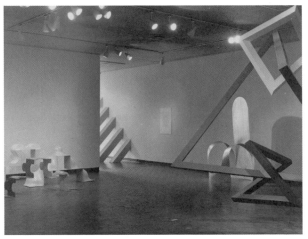

Judy Gersowitz, Rainbow Picket; Peter Forakis, JFK; William Tucker, Meru I, Meru II, Meru III; Forrest Myers, Zigarat

UNDERSTAND / KEY EXHIBITION

Primary Structures *April 27-June 12, 1966, Jewish Museum*

In 1966, curator Kynaston McShine brought together 42 American and British sculptors and abruptly changed the narrative of art history. Among the artists included at the The Jewish Museum show "Primary Structures" were a group who would go on to define Minimalism: Dan Flavin, Carl Andre, Donald Judd and Sol LeWitt. Also including Ellsworth Kelly, Robert Smithson and Judy Chicago, the show filled seven of the museum's galleries (plus the entryway and lobby) with colossal and cold geometric sculptures the likes of which no one had ever seen. Critics proclaimed the show a success and the birth of a new moment in art: "Everything here—their scale, their materials, their radical renunciations—is a reminder that a new esthetic era is upon us," wrote *The New York Times* critic Hilton Kramer in his review "'Primary Structures'—The New Anonymity."

UNDERSTAND / IMPORTANT FIGURES

Donald Judd (1928-1994) Judd, an art critic turned artist was one of the strongest opponents to the term Minimalism, as well as its best known practitioner. His aluminum, acrylic, Plexiglas, plywood and steel "primary structures"—often industrially manufactured—featured repetitive groupings of geometric figures, though he also explored furniture and architecture.

Carl Andre (born 1935) One of Andre's greatest contributions to art was removing the pedestal and placing his sculpture—often horizontal grids of bricks or sheets of metal and stone—directly onto the floor and inviting the viewer to walk upon it.

Dan Flavin (1933-1996) Flavin is best known for his work in neon—defining his art not by its physicality, but by the intangible aura created by the glowing tubes.

Sol LeWitt (1928-2007) In his early career, LeWitt worked in the Minimalist mode, building hollow, grid-like structures like the open, nine-cube structure included in the "Primary Structures" show.

Richard Serra (born 1939) Serra has worked in molten iron and one ton-blocks of lead, but is best known for his colossal sculptures in Cor-Ten steel.

Agnes Martin (1912-2004) Martin considered herself an Abstract Expressionist painter, but her use of grids and monochromatic canvases cause many to place her among the Minimalists. However, her work features a warmth and evidence of the artist's hand not usually found in Minimalism.

POST-PAINTERLY ABSTRACTION

While Minimalism was a largely sculptural practice, painters were exploring similar austere forms. Continuing the Modernist push of the Abstract Expressionists, while rejecting the AbEx idea of the heroic artist, these painters worked with pure color, removing any trace of the artists' hand. In 1964, the Modernist critic Clement Greenberg coined the term Post-Painterly Abstraction to describe these new paintings.

Their forms ranged from the Hard-Edge paintings of California artists John McLaughlin to the sweeping shaped canvases of Frank Stella. While the Hard-Edge painters refined the work of the earlier Color Field painters into coolly smooth surfaces of color, Stella pushed forward Greenberg's concept of all-over composition by integrating the canvas' shape into the composition itself.

ABOVE: Frank Stella,
Empress of India, 1965
OPPOSITE: Exhibition view, "Primary Structures," Jewish Museum, 1966

CONCEPT

wa·ter (wâ′tẽr), *n.* [AS. *wæter* = D. *water* = G. *wasser*, akin to Icel. *vatn*, Goth. *watō*, water, also to Gr. ὕδωρ, Skt. *udan*, water, L. *unda*, a wave, water; all from the same root as E. *wet*: cf. *hydra*, *otter*[1], *undine*, and *wash*.] The liquid which in a more or less impure state constitutes rain, oceans, lakes, rivers, etc., and which in a pure state is a transparent, inodorous, tasteless liquid, a compound of hydrogen and oxygen, H_2O, freezing at 32° F. or 0° C., and boiling at 212° F. or 100° C.; a special form or variety of this liquid, as rain, or (often in *pl.*) as the liquid ('mineral water') obtained from a mineral spring (as, "the *waters* of Aix-la-Chapelle".

Joseph Kosuth, 'Titled (Art as Idea as Idea) [Water], 1966

con·cep·tu·al art (kən'sep CH oōəl ärt), *n*. **BY THE LATE 1960s IT SEEMED PAINTING WAS DEAD, AND THE NOTION OF THE PRECIOUS ART OBJECT HAD GONE ALONG WITH IT.**

Throughout the decade, artists were questioning the very notions of art — namely the Modernist emphasis on formalism championed by critic Clement Greenberg — and the increasing commodificiation of the work of art. As if in protest, a wave of artists pushed the boundaries of Minimalism to the extreme and streamlined the art object until it no longer even existed.

Sol LeWitt was a leader in the move toward a form of art that existed mostly in the mind. Like others grouped under the Minimalist label (a term he did not approve of) Le Witt was included in "Primary Structures," the movement-defining Minimalist exhibition of 1966. He had begun working in sculpture, but by 1968 LeWitt was experimenting with a new way of making art — his famous *Wall Drawings*, artworks created by a team of assistants based on LeWitt's written instructions.

While artists such as Donald Judd had already used industrial manufacturers to fabricate their works of art, LeWitt's approach to art-making took the idea a step further. Instead of an object created from a set of specifications from the artist, a simple idea — or formula — was itself the artwork. As LeWitt wrote in his groundbreaking 1967 *Artforum* article "Paragraphs on Conceptual Art": "The idea itself, even if not made visual, is as much a work of art as any finished product."

In this way, many of the best-known Conceptual pieces exist only in their documentation — photographs, notes and other ephemera. In a radical departure, art had become intangible. All of a sudden, as the artist Lawrence Weiner stated, knowledge of a work of art became equal to ownership.

Meanwhile, other artists, such as Joseph Kosuth, explored different ways to create art without putting brush to paper, combining words and concepts. Kosuth's famous 1965 work, *One and Three Chairs*, now in the collection of the Museum of Modern Art, combines a photograph of a chair, a dictionary definition of the word chair and an actual chair. The work harkens back to the root of Conceptualism, which reaches back to Marcel Duchamp's early Readymades — appropriated objects elevated to the status of art simply by the artist's discretion.

UNDERSTAND / CONCEPTS

*Idea or Concept Over Form and Execution, Information as Art,
Language as Medium, Challenging the "Unique Art Object,"
Removal of "Caprice, Taste and Other Whimsies" (Sol LeWitt,
"Paragraphs on Conceptual Art") from the Making of Art ,
Documentation as Evidence of an Ephemeral Act*

UNDERSTAND / TEXTS

Sol LeWitt, "Paragraphs on Conceptual Art," *Artforum*, June 1967
Sol LeWitt, "Sentences on Conceptual Art," 0-9, 1969

UNDERSTAND / KEY EXHIBITION

Conceptual Art and Conceptual Aspects
April 10–August 25, 1970
New York Cultural Center

The 1970 exhibition "Conceptual Art and Conceptual Aspects" included
works from 29 artists from seven countries, including New York artists
Joseph Kosuth, Robert Morris, Adrian Piper, On Kawara and Lawrence
Weiner, California artists Ed Ruscha and Bruce Nauman, as well as the
British group Art and Language.
Much of the work in the show was text-based, leaving the show
"austere, scholarly and almost completely free of visual stimulation,"
wrote critic Peter Schjeldahl in his *New York Times* review, "Don't
Just Stand There—Read." One such piece was Kosuth's *Information
Room*, a collection of books and magazines from the artist's personal
collection —"a 'documentation' of the artist's mind" wrote Schjeldahl.

OPPOSITE: Lawrence Weiner,
Cat #151 (1970) EARTH TO EARTH ASHES TO ASHES DUST TO DUST, 1970

UNDERSTAND / IMPORTANT FIGURES

Sol LeWitt (1928-2007) Associated with several artistic movements including Minimalism, LeWitt was a pioneer of Conceptual Art, experimenting with work in which a vague set of instructions— not their outcome—was most important.

Joseph Kosuth (born 1945) Kosuth has explored ideas of understanding and meaning in his work, like *Five Words in Green Light*, 1965, a simple rendering of the title spelled out in green neon.

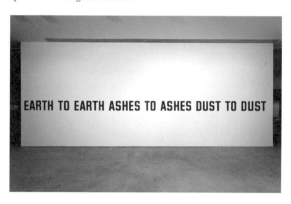

Lawrence Weiner (born 1942) Weiner was one of the first artists to experiment with language as a medium. In his 1968 *Declaration of Intent*, Weiner stated that it is inconsequential whether or not a work of art is ever built, fabricated or constructed.

Adrian Piper (born 1948) Since the beginning of her career, text has been an important part of Piper's practice. In a 2007 performance with Creative Time, Piper wrote the message "Everything will be taken away" on participants' foreheads. The message, written backwards to be read in a mirror, slowly disappeared over time.

Dan Graham (born 1942) In his early conceptual work, Graham rejected the notion of the gallery or museum by publishing his work in magazines. One such magazine series, 1966's *Homes for America*, commented on contemporary life with a combination of text and photography.

On Kawara (born 1933) Kawara is best known for his *Today Series* paintings. Begun in 1966, it includes thousands of canvases featuring only the day's date, each completed in a single day or destroyed. Thirty-six of these paintings—one for each year from 1966 to 2001—can be seen at Dia: Beacon.

PERFORI

IN
MANY
WAYS, THE
FAMOUS ACTION
PAINTINGS OF JACKSON
POLLOCK FROM THE LATE
1940s ARE CONSIDERED THE
FIRST EXAMPLE OF PERFORMANCE
ART. LAID ON THE FLOOR, THE CANVAS
RECORDED EVERY WHIP OF POLLOCK'S HAND
AS HE SPLATTERED PAINT ACROSS THE STUDIO.

Marina Abramovic, <u>Rhythm 5</u>, 1974

Throughout the 1950s, visual artists were experimenting with other performative forms, as in Robert Rauschenberg's collaborations with dancer Merce Cunningham, composer John Cage and the other members of the avant-garde to emerge from the Black Mountain College scene. These blurred lines set the stage for the first Happenings, experimental performance events hosted by the likes of Allan Kaprow, Red Grooms, Claes Oldenburg and Jim Dine at alternative downtown spaces like the Judson Gallery. Around the same time, the French artist Yves Kline invited viewers to watch as he painted with "living brushes," naked female models covering their bodies in his signature shade of blue paint.

Throughout the 1960s and '70s, performance would take many forms, influenced in equal parts by the experimental spirit of Dada, the anti-art sensibilities of Fluxus and the immateriality of Conceptualism. As artists explored the limitations of performance, the definition expanded to include all types of actions. These works ranged from the lectures of German artist Joseph Beuys to Vito Acconci's *Following Piece*, in which the artist followed strangers through the streets of New York City until they entered into a private space. Increasingly, the audience became less of a central figure as artists used photography, text, audio and film recordings to document their performative acts.

UNDERSTAND / CONCEPTS

Live Art Event
Art in Action Rather Than in the Object
Art as Ephemeral Moment
Combination Art and Music, Dance, Poetry and/or Film
Time-based Art Work

PERFOR

UNDERSTAND / IMPORTANT FIGURES

Allan Kaprow (1927-2006) Kaprow coined the term "Happening" for his 1959 event "Eighteen Happenings in Six Parts," a series of choreographed events at the Reuben Gallery in the East Village.

Red Grooms (born 1937) In the late 1950s, Grooms hosted a series of performances in his Delancey Street loft, including *Burning Building*, a scripted performance which, unlike the work of Kaprow and others, did not encourage audience participation.

Carolee Schneemann (born 1939) At the Judson Memorial Church, Schneemann became involved with such pioneering figures in performance as Allan Kaprow, Robert Rauschenberg and Jim Dine. Her performances range from the deeply personal to more collaborative works such as *Meat Joy*, a 1964 performance in which eight naked participants writhed in a sea of paint, chicken, sausages and raw fish.

Vito Acconci (born 1940) Vito Acconci has staged performances both inside and outside the gallery. In 1971, he took residence inside the Sonnabend Gallery for the exhibition *Seedbed*, masturbating under a raised floorboard while gallery goers walked above. His performative acts outside the gallery, such as *Step Piece*, in which he climbed a stepstool daily in his apartment, remain thanks to a combination of text and photographic documentation.

Marina Abramović (born 1946) Much of Belgrade-born artist Marina Abramovic's work has dealt with ideas of pain, endurance and the artist's relationship to the audience, such as 2002's *House With An Ocean View*, in which she lived in Chelsea's Sean Kelly Gallery for twelve days.

Laurie Anderson (born 1947) Since the late 1960s Laurie Anderson has explored the intersection of performance art, avant-garde music, experimental instruments and, more recently, video.

Ana Medieta, Film stills from <u>Untitled (Blood Sign #2 / Body Tracks)</u>, 1974

ANCE ART

UNDERSTAND / IMPORTANT SHOW

Eighteen Happenings in Six Parts
October 1959, Reuben Gallery

In 1959, Allan Kaprow presented a new type of art. He invited viewers to the Reuben Gallery, of which he was a co-founder, "to collaborate with the artist, Mr. Allan Kaprow, in making these events take place." The letter promised that not only would viewers experience the exhibition, they would also "become a part of the happenings."

Each of the 75 audience members were given cards which ushered them through a series of three rooms, each divided with plastic sheets and with its own lighting and musical score. Each room featured choreographed actions, including a man painting, a woman squeezing oranges and another drinking slowly from twelve glasses. At the beginning of each of the Happening's six parts, a bell was rung and each audience member was moved to a new room, so no person would experience all eighteen acts.

BODY ART As performance became a dominant art form throughout the '60s and '70s, artists increasingly used the human body as a medium, staging shocking feats of self-harm or extreme endurance. Body Art was particularly suited to the emerging feminist movement in art. In Interlor Scroll, 1975, Carolee Schneemann stood naked on a table in front of an audience and extracted a paper scroll from her vagina, from which she read a feminist text. Another artist to use the body was Ana Mendieta, whose poetic work includes Body Tracks of 1974.

SUICIDE OR SOMETHING SINISTER? THE DEATH OF ARTIST ANA MENDIETA

Scandal rocked the art world on September 8, 1985 with the mysterious death of Ana Mendieta, the 36-year-old performance artist and wife of famed sculptor Carl Andre. Mendieta had fallen from the 34th-floor window of the couple's Greenwich Village hi-rise; immediately, suspicions pointed to her husband. Andre was there when Mendieta fell and neighbors reported hearing the couple arguing. He called 911 and reported that his wife "went out the window."

The case caused a divide among the art world: those who supported Andre (including Frank Stella, who offered to pay Andre's $250,000 bail, Claes Oldenburg who offered Andre his apartment, and gallerist Paula Cooper) and those who spoke out for Mendieta, including feminist performance artist Carolee Schneemann. The public debate heated up when Andre went to trial in 1987, just three days after a retrospective of Mendieta's work opened at the New Museum in SoHo. Leading up to the exhibition, signs appeared around the city urging: "Suicide? Accident? Murder? Anyone With Information Please Call." Though no one claimed to have made the posters, many guessed it was the work of the Guerrilla Girls, an anonymous group of feminist artists. Andre was tried without a jury and acquitted.

DOCUMENTARY

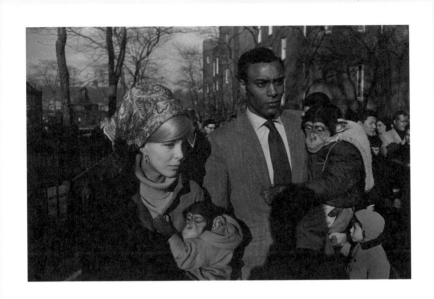

SINCE THE ADVENT OF PHOTOGRAPHY, ARTISTS HAVE USED THE CAMERA TO CHRONICLE THE WORLD AROUND THEM. BEGINNING IN THE NINETEENTH CENTURY WITH JACOB RIIS' **HOW THE OTHER HALF LIVES,** PHOTOGRAPHY WAS USED TO HIGHLIGHT SOCIAL ILLS. PHOTOGRAPHY WAS CONSIDERED A UTILITARIAN MEDIUM – A TOOL FOR PHOTO-JOURNALISTS AND FORMAL PORTRAITS.

PHOTOGRAPHY

By the 1960s, the advent of more compact camera equipment brought a new type of photographer onto the street. Using small- and medium-format cameras, they blended in, capturing the "social landscape" of everyday America.

But unlike those that came before them, the documentary photographers of the 1960s — Diane Arbus, Lee Friedlander and Garry Winogrand — weren't interested in capturing newspaper-worthy images. Instead, they focused on the kind of small, everyday occurrences and personal moments that might otherwise go unnoticed. For them, photography was a way to explore the world, not to explain it. "Photography is not about the thing photographed," said Winogrand. "It is about how that thing looks photographed."

Around 1965, the medium underwent a major change when Memphis photographer William Eggleston began experimenting with color. His saturated images of everyday American life helped color photography be accepted as an artistic medium. Other key figures using color photography to create documentary images include street photographer Joel Meyerowitz and large-format photographer Joel Sternfeld.

Since then, photographers have continued to use snapshot-style photography to record the world around them. Mary Ellen Mark has used the black-and-white snapshot to capture images of homelessness, drug addiction and prostitution, especially among children and young adults, in a combination of fine art and photojournalism.

UNDERSTAND / CONCEPTS

Snapshot Style , Capturing Moments from Everyday Life, Personal Subjects Over Social Concerns

Garry Winogrand, <u>Central Park Zoo</u>, New York City, 1967

DOCUMENTAR

UNDERSTAND / KEY EXHIBITION

New Documents *February 28 – May 7, 1967, Museum of Modern Art*

In 1967, the Museum of Modern Art's Director of Photography, John Szarkowski, proposed a radical exhibition. The show featured three little-known photographers — Diane Arbus, Lee Friedlander and Garry Winogrand — all under the age of 40, and all the recipient of at least one MacArthur "Genius" Award. He called the show "New Documents."

The show consisted of nearly 100 snapshot-like images. Winogrand and Friedlander's informal photos of city streets and sidewalks shared a gallery, while Arbus' more constructed, yet striking, medium-format portraits were given a gallery of their own. Szarkowski asserted that until that point, documentary photography had been used as a tool to point attention to social problems. But a new wave of artists was using photography to a more personal end. "Their aim has been not to reform life," he wrote, "but to know it."

UNDERSTAND / IMPORTANT FIGURES

Weegee (1899-1968) Born Usher Fellig, Weegee is the grandfather of documentary photography. He captured the street life of the Bowery and the underworld of crime in his candid photos taken for New York's tabloid newspapers.

Sid Grossman (1915-1955) In 1936, Grossman founded The Photo League, a group dedicated to using photography to highlight social value of the medium. He is best known for his scenes of Harlem life.

Lisette Model (1901-1983) A member of The Photo League, Model's frank and direct portraits convey a sense of grandeur in even the most humble of subjects.

Diane Arbus (1923-1971) Having studied under Lisette Model, Arbus is best known for her medium-format portraits of misfits and outcasts ranging from dwarfs to transvestites to triplets.

Lee Friedlander (born 1934) Friedlander captures the "social landscape" of urban street life — signs, storefronts and strangers — in black-and-white 35mm.

Garry Winogrand (1928-1984) Winogrand's photographs document the hidden — and often humorous — moments of New York City life, from a night at hot spot El Morocco to a day spent at the zoo. Famous for his prolific image-making, Winogrand left thousands of undeveloped rolls after his death. He was sometimes accused of setting up his photos, to which he'd respond that you "couldn't make this stuff up."

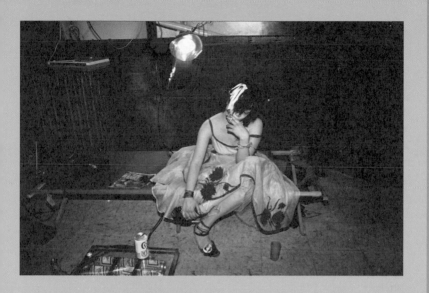

DOCUMENTARY PHOTOGRAPHY
AFTER NEW DOCUMENTS

Throughout the second half of the 20th century, a number of photographers turned their lenses towards contemporary city life. Perhaps the most well known is Nan Goldin, whose brutally honest snapshot-style photos documented the downtown scene of the 1970s and '80s. In saturated color, her famous slideshow *The Ballad of Sexual Dependency*, taken between 1979 and 1986, captures the darker side of sex, drugs and rock 'n' roll.

A generation later, Ryan McGinley began taking snapshots of his fellow skaters, slackers and artists, taking Polaroids of everyone who visited his Bleecker Street apartment and documenting their late-night antics. In 2003, he became the youngest-ever artist, at the age of 26, to have a solo show, called "The Kids Are Alright," at the Whitney. Since then he has begun exploring staged photos, many taken on his annual summer road trips.

Nan Goldin, <u>Trixie on the cot, NYC</u>, 1979

APPRO

IN THE LATE '70S AND EARLY '80S, A NEW GENERATION OF NEW YORK ARTISTS TACKLED THEIR DECADE'S SATURATION OF POP CULTURE IMAGERY AND 21ST-CENTURY OVERSTIMULATION. THESE ARTISTS – LATER DUBBED THE PICTURES GENERATION – TRANSLATED THE CULTURAL CITATIONS OF POP ART INTO A CONCEPTUAL FORM OF PHOTOGRAPHY, ONE WHERE THE SOURCE AND PROCESS BEHIND THE IMAGE SAID AS MUCH AS THE IMAGE ITSELF.

The group got its name from "Pictures," a landmark 1977 exhibition at Artists Space. The show included Robert Longo, Sherrie Levine, Jack Goldstein, Troy Brauntuch and Philip Smith. However, the artists who would become the movement's most famous members, Richard Prince and Cindy Sherman, weren't included in the show (although Sherman was the cover star of the group's 2009 retrospective at the Metropolitan Museum of Art).

Intelligent and highly versed in art history, these Postmodern artists came up through the art school system, many from the California Institute of the Arts and the State University of New York in Buffalo. They were extremely self-aware, and aware of the public's relationship to mass media. Together, they played with the abundance of images from TV and advertising, using images to explore how we see ourselves: Sherman's staged photographs investigate the archetypes of B-Movie starlets and, later, magazine centerfolds and fashion shoots. Prince pulled images from advertising, stripped the text, photographed the ads and presented these images as his own.

These artists delved into the collective memory, creating their own iconic images and blurring the lines between original and copy, between mass media and fine art. In the process they changed photography from a second-class practice to a tool for making conceptual art.

Sherrie Levine, <u>Untitled (President: 5)</u>, 1979

UNDERSTAND / CONCEPTS

Photography as Vehicle for Conceptual Art, Appropriation of Advertising and Mass Media Imagery, Juxtaposition of Conflicting Ideas/Images, Satire

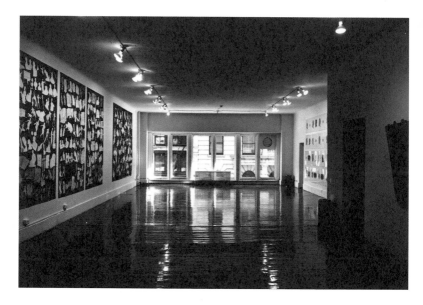

UNDERSTAND / IMPORTANT EXHIBITIONS

Pictures *September 24–October 29, 1977, Artists Space*

"For their pictures, these artists have turned to the available images in the culture around them," Douglas Crimp wrote in his essay for the exhibition "Pictures" at Artists Space in 1977. The essay defined a moment in time when artists who had come of age in a world of TV, fast food and Cold War paranoia dominated the downtown New York art scene.

The show included works from only five artists: Robert Longo's contorted cosmopolitan characters, Sherrie Levine's fashion magazine cut-outs, Jack Goldstein's three-minute video of a barking German shepherd, Troy Brauntuch's blend of photography and printmaking and Philip Smith's chaotic drawings. However small this group, Crimp's landmark essay signaled a new moment in art history, one that would be revisited by the Metropolitan Museum of Art with the 2009 show "The Pictures Generation."

UNDERSTAND / IMPORTANT FIGURES

Cindy Sherman (born 1954) To create her photographs, Sherman assumes alternate identities from film and other sources, then photographs herself in poses both arresting and vaguely familiar. Though slick on the surface, these images reveal their artificiality through hidden clues such as a camera's shutter release cord snaking through the frame.

Robert Longo (born 1953) For Longo's early series, "Men in the Cities," the artist photographed dancing figures mid-motion, then translated them to drawings, in the process transforming his No Wave contemporaries into iconic figures.

Barbara Kruger (born 1945) Text and photography combine to send in-you-face messages — "I shop therefore I am", "Your body is a battleground" — in Kruger's work.

Sherrie Levine (born 1947) Levine's appropriated images include Walker Evans photographs and images cut from magazines into the shapes of presidential silhouettes.

Laurie Simmons (born 1949) Simmons uses dolls and dummies to create domestic scenes that are both wholesome and creepy.

Richard Prince (born 1949) Stripped of their original context, Prince's photographs of print advertisements generate questions about who is the actual author of a work of art.

OPPOSITE: Douglas Crimp's "Pictures" exhibition at Artists Space, 1977
THIS PAGE: Jeff Koons, <u>Three Ball 50/50 Tank (Two Dr. J Silver Series, Wilson Supershot)</u>, 1985

NEO POP OR NEO GEO: THE APPROPRIATION OF JEFF KOONS

The "Pictures" artists weren't the only Postmodernists to mine pop culture for inspiration. Jeff Koons is a singular artist whose style is difficult to define, but he has always played with popular imagery with sinister glee and marketing savvy. His early work combined the austerity of Minimalism with mass-produced consumer products in Readymade-style sculptures. Koons has gone on to reference everything from the Pink Panther and Michael Jackson to magazine advertisements and pornography.

Koons burst onto the scene in 1986 with a show at the prestigious Sonnabend Gallery, along with Ashley Bickerton, Peter Halley and Meyer Vaisman, his colleagues from East Village gallery International with Monument. They were called "The Hot Four" and their diverse art described as Neo-Geo (short for Neo-Geometric Conceptualism), a term most closely related to Halley's paintings of cells and conduits.

Perhaps the closest relative to Koons is Takashi Murakami, a Japanese artist who explores the popular imagery of anime in his slick sculptures and "Superflat" paintings. Like Koons, Murakami uses a team of artists to create his artwork in his Kaikai Kiki workshop.

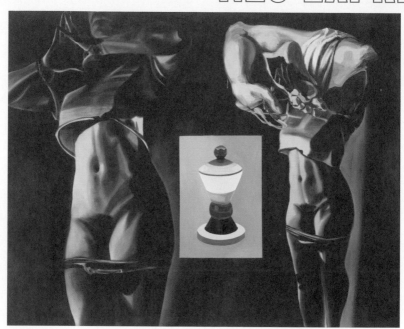

"PAINTING IS DEAD"

SEEMED TO BE THE BATTLE CRY AS ART MARCHED ON AFTER ABSTRACT EXPRESSIONISM. ARTISTS HADN'T STOPPED PAINTING, OF COURSE, BUT THE PRACTICE HAD BECOME TABOO, SEEN AS DECORATIVE AND ANTI-INTELLECTUAL.

In the late 1970s, painters began to show up again in New York's galleries. Not only were they painting, they reveled in the most loathed aspects of the medium: narrative, symbolism and the human figure. Though their styles varied—from Julian Schnabel's gestural brushstrokes to David Salle's cool, collage-like compositions—these artists shared an exuberance of color and line, as well as a heroic sense of purpose and belief in artistic self-expression.

As the Neo-Expressionists rose to celebrity status, prices soared. But critics weren't so quick to embrace the style. Some called it "Bad Painting."

David Salle, Gericault's Arm, 1985

Others dismissed dealer Mary Boone's growing stable of hot young painters as the product of a hype machine. Either way, the artists cornered the market, and their work is still found in prominent museums and private collections today.

New York's Neo-Expressionists weren't alone. Italy's Three Cs — Francesco Clemente, Enzo Cucchi and Sandro Chia — of the Transavantgarde, and a group in Germany had begun experimenting with paint again. These artists also worked with grand themes: Anselm Kiefer explored postwar German identity on canvases filled with straw, tar and paint, while Georg Baselitz painted twisted figures and a world of turmoil.

UNDERSTAND / CONCEPTS

Expressive Use of Paint, Primitivism, Figures and Narrative Subject Matter, Emotion over Logic

UNDERSTAND / KEY EXHIBITION

Julian Schnabel *April 4 – May 2, 1981*
Mary Boone Gallery & Leo Castelli Gallery

While working as a chef at hot spot One University, Julian Schnabel approached Mary Boone and invited her to visit his studio. She was stunned by what she saw there: massive canvases covered in wax and oil paint.

Boone began aggressively promoting Schnabel, and eventually convinced legendary dealer Leo Castelli — whose gallery was located in the same building — to give the artist a chance. "Here was something I was confronted with," Castelli told writer Anthony Haden-Guest. "It was like when I went to see Jasper in '57 or Stella in '59. It was a *coup de foudre*." With Schnabel, Castelli was able to align himself with a rising star, while Boone and her artist gained the approval of the old guard. Reviews were mixed, but the show was impossible to ignore.

"For eyes starved by the austere nourishments of Minimal Art, Mr. Schnabel's work provides the pictorial equivalent of a junk-food binge," wrote Hilton Kramer in *The New York Times*. "It is understandable, therefore, if it causes a certain amount of indigestion in the process."

NEO EXPRES

UNDERSTAND / IMPORTANT FIGURES

Philip Guston (1913-1980) Guston was a contemporary of the Abstract Expressionists, but in the 1960s the painter abandoned pure abstraction and began painting humorous, cartoon-like figures that would lead the way for the Neo-Expressionists in New York.

Julian Schnabel (born 1951) In 1981, Schnabel burst onto the scene with a dual show at the galleries of Mary Boone and Leo Castelli. Monumental in their scope, Schnabel's paintings referenced art history and religion, using a field of broken crockery embedded in putty to create a jagged surface for his impasto brushstrokes. With his larger-than-life personality (and ego to match), Schnabel became the most notorious artist of the '80s, considered by some a symbol of the decade's over-hyped market. He has since gone on to become a successful film director.

David Salle, *Muscular Paper*, 1985

David Salle (born 1952) Part of the original Mary Boone stable, Salle studied under John Baldessari at CalArts, where he developed a style that combined Pop Art pastiche with a renewed interest in figural painting.

Francesco Clemente (born 1952) Clemente was one of the "Three Cs" of the Italian Transavantgarde before he moved to New York in 1981. His work combines Surrealist and Expressionist styles with epic themes from history and religion, and influences from his extensive travels in India.

Eric Fischl (born 1948) Fischl joined Mary Boone gallery in 1984, after the initial Neo-Expressionist explosion. His paintings include images of affluent American life, at once grotesque and utterly banal.

Jean-Michel Basquiat (1961-1988) Basquiat got his start in the graffiti scene, but his mature paintings shared with the Neo-Expressionists an interest in history, world cultures and the formal qualities of color and brush stroke.

GRAFFITI

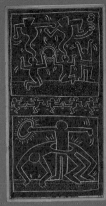

As painting popped up in New York's galleries, it was also showing up in the city's subways and streets in the form of graffiti. In 1981, Blondie's video "Rapture" introduced the hip-hop scene to post-punk. That same year, underground film star Patti Astor opened the Fun Gallery in the East Village, showing graffiti artists Fab 5 Freddy, Lee Quinones, Futura 2000 and Jean-Michel Basquiat. Soon limos were pulling up to East Village galleries in search of the next big thing.

The gallery was the epicenter of the scene until it closed in 1985 due to rising rents in the area. While some Fun artists—including Basquiat, Kenny Scharf and Keith Haring—successfully crossed over into the fine art scene, others were abandoned by the art world when artistic tastes moved on. The graffiti scene's art-world rise is captured in the 1983 film Wild Style, starring Astor and a number of Fun Gallery regulars.

Keith Haring, Untitled (Subway Drawing), 1983

MARY BOONE

Mary Boone Gallery: Julian Schnabel 1979 and 1981, (bottom) David Salle, Julian Schnabel and Ross Bleckner (1980)

Mary Boone was only 26 years old when she opened her gallery in 1977 at 420 West Broadway, in the same building as leading gallerists Leo Castelli and Ileana Sonnabend. Her first two artists, Julian Schnabel and David Salle, were painters at a time when the medium was taboo, and their work (along with Schnabel's larger-than-life persona) attracted major international attention. In 1981, Boone convinced Castelli to co-host a show of Schnabel's work, aligning herself and her artist with one of art's most powerful names. New York magazine proclaimed her "The New Queen of the Art Scene," and her fashionable roster was the epicenter of the Neo-Expressionist explosion.

Along the way, her red-hot gallery grew to include Ross Bleckner, Eric Fischl, Francesco Clemente and Jean-Michel Basquiat. Boone aggressively courted collectors, driving up prices and introducing a waiting list for work not yet produced. When the market came crashing down in 1991, some were quick to blame Boone's approach for inflating the market. She has since rebounded, and though Schnabel left the gallery, Boone still represents Salle, Bleckner and Fischl, plus exciting new additions like Will Cotton, Aleksandra Mir and Terence Koh. Boone's galleries—now located in Chelsea and Midtown—remain among the most exciting in the city.

INSTA

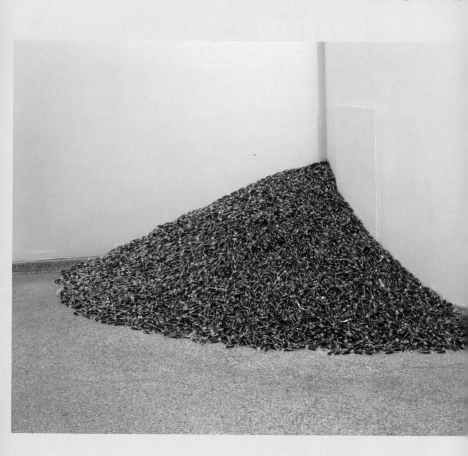

Felix Gonzalez-Torres, Untitled (Public Opinion), 1991

INST-ALLATION ART CONSISTS OF SITE-SPECIFIC WORKS THAT CHANGE THE AUDIENCE'S EXPERIENCE OF A SPACE. THIS CAN RANGE FROM SUBTLE CHANGES IN TEMPERATURE, LIGHT OR SOUND, TO DRAMATIC SCULPTURAL ASSEMBLAGES.

One of the first of such works was Allan Kaprow's *Apple Shrine* of 1960. To create his "environment," the artist transformed Judson Gallery into a fun-house maze, complete with crumpled newspapers and bare light bulbs swinging from the ceiling. Critics were not sure how to respond to this ephemeral new art. "Admittedly, Mr. Kaprow's art causes problems. The exhibition is now dismantled, its materials have been carted away by the junkman and it will not be seen again," read the exhibition's *Village Voice* review.

By the late 1960s, artists were creating site-specific works outside of the gallery space. Perhaps the most famous earthwork is Robert Smithson's *Spiral Jetty*, a 1,500-foot-long coil of rock, salt and mud created on the shore of the Great Salt Lake in 1970. Another well-known creator of environmental artwork was the duo Christo and Jeanne-Claude, who used fabric in projects including the wrapping of the Reichstag and *The Gates*, a series of more than 7,500 orange vinyl "gates" in New York's Central Park in 2005.

Installations range from the temporary to the permanent, and can be independent works of art or used in conjunction with other media, such as video, sound or performance.

UNDERSTAND / CONCEPTS

Art Directly Related to Space, Shifting the Experience of an Environment, Art That Envelops the Viewer, Art as Experience Rather than Object

UNDERSTAND / SEE IT

Walter De Maria, *The New York Earth Room* *141 Wooster Street*

One of SoHo's most surprising secrets is Walter De Maria's *The New York Earth Room*. The long-term installation, created in 1977, consists of 250 cubic yards of earth, 22 inches deep, filling a room located on the second floor of a nondescript building. The sheer vastness of damp dirt fills the room with an earthy humidity, adding to the unexpected experience. The installation is maintained by the Dia Art Foundation, which regularly waters the dirt and prevents mushrooms from growing.

James Turrell, *Meeting, PS1, Queens*

James Turrell is one of the most ambitious and adventurous artists working today. Much of his work manipulates light as a medium. In 1986, Turrell created *Meeting* at PS1 in Queens. The work, which Turrell calls a "skyscape," consists of a room with a hole cut in the ceiling. The room opens daily one hour before sunset, weather permitting.

As viewers sit facing each other, the sky above — which initially appears to be the room's ceiling — transitions. Clouds roll by and light changes as the sun sets.

UNDERSTAND / IMPORTANT FIGURES

Walter De Maria (born 1935) De Maria's work combines the austerity of Minimalism with large-scale installations both indoors an out. In New York, the Dia Art Foundation maintains two long-term installations by the artist — *The New York Earth Room* and *The Broken Kilometer*, wherein 500 polished brass rods are arranged at precise increments.

Louise Bourgeois (1911-2010) Pioneering artist Bourgeois created large-scale installations full of symbolic sculptures rife with sexual symbolism and psychological tension.

Bruce Nauman (born 1941) Nauman uses light, video and objects to create immersive environments.

ATION

Ilya Kabakov (born 1933) Russian-born Kabakov creates cultural commentary though works such as *The Man Who Flew Into Space from His Apartment*, a room papered with Soviet propaganda, with a catapult and a hole in the ceiling, originally shown in the U.S.S.R. in 1968.

Jenny Holzer (born 1950) Conceptual artist Jenny Holzer uses text as a medium, by projecting messages — often simple "truisms" shown on a stock ticker — in various public spaces.

Felix Gonzalez-Torres (1957-1996) Cuban-born Gonzalez-Torres used installations as a way to comment on the AIDS crisis. In 1991, the artist created a poignant commentary on the loss of his partner, a series of billboards throughout the city showcasing an empty bed. Other works included strings of light bulbs, lit until they burned out, and large piles of candy or posters, which viewers were invited to take.

THE URBAN INTERVENTIONS OF GORDON MATTA-CLARK

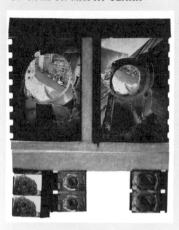

Gordon Matta-Clark used the urban environment as his canvas. Trained as an architect, Matta-Clark created work in the blight-ridden New York of the 1970s, photographing housing projects in the Bronx and purchasing undesirable slivers of unusable land from government auctions. He is best known for his building cuts, works where he used a chain saw to remove pieces from abandoned buildings. The most dramatic of these was <u>Splitting</u>, 1971, in which the artist cut a suburban New Jersey home in half. Matta-Clark documented his work in photographic collages, which show the dramatic interplay of light, texture and architecture created from the artist's cuts.

Gordon Matta-Clark,
<u>Conical Intersect</u>, 1975

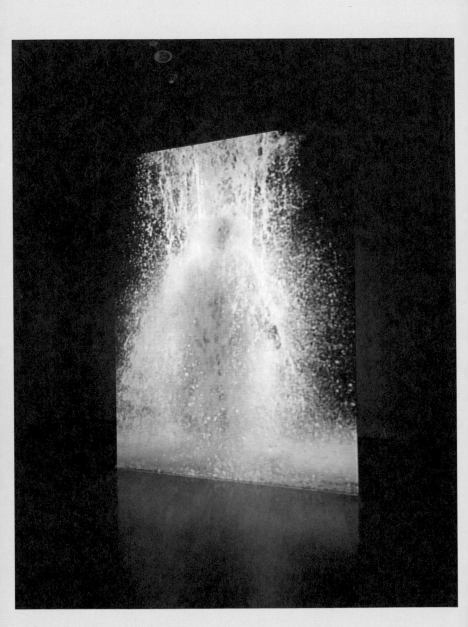

Bill Viola, <u>The Crossing</u>, 1996. Video/sound installation.

BY THE LATE 1960s, MARSHALL MCLUHAN HAD MADE HIS FAMOUS DECLARATION "THE MEDIUM IS THE MESSAGE" AND TELEVISION WAS QUICKLY ON ITS WAY TO BECOMING AMERICA'S MOST UBIQUITOUS MEDIUM.

Artists were eager to explore this new technology, but film was expensive and cumbersome, its use limited to art films like Andy Warhol's famous *Screen Tests*. In 1967, all that changed with the introduction of the Sony Portapak, the first camera that a single person could operate in the field, without a studio, assistants or the need to develop film. It was a landmark in the history of art and communication — video had become democratic.

At the same time, the art object had been questioned and artists were experimenting with ways to document performance art. One of the first people — let alone artists — to own a consumer camera was the Fluxus artist Nam June Paik. Paik had been experimenting with film and television since the early 1960s, using magnets to manipulate television screens and splicing together video clips from around the world. His earliest videos captured the pope's 1965 visit to New York City.

Throughout the '70s, video art mainly explored the limitations of the new medium, with little regard to plot or dialogue. Artists like Peter Campus took advantage of new techniques like blue screen and digital manipulation. These early works often depended on video's relationship to television, with many artists creating work to be distributed over cable access and others confronting the television's boxlike frame.

As video became more common, artists began to use the technology in new ways. Some, such as Bill Viola, have created longer-form narratives and large-scale works. Others, such as Tony Oursler and Doug Aitken, have used evolving technology to project video in site-specific installations; in Aitken's case, directly onto the façade of the Museum of Modern Art.

UNDERSTAND / CONCEPTS

Exploring the Limits of Technology, Playing with the Medium of Television, Television and Video as Mode for Artistic Communication

UNDERSTAND / IMPORTANT FIGURES

Nam June Paik (1932-2006) The Korean-born Fluxus artist was one of the first artists to explore the mediums of video and television. Paik's work involves the sculptural and performative aspects of video, as seen in his collaborations with cellist Charlotte Moorman, in which the musician "played" two televisions stacked in the shape of a cello, each of which displayed different videos as she moved her bow across the "instrument."

Eleanor Antin (1935) Since the late 1960s, Antin has explored ideas of identity by creating characters for herself in video, film, photography and installation. In the 1971 video, *Representational Painting*, the artist applies makeup to create a mask with which she presents herself to the world.

Peter Campus (born 1937) Campus was an early explorer of the limitations of various video technologies, as seen in works like 1973's *Three Transitions*, in which the artist uses a blue-screen to manipulate his own image in different ways: climbing through his body, burning his reflection and erasing his face.

Martha Rosler (born 1943) Rosler uses various media — spanning from performance to installation to video to combinations of photo and text — to deal with social issues. In her landmark 1974 video, *Semiotics of the Kitchen*, the artist parodies the television cooking show host, listing familiar items from the life of the housewife from A to Z, introducing each with increasing intensity.

Bill Viola (born 1951) Viola combines the epic concerns of art history — themes such as birth, death, love and religion — with the format of video. The 1995 work *The Greeting* recreates a 16th-century Italian painting, while the two-channel video *The Crossing* shows a larger-than-life figure emerging from water on one side and being consumed by fire on the other.

Matthew Barney (born 1967) Barney began using video to document his performance art while a student at Yale, but his best-known work is the Cremaster Cycle, a series that expands the art film to Hollywood proportions in a series of feature-length films spanning from 1994 to 2002.

ART

E: Nam June Paik, <u>TV Garden, 1974</u> (2000 version)
BAR: Still from Aleksandra Domanovic, <u>19:30</u>, 2010

UNDERSTAND / SEE IT

Founded in 1976 at the beginning of the media art movement, the Video Data Bank is dedicated to preserving and distributing videotapes by and about contemporary artists. The VDB is home to an archive of over 1,600 works dating back to the late 1960s, including videotaped performance pieces as well as early "guerrilla" documentaries.

Highlights include the Early Video Archive, featuring more than 200 videos from 1968 to 1980, and Independent Video and Alternative Media, a collection dealing with themes such as culture jamming, feminism, AIDS, gender studies and identity. Based at the School of the Art Institute of Chicago, the VDB is sponsored by the National Endowment for the Arts and the Illinois Art Council.

For more information, and to see the videos yourself, visit vdb.org.

NEW MEDIA ART

As early as the 1990s, artists began working with new technologies ranging from websites and e-mail to virtual reality. By the time art entered the 21st century, a new generation of artists—many raised on a steady diet of mass culture—began to respond to new, digital technologies.

Artists have dealt with the onslaught of new technology in myriad ways, from Cory Arcangel, who plays with the anachronistic simplicity of Nintendo and other technology from the recent past, to Ryan Trecartin, who revels in the over-saturated, over-stimulated media landscape of contemporary America in densely layered video installations.

Rhizome is an organization dedicated to the creation, presentation, preservation and critique of emerging artistic practices that engage technology, in partnership with the New Museum. Through open platforms for exchange and collaboration, the Rhizome website serves to encourage and expand the communities around these practices. Rhizome's programs, many of which happen online, include commissions, exhibitions, events, discussion, archives and portfolios.

For more information visit rhizome.org.

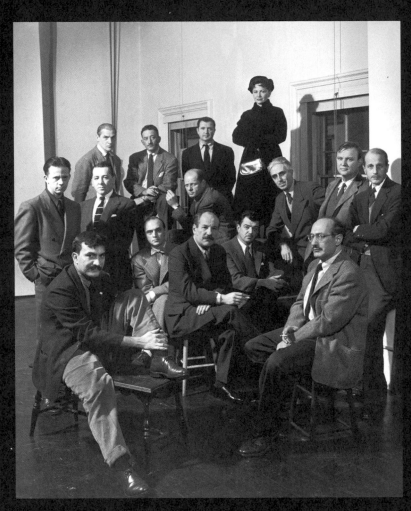

American abstract artists, The Irascibles: including William Baziotes, James C. Brooks, Jimmy Ernst, Adolph Gottlieb, Hedda Sterne, Clyfford Still, Willem de Kooning, Bradley Walter Tomlin, Barnett Newman, Jackson Pollock, Theodoros Stamos, Richard Pousette-Dart, Robert Motherwell Ad Reinhardt, and Mark Rothko. Photo by Nina Leen for Life magazine, 1950.

58 MARK ROTHKO

66 JACKSON POLLOCK

72 ROBERT RAUSCHENBERG

78 YOKO ONO

84 ROY LICHTENSTEIN

90 ANDY WARHOL

96 DONALD JUDD

102 CINDY SHERMAN

108 JEFF KOONS

MARK

Mark Rothko, 1961

MARK ROTHKO by Jordan Hruska

It might seem contradictory that Mark Rothko, a contentious curmudgeon who laid out strict ultimatums for abstract art, would all along advocate for an amorphous, subjective aesthetic, a style meant to invoke a profound, visceral feeling. But this isn't to say that Rothko was insensitive.

Looking at his painting, *No. 3/No. 13* (1949), completed early in his program of abstract registers of color, it's easy to classify the shapes in his painting as a series of lozenges or rectangles. To labor on their figurative definition, however, misses the real action; their presence is as important as the spaces between them. The idea of the void is important to sullen Rothko. He once said to the critic Harold Rosenberg, who recounted this in his 1970 *New Yorker* obituary for the artist, "I don't express myself in my painting. I express my non-self."

Mark Rothko was born Marcus Rothkowitz in Dvinsk, Russia (now Daugavpils, Latvia) in 1903, and emigrated with his family to Portland, Oregon, in 1913. By the time he moved to New York in the early 1920s he had picked up a populist edge and a suspicion of the inauthentic and bourgeois, dropping out of Yale because he considered it elitist. Throughout his life, his politics influenced his conception of art and colored him, at times, antagonistic.

"I DON'T EXPRESS MYSELF IN PAINTING. I EXPRESS MY NON-SELF."

In the early 1920s, New York was in the throws of a booming economy with skyscrapers racing upwards along with the stock market. Rothko found work as a cutter in the garment district, along with other odd jobs.

He discovered drawing after a visit to the Art Students League of New York and began taking art classes at the New School, then a hive of alternative thinking and education in Greenwich Village. Here, he was taught by artist Arshile Gorky, who was flirting with post-Impressionist and Surrealist styles, much like Rothko would several years later.

Rothko befriended the successful artist Milton Avery and ran in the circle of The Opportunity Gallery — formed as an alternative to the dealer-dominated system of Midtown galleries concentrated around 57th Street in 1927. Avery was a tremendous influence on Rothko's view of abstraction and the two became fast friends; Rothko often vacationed with Avery and his wife, Sally. In an interview, Sally Avery remembers how the young, ambitious Rothko first lived in an East Side tenement with a bathroom in the yard. Although he would socialize with the Averys in their more accommodating apartment, Rothko invited them over one night to his apartment, which doubled as his studio, and confused the teapot with his canvas glue container, mistakenly serving a toxic concoction to his guests.

Avery describes Rothko as neurotic to the point where he succumbed to hypochondria, checking himself into a hospital for three weeks to undergo treatments for a sickness the doctors never validated. "[Rothko] was always a brooding type of person, but we just considered that was the Russian in him," Avery said in an interview with the Smithsonian Institution's Archive of American Art.

In the early '30s, Rothko channeled German Expressionism, painting urban scenes not unlike those of Ernst Ludwig Kirchner. By now, the Depression was in full swing and Rothko was drawn to the underworld of the subways. In *Untitled (Subway)*, 1939, Rothko extends the subway tracks across an almost entire register of a vertical canvas, with an adjacent

subway platform rendered in plaster white with no shading to suggest depth. Three ghastly figures linger among the different depths of the platforms, one reading a newspaper, a fedora pulled low over his eyes. This almost architectural composition of floating rectangles would return in his later abstract works.

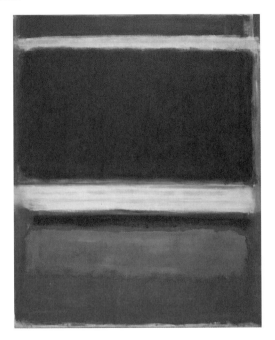

Mark Rothko, No. 3/No. 13, 1949. This painting, also known as Magenta,Black, Green on Orange, is one of Mark Rothko's best-known works and a highlight of the collection of the Museum of Modern Art.

Rothko and his peers were inspired by the European Surrealists to paint their most untenable emotions. And like his tight-knit predecessors, Rothko formed a group called "The Ten," comprised, deceivingly, of only nine artists—including Adolph Gottlieb and John Graham—whom were united against figurative representation in American painting. "A time came when none of us could use the figure without mutilating it," Rothko declared, responding to the need for new forms to express the powerful emotions that arose as a result of the Depression and World War II. Rothko galvanized the group, acting as its spokesperson, despite the fact that his paintings were considered by some critics to be the most unwieldy and undeveloped of The Ten.

In 1942, Rothko and Gottlieb were asked to exhibit works in Macy's department store. Rothko found inspiration in Greek myths and philosophy, translating these ideas to canvas in abstract forms he felt could represent the full complexity of emotion, subconscious and history. *The New York Times* critic Edward Alden Jewell was perplexed by the abstraction and dismissed both artists. The fiery Rothko responded with Gottlieb in a June 1943 editorial. "We do not intend to defend our pictures. They make their own defense. We consider them clear statements. Your failure to dismiss or disparage them is *prima facie* evidence that they carry some communicative power." The artists went on to sarcastically suggest a different mode of abstraction: "Would you have us present this abstract concept, with all its complicated feelings, by means of a boy and girl lightly tripping?"

"A TIME CAME WHEN NONE OF US COULD USE THE FIGURE WITHOUT MUTILATING IT."

At the time, abstraction bubbled up in galleries such as Opportunity and Peggy Guggenheim's Art of This Century, a bold institution that was a node for Surrealist and abstract art of international standards. Rothko exhibited at Art of This Century in 1945, showing works from the Macy's show, including *The Syrian Bull,* which he called a "new interpretation of an archaic image, involving unprecedented distortions." Most critics were unconvinced and the show was largely ignored. Rothko was furious and wrote another defense, "If I have faltered in the use of familiar objects, it is because I refuse to mutilate their appearance for the sake of an action which they are too old to serve."

The same year, Rothko was vindicated. He garnered raves at a group show at 67 Gallery called "A Problem For Critics." The gallery brought to-gether artists who would form the movement of American Abstract Expres-sionism including Rothko, Hans Hofmann, Jackson Pollock, Lee Krasner and Rothko's former teacher, Arshile Gorky. "I believe we see real American painting beginning right now," wrote the gallery's owner, Howard Putzel.

In 1949, Rothko reached a turning point in his work. He had long been mixing his own colors, but was now applying them with the ethereal sophisti-cation of Peter Bonnard, whose retrospective at the Metropolitan Museum of Art two years earlier inspired Rothko to be less concerned with the invention of forms and figures, and to use color as a vehicle for his spirituality instead. That year, he made his first painting for which most know him today: *No. 1, 1949,* a large, vertical canvas that is bracketed by a large zone of yellow color at the top, a larger block of orange color at the bottom and an area of blue and black in between with frenetic strokes of mustard-colored oil paint. Knowing

MARK

that this was a momentous turn, he began re-naming his works by numbers.

During the late 1950s, Rothko's works were heralded by critics and bought by museums worldwide and the artist produced—despite illness and instability in his personal life—approximately twenty canvases a year. Meanwhile, other Abstract Expressionist painters such as Jackson Pollock, Barnett Newman and Robert Motherwell matured around him. They held court downtown at the Cedar Tavern, an infamous dive that saw public urination from writer Jack Kerouac, drunken rants from Pollock and countless other legendary evenings. Rothko, too, partook in heavy drinking, a habit which contributed to his declining health in later years.

In January 1951, Rothko and seventeen other New York School artists were catapulted into the public sphere with a photograph published in *Life* magazine titled "The Irascible Eighteen." Despite his camaraderie with this group and their shared philosophy, the suspicious Rothko was careful about how he presented himself.

"Rothko was circumspect with how he discussed his work," says Emilee Dawn Whitehurst, Executive Director of the Rothko Chapel, a Rothko-conceived religious space in Houston, home to some of his final paintings. "He resisted any sort of classification or summation." He despised critics and wrote disparagingly about their craft in his personal writings and newspaper editorials, claiming that they were "parasites feeding on the body of art." Upon several visits to California, Rothko formed a great respect for his West Coast counterpart, abstract painter Clyfford Still, who was just as stubborn, cranky and suspicious of the art world business.

Although his fame grew, Rothko remained a purist at heart, and held fast to his very personal formula of abstract painting. In his personal writings, Rothko described the zones of color in his canvases as "actors" whose relationship on the canvas stood in for deep personal truths and emotions, rooted in concepts of tragedy. For Rothko, these shapes were activated by their sheer size on the humongous canvases, the luminosity with which they were painted and the charged spaces in between them.

Rothko's idealism eventually cost him a commission. In 1958, then-budding modernist architect Philip Johnson asked Rothko to paint a series of canvases for the interior of the Four Seasons Restaurant, located at the base of the Seagram Building, a landmark monolithic skyscraper Johnson co-designed with his mentor Ludwig Mies van der Rohe. The antithesis of the Cedar Tavern, it was envisioned as the most expensive restaurant in

"I BELIEVE WE SEE AMERICAN PAINTING BEGINNING RIGHT NOW."

Mark Rothko, <u>No. 1</u>, 1948. Mark Rothko began painting
"Multiform" works, like this painting from the Museum
of Modern Art, in 1946. By removing figures and other
recognizable forms, these paintings paved the way for
Rothko's mature Color Field works.

New York, where the upper class could feast on the finest French cuisine in a palatial dining room with an interior fountain. Although reports are conflicting, some suggest that Rothko took the commission out of spite, to nauseate bourgeois diners by using an unappetizing color palette and replicating the vertical bars of a jail cell. In any case, Rothko was unhappy with the intended placement of the work in the restaurant and returned his money to Johnson.

After this public controversy, Rothko dove deeper into the spiritual. His last major body of work strayed from the warm browns and reds of his earlier paintings and incorporated ominous shades of black, grey and blue. Made specifically for the chapel, they were intended to elicit universal emotions. "Rothko believed that painting could bring people to the threshold of the divine," says the Rothko Chapel's Emilee Dawn Whitehurst.

Some critics claim that Rothko was well aware of his mortality at this time — his health was waning from cirrhosis of the liver and emphysema — and that these works were his homage to finality. He painted in a studio on the Upper East Side, outfitted with a pulley system that could raise his enormous canvases. He hired two assistants to help him, because his health was failing after a prolonged aneurysm, which needed to be mediated

MARK

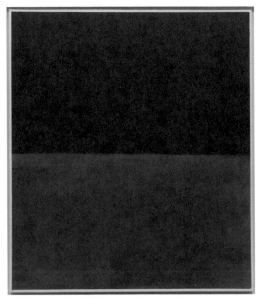

Mark Rothko, <u>Untitled (Black on Gray)</u>, 1969/70. Near the end of his life, Mark Rothko began working in a somber palette of blacks and grays, as seen in this canvas and the Rothko Chapel in Houston, Texas.

through a healthier diet and complete abstinence from alcohol and tobacco. But the stubborn Rothko ignored these orders. His discomfort caused his marriage to suffer, leading to divorce and a dark depression.

Before the chapel's dedication, Rothko committed suicide in 1970 by slitting his wrists and overdosing on anti-depressants, leaving his assistant to find him on the kitchen floor. By then, Abstract Expressionism had given way to the caprices of Pop. Ṁ

MARK ROTHKO IS COVERED IN THE MOVEMENT "ABSTRACT EXPRESSIONISM" ON PG. 10

ABOVE: The Kawamura Memorial Museum in Sakura City, Japan. The museum features seven of Mark Rothko's Segram Murals (right).

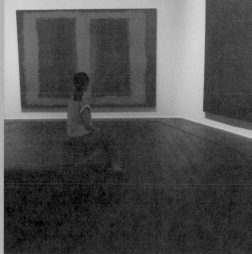

SEAGRAM MURALS GO GLOBAL

In 1958 Mark Rothko received the largest commission of his life — $35,000 to paint a series of murals for a new luxury restaurant designed by Philip Johnson for Ludwig Mies van der Rohe's brand-new Seagram Building. It was the most prolific commission of abstract art to that time, and MoMA director Alfred Barr had personally recommended the artist for the project.

Over the course of three months, Rothko painted dozens of massive canvases for the restaurant in his Bowery studio, dark works in deep reds, crimsons and maroons. He primed the canvases with red and blue pigments in heated rabbit skin glue, furiously applied to create an even maroon surface. On top, he slowly built up oil paint in various shades of black. When the Four Seasons opened, works by Jackson Pollock hung while the restaurant eagerly waited for Rothko's canvases. But they never arrived. The artist returned his commission and kept the paintings.

On the morning of Rothko's suicide in 1970, nine canvases arrived at London's Tate Museum (tate.org.uk). Other works from the series made their way to the Kawamura Memorial Museum (kawamura-museum.dic.co.jp) in Sakura City, Japan. The museum, which acquired the canvases in 1990, is located about an hour from Tokyo's Narita Airport by train and shuttle bus. Along with seven of the Seagram paintings, the museum boasts an impressive collection of postwar American art, including works by Barnett Newman and Frank Stella.

Jackson Pollock and Lee Krasner in Pollock's studio,
Springs, New York, 1950

JACKSON POLLOCK by Michael B. Dougherty

Jackson Pollock was introduced to the world with the question—"Is he the
greatest living painter in the United States?"—but New Yorkers already knew
the answer. *Life* magazine's August 8, 1949 profile of the artist, which opened
with this query, served as his entry into the American consciousness, but in
New York he'd been a fixture in the art scene's firmament for nearly twenty
years. Pollock, with his visionary style and self-destructive personal life,
had established himself as a leading figure of postwar painting, developing,
emerging and imploding within the parameters of the city.

 Jackson Pollock was born Paul Jackson Pollock on January 28, 1912 in
Cody, Wyoming. He spent his early years in Arizona and California absorbing
the local native artistic traditions, a later source of imagery and inspiration in
his own work. Indulging his growing interest in the arts while a high school

student in Los Angeles, Pollock ventured east to New York in 1930 to study with Thomas Hart Benton at the Arts Students League.

Benton was Pollock's mentor and teacher, but also his surrogate father in New York. Pollock developed a close relationship with the artist's entire family, babysitting the children, vacationing with them on Martha's Vineyard and selling painted ceramics out of Benton's gallery. During these early years in the city, Pollock lived a peripatetic existence downtown due to financial hardship, initially living with his brother Charles on West 14th Street. He would move often over the next few years: East 10th Street (1931), to Carmine Street (1932), to East Eighth Street (1933), to 76 West Houston Street (1934), and finally, back to East Eighth Street (1935-45).

JACKSON POLLOCK WAS INTRODUCED TO THE WORLD WITH THE QUESTION,"IS HE THE GREATEST LIVING PAINTER IN THE UNITED STATES?"

At this time New York was—along with the rest of the country—firmly in the grip of the Great Depression, and Pollock was feeling the squeeze. In February of 1935 he sought out work from the Emergency Relief Bureau, an early social services organization, which found him a job cleaning the statue of industrialist Peter Cooper in the East Village's Cooper Square. Prior to this, Pollock had worked briefly as an art teacher for the City and Country School, on West 13th Street, and as a janitor at Greenwich House Annex on Jones Street. His situation was dire enough that there are even stories of Pollock and his brother Sande stealing food and fuel to survive while living together on West Houston Street, where they were without heat.

In a reaction to the desperation surrounding them, a number of unemployed artists in the city (such as Gertrude Greene and Ilya Bolotowsky) formed the Artists' Union, a group that agitated the government and private institutions for relief. By August, the government had created the Federal Art Project—part of the Works Progress Administration—that would finally bring Pollock some financial stability, and thus a chance to develop his art. He was also interacting with his artistic contemporaries in the city, attending influential exhibitions such as the Museum of Modern Art's "Cubism and Abstract Art." In 1936, the politically charged Mexican muralist David Alfaro Siqueiros was in town to host an experimental workshop. It was here that Pollock first dabbled with liquid paint and a kinetic style of pouring and splattering that Siqueiros encouraged with a mantra of "anything but brushes." The experience would become a watershed moment in Pollock's evolution

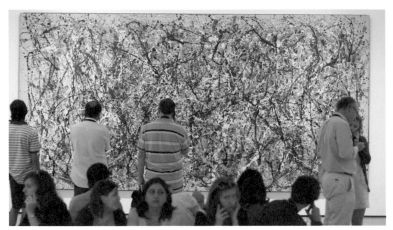

Jackson Pollock, <u>One: Number 31, 1950</u>. At the Museum of Modern Art audiences ponder a wall-sized painting by Jackson Pollock, one of the largest Pollock ever created and a masterpiece of his Action Painting style. To create this painting, Pollock placed the canvas on the floor and splattered paint directly from the can and with brushes and sticks.

towards Abstract Expressionism.

For the remainder of the '30s and early 1940s, Pollock worked in the Federal Art Project's easel-painting divisions, refining his personal style, which began to emulate the symbolism of the Surrealist painters he greatly admired. But as Pollock crystallized into a mature artist, his personal tumult cast a growing shadow. All throughout his adult life Pollock had struggled with crippling alcohol abuse and by 1937 his brother Sande was sufficiently concerned that he asked Jackson to undergo psychiatric treatment. Over the coming years Pollock would try several therapists, alternative medicine and even volunteer for in-patient hospital treatment, but the alcoholism would forever haunt and define him. His fa-

POLLOCK'S TEACHER DAVID SIQUEIROS ENCOURAGED A KINETIC STYLE OF POURING AND SPLATTERING WITH A MANTRA OF "ANYTHING BUT BRUSHES".

vorite bar was the now-closed Cedar Tavern on University Place, where a who's-who of beat poets and Abstract Expressionists socialized, including Willem de Kooning, Mark Rothko and Franz Kline. During one especially rowdy night, Pollock kicked the men's bathroom door off its hinges. "It colored every aspect of his life, everything," says Helen A. Harrison, director of the Pollock-Krasner House and Study

Center in East Hampton, New York. "There was nothing that was not touched by his alcoholism."

In early 1942, Pollock's career received a huge break when he was asked to exhibit alongside Pablo Picasso, Henri Matisse and other European heavyweights at the McMillen Gallery. His work received a critical review for the first time in *ARTnews*, but, more importantly, he met the only female participant in the show, artist Lee Krasner—his future wife. It was also in that year that another important woman in Pollock's life appeared, Peggy Guggenheim. An avid collector and patron of the arts, Guggenheim was a modern-day Medici who had returned from living in Europe determined to find a home for her expanding modern art collection. She opened a gallery on West 57th Street called Art of This Century and, with the encouragement of her friend Marcel Duchamp, gave Pollock his premiere solo show: "First Exhibition: Jackson Pollock, Paintings and Drawings."

"What we need is more young men who paint from inner impulse without an ear to what the critic or spectator may feel—painters who will risk spoiling a canvas to say something in their own way. Pollock is one," James Johnson Sweeney wrote in the exhibition catalog. *The New Yorker* quipped, "At Art of This Century there is what seems to be an authentic discovery—the paintings of Jackson Pollock." The show kicked off a long and fruitful relationship between Guggenheim and Pollock. She made a then unheard-of move, by signing him to a one-year, $150 per month contract so that he could paint freely. She also commissioned a mural for her East 61st Street townhouse, and would buy paintings as gifts for her friends and herself.

While purely professional, despite what others have suggested over the years,

LEE KRASNER

Lee Krasner was born Lena Krass-ner in Brooklyn, New York, in 1908. She studied at the Women's Art School of the Cooper Union, the Art Student League and the National Academy of Design, but clashed with the traditional ap-proach of her instructors.

By 1937 Krasner had begun to explore New York's bohemian underground, and with Hans Hofmann she experimented with adventurous European techniques of Surrealism and Cubism, which became major influences on her work. In 1942, Krasner was included in an exhibition with a young artist named Jackson Pollock. Surprised to discover an artist she did not know, Krasner turned up at Pollock's studio unannounced and one of art's great partnerships was born.

They married in 1945 and moved to rural Springs, New York. Around this time, Krasner embarked on some of her best-known works, the "Little Images" paintings—tight compositions in which calligraphic symbols fill a grid of rectangles. Throughout her career, Krasner continued to refine her style, sometimes destroying earlier canvases, or reworking them into Matisse-inspired collages.

Lee Krasner, <u>Gaea</u>, 1966.
Throughout her career, Lee Krasner experimented with a number of different styles. Her later work, such as this piece fro m the Museum of Modern Art , shows a looser, more organic approach.

Jackson Pollock, <u>Easter and the Totem</u>, 1953. Late in Pollock's career, figures and symbolic imagery began reappearing in the artist's work, as in this example from the collection of the Museum of Modern Art.

Pollock and Guggenheim's relationship was not without its difficulties. Guggenheim's rarified world of socialites and collectors disconcerted Pollock, who nonetheless depended on their patronage. Upon installing a mural at Guggenheim's townhouse, Pollock got drunk, wandered naked into a party in the sitting room and urinated in the fireplace. As for Guggenheim, when she returned to Europe in 1947 she wrote to Pollock's new gallerist, Betty Parsons, to bitterly express what she viewed as his lack of gratitude for all she'd done for him.

In the February 1944 issue of *Arts and Architecture* magazine, Pollock said of life in the city, "Living is keener, more demanding, more intense and expansive in New York than in the West." But Pollock was also being crushed by the weight of it, the drinking having cost him friends and jobs. Now married to Krasner, Pollock purchased (with a loan from Guggenheim)

a ramshackle farmhouse in Springs, a neighborhood of Long Island's East Hampton, in 1946. "Jackson told [a local shopkeeper] more than once that he didn't really move to the country, he moved away from the city. It was killing him," says Harrison.

A small barn on the property became the site of some of Pollock's most famous works. He converted it into a studio, with a small, single-story entry leading into a larger workspace. Without heat or artificial light, Pollock danced, dribbled, splashed and ashed upon large canvases laid out on the floor—as seen in Hans Namuth's famous photos—the aftermath of which is still visible today. With the fabled East End light seeping through the loosely fitted walls, Pollock seemed truly happy for the first time.

With the move came a new direction in Pollock's work, towards his "drip" series, and a general improvement on his demeanor, including several years of sobriety. Each subsequent exhibition brought more critical accolades and international success, but it wasn't long before his life began to retrograde. Drinking again by 1951, he returned frequently to the city for a series of unsuccessful therapy sessions, staying at the Hotel Earle (now the Washington Square Hotel). By 1955 he'd completely stopped painting.

With their marriage strained to the point of collapse, Krasner left for a summer trip to Europe the next summer as Pollock took a mistress. It was in Paris that Krasner received the phone call: Pollock, on August 11, 1956, had been killed in a car accident while driving drunk near their East Hampton home. Later that year, The Museum of Modern Art went ahead with its Pollock exhibition. What was originally meant to showcase an artist in mid-career became, tragically, a memorial retrospective. M̂

JACKSON POLLOCK IS COVERED IN THE MOVEMENT "ABSTRACT EXPRESSIONISM" ON PG. 10

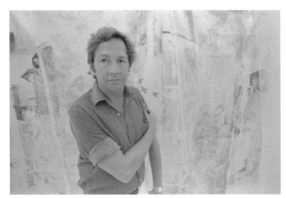

Robert Rauschenberg, 1975

ROBERT RAUSCHENBERG by Maxwell Williams

Right up until he passed away in 2008, Robert Rauschenberg was creating art, breaking conventions and generally being one of the most beloved figures in art history. He was the swashbuckling Ernest Hemingway of the art world and his stories followed him around like a puppy. There's the one about de Kooning; there's the one about the goat; there're the ones about him and his lover and fellow iconoclast Jasper Johns. Having come of age during a time when Abstract Expressionism ruled the artistic landscape, Rauschenberg was one of the earliest antagonists of the idea that painting was the only way to be institutionally accepted as an artist.

Rauschenberg was floundering as a painter when his then-girlfriend Susan Weil announced she was going to Black Mountain College, the famed artist's institute in Asheville, North Carolina. Rauschenberg followed suit, and studied under Josef Albers. While Albers looked towards the European constructivists and the American abstractionists, Rauschenberg felt boxed in by these strict disciplines. This would become a theme. "He was so clear in his direction, that I was able to figure out what I was," stated Rauschenberg in a 1998 television interview with Charlie Rose. "The 'white paintings' came

out of the Albers frustration. I wanted to push painting as far as I could physically imagine it, but they didn't really succeed because there was one thing I couldn't eliminate was [the] size and proportion [of the canvas]."

From the "white paintings"—basically, canvases painted white—sprung Rauschenberg's most dilettante moment. When he moved to New York in the late '40s, attracted by the city's art-centricity, Rauschenberg was confronted with the reign of Willem de Kooning and the school of Abstract Expressionism. He frequented the Cedar Tavern where Jackson Pollock, Mark Rothko, Barnett Newman and de Kooning spent their evenings drinking, discussing and fighting. They didn't take Rauschenberg's work seriously—they found Rauschenberg's grass paintings (framed dirt and seed which required watering) humorous but insouciant, for example—so they liked him. He didn't seem like a competitor. Little did they know that Rauschenberg would almost single-handedly accelerate AbEx's obsolescence with one brave piece.

> **RAUSCHENBERG KNOCKED ON DE KOONING'S DOOR WITH A BOTTLE OF JACK DANIELS AS AN OFFERING, AND SAID HE WANTED TO ERASE ONE OF DE KOONING'S PAINTINGS.**

One day, a nervous Rauschenberg knocked on de Kooning's Greenwich Village studio door with a bottle of Jack Daniels as an offering, and said he wanted to erase one of de Kooning's paintings. Rauschenberg hoped the notoriously testy de Kooning wasn't there, "and that would be the work," he said. Alas, the elder artist was, and, to Rauschenberg's surprise, de Kooning (after sinisterly placing a painting in front of the door, blocking any attempt at escape by Rauschenberg) consented. De Kooning gave Rauschenberg a very difficult drawing to erase—"I want to give you one that I'll miss," warned de Kooning—made of charcoal, oil paint, pencil and crayon. After a month of meticulously erasing the drawing, Rauschenberg showed the piece. It created a hysteria. It was called a challenge of the reigning masters; a removal of an important piece from the history of art; a protest; a pure act of destruction. But for Rauschenberg, it was something different. "It's poetry," he said when asked about his intention behind the work in a later interview, laughing off the suggestion he was trying to destroy the master.

Erased de Kooning came in 1953, but Rauschenberg had been making "white paintings" and "black paintings" in New York for years, striking up legendary friendships with John Cage, Merce Cunningham and, of course,

Jasper Johns. Musical composer Cage and choreographer Cunningham were romantic partners and early developers of modern dance. Rauschenberg collaborated with Cunningham on set designs, once building an entire set from materials found around the theatre the dance was to be performed in; Rauschenberg and Cage created prints and visual works. Rauschenberg and Johns were especially close, sharing a downtown studio on Pearl Street. They were lovers (Rauschenberg had left his wife Susan Weil by then and had already had a relationship with Cy Twombly) and quarrelers (Rauschenberg felt slighted because gallerist Leo Castelli dropped by his studio for a visit and ended up giving Johns a solo show before Rauschenberg got one) and they pushed each other to the brink of what art meant. They painted store windows together under the name "Matson-Jones" and were generally insep-arable. "Nobody cared about his work and nobody cared about my work," said Rauschenberg, "so we had a very exclusive club."

It was around this time that Rauschenberg began a series of painted works out of found metal, wood, cardboard and whatever turned up within the vicinity of the studio. "His rule that he had when he was making the 'combines,'" says the artist's son Christopher, himself a photographer in the Pacific Northwest, "[was] he would walk around the block once — that was where you were going to get the material for your painting — with the escape clause that if it wasn't good enough, you were allowed to do a second block." Critics didn't know how to categorize them, so Rauschenberg called them "combines" — paintings combined with sculpture. "I figured if I would just pull the paintings from the wall," he said in an interview, "there would be a whole new surface there that I could enjoy."

One early combine in particular raised eyebrows: *Monogram*. Made between 1955-1959, *Monogram* was made from a taxidermied Angora goat Rauschenberg had bought from the dirty window display of a second hand office supply store. He placed it on a painted canvas, at an angle, but it didn't quite look right. "It had too much character. It looked like art," he said in an interview, "with a goat." When Rauschenberg, with an eye to the ab-surdism of Dada, placed a tire around the midsection of the goat, it gave the combine a sense of sculpted balance. It was funny, and yet it didn't make any

> "WHEN HE WAS MAKING THE COMBINES HE WOULD WALK AROUND THE BLOCK ONCE WITH THE ESCAPE CLAUSE THAT IF THE MATERIAL WASN'T GOOD ENOUGH, YOU WERE ALLOWED TO DO A SECOND BLOCK."

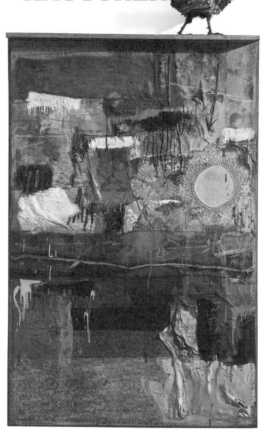

Robert Rauschenberg, <u>Satellite</u>, 1955. Robert Rauschenberg's groundbreaking combines incorporated elements of painting and sculpture, as seen in this work from the Whitney Museum of American Art.

sense whatsoever; there was not a trace of symbolism that people had come to expect. Again, critics didn't know what to make of Rauschenberg.

"The primary factor about my father," explains Christopher Rauschenberg, "the thing that made him really unusual, was that he had this unbelievable level of curiosity that is responsible for him doing such wide ranging work and doing work that was different from what everybody else was doing. It also made him very interested in collaboration. He was the painter that was hanging around with Merce Cunningham's dance company when no one was interested in Merce, not even the dancers!" He became a stage manager with the dance company as it traveled around the world. This led to a whole series of performances and collaborations in the '60s, including a non-profit organization called Experiments in Art and Technology that brought artists

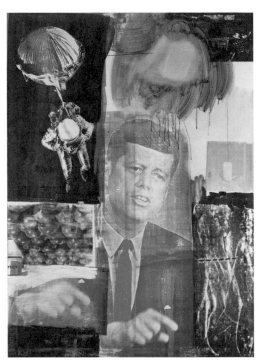

Robert Rauschenberg, <u>Retroactive I</u>, 1964. Robert Rauschenberg's silkscreen collages pulled imagery from pop culture, leading the way for Pop Art.

and engineers together so that they could experiment with technology to help bring the viewer closer to the work. Was this ability to breach the hull of convention his trademark and greatest contribution to art? "In terms of opening up possibilities by doing things that transcended what people were used to," laughs Christopher Rauschenberg, "I think, yeah, that's probably it."

Meanwhile, Rauschenberg began experimenting with silkscreening techniques, transferring a growing interest in photography as art to a canvas. He began to collage images from newspapers, such as iconic photos of the recently assassinated John F. Kennedy and other monumental moments of the '60s. We take it for granted today, but media saturation was still in its beginning stages. Rauschenberg had just witnessed Kennedy's assassination and the first spacewalk. Astronauts and Kennedy were indelible reminders that art need not be timeless, that an artist's moment in time was worthy of artistic exploration. His collage work helped set the stage for Pop Art, as well as the acceptance of photography as an art form.

Rauschenberg's 1964 Grand Prize win at the Venice Biennale—a first for an American artist—was well-earned recognition, and it also brought him celebrity. He had broken through and changed art, but Rauschenberg was now in the position that the AbEx painters had been before: the establishment. The parties and accolades wore on him, and he yearned for a quiet life in which to work. "What he said about it was that he knew a bunch of people who were getting divorced," says Christopher of his father's move to the beach, "and he went to his astrologer and said, 'How come everyone's getting divorced,' and the astrologer said, 'You have to live near the water.' It was Warhol's time and there was all this partying—my feeling is he wanted to work in the studio more and party less."

> "HE WAS THE PAINTER THAT WAS HANGING OUT WITH MERCE CUNNINGHAM'S DANCE COMPANY WHEN NO ONE WAS INTERESTED IN MERCE, NOT EVEN THE DANCERS!"

In the late '60s, Rauschenberg began a slow shift from the fast-paced, Warhol-dominated art world of New York to the quiet, secluded island of Captiva, Florida. He set up shop and recruited a horde of assistants. He silkscreened all day, embarking, in his later years, on some of the most ambitious works of his career: *ROCI*, a series where he traveled to eleven countries to work with local artists and personalities to create works, and *¼ Mile Piece*, a 195-panel-long, self-reflective and career-spanning autobiographical work augmented with audio effects. He worked well past the age in which most people, let alone artists, had retired. "He loved to be in his studio," explains Christopher Rauschenberg. "That was his favorite thing."

He continued to work in Captiva until his death, his influence gestating to the point of celebrity. By then, he was one of the most significant and beloved figures in art history—becoming the type of figure he flailed so vehemently against in his youth. Ṁ

ROBERT RAUSCHENBERG IS COVERED IN THE MOVEMENT "NEO DADA" ON PG. 14

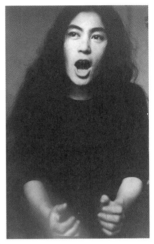

VOICE PIECE FOR SOPRANO

Scream.
 1. against the wind
 2. against the wall
 3. against the sky

1961 autumn

Yoko Ono performing *Voice Piece for Soprano*, 1961.

YOKO ONO by Alex Gartenfeld

Like so many other essential New Yorkers, Yoko Ono wasn't born in the city, and while New York has taken a lot from her, she's asked a lot of it, too. As it is in life, so is it in art, and Ono's work—epitomized by her poetic text commands—asks a lot of her viewers: primarily that they embrace fantasy and defy convention.

In the summer of 2010, in the mezzanine of the Museum of Modern Art, Ono exhibited her *Voice Piece for Soprano* (originally performed in 1961), in which a viewer is instructed to step up to a microphone and "Scream. 1. against the wind; 2. against the wall; 3. against the sky." At the opening, Ono was the first to perform, letting out a cry that spoke not just to the frustrations of human experience, but also her personal history as a woman in a male-dominated (art) world: a widow to one of the 20th century's most famous people, who's worked hard to have her own voice heard, and a person now deep into her 70s, full of energy and preserving her legacy.

Ono was born in Tokyo on February 18, 1933, a descendant of the famed Yasuda banking family. In her early childhood, Ono shuttled back and forth between San Francisco, Hanoi and Japan, following her father's professional transfers. The family also briefly lived in New York in 1940. During World War II, her family hid out in the mountains of Japan following widespread bombings. "I was a war child: life was transient, and often with sudden changes," she said to curator Hans Ulrich Obrist, describing the war's influence on her conceptual approach to art. "Static life seemed innately false to me. It was a fact that statues and paintings deteriorated in time, or were destroyed by political considerations." After the war, her family moved to Scarsdale, a suburb of New York City. She joined them in 1950, enrolling at Sarah Lawrence College, where she decided to pursue the life of an artist. And while she aims not to be static, and her art is resolutely immaterial, Ono has maintained a consistent base in New York ever since.

"LOWER MANHATTAN WAS FILLED WITH A PALPABLE DIY ARTISTIC ENERGY, AND 112 CHAMBERS WAS AN EXCITING AND CHAOTIC AVANT-GARDE HUB."

In December 1960, Ono moved into a loft at 112 Chambers Street and embarked upon a streak of groundbreaking performance and conceptual art that would be the source of her early notoriety. For an intense period in the early 1960s, she and minimalist composer La Monte Young programmed the apartment space with events associated with Fluxus, the postwar movement that had used deskilled and democratic ways of making art, like concerts based on silence and chance. From 1956 to 1962, Yoko was married to composer Toshi Ichiyanagi, who performed in the apartment space—so did Young, Henry Flynt, and Minimalist Robert Morris. She was the one woman amongst these self-proclaimed luminaries.

Although 112 Chambers was an "exceptionally gray dingy building," wrote Flynt, the irascible Fluxus artist and writer, "the events that occurred here … have become part of the cultural monolith."

"Yoko was very involved with the space, although she never hosted an event," says Jon Hendricks, a scholar who has long worked with Ono as a curator of her exhibitions "Maybe because she felt because she was organizing the space it wasn't right to also act as the performer." Yet the space played host to works by Ono—like *Painting to be Stepped On*, a bare canvas set on the floor, and *Smoke Painting*, which "ends when the whole canvas is gone"— that have become important parts of the conceptual art canon.

It was a time when Lower Manhattan was filled with a palpable D.I.Y. artistic energy, and 112 Chambers was an exciting and chaotic avant-garde hub. Composer John Cage brought over established figures like Peggy Guggenheim, Max Ernst and Marcel Duchamp. Park Place, another artist-run collective, was farther south—at the future site of the World Trade Center. Jasper Johns and Robert Rauschenberg were downtown on Pearl Street, while James Rosenquist and Robert Indiana lived and worked in Coenties Slip. "There were a few artists down there," said Hendricks of the downtown scene. "I didn't often venture down there; it was pretty bleak." In her unpublished memoir, Alexandra Munroe, the director of the Japan Society, remembers heading "really, really way Downtown" to Chambers Street and being afraid the place was going to burn down because Ono was setting fire to a canvas.

In New York, Ono found a home with the city's avant-garde, which was gripped by Fluxus, a form of art that used readymade materials to critique the traditionally bourgeois place of art. George Maciunas, the movement's Romanian founder, had set up AG Gallery for like-minded artists at 925 Madison Avenue. It was here that Ono first showed her "instruction paintings," renderings of black text on a white background, often in calligraphy by her husband, that offered philosophical suggestions like "Cut a hole in a bag filled with seeds of any kind and place the bag where there is wind" (*Painting for the Wind*, 1961). The work challenged many of the conventions of art, but went rather unnoticed. "This was the underground, so there wasn't going to be a big public response," says Hendricks. But interest in the gallery was focused: German art shaman Joseph Beuys, Fluxus artist and composer George Brecht and early video artist Nam June Paik all played a part. Maciunas, who was prone to unfortunate situations, had deliberately rented a beautiful and spacious room in the fanciest part of Manhattan, but in the course of publishing an anthology on Fluxus he ran out of money and soon after had to give up the gallery.

Around this time, Ono went back to Japan from '61 to '64 to work and present a one-woman show in Tokyo. There she published her seminal *Grapefruit*, an artist's book consisting of "event scores": works that the viewer could enact, in lieu of art objects. She also first performed *Cut Piece*, in which the artist invited members of the audience to cut away pieces of her clothing. It was a gruesome experience of sharing physical proximity and a silver pair of scissors. "It was a form of giving, giving and taking," Ono told interviewers when she returned to New York and performed it again at Carnegie Hall in 1965.

Back in New York, Ono continued making work with a conceptual bent, combining unexpected media with performative, often participatory, actions.

"THIS WAS THE UNDERGROUND"

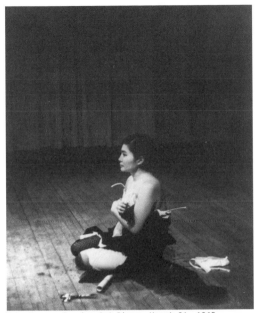

Yoko Ono preforming <u>Cut Piece</u>, March 21, 1965,
Carnegie Recital Hall, New York. Yoko Ono's
performance pieces challenge viewer expectations, as
in Cut Piece, in which the audience is given scissors
and is invited to use them upon the artist.

At Judson Memorial Church — site of early Happenings in the late 1950s,
featuring artists later affiliated with Pop, including Claes Oldenburg and Jim
Dine — Ono and Hendricks put on a show at the space, featuring *Painting to
Shake Hands*, for which the curator "stood behind a canvas and shook hands
with visitors," and *Sky Machine*, a dispenser into which visitors inserted a
quarter and received a little card that said "sky."

In 1967, Maciunas converted 80 Wooster Street into a co-op loft, which
first hosted artist Jonas Mekas' experimental film institution the Anthology
Film Archives, now on Second Avenue in the East Village. It's there in 1970
that Ono and John Lennon organized "Fluxfest," a group show of Fluxus
artists comprising instruction cards and posters. In the interim, "The Ballad
of John and Yoko" had rolled out: trips through Gibraltar and Amsterdam,
and a very notorious bed-in. Ono and her third husband had met, or so the
story goes, on November 9, 1966, at her show at the Indica Gallery in London.
In typically provocative fashion, she asked him to pay five schillings to
hammer a nail; he offered five not to hammer it. A match was made, and a
firestorm of public attention ensued.

YOKO

Ono continued to create art on her own terms (with her own curator, at that, and in unconventional spaces). One now-lost staple of New York culture is Charlotte Moorman's Avant-Garde Festival, which ran from 1963-1991. In December of 1973, it was held at Grand Central Terminal, and Ono installed works in a deserted underground subway car. "Yoko's not like a painter who goes into a studio to paint … she works in her mind," says Hendricks.

She has also worked in the recording studio, and at New York's Town Hall and Carnegie Hall, where she has frequently performed. Beginning in 1968, she collaborated on four albums with John Lennon, including the No. 1 *Double Fantasy*, and she's subsequently released a dozen full-length albums on her own. For her 2007 album, *Yes, I'm a Witch*, Ono collaborated with her son, musician Sean Lennon, and Yuka Honda of the band Cibo Matta. That same year, she headlined Pitchfork's music festival with Sonic Youth's Thurston Moore, wailing over his feedback. She's worked with a variety of producers and the seminal indie band Yo La Tengo. As of 2010 she has had four No. 1 dance songs — remixes of hit singles originally recorded by the Plastic Ono Band.

She has revisited her visual art with contemporary voices as well; for a 2010 installation at the Whitney Museum of American Art, she re-did her *Painting to be Stepped On* (which is exactly that, a canvas on the floor), with New York artist Nate Lowman. Ono's collaborations evidence her continuing interest in spontaneity, experimentation and a lifelong quest to defy convention. As she told artist Takashi Murakami of her vast body of work: "Maybe there's some 'framework' that I am not aware of."

In 1988, the Whitney honored Ono with a retrospective. *The New York Times* review of the show began, "As well as being one of the world's most fabled widows, Yoko Ono is one of its wealthiest artists. Yet even stranger for one so famous is that her art is actually little known." Perhaps it's fitting then that for the show she revisited many seminal works from the 1960s and 1970s, and set them in bronze so that the public might once and for all fix its opinions about her ephemeral works.

Artists (especially women, and especially those in their 70s) who mix with other industries — in Ono's case, music — and celebrity are some of the world's most scrutinized people. But the artist once reviled for "breaking up the Beatles" has seen late-career vindication. Her 2001 retrospective, "YES Yoko Ono," which originated at the Japan Society, was named Best Museum Show Originating in New York City by the International Association of Art Critics. At the 2009 Venice Biennale, Ono received the Golden Lion for Lifetime Achievement Award. "It felt like a fog disappeared … and the sky once again opened up," she said at the award reception. She thanked, specifically, the coalition of women who helped her produce the show.

Ono links her artwork to the activism she's pursued since the 1960s, when she and John Lennon controversially took to bed for two weeks in protest of the Vietnam War. Of her "Instruction Paintings," Ono has said, "you don't just give a finished art work. You're giving an instruction, and so then [the audience has] to participate; they have to do their own sort of production, and soon enough we understand that we're all together—and there's a connection with peace there. World peace is one project that we have to do together." She founded her own peace award, The Lenono Grant for Peace, a gift for artists working in regions of conflict, and she's both donated money and designed T-shirts for AIDS-related causes.

> "YOKO'S NOT LIKE A PAINTER WHO GOES INTO A STUDIO TO PAINT...SHE WORKS IN HER MIND."

The myth of Yoko Ono, artist and widow, is culminated in her place of residence. Few apartment buildings in New York are so closely linked to a single occupant, as is the case of The Dakota and Yoko Ono. In 1973, the artist and husband John Lennon moved into five apartments in the landmark nineteenth-century building on 72nd Street and Central Park West with high gables and North German Renaissance detailing, and she's stayed there to live and work amidst scrutiny and tragedy. It's in the entrance to the building that her husband, Lennon, was shot dead at the age of 40 on December 8, 1980. Across the street, in a two-and-a-half acre landscaped plot in Central Park that she dedicated to Lennon in 1985, Ono holds an annual public memorial on the anniversary of his death.

Ono's New York life has been as ephemeral as her work, but she's still in full evidence. The sheer number of interviews she's completed—with *The New York Times* and bloggers alike—attests to her sustained and democratic outreach. In 2009 she judged a Twitter contest, helping to decide the best 140-character haikus, and she remains an active presence on the site. Perhaps it's the spirit of New York that has allowed Ono to simultaneously embrace legend and stay contemporary. Ṁ

YOKO ONO IS COVERED IN THE MOVEMENT "FLUXUS" ON PG. 18

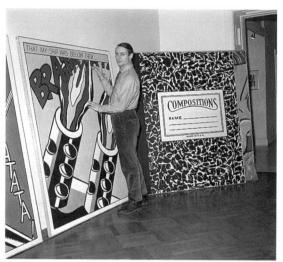

Roy Lichtenstein in his New York studio, March 1964

ROY LICHTENSTEIN by Alex Gartenfeld

For Halloween in 1965, Roy Lichtenstein dressed as Andy Warhol. He sprayed his hair silver and wore a distressed leather jacket; his soon-to-be second wife, Dorothy Herzka, wore a white mini-dress and tights like Edie Sedgwick: "When people said anything to me at the party I said, 'Oh, wow' or 'How glamorous,'" he recalled. "Andy does exactly what I don't do. He was his art. His studio was his art. Edie was his art." Of course, Warhol would never have dressed up as the world's other most-famous Pop artist, Roy Lichtenstein. But Lichtenstein ultimately succeeded at mining the mundane more than Warhol ever could.

Today, Lichtenstein is best known for his blown-up cartoon images, dramatic freeze-frames with exaggerated printer's dots. Along with Warhol, Lichtenstein shares the title of King of Pop Art; while both artists dealt with pop culture, each explored it in wildly different directions. Lichtenstein started

working with cartoons earlier than Warhol and never really gave up devoting his art to the object, rather than to the performance and the persona of the artist. While Warhol was the consummate art star, Lichtenstein was a family man, a painter who transported canvases onto of his station wagon, and had his lunch daily at exactly 1 p.m.

In 1962, when Lichtenstein made his debut at Leo Castelli Gallery on Manhattan's Upper East Side, he enraged most critics. Writer and artist Donald Judd was an exception, who commented that the paintings were about the way we see, writing that Lichtenstein's style of Ben-Day dot pixilation

LICHTENSTEIN WAS A FAMILY MAN, A PAINTER WHO TRANS-PORTED CANVASES ON TOP OF HIS STATION WAGON, AND HAD HIS LUNCH DAILY AT EXACTLY 1 PM.

"is representing this representation—which is very different from simply representing an object or view." At Castelli, Lichtenstein showed, among other works, precise and deadpan oil paintings like *Turkey, Washing Machine* and, most famously, *The Kiss.* The images looked as if they'd been run through a commercial printing press, composed of washes of color and Ben-Day dots, single-color circles pulled from a comic book. *The New York Times* critic Michael Kimmelman called it "the equivalent of a giant pin aimed at the hot-air balloon of Abstract Expressionism, with its soul-searching claims and emphasis on the eloquence of a painter's touch." By January 1964, *Life* magazine was asking: "Is He the Worst Artist in the U.S.?"

The writer of the *Life* article actually admired the artist—the title was a polemic, playing at the difference between art cognoscenti and an easily scandalized popular media. The collectors admired him, too: The show sold out before the opening. The world's most famous modernist architect, Philip Johnson, started the high-profile charge for Lichtenstein's work a year earlier, purchasing *Girl With Ball* from the artist's studio. The now-canonical painting features a generic pin-up tossing her hair and catching a ball in matte commercial color. This was before the legendary Castelli, who had previously championed European Surrealism and Abstract Expressionism, solidified his trademark stable of Pop artists (losing his Abstract Expressionist talent along the way). And it was before Andy Warhol would show his paintings of Campbell's soup cans at Ferus Gallery in Los Angeles, in August 1962.

"The crucial year is 1961, the year he starts doing the Pop," says Isabelle Dervaux, a curator at the Morgan Library in New York who organized a 2010 show of the artist's drawings. "Before that he was doing Abstract Expression-

ROY

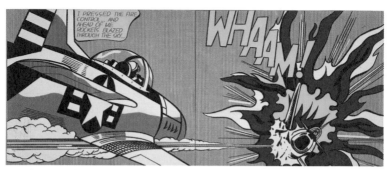

Roy Lichtenstein, Whaam! 1963. One of Roy Lichtenstein's most famous images, Whaam!, was pulled from a 1962 DC comic called All American Men of War.

ism." Throughout the 1950s, Lichtenstein, who had been living in Ohio, had been transitioning out of the AbEx style, incorporating found images, "like de Kooning doing Mickey Mouse," describes Dervaux. Lichtenstein developed his proto-Pop style one day after his sons came home from school crying because another student said that Abstract Expressionism was for artists who couldn't draw. Lichtenstein proved his mettle by reproducing the outline of Mickey Mouse. "He starts with extremely crude commercial drawings as a source, very awkward, and moved forward," explains Dervaux. "He wanted to see what's the difference between that kind of drawing and fine art drawings."

Lichtenstein had been showing in his native Manhattan since 1951, when he first exhibited at the Carlebach Gallery. He refused to show there again, and the gallery later turned its attention exclusively to primitive art. At the time, Lichtenstein was painting in the style of the famed Abstract Expressionists and making trips from Ohio to New York City to see the art shows and to sit at the famed artist hangout Cedar Tavern, although he claimed to be too shy to meet the famous New York School painters who hung out there.

By the time he became famous, Lichtenstein was nearly 40 and already had two kids. He was born in 1923 in Manhattan. His father, Milton, was a successful real-estate broker and the family lived at various locations on the Upper West Side, primarily 305 West 86th Street, where he lived with his parents, sister and maternal grandfather in a seven-room apartment. His father's business was relatively unaffected by the Depression, and Lichtenstein attended the prestigious Franklin School for Boys (now the Dwight School). Growing up, he took art classes at Parsons and visited jazz clubs like Staples on 57th Street and the Apollo Theater in Harlem. He studied at the Art Students League under Social Realist Reginald Marsh. "I did sort of appalling paintings," Lichtenstein once admitted. "A kind of Reginald Marsh realism."

Roy Lichtenstein, <u>Drowning Girl</u>, 1963. Roy
Lichtenstein painted this dramatic image, pulled
from a DC Comics release called <u>Run For Love!</u>,
around the time of his divorce. It can be seen at
the Museum of Modern Art.

Much of Lichtenstein's early adulthood was spent in Ohio; he attended
college at Ohio State. At the time he was active in fraternity life, studying
watercolor painting and art history, making abstract still-life paintings and
landscapes. While at Ohio State, he was drafted and drew maps for the military,
before engaging in combat in England and France during World War II. After-
ward, he spent some time in Paris, before returning to Ohio. In 1946, Lichten-
stein received his B.F.A. and enrolled in Ohio State's master's program, where
he taught undergrads while studying art history and criticism. He also began
showing his art at Cleveland's Ten-Thirty Gallery, where he met his future wife,
Isabel Wilson.

Yet he remained interested in New York, where the postwar art commu-
nity was beginning to thrive. He began to visit galleries, especially Charles
Egan and Betty Parsons, which were the leaders of Abstract Expressionism. In
1952, he started shopping his paintings to New York galleries like M. Knoedler
and Sidney Janis, showing up with canvases strapped to the top of his station
wagon—drawings and paintings based on advertising images. His first solo
exhibition in New York, at the Carlebach Gallery, included abstract paintings in
mauve and assemblages of found materials.

When Ohio State University cut its funding, Lichtenstein was laid off as an
assistant professor; in 1960 he was hired by Douglass College, part of Rutgers State
University of New Jersey. From there, he traveled to New York galleries, which

Roy Lichtenstein, <u>Girl with Ball</u>, 1961. In the early 1960s Roy Lichtenstein began using mass media as source material. He found the image that inspired <u>Girl with Ball</u>, now at the Museum of Modern Art, in an ad for a Pennsylvania resort.

were beginning to show the works of artists like Jim Dine and Claes Oldenburg.

Lichtenstein—increasingly interested in commercial art and the industrial modes of production that were booming in postwar America—was rendering found images in half-tone dots and flat printed areas of color, exaggerated versions of newspaper and cartoon imagery. To produce *Look Mickey*, reputedly his first "Pop" painting, the artist used a plastic dog-grooming brush dipped in oil paint. Later, he'd use stencils and, as the dots in the paintings became larger, he hired an assistant to painstakingly paint them by hand.

Allan Kaprow—the innovator of the spontaneous performance art "happenings"—was a colleague at Rutgers and introduced Lichtenstein to Dine

and Oldenburg, as well as other pioneers of Neo-Dada and Fluxus. Kaprow once told Lichtenstein, "You can't teach color from Cézanne, you can only teach it from something like this," pointing to a Bazooka gum wrapper. Kaprow also introduced Lichtenstein's work to Leo Castelli and his wife, dealer Ileana Sonnabend, and his trailblazing director Ivan Karp.

At first, those dealers showed limited interest, but one painting in particular — *Girl with Ball*, an image ripped from a advertisement for a Poconos resort — caught Castelli's eye. Karp showed *Girl with Ball* to Warhol, and soon after Warhol and Lichtenstein met at the latter's Lexington Avenue studio. Lichtenstein's art was "anti-" everything, a sterile, cool and anonymous contrast to the gravitas of Abstract Expressionism. In 1962, Lichtenstein had his first show with the gallery; within a year he was included in a group show at the Guggenheim with Jim Dine, Andy Warhol and James Rosenquist.

HE GLEEFULLY MINED THE MOST TABOO OF SUBJECTS: COMMERCIAL ART.

As Lichtenstein's career grew, his personal life faltered. In 1963, he separated from his wife and she moved with the children to Princeton. At the same time, Lichtenstein returned to Manhattan, moving to a studio on the Bowery. Here he painted some of the most famous images of his career, comic-inspired images such as *Drowning Girl* and *Frightened Girl*.

Throughout the '60s, Lichtenstein was happy to play the role of art-world provocateur. At a time when artists rebelled against commercialism, he gleefully mined the most taboo of subjects: commercial art. He met Dorothy, his second wife, and married her in 1968. The two split their time between Manhattan and Southampton, New York.

Over the next four decades, Lichtenstein experimented with the forms that made him famous, loosening his lines and breaking up figures into monumental, colorful sculpture. His source material changed from popular imagery to the art-historical icons of Cézanne, Picasso and Monet. In 1984, he set up an art studio on East 29th Street, running an efficient art-making factory, the absolute antithesis of Warhol's celebrity-filled and drug-filled Factory.

Throughout his life, Lichtenstein had refused the spectacle of the Pop machine. At the height of his career, *Life* magazine described Lichtenstein: "A quiet, affable man of 40, he fully expected to be condemned for the subject matter as well as the style of his paintings." M̂

ROY LICHTENSTEIN IS COVERED IN THE MOVEMENT "POP ART" ON PG. 20

ANDY

Andy Warhol (center) with The Velvet Underground, Nico
(bottom left), Paul Morrisey (far right) and Gerard
Melanga (bottom right), c. 1966

ANDY WARHOL by Maxwell Williams

A glimpse into the window of Andy Warhol's Factory, his silver-swathed art studio in Midtown: a camera rolls, helmed by Paul Morrissey. Warhol leans over Morrissey's shoulder and whispers something in his ear. Brigid Berlin and Nico laugh on a bed, while off in another corner of the studio Ultra Violet smokes a cigarette on a couch, her lilac hair flickering to photographer Stephen Shore's flashes. Elsewhere, the Factory is in full effect, an assembly of squeegees runs across printing screens, creating prints that will later be sold in galleries and, later still, hung in museums. Both the focal point and a meek, impish man, Warhol is smirking at something Morrissey has said. The mononym "Andy" is whispered from all corners of the Factory. Creation is underway, all under his watchful eye. Is he a puppet master? A god? An artist? Is this the most creative point in the history of art, or is it the death of art as a beautiful, pure, skillful, upper-crust organism?

 Only a very, very small handful of people have conquered both art and popular culture in such a way as Andy Warhol. This is not an overstatement—Andy Warhol, with his coke-bottle glasses and tufted white-blond hair, was transcendental in terms of breaking through to the cultural zeitgeist. He

was an artist of celebrity status, whose name is still instantly recognizable. The Factory is synonymous with '60s and '70s art glam excess. There have been dozens of films dedicated to Warhol, hundreds of books, thousands of essays, tens of thousands of photos. He started *Interview* magazine, which remains an esteemed publication that features celebrities and artists, just the way he wanted it. He was beloved and loathed, boring and exciting, the establishment and the groundbreaker. "He's not an artist, in a funny way, *and* he's the greatest artist," writer Wayne Koestenbaum once said.

IS HE A PUPPET MASTER? A GOD? AN ARTIST?

Andrew Warhola was born into depressed Pittsburgh, Pennsylvania to a Slovakian immigrant family in 1928. He worked his way into the Fine Arts program at the Carnegie Institute of Technology in Pittsburgh before moving to New York in 1949, embarking upon a career in magazine and commercial illustration. While he was working in advertising, Warhol recognized the power of mass media. In the early 1960s, he began to make prints — a solo show in November, 1962 at Stable Gallery in New York featured many of Warhol's best known works: *Marilyn Diptych*, *100 Soup Cans*, *100 Coke Bottles* and *100 Dollar Bills*. The rest is, literally, art history.

Warhol was the consummate outsider, ridiculed in the art world from the start. He was geeky and weird, but the real source of derision came from somewhere deeper. "He was effeminate," says Warhol Museum director Tom Sokolowski. "People in the gallery world, even though the preponderance of people were gay, didn't want it to be public. They would say the most horrible things: 'What's that faggot pinkie chinko scum from Pittsburgh doing here?' At first he was absolutely wounded, and then he thought, 'Fuck it, I'm going to do what I want.' And then he would appear with the most handsome men and beautiful women. He achieved fame and then, *voila*: history."

He set up the Factory — its name a tribute to a childhood spent growing up amongst ironworkers — and had his friend Billy Name cover it in silver foil and silver paint. Through Warhol's magnetic personality, the Factory soon became populated with a kaleidoscopic crew of outcasts and hangers-on, all of whom figured into the art-making process. And then, when all the screens were washed and stacked away, the Superstars and the Factory workers would all snort cocaine until their eyeballs rolled in the backs of their heads. Drugs ran rampant in the Warhol set, and it claimed many victims, both indirectly and through ODs like Edie Sedgewick. "Andy flirted with coke," said former *Village Voice* writer Bob Colacello in a later interview, "though he was really sneaky about it ... Andy wasn't taking anywhere near as much as the rest

Andy Warhol, <u>Nine Jackies</u>, 1964. Andy Warhol was fascinated with celebrity. Figures such as Jackie Kennedy were a frequent subject in his work, as in this piece from the Whitney Museum of American Art.

of us because he knew that he had the most addictive personality of all. It came out in his shopping, collecting, painting, pill-taking and in the way he'd throw back four or five straight vodkas in a row when he wanted to 'get good and drunk.' Of course, he always denied taking coke. I even heard him deny taking it as he was sticking it up his nose."

"THEY WOULD SAY THE MOST HORRIBLE THINGS: 'WHAT'S THAT FAGGOT PINKIE CHINKO SCUM FROM PITTSBURGH DOING HERE?'"

True to its name, Warhol's studio became an art-making assembly line. The crew began making "multiples"—series of the same work, each made slightly different by the process, which was, in Warhol's case, usually silkscreen beacause it was conducive to mass production. Critics saw this mass production process as an important subversion of the current legion of

painters in New York. "He was one of the first modern artists to react against Abstract Expressionism," said art historian John Richardson in an interview with the BBC, "where the artist was smearing himself and his psyche all over the canvas and the brushstrokes meant everything and the gesture meant everything. And with Andy, it was exactly the reverse: it didn't matter whether he added the brushstrokes or one of his assistants did. The assistants would come in at night and run off a few copies for themselves. But did that make

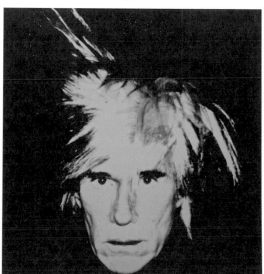

Andy Warhol, Self-Portrait, 1986. Throughout his career Andy Warhol used himself as subject in both paintings and photographs. This version, from the collection of the Guggenheim Museum of Art, is part of a series created just nine months before his death.

them any less authentic than the ones they ran off for Andy during the day?"

Warhol's star continued to rise through the '60s, and he began to direct and produce experimental films, including *Chelsea Girls* and *Vinyl*, an early adaptation of Anthony Burgess' novel *A Clockwork Orange*. The films were difficult and raw—Warhol's protégé Paul Morrissey once admitted in an interview at the San Francisco Film Festival that, "Not every film is destined to please an audience." In 1964, Warhol befriended The Velvet Underground, an art-rock band fronted by Lou Reed. He and Morrissey became the band's "managers" and implanted the German model Nico into the group. The band was "Andy's desire to stir up the bourgeois," according to Reed, with drug-themed songs like "Heroin" and "I'm Waiting for the Man." His mixture

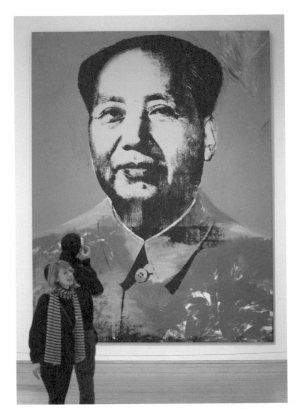

Andy Warhol, <u>Mao</u>, 1973. Andy Warhol first painted Chairman
Mao Zedong in 1973 at a time when he was mostly creating
portraits for wealthy patrons. This version can be seen at
the Metropolitan Museum of Art.

of film and music and visual art was a concoction like no other. It was as if
Warhol was a soothsayer for where popular culture was headed ... or else he
steered it in that direction. "He commented about what a cell phone would
be before it was even known," muses Sokolowski. "Reality TV: he did it in his
movies and where are we today? Everyone wants their moment."

And Warhol was famous himself, often followed around by early ver-
sions of entourages and paparazzi hoping to catch decadent acts. There is,
of course, the ubiquitous Warholism from 1968: "In the future, everyone will
be world-famous for fifteen minutes." The parties and everything that came
along with the Warhol's fame still resonate in the art world today. But there
was a sensitive side to Warhol, too. Pioneering photographer Stephen Shore
met Warhol in 1965 at the Filmmakers' Cinematheque, where they were

both showing short films. Just 18 at the time, Shore introduced himself and asked Warhol if he could photograph at the Factory. Warhol consented, and Shore hung around for a few years before his own star began to rise. "One afternoon," Shore says through e-mail, "when Andy arrived at the Factory, he asked me if I happened to have watched a particular film that was on TV in the middle of the night the previous evening. It was a terrible, 1930s tearjerker starring Priscilla Lane. I told Andy that in fact I had. He wanted to know what happened in the film because, he said, he started crying and fell asleep. He then told me, 'When I woke up my TV was off. My mother must have come in and turned it off.'"

IT WAS AS IF WARHOL WAS A SOOTHSAYER FOR WHERE POPULAR CULTURE WAS HEADED...OR ELSE HE STEERED IT IN THAT DIRECTION.

Warhol's influence on art is impossible to gauge, but it touches even the furthest reaches of contemporary art. He was both Svengali and savant, great mind and superficial mirth-chaser. Later in his career, he became something of a joke, the 1980s being the cruel time that they were to contemporary art. And yet, while he was scoffed at critically, the 1980s were a boon to him, financially. The world had caught up to his assertion that art was a commodity, and businessmen became interested in the value of Warhol's art. He created work-for-hire, appeared on television commercials and exploited his own celebrity value right up until he died. Even after his death, his works continue to be printed as art prints, like Ford continued on after Henry's passing. In that, Warhol is the closest thing art will have to a perpetual-motion machine. ᴍ̂

ANDY WARHOL IS COVERED IN THE MOVEMENT "POP ART" ON PG. 20

FIFTEEN MINUTES PREMIERES ON MTV **FEBRUARY 22, 1987** DIES IN NEW YORK FOLLOWING ROUTINE SURGERY

DONALD

Donald Judd

DONALD JUDD by Maxwell Williams

"How could this be art?" seemed to be the conventional reaction to Donald Judd. The critics scratched their chins, huffed and finally went home to reevaluate the entirety of art history until this moment. Some tried to grasp it, to be open-minded, but bad reviews came in, too. It was, quite simply, a transitional moment: art was supposed to beautiful and passionate, paint slathered on canvas or sculptures of discernible objects. But here was something else.

It was 1966, the venue was the Jewish Museum and the group show was called "Primary Structures." Attached to the wall, emanating something different than the artistic ideals of the time, were a series of squares, made of an unearthly shiny metal; a second series lay on the floor. The two works were untitled. Judd's work was overwhelming. The squares transformed the gallery into something powerful, making its walls and floors extensions of the artist's work. The hovering forms, pure and impersonal, seemed to exaggerate the enormity of the space. It wasn't much, just a couple of prefabbed squares, but Judd's work marred the simplicity of "art vs. not art," opening up new possibilities in technique and formalism forever.

As a result of that fateful show, Donald Judd is probably New York's best-known Minimalist sculptor. Too bad the title doesn't really fit. Judd felt his works were almost *maximalist*, imbued with so much conceptuality that they were philosophical in nature. "He didn't like the term 'minimal' applied to his and other work," wrote Grace Glueck in a late-'60s profile on Judd for *The New York Times*, "not only because it made it seem less than what went before, but because it suggested a 'movement.'"

The fact remains, Judd's legacy is based around "specific objects": gleaming sculptures that utilize the spatial relationship of the viewer's proximity. It's not really that complicated—look at it from a different angle; perceive it a different way. They are powerful works whether you're standing next to them, walking around them, looking into them or seeing through them.

DONALD JUDD IS PROBABLY NEW YORK'S BEST-KNOWN MINIMALIST SCULPTOR. TOO BAD THE TITLE DOESN'T REALLY FIT.

Donald Judd was born in Missouri in 1928. By 1949, he was in New York studying philosophy and art history at Columbia University. He was a respected scholar and critic through the '50s and even took a crack at a show of Abstract Expressionist paintings toward the end of the decade. Yet Judd didn't fit in with the contemporary art scene; his early works bore no relationship to what he would become. His early writings show a disgruntled view of the current in art that pushed metaphor to the fore. "Judd was a philosophy student and he was also in a postwar situation," said critic John Yau. "He would be against metaphor because he would understand instantly that metaphor could not in any way be a vehicle of meaning after the Holocaust and the dropping of the atom bomb, that metaphor had been called into serious question and doubt. He had to find a way to make art that could exist on its own terms."

This critical drive culminated in 1963, when Judd began to show work that resembled the thoughtful and beautiful pieces that have become a big part of New York art history. The 1963 show, at Richard Bellamy's Green Gallery, was made entirely of light cadmium red-painted plywood sculptures because, as Judd later clarified, red "seems to be the only color that makes an object sharp and defines its contours and angles," as opposed to black, which tended to murk the lines.

This intense dialogue with the spatial aesthetics of his work made critics prick their ears. The show was the talk of the town, and Judd became a New York art star. Judd found his new notability confounding—he relished the op-

DONALD

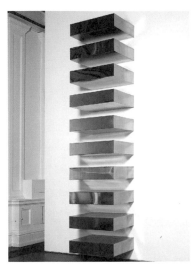

Donald Judd, _Untitled_, 1969. At first, critics were shocked by the austerity of Donald Judd's prefabricated objects such as this piece from the Guggenheim.

portunities to expound on his contemporaries' work in a critical sense, but he was disinterested in having to answer questions about his own work. During this period, his focus shifted from plywood to galvanized iron to purple Plexiglas—all American materials. At first, Judd made all of his works by hand. Then, he made an about face. He decided that he wanted to wipe all evidence of the artist's presence from the work itself. Feeling that his personal preferences, aesthetics and choices could cloud the neutrality of the work, Judd began to have his sculptures fabricated by outside manufac-

turers. The work would be experience only through the viewer's perceptions. The artist removing himself from the artwork was unheard of, and was widely debated amongst artists and critics. "I remember having fierce arguments with [Robert] Smithson over Judd's preference for materials," wrote Richard Serra in an article for _Artforum_ in 1994. "I was taken aback by what I considered to be Don's fetishizing attitude, his hedonism, by the slickness and glitz of fluorescent Plexiglas, anodized aluminum, stainless steel, polished brass, metallic paints, and honey-lacquered finishes; I was inclined to dismiss all this as sterile, high-tech positivism, I was leery of the content it implied and yet, when I stood in front of a Harley Davidson—red-lacquered, galvanized-iron, bull-nosed progression and uttered 'Goddammit' under my breath, I completely embraced his aesthetic on his terms."

In 1968, the decay of downtown New York created an environment where artists could find cheap housing and spacious studios. Judd paid $68,000 for a five-story cast-iron building at 101 Spring Street in SoHo, and built a hybrid living/studio space (before the concept of "artist's loft" even really existed). This would become the epicenter of Judd's work, and he left it spare, furnishing it only with his own tables and chairs (which were, of course, spare and streamlined). Judd would sequester himself in a third-floor studio, drawing sculpture designs in the dense quietude of the nearly empty room. He forbade the use of communication devices within the studio and even made access by

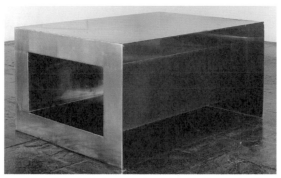

Donald Judd, <u>Untitled</u>, 1968. Donald Judd often worked in industrial materials, such as plexiglass and stainless steel, as seen in this work from the collection of the Whitney Museum of Art. Judd referred to such pieces as "specific objects" rather than sculptures.

elevator difficult. But Judd was as much a social being as he was a meditative worker; often 101 Spring was the host to 40 to 50 breakfasters munching on cheese, flatbreads and salmon. And there was Judd, in the middle of it all, his perfectly sparse home, uncluttered by much except his own sculptures and the artwork of his contemporaries such as Frank Stella, John Chamberlain and Carl Andre.

The building at 101 Spring is where Judd parked many pieces of his and others' work, pioneering what came to be known as "permanent installation." At Judd's behest, everything at 101 Spring Street must remain there forever, and will be on view to the public as early as 2013. The artist's children, Rainer and Flavin, lead The Judd Foundation, which preserves Judd's legacy in both New York and Texas. "This building," Rainer wrote in a recent speech, "teaches us that space matters, quiet places inspire, warm wood and earthy plaster surfaces provide comfort, art enlightens, light restores every day, where you choose to eat and meet defines a mood and creates an environment and a single person's work and contributions can influence us, long after that person is gone."

By the late '60s and early '70s, New York was Judd's. He had 101 Spring Street. He hung out at artist Gordon Matta-Clark's restaurant Food, a well-known SoHo artists' haven. He would have long discussions about art with Dan Flavin and Richard Serra. He was one of the most adored artists in the city, and he was very successful in selling his works. But with success

"HE HAD TO FIND A WAY TO MAKE ART THAT COULD EXIST ON ITS OWN TERMS."

came discontent. "I think his relationship with New York changed," says Rainer over the phone. "That was the only place for him to be in the '50s and '60s. Then, like most people would, he got really restless with it."

Judd's discontent with New York festered, and the art world closed in on him. He escaped, with the rest of the Judd clan in tow, first to Baja California, Mexico, then to California's Venice Beach. Finally, having found both Baja (too far) and Venice Beach (too Venice) unsuitable for a Southwest winter home, Judd happened upon Marfa, Texas, a town that would become the home to an artists' community. In 1977, Judd—with help from his friend Heiner Friedrich's newly minted Dia Art Foundation—purchased Fort Russell, an abandoned 340-acre army post, complete with empty barracks, artillery sheds and other perfectly pre-fabricated art spaces. Judd's development of Marfa in the late '70s has turned the town into an art mecca, with his contemporary art museum, The Chinati Foundation, as the main attraction.

But Judd couldn't stay away from New York entirely and, in 1983, he returned so that Rainer and Flavin (named for Judd's contemporary, the god-

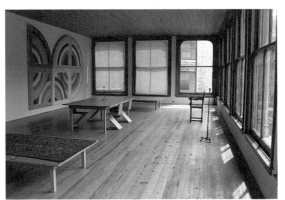

101 Spring Street Donald Judd's SoHo home and studio remains a permanent installation of his work, featuring with furniture by Judd Furniture and painting by Frank Stella.

father of neon light art, Dan Flavin) could attend school in Manhattan and learn by being around Judd's significant art world friends. "I got an education from being included, tagging along," Rainer notes, "but also Paula Cooper was in the neighborhood and there were still all those galleries at 420 Broadway. I remember he was specifically supportive of certain artists at that time, like Roni Horn and Meg Webster. And there were his artist buddies like [Claes] Oldenburg and [John] Chamberlain who would come over for dinner."

Despite his art world heavyweight friends, Judd wasn't quite part of the early '70s social scene that defined the New York art world. "I was at NYU and it was 1988," Rainer reminisces. "I remember being in the library looking at the New York art world pictures—all these photos of Warhol and all these cool people at parties—and looking for my dad in these pictures. Wondering: I know he was in New York, why isn't he in these pictures with all these cool people? Was he a total nerd? So, I went home and had dinner with him, and was like, 'So, where were you?' He just said that he was down the street at the bar with Barnett Newman, [the Abstract Expressionist icon]. I thought that was a really kick-ass answer."

By the end of the '80s, Judd decided to begin working on the permanence of 101 Spring Street. He continued to seal his work into pre-destined spaces. He had conceived the Judd Foundation in 1977 and it was officially formed in 1996, after his death.

In 1988, the Whitney organized an extensive retrospective of his work that traveled throughout the world. It is considered a landmark show in contemporary art. He continued to write critical theory, such as his discourses on the convergence of art and architecture, and create works up until his passing in 1994 from Non-Hodgkin's lymphoma. Judd's impact on the art world reaches wide, whether it's his staunch insistence that an artist need not make his own works, which redefined traditional art-making processes, or his lasting legacy as a master of space. His works remain housed in permanent one-artist museums for generations to view and be inspired by forever. Ⓜ

MARFA

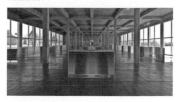

In 1971, Donald Judd visited Marfa, Texas, a quiet town 200 miles southeast of El Paso. By 1977 he had left New York for Texas. He found the sprawling former military base, Fort D.A. Russell—340 acres of abandoned bunkers, barracks and sheds—and, with the help of the Dia Art Foundation, he began to install his work. The Chinati Foundation opened to the public in 1986. Along with 115 aluminum and concrete works by Judd, the museum is home to sculptures by Dan Flavin, Carl Andre, John Chamberlain and Ilya Kabakov.

Judd's presence attracted artists to the area, some at his invitation and others on their own, like Michael Elmgreen and Ingar Dragset who in 2005 opened the installation Prada Marfa—an eternally closed boutique in nearby Valentine, Texas.

The Chinati Foundation can be visited by guided tour only, Wednesday through Sunday. The Judd Foundation offers tours that track the artist's life in the city. For more information visit chinati.org or juddfoundation.org

Donald Judd, 100 untitled works in mill aluminum, 1982-1986. A detail from the permanent installation of Donald Judd's work at the Chinati Foundation in Marfa, Texas.

DONALD JUDD IS COVERED IN THE MOVEMENT "MINIMALISM" ON PG. 24

CINDY

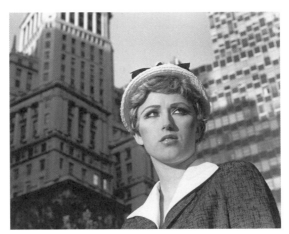

Cindy Sherman, *Untitled Film Still*, 1978.

CINDY SHERMAN by Jordan Hruska

In Cindy Sherman's early photographs of herself, the empty cityscape of New York often forms an anxiety-ridden backdrop. The camera captures the artist as a young woman on her way to work, the Woolworth Building looming behind her. In another of these *Untitled Film Stills*, Sherman, in a dark wig, looks up in front of a wall of buildings, a scarf blowing in the wind.

This was the mid-'70s, an era now romanticized by artists. Real estate was cheap and white flight had virtually decimated the downtown residential population. These hollowed urban canyons became ad-hoc movie sets for Sherman's *Untitled Film Stills*, where the artist photographed herself in compositions reminiscent of 1950s B-movie thrillers. Through her lens, we see the city at its Hollywood-created pinnacle of midcentury sophistication, and in its reality as a desolate cityscape — a city undergoing an identity crisis.

Sherman moved to New York in 1977 from Buffalo, New York, with fellow artist, classmate and boyfriend Robert Longo. At college in Buffalo, she had flunked out of her first photography class at a crucial time when she

was thinking of switching her major to the discipline. Here, she had already created a body of work depicting urban personalities. In one of her first photographic series, *Bus Riders* (1976), Sherman photographed herself in different pedestrian guises. She had a bare-bones studio set-up for these photographs where she would work alone, just like she still does today. In the finished photo, the shutter release wire sneaks into the frame, hiding underneath her costume, a trigger she'd pull at the specific moment when she was most settled into her characters. There's the pimply, teenage boy with the sports jersey and his legs wide open, and the frail, elderly African American woman with a wool parka and glassed-over eyes. These characters wouldn't stay in Buffalo—she brought them to the big city.

THROUGH HER LENS, WE SEE THE CITY AT ITS HOLLYWOOD — CREATED PINNACLE OF MIDCENTURY SOPHISTICATION, AND IN ITS REALITY AS A DESOLATE CITYSCAPE — A CITY UNDERGOING AN IDENTITY CRISIS.

As the youngest of five siblings, Sherman was always shy. The chaotic city streets of New York had scared her as a kid and even in college, but when she received a grant of several thousand dollars from the National Endowment for the Arts, she got the courage to move to New York with Longo. She and Longo moved in together into a loft downtown, at Fulton and Gold streets, an illegal sublet space with the toilet down the hall. As Sherman recalled in *New York* magazine, she was often scared and lonely when she first arrived in New York, and took a job at the department store Macy's, but only lasted one day. In a *New Yorker* profile, Longo mentioned that despite Sherman's early artistic confidence, she was a bit of a shut-in, often going an entire day without leaving the house. In a year's time, she was able to produce at least fifteen of her *Untitled Film Stills*. After a year in the city, she ventured outside the apartment, shooting photographs on impromptu sets with Longo, using the city as a backdrop for her imagined narratives.

Just as Sherman merged pop culture and photography, her contemporaries—Longo, Richard Prince and others—also used photography to re-align the audience's idea of how images were made and communicated to the public *en masse*. They synthesized media like music, graphic design and advertising to challenge every day social constructs. Irony was rife during these tough times in New York City, and its artists (like Sherman) were there to mine it.

These artists have been dubbed "The Pictures Generation," the name referencing the ground-breaking *Pictures* show, of which Longo was a part

of at SoHo's Artists Space in 1977. Although Sherman wasn't included in this initial landmark exhibition, she was rightfully included in an anniversary exhibition in 2009 at the Metropolitan Museum of Art, called *The Pictures Generation 1974-1984*. The show looked at a broader range of American artists, such as John Baldessari, working in media appropriation at the time, and the younger artists who were influenced by them. Both the poster and catalogue cover for the show featured one of Sherman's early *Untitled Film Stills*.

When Longo was hanging his work for *Pictures* at Artists Space, the gallery's director hired Sherman as a receptionist. Her quiet, yet friendly, disposition won over its staff. So did the unpredictable costumes she donned for work: a nurse one day, a '50s-style career secretary another. At the same time, Sherman explored such female archetypes in her *Untitled Film Stills* series. In the 69 photographs of this early body of work, Sherman assumes the role of an actress, mimicking gestures and situations common to filmic representations of women in the 1950s. In *Untitled Film Still #10, 1978*, Sherman crouches over a bag of spilled groceries in a small kitchen with coat half-off, as if she's a lonely single woman in the city, performing the constricted ballet of life in a cramped efficiency apartment.

Directors at Artists Space saw these early images and offered Sherman a spot in a 1978 show there, and then, two years later, a solo art show at a newly created commercial gallery co-founded by an Artists Space alum Helene Winer called Metro Pictures. Metro Pictures was a ground-breaking institution, which held fast, but not exclusively, to the representation of the photographic image in art.

"Cindy was very instrumental in the process of artist's photographic work being accepted by collectors and institutions," says Winer. "Photography as a separate practice was well appreciated, but this did not apply to artists working in the medium. When we opened Metro Pictures in 1980 there was virtually no one collecting photographic work by artists. Cindy was one of the few and new artists to work exclusively with photographs, and was, I believe, the first to bridge the divide."

This first solo show would begin an ongoing relationship with Metro. And unlike most celebrity artists whose work is sometimes negatively judged by the firing squad of fickle New York critics, Sherman has consistently received overwhelmingly positive reviews up until today. *Artforum* has used the superlative "modern master" to describe her status in the art world.

THESE CHARACTERS WOULDN'T STAY IN BUFFALO – SHE BROUGHT THEM TO THE BIG CITY.

Cindy Sherman, <u>Untitled</u>, 1981. The Centerfold photos were created for *Artforum*, but rejected by the magazine. This photograph is now in the collection of the Museum of Modern Art.

But her work hasn't been static. Sherman's controversial "Centerfold" photographs — originally made for *Artforum* — were shown at Metro Pictures in 1981. In the series, Sherman tackles the centerfold format common to porno magazines with horizontal images of herself dressed as different characters. The narratives she creates here are less nostalgic and precious than those of her *Film Stills*, but they are just as specific in character development. At the time, the images caused controversy. Many thought Sherman was objectifying her female characters, that their defenseless positions somehow screamed "rape." In a post-feminist climate, *Artforum* decided its readers wouldn't get the joke.

But, for Sherman, there was not really that much of a joke to begin with. She has often spoken of how all her work is a personal, creative endeavor without a political or feminist agenda, further explaining how she developed certain characters in the centerfold series. What was perceived by some reactionary viewers as a post-rape stare of one of her characters, was, in Sherman's conception, the stare of disbelief and exhaustion at seeing the sun rise after a night of partying.

Sherman is quick to say in many interviews that although she has read hallmark feminist texts, she is in no way steeped in this theory. *Artforum* wouldn't publish the images, however, but critics like the *New Yorker*'s Peter Schjeldahl say that the eventual show of the images in 2003 at Skarstedt Fine Art was one of the most revelatory he's every experienced. The viewer is shocked to observe the expansive range of emotions these characters seem to possess in a conversely simplistic setting and format.

From here, Sherman took on the fashion world after being asked by French *Vogue* to shoot a story. In her own personal notes reprinted in the monograph for her 1997 retrospective at the Museum of Contemporary Art, Los Angeles, Sherman sets up parameters so she doesn't fall into the trappings of fashion-world mythmaking. As a result, the clothes in these photographs help construct surreal characters, who the viewer can't imagine wearing anything else but what Sherman was offered. In this way, identity becomes fused with the character's outer identity; these two "identities" meet where a sort of dementia bubbles up in Sherman's characters' expressions.

These aren't self-portraits of the artist. But, then again, Sherman isn't hiding from the camera, either. She makes sure viewers understand that there is rarely truth in portraiture and that, despite our controlled outward pre-

Cindy Sherman, <u>Untitled</u>, 2008. Thirty years after the <u>Untitled Film Stills</u>, Cindy Sherman began a series of work in which she steps into the guise of various types of upper-crust, middle-aged women.

sentations of ourselves, there's much more below the surface that creeps out anyway. To address this dichotomy more overtly, Sherman began using props like masks, prosthetic devices and make-up to highlight the absurdity of her invented subjects' superficiality.

Twisted, demonic expressions don the faces of Sherman's later "fairy tale" portraits, where she creates more fantastic, yet still dark, characters and settings. The concept of "self" eventually moved from its outward representation of controlled public identity to the inner subconscious where Sherman

eliminated the figure altogether. In these photographs, she shows highly stylized dystopian still-lifes complete with discarded and charred doll parts, sexually explicit scenarios involving prosthetic medical models, and other cacophonous compositions.

By the time Sherman returned to photographing herself in the late 1990s and early aughts, she had merged the grotesquerie of these inner landscapes with her portraits. For these personas, make-up is more liberally and artificially applied and poses are more conservative to the photographic lineage of portraiture. In an age where identity is swiftly augmented with the stroke of a Photoshop airbrush, Sherman references this digital representation with computer-designed backgrounds and effects.

Because of her early and unexpected success, Sherman has never been one for the art world social spotlight, but has made a splash recently with her romantic involvement with her New Wave peer, David Byrne. She continues to meditate on characters alone in her combined studio and residence in TriBeCa where she keeps an entire library of props, costumes and guises. Each of these items she uses to create characters derived from

THESE AREN'T SELF-PORTRAITS. BUT THEN AGAIN, SHERMAN ISN'T HIDING FROM THE CAMERA, EITHER.

a protracted session of dress-up. She doesn't conceive of any beforehand; instead she puts on music, and eases into the headspace, most recently of both middle-aged society women and hysterical clowns.

Sherman's photographs continue to increase in value and are referenced as inspiration for younger artists. The Museum of Modern Art has spent a reported $1 million to purchase one full set (one of ten) of Sherman's seminal *Untitled Film Stills* photographs. And her investigation of the many selves, just like our own, continues to offer rich returns in investment. Ṁ

CINDY SHERMAN IS COVERED IN THE MOVEMENT "APPROPRIATION" ON PG. 40

S NATIONAL ARTS AWARD **2009** INCLUDED IN "THE PICTURES GENERATION" SHOW AT THE MET MUSEUM OF ART

JEFF

Jeff Koons in his studio.

JEFF KOONS by Michael B. Dougherty

When Jeff Koons' *Rabbit*—a giant silver balloon bunny—soared over New York as part of the 2007 Macy's Thanksgiving Day parade, the metaphor couldn't have been more perfect. Koons, who has consistently rejected attempts to ascribe any deeper meaning to his work, creates playful fine art manifestations of banal objects, often at a massive scale and with a highly reflective surface. To encounter these *tabula rasa* creations at museums, galleries and in public spaces around the city is to see yourself, and New York, in his image.

He's been called a "mean son-of-a-bitch," told his work fails "every known test for quality" and faced accusations of generating "the sort of self-promoting hype and sensationalism that characterized the worst of [the 1980s]." But Jeff Koons retains his impish smile, perhaps because, despite the detractors he's remained New York's most successful artist of the new millennium (and also its richest). Whether you feel he is the rightful heir to Andy Warhol, or a shameless impersonator, one this is certain: Koons knows exactly what he's doing.

Born in York, Pennsylvania in 1955, Koons attended the Maryland Institute College of Art in Baltimore, and studied at the School of the Art Institute of Chicago, before moving to New York in 1977. He once told a *Forbes* interviewer that it was his childhood job selling candy and gift-wrap door-to-door

that led him to pursue art because it sparked a desire to communicate with people. Koons took a job at the Museum of Modern Art, first at the ticket desk and then in membership services. While working at the latter, he doubled the museum's membership revenue, but he was also asked to temporarily vacate his post one day due to his propensity for flamboyant attire, including paper vests and inflatable flowers (allegedly as to not offend a visiting Russian diplomat).

TO ENCOUNTER THESE TABULA RASA CREATIONS IS TO SEE YOURSELF, AND NEW YORK, IN HIS IMAGE.

Koons' aptitude with finance led him to become a commodities broker on Wall Street, but it wasn't a career change, it was a life support system for his work. He landed his first solo show in 1980 at the New Museum of Contemporary Art, originally located at 65 Fifth Avenue and now on the Bowery. Entitled "The New," it consisted of Hoover vacuum cleaners entombed in Plexiglas boxes. In the September issue of *Artforum* that year Ronny Cohen observed, "Jeff Koons' sculptures ... investigate another step in our cultural pre-conditioning as consumers—the appeal of newness." Like Marcel Duchamp and Warhol before him—two of his most respected influences—Koons began to experiment with the elevation of the everyday object to the gallery's pedestal.

For the remainder of the decade Koons would continue to expand upon these elements of Pop Art and Minimalism in his work, as he himself rose in notoriety (and infamy, sometimes giving interviews in the third person). He began to attract the attention of megawatt collectors like England's Charles Saatchi, who named Koons' 1985 show "Equilibrium" at the East Village gallery International with Monument as one of his all-time favorites, and Dakis Joannou, the Greek billionaire who would go on to become one of his biggest collectors. While short-lived, the Monument gallery was an incubator for Koons and his East Village contemporaries, artists like Peter Halley, Richard Prince and Laurie Simmons, who mined a similar post-modern vein.

In 1988, Koons unveiled one of his most iconic works at the upscale Sonnabend Gallery. Part of the "Banality" series, Koons created a ceramic sculpture of singer Michael Jackson and his pet chimp, Bubbles. But just as memorable at the time were the ads Koons placed, of himself, in *Artforum* and other art magazines to promote the show. Cradling pigs in one and sitting at the head of a children's classroom—with "Exploit the Masses" and "Banality as Savior" written on the chalkboard behind him—in another, Koons seemed to be making as much of a statement about the art world he was quickly coming

JEFF

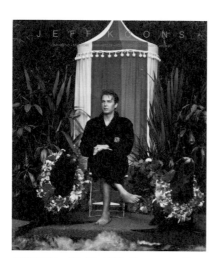

Jeff Koons, <u>Art Ad</u>, 1988. To promote the show "Banality," at Sonnabend Gallery, Jeff Koons placed ads in art magazines featuring himself.

to dominate as he was about celebrity culture and kitsch. But despite what many have interpreted as provocation, Koons continually frames his work as anodyne and gleefully experiential.

It was nothing compared to what came next, however. In 1991, Koons married Ilona Staller, a Hungarian-born porn star elected to the Italian parliament (who performed under the name La Cicciolina). That same year at Sonnabend he debuted a show entitled "Made In Heaven," featuring sculptures and photographs of the couple looking like lusty Greek gods while enacting various sexual positions (titles like "Dirty — Jeff On Top" got right to the point). Michael Kimmelman, writing for *The New York Times*, sniffed, "Dolled up in boots, garters and bustiers, her blond head garlanded with flowers, Cicciolina epitomizes the standard reactionary pornographic male fantasy of the Madonna-whore."

The odd union did not last, and in 1994 the couple divorced. Koons was awarded custody of their son, Ludwig, but Staller took the boy to Italy with her, sparking an expensive and acrimonious legal battle that continues to this day. In the wake of this painful experience Koons established the Koons Family Institute on International Law and Policy at Virginia's International Centre for Missing & Exploited Children. He would later remarry to Justine Wheeler, a former studio employee with whom he has four sons, living in a thirteen-room townhouse on the Upper East Side.

KOONS BEGAN TO EXPERIMENT WITH THE ELEVATION OF THE EVERYDAY OBJECT.

By 2000, Koons was operating a large-scale production studio at 600 Broadway, which has since moved to Chelsea, employing upwards of 100 assistants. (It's a well-known fact that Koons conceives but does not fabricate his work, something for which he makes no apologies.) He was also quickly be-

coming one of the richest artists in the world, partially due to the reception of his "Celebration" series. Comprised of towering balloon animals, outsized hearts and Godzilla-sized jewels — all in eye-popping, reflective colors — the sculptures have been seen everywhere from the Metropolitan Museum of Art's roof to the current *Balloon Flower* installation at 7 World Trade Center to Sotheby's, where in 2007 his *Hanging Heart* sold for a record $23.6 million to his current gallery, Gagosian. Because of his headline-making commercial success Koons' art is often dismissed as the work of a cunning businessman. But, as he once told ArtInfo.com, "My work's not about business, but I was

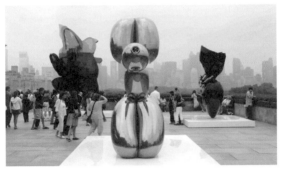

Jeff Koons, Balloon Dog (Yellow), 1994-2000 (center), with Coloring Book, 1997-2005 (left) and Sacred Heart, 1994-2007 (right). In 2008. the Metropolitan Museum of Art celebrated Jeff Koons with an installation of three works from the artist's "Celebration" series on the roof of the museum.

brought up to be very self-reliant, so whatever I do in life I believe I should be able to take care of myself and my family."

It's impossible to predict where Koons will focus his wry lens next, but suffice to say it will elicit an immediate and strong reaction, such as when he curated the New Museum's 2010 "Skin Fruit" exhibition of the Joannou collection — widely rejected as an opportunist move by the museum, the collector and the artist. Whatever form it takes, Koons will likely continue to delight in his forte: amusing viewers while confounding critics in equal measure. He himself remains characteristically unperturbed by the debate; whether by virtue of arrogance or confidence, Koons often views critical failure as a lack of communication and not a commentary on his abilities. As *New York* magazine's senior art critic, Jerry Saltz, has said, "Jeff Koons contains multitudes." Ⓜ

JEFF KOONS IS COVERED IN THE MOVEMENT "APPROPRIATION: NEO POP" ON PG. 43

254
**HARLEM &
NORTH**

248
**UPPER
WEST SIDE**

228
**UPPER
EAST SIDE**

210
MIDTOWN

180
CHELSEA

204
**MIDTOWN
SOUTH**

262
QUEENS

156
**GREENWICH
VILLAGE**

168
**EAST
VILLAGE**

122
SOHO

134

**BOWERY ARTS
DISTRICT**

114
DOWNTOWN

268
BROOKLYN

114 **DOWNTOWN**

122 **SOHO**

134 **BOWERY ARTS DISTRICT**

156 **GREENWICH VILLAGE**

168 **EAST VILLAGE**

180 **CHELSEA**

204 **MIDTOWN SOUTH**

210 **MIDTOWN**

228 **UPPER EAST SIDE**

248 **UPPER WEST SIDE**

254 **HARLEM & NORTH**

262 **QUEENS**

268 **BROOKLYN**

286 **EXTENDED TRAVEL**

LISTINGS

FOR MUCH OF THE 20TH CENTURY, LOWER MANHATTAN WAS A NO-MAN'S LAND, THE FINAL FRONTIER FOR GENERATIONS OF ARTISTS – JASPER JOHNS, ROBERT RAUSCHENBERG, YOKO ONO AND JAMES ROSENQUIST – LOOKING FOR CHEAP STUDIO SPACE. EVEN UNTIL THE EARLY 1980S, TRIBECA WAS A FRINGE NEIGHBORHOOD ON THE EDGE OF SOHO, HOME TO THE MOST ALTERNATIVE AND AVANT-GARDE ARTISTIC ESTABLISHMENTS, A FEW OF WHICH REMAIN TODAY. FURTHER SOUTH, THE BANKS AND SKYSCRAPERS OF THE FINANCIAL DISTRICT HOST SOME OF THE CITY'S BEST EXAMPLES OF PUBLIC ART.

DOWNTOWN

DOWNTOWN

HOUSTON STREET

WEST BROADWAY

BROOME STREET

BROADWAY

GRAND STREET

CANAL STREET

LAFAYETTE STREET

CENTRE STREET

BOWERY

GREENWICH STREET

HUDSON STREET

CHURCH STREET

6

14

7

1

20

2

5

17

4

19

3

CHAMBERS STREET

16

18

BARCLAY STREET

WEST STREET

ST. JAMES PLACE

MANHATTAN BRIDGE

9

BROADWAY

WATER STREET

FDR DRIVE

11

8

10

12

15

BROOKLYN BRIDGE

WATER STREET

13

GALLERIES
1 Apex Art
2 Art in General
3 Clocktower Gallery
4 Dash Gallery
5 Ethan Cohen Fine
6 Jack Hanley
7 Soho Photo

PUBLIC ART
8 Jean Dubuffet, Group of Four Trees, 1962-72
9 Jeff Koons, Balloon Flower (Red), 1995-1999
10 Louise Nevelson, Shadows and Flags, 1977
11 Isamu Noguchi, The Red Cube, 1967
12 Isamu Noguchi, Sunken Garden, 1961-64

HISTORICAL
13 Coenties Slip
14 Fine Arts Building
15 Jasper Johns and Robert Rauschenberg Studio
16 The Lower Manhattan Ocean Club
17 The Mudd Club
18 Yoko Ono Studio

RESTAURANT
19 The Odeon

SHOP
20 Pearl Paint

DOWNTOWN

DOWNTOWN

❶ APEX ART

291 Church Street
212-431-5270
apexart.org
Tues-Sat 11 a.m.-6 p.m.

Apex Art is a forum for independent curators to present the work of emerging and international artists. Over 1,000 artists have shown at the nonprofit since 1994, including established names such as Sophie Calle, Vito Acconci, Bruce Nauman and Martha Rosler.

❷ ART IN GENERAL

79 Walker Street
212-219-0473
artingeneral.org
Tues-Sat noon-6 p.m.

Art in General offers artists an opportunity to show unconventional artwork and engage in artistic dialogue. More than 3,000 artists have shown at the gallery since 1981. The nonprofit supports artists through commissions and residencies.

❸ CLOCKTOWER GALLERY

108 Leonard Street, 13th Floor
212-233-1096
artonair.org
Tues-Fri noon-5 p.m.

Founded by Alanna Heiss in the early '70s, the Clocktower has hosted exhibitions by the likes of Gordon Matta-Clark, who famously dangled from the face of the building's clock. In its latest incarnation, the gallery hosted actor James Franco's first solo show. It's also home to Art International Radio.

❹ DASH GALLERY ▾

172 Leonard Street
thedashgallery.com
Mon-Fri 1-6 p.m.

The Dash Gallery was founded as part of Roc-A-Fella mogul Damon Dash's DD172 media initiative. The four-story space is both a gallery and workshop featuring art in all media and a D.I.Y. spirit. Working with both new and established artists, the gallery aims to nurture young talent and foster new audiences, all while partnering with charity and educational organizations.

❺ ETHAN COHEN FINE ART

18 Jay Street
212-625-1250
ecfa.com
Tues-Sat 11 a.m.-6 p.m.

Established in 1987, Ethan Cohen Fine Art was the first New York gallery to specialize in Chinese contemporary art. The gallery represents leading names from the booming Beijing scene including Zhang Xiaogang and the Gao Brothers.

❻ JACK HANLEY

136 Watts Street
646-918-6824
jackhanley.com
Tues-Sat 11 a.m.-6 p.m.

San Francisco import Jack Hanley has exhibited a long list of quirky artists, including Austrian sculptor Erwin Wurm, who presented a show of self-portraits in the form of pickles in 2010, and Tauba Auerbach, a stylish young artist recently signed by Paula Cooper.

❼ SOHO PHOTO

15 White Street
212-226-8571
sohophoto.com
Wed-Sun 1-6 p.m.

Soho Photo is a non-profit cooperative photography gallery, with over 100 members, each selected through a portfolio review process.

PUBLIC ART

❽ JEAN DUBUFFET
GROUP OF FOUR TREES, 1962-72

1 Chase Manhattan Plaza

Jean Dubuffet's playfully rendered trees are a continuation of the l'Hourloupe series, and its interlocked squiggling lines both compliment and contrast the black-and-white skyscraper behind it. The piece was Dubuffet's first public work, commissioned by David Rockefeller.

❾ JEFF KOONS ▲
BALLOON FLOWER (RED), 1995-1999

7 World Trade Center

Jeff Koons' sculpture of a giant twisted balloon—part of his Celebration series—adds a cheerful element to 7 World Trade Center, the first building to be reconstructed at the World Trade Center site.

❿ LOUISE NEVELSON
SHADOWS AND FLAGS, 1977

Louise Nevelson Plaza (William Street and Maiden Lane)

The small triangular park named for sculptor Louise Nevelson was the first New York park dedicated to an artist. It features seven twisting steel sculptures by the artist ranging in height from 20 to 70 feet.

⑪ ISAMU NOGUCHI
THE RED CUBE, 1967

140 Broadway

The skewed lines and bright color of Isamu Noguchi's *Red Cube* make a bold statement surrounded by the clean lines of modernist buildings.

⑫ ISAMU NOGUCHI
SUNKEN GARDEN, 1961-64

1 Chase Manhattan Plaza

Isamu Noguchi's calming rock and water garden can be viewed from the plaza above, or from the floor-to-ceiling windows inside the building below.

HISTORIC

⑬ COENTIES SLIP

Alley between Pearl & South Streets

In the late '50s and early '60s this tiny street was home to a group of artists experimenting with the ideas that would become Pop and Minimalism, including Agnes Martin, James Rosenquist, Ellsworth Kelly, Robert Indiana and Jack Youngerman. Their work was the subject of a 1993 show at The Pace Gallery.

⑭ FINE ARTS BUILDING

105 Hudson Street

In the late 1970s, this near-vacant office building was a haven for alternative arts organizations including Artists Space, as well as the New Museum and Printed Matter.

⑮ JASPER JOHNS AND ROBERT RAUSCHENBERG STUDIO

278 Pearl Street

In 1954, Jasper Johns set up an early version of the artist's loft in a condemned brick building on Pearl Street. One year later, Robert Rauschenberg moved in from his nearby Fulton Street apartment, occupying the floor above Johns. Rauschenberg was five years older and had already made a name for himself with his early paintings. However, when leading gallerist Leo Castelli paid Rauschenberg a studio visit, the dealer saw Johns' *White Flag* and offered Johns, not Rauschenberg, a show.

⑯ THE LOWER MANHATTAN OCEAN CLUB

121 Chambers Street

Max's Kansas City owner Mickey Ruskin opened the Ocean Club in 1976, before TriBeCa was even on the map. The bar hosted performances by the Talking Heads and Patti Smith and featured décor by Lawrence Weiner and Frosty Myers. Julian Schnabel cooked and washed dishes here while painting on the side.

⑰ THE MUDD CLUB ▼

77 White Street

Opened in 1978, The Mudd Club was a gritty counterpoint to the flashy disco scene at uptown club Studio 54, with a metal chain instead of a velvet rope. Located in a building owned by artist Ross Bleckner and owned, in part, by curator Diego Cortez, the club was the scene of performances by bands like Blondie, the B-52s and Jean-Michel Basquiat's Gray, and was home to a gallery curated by Keith Haring.

⑱ YOKO ONO STUDIO

112 Chambers Street

In 1960 Yoko Ono moved into a fifth-floor loft in a desolate neighborhood, a cold-water walkup with no electricity; her rent was $50.50 a month. There she hosted avant-garde performances, including a series of concerts organized by La Monte Young and her early conceptual works *Painting to be Stepped On* and *Smoke Painting*, attracting the attention of Marcel Duchamp and Fluxus founder George Maciunas.

Mudd Club, 1978–1981

RESTAURANT

⑲ THE ODEON

145 West Broadway
212-233-0507
theodeonrestaurant.com

When the Odeon opened its doors in TriBeCa in 1980, its neon lights were a beacon in a frontier neighborhood. Almost immediately, the restaurant became the go-to spot for the artistic elite. Everyone from Andy Warhol and Jean-Michel Basquiat to dealers Larry Gagosian and Mary Boone's stable of cool kids—Julian Schnabel, David Salle and Ross Bleckner—hung out at the Odeon, as did Wall Street types riding the '80s economic boom. Members of the old guard came by too, including Leo Castelli, Ileana Sonnabend, Robert Rauschenberg and Richard Serra, who famously got kicked out after a fistfight. But unlike the Cedar Tavern, the Odeon wasn't a forum for discourse and dialogue, this was a place to see, a place to be seen; a janitor's closet under the stairs was the place to indulge in sex, cocaine and other forms of 1980s hedonism.

SOHO'S STORY IS THE QUINTESSENTIAL TALE OF A NEIGHBORHOOD TRANSFORMED BY THE ART WORLD. BUT EVEN AS REAL ESTATE BOOMS AND DEVELOPMENT HAVE TURNED IT FROM INDUSTRIAL WASTELAND TO ARTIST'S HAVEN TO PRICEY SHOPPING STRIP, SOHO HAS MANAGED TO KEEP ITS COOL. A FEW CHOICE GALLERIES REMAIN AMID THE LUXURY BOUTIQUES, AND THE CITY'S RICH RECENT ART HISTORY IS PALPABLE AMID ITS CAST-IRON BUILDINGS AND COBBLESTONE STREETS.

SOHO

SOHO

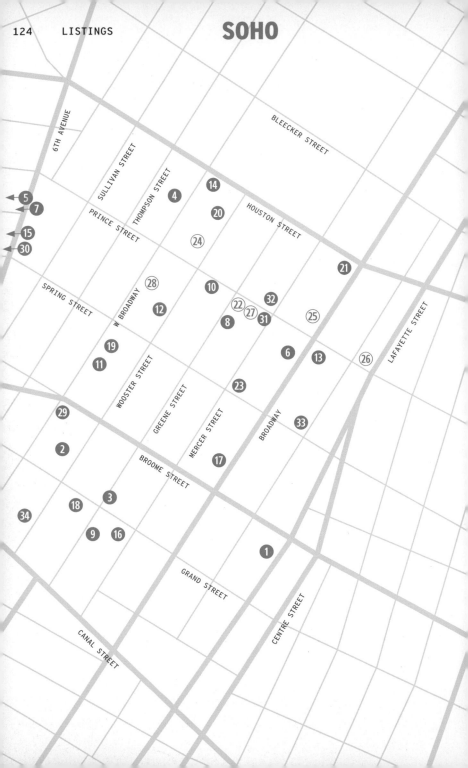

SOHO

MUSEUMS
1. Children's Museum of the Arts
2. The Drawing Center

GALLERIES
3. Artists Space
4. Eli Klein Fine Art
5. Harris Lieberman
6. ISE Cultural Foundation
7. Kate Werble Gallery
8. The Hole
9. Location One
10. Morrison Hotel Gallery
11. OK Harris
12. Peter Blum Gallery
13. Peter Freeman, Inc.
14. Pop International Galleries
15. Renwick Gallery
16. Ronald Feldman Fine Arts
17. Swiss Institute
18. Team

INSTALLATION
19. Walter De Maria
 The Broken Kilometer
20. Walter De Maria
 The New York Earth Room

PUBLIC ART
21. Forest Myers, The Wall

HISTORICAL
22. 112 Greene
23. 101 Spring
24. Food
25. Guggenheim SoHo
26. Keith Haring's Pop Shop
27. Paula Cooper Gallery
28. The SoHo Gallery Building

RESTAURANTS
29. The Cupping Room Café
30. Ear Inn
31. Fanelli's Cafe

HOTELS
32. Mercer Hotel

STORES
33. MoMA Design Store
34. SoHo Art Materials

SOHO

MUSEUMS

❶ CHILDREN'S MUSEUM OF THE ARTS

182 Lafayette Street
212-274-0986
cmany.org
Wed-Sun noon-5 p.m.
Thurs noon-6 p.m.
$10

The Children's Museum of the Arts is all about discovery. Featuring a collection of over 2,000 works by children all over the world—including some dating back to the 1938 Works Progress Administration Children's Art Project—the museum aims to inspire the next generation of artists and art lovers. Kids ages 10 months to 12 years are invited to get creative through hands-on programs taught by working artists.

❷ THE DRAWING CENTER

35 Wooster Street
212-219-2166
drawingcenter.org
Wed, Fri-Sun noon-6 p.m.
Thurs noon-8 p.m., FREE

Established in 1977, The Drawing Center is the only space in the U.S. dedicated solely to the study and exhibition of drawings. Since its first show, titled "Paintings on Paper," exhibitions have included close-up looks at the drawing practice of many major artists including Sol LeWitt's *Wall Drawings* and works on paper by Neo-Expressionist painter Gerhard Richter and multimedia artist Louise Bourgeois.

GALLERIES

❸ ARTISTS SPACE

38 Greene Street, 3rd Floor
212-226-3970
artistsspace.org
Wed-Sun noon - 6 p.m.

Since 1972, Artists Space has been a breeding ground for cutting-edge talent. With its for-artists, by-artists sensibility the alternative, non-profit space has never shied away from challenging or provocative shows, including the landmark "Pictures" show organized by Douglas Crimp in 1977. A young Cindy Sherman worked as a part-time receptionist here—sometimes showing up in 1950s secretary costumes from her photo shoots.

❹ ELI KLEIN FINE ART

462 West Broadway
212-255-4388
elikleinfineart.com
Daily 11 a.m.-7 p.m.

With galleries in New York and Beijing, Eli Klein focuses on the quickly emerging field of contemporary Chinese Art.

❺ HARRIS LIEBERMAN

89 Vandam Street
212-206-1290
harrislieberman.com
Tues-Sat 11 a.m.-6 p.m.

This SoHo gallery's program focuses on emerging contemporary artists. It regularly hosts exciting group shows, like "And so on, and so on, and so on," curated by artist Matt Sheridan Smith and exploring repetition in the work of artists such as Rirkrit Tiravanija, Fia Bakström and Das Institut.

❻ ISE CULTURAL FOUNDATION

555 Broadway
212-925-1649
iseny.org
Tues-Sat 11 a.m.-6 p.m.

ISE Cultural Foundation supports emerging and under-represented artists and curators with opportunities and initiatives such as its Program for Emerging Curators and art student exhibitions.

❼ KATE WERBLE GALLERY

83 Vandam Street
212-352-9700
katewerblegallery.com
Tues-Sat 10 a.m.-6 p.m.

Since 2008, Kate Werble has exhibited up-and-coming contemporary artists, including Sarah E. Wood, who makes elegant, rhythmic suspended sculptures in string and steel and Ernesto Burgos, an artist who includes furniture in his assemblage sculptures.

❽ THE HOLE

104 Greene Street
212-226-3000
theholenyc.com
Tues-Sat noon-6 p.m.

Founded in 2010 by two former staffers of the ultra-hip Deitch Projects (now closed), The Hole is a gallery on a mission to "fill a hole in the downtown community." The Greene Street space retains Deitch's cool-as-can-be spirit, and early shows have boasted an impressive roster of young art talent including Aurel Schmidt, Terence Koh and Nate Lowman. Opening night here guarantees a who's who of downtown's coolest characters.

OPPOSITE Charlotte Posenenske, Series D Vierkantrohe (Square Tubes), 1967, configured by Ei Arakawa, 2010. ABOVE Cody Critcheloe & Ssion, Boy, Aug 26-Sept 11, 2010, The Hole.

SOHO

❾ LOCATION ONE

26 Greene Street
212-334-3347
location1.org
Tues-Sat noon-6 p.m.

Independent and non-profit, Location One presents challenging works of art with a focus on technology, social discourse and collaboration. The residency programs offer artists at various points in their careers a chance to explore projects outside of their usual practice; past senior artists-in-residence include Martha Rosler, Laurie Anderson and Carolee Schneemann.

❿ MORRISON HOTEL GALLERY

124 Prince Street
212-941-8770
morrisonhotelgallery.com
Mon-Thurs 11 a.m.-6 p.m.
Fri-Sat 11 a.m.-7 p.m.
Sun noon-6 p.m.

Morrison Hotel specializes in music photography from the 1940s until today, featuring New York City stars from Billie Holiday to Patti Smith to Blondie, as well as imports Led Zeppelin and the Rolling Stones.

⓫ OK HARRIS

383 West Broadway
212-431-3600
okharris.com
Tues-Sat 10 a.m.-6 p.m.

Founded by former Leo Castelli director Ivan Karp in 1969 at nearby 485 West Broadway, OK Harris was one of SoHo's first galleries. The gallery continues showing contemporary art and photography, featuring up to five one-person shows at a time.

⓬ PETER BLUM GALLERY

99 Wooster Street
212-343-0441
peterblumgallery.com
Tues-Fri 10 a.m.-6 p.m.
Sat 11 a.m.-6 p.m.

Peter Blum co-founded the legendary arts magazine *Parkett* in 1984, and opened his SoHo gallery in 1993. Since then the gallery has hosted exhibitions of new work as well as historical surveys, including such important artists as Louise Bourgeois, Agnes Martin, Robert Ryman and Alex Katz.

⑬ PETER FREEMAN, INC.

560 Broadway Suite 602 / 603
212-966-5154
peterfreemaninc.com
Tues-Sat 10 a.m.-6 p.m.

Peter Freeman, Inc. was founded in 1990, specializing in important works from the 20th century, with a focus on early Pop and Minimal work. Each year the gallery puts on five exhibitions, including Frank Stella's abstract paintings, Mel Bochner's text-based work and Alex Hay's paintings of everyday objects.

⑭ POP INTERNATIONAL GALLERIES

473 West Broadway
212-533-4262
popinternational.com
Mon-Sat 10 a.m.-7 p.m.
Sun 11 a.m.-6 p.m.

Retail gallery Pop International offers prints and photographs from some of Pop Art's biggest names, including Andy Warhol and Roy Lichtenstein, as well as second-generation Pop stars Keith Haring and Jean-Michel Basquiat.

⑮ RENWICK GALLERY

45 Renwick Street
212-609-3535
renwickgallery.com
Tues-Sat 11 a.m.-6 p.m.

For the opening of Renwick Gallery, dealer Leslie Fritz flew video artist Meredith Danluck to Tokyo for a 30-second meet-and-greet with Michael Jackson for the the video *Michael Jackson, Jesus Christ ... Coca-Cola*.

⑯ RONALD FELDMAN FINE ARTS

31 Mercer Street
212-226-3232
feldmangallery.com
Tues-Sat 10 a.m.-6 p.m.

Founded in 1971, Ronald Feldman Fine Arts exhibits contemporary work in all media, including early feminist artist Hannah Wilke, painter Leon Gloub and Eleanor Antin, who explores history in her performance and films.

⑰ SWISS INSTITUTE

495 Broadway, 3rd Floor
212-925-2035
swissinstitute.net
Tues-Sat noon-6 p.m.

The Swiss Institute was founded in 1966 to foster artistic dialogue between Switzerland and the United States. Today the non-profit has expanded its mission to represent contemporary artists from throughout Europe in a sprawling SoHo loft.

SOHO

⑱ TEAM

83 Grand Street
212-279-9219
teamgal.com
Tues-Sat 10 a.m.–6 p.m.

José Freire's Grand Street gallery boasts one of the art world's coolest contemporary rosters, featuring young stars such as photographer Ryan McGinley, new media artist Cory Arcangel and Banks Violette, who explores goth and black metal subculture in his multimedia installations.

INSTALLATIONS

⑲ WALTER DE MARIA
THE BROKEN KILOMETER

393 West Broadway
diaart.org
Wed-Sun, noon-6 p.m.
(closed from 3–3:30 p.m.)

On view since 1979 and maintained by the Dia Art Foundation, *The Broken Kilometer* is a Minimalist sculpture installation featuring

an arrangement of 500 brass rods, each measuring 2 meters in length. Laid end-to-end the rods would span a full kilometer.

⑳ WALTER DE MARIA
THE NEW YORK EARTH ROOM

141 Wooster Street
diaart.org
Wed-Sun, noon-6 p.m.
(closed 3–3:30 p.m.)

Walter De Maria's arresting installation *The New York Earth Room* consists of a room filled with 250 cubic yards of soil. Installed in 1977, this was De Maria's third *Earth Room*—the other two were in Germany—but it's the only one that remains. The site has been open to the public since 1980 and is maintained by the Dia Art Foundation.

PUBLIC ART

㉑ FORREST MYERS
THE WALL

599 Broadway

Originally installed in 1973 to hide 42 aluminum beams protruding from the building, Forrest "Frosty" Myers' massive blue wall installation at the corner of Broadway and Houston is the unofficial "Gateway to SoHo." Since then it has been the subject of major controversy—a court case brought the Minimalist work down in 2002, but it was triumphantly reinstalled in 2007.

HISTORICAL

㉒ 112 GREENE

Gordon Matta-Clark is credited with creating (or at least fueling) the SoHo art scene. In 1970, Matta-Clark opened the exhibition space 112 Greene, the first cooperative gallery in America, which ran until 1980. Today the gallery lives on as White Columns at 320 W. 13th Street.

㉓ 101 SPRING
101 Spring Street
juddfoundation.org

Artist Donald Judd purchased the five-story building 101 Spring in 1968, in the early days of SoHo's transformation. Before his death, the artist arranged for the space to remain a permanent installation of his work, including museum-quality sculpture and furniture. The Judd Foundation is currently restoring the space with plans to open to the public in 2013.

㉔ FOOD
127 Prince Street

Founded by conceptual architect Gordon Matta-Clark and Carol Goodden in 1971, Food was equal parts restaurant, art project and the first-ever SoHo artist's hangout. Regulars at the artist-run, artist-staffed restaurant included Robert Rauschenberg and Philip Glass.

㉕ GUGGENHEIM SOHO
575 Broadway

In 1992, the Guggenheim Museum opened a SoHo branch, bringing the museum's modern and contemporary collection downtown in a loft-like space. Before it closed in 2001, exhibitions included the works of Bill Viola, Robert Rauschenberg and a permanent installation of Andy Warhol's *The Last Supper*.

LEFT Forrest Myer's installation The Wall at the corner of Broadway and Houston Street.
OPPOSITE Team Gallery.

SOHO

㉖ KEITH HARING'S POP SHOP

292 Lafayette Street
haring.com

Artist Keith Haring opened his retail space in 1986, offering his famous graffiti characters on everything from T-shirts to mugs to skateboards. With its floor-to-ceiling black-and-white murals, the Pop Shop was an iconic SoHo landmark until it closed in 2005.

㉗ PAULA COOPER GALLERY

96 Prince Street

Pioneering art dealer Paula Cooper opened SoHo's first art gallery in 1968 with a show featuring Dan Flavin, Donald Judd, Carl Andre and Sol LeWitt's first *Wall Drawing*. The space moved to Chelsea in 1996, and continues to exhibit leading artists in Conceptual and Minimal art.

㉘ THE SOHO GALLERY BUILDING

420 West Broadway

Now luxury loft apartments, the SoHo Gallery Building was the epicenter of the art scene from the early 1970s until 1999, boasting leading galleries Leo Castelli, Sonnabend and a young startup named Mary Boone.

RESTAURANTS

㉙ THE CUPPING ROOM CAFÉ

359 West Broadway
212-925-2898

Opened in 1977 as a cheap artists' hangout, this neighborhood restaurant, bar and bakery still hosts low-key art exhibitions and live music.

㉚ EAR INN ▲

326 Spring Street
212-431-9750
earinn.com

Located in an 1817 Federal townhouse, this low-key Westside hangout has been a second home for generations of musicians and artists, including Fluxus founder George Maciunas, who was once a waiter here.

⓷ FANELLI'S CAFE

94 Prince Street
212-226-9412

Originally opened in 1847, this old-school pub has been known for its burgers and beer since the Fanelli family took over in 1922. During SoHo's transformation, Fanelli's became the go-to hangout for the artist set: In 1998 pioneering neighborhood gallery OK Harris hosted a group show featuring over 140 artists from the Fanelli scene. At one time, art star Jeff Koons was also a regular.

HOTEL

⓸ MERCER HOTEL ▾

147 Mercer Street
212-966-6060
mercerhotel.com

This intimate, 75-room boutique hotel, which spans six floors in a Romanesque Revival building, offers loft-style living in the heart of SoHo. Before its conversion to a hotel in the 1990s, it served as a space for artists' lofts and studios. The lobby has a 50-foot bookcase with an extensive collection of books dedicated to art, architecture, fashion and design.

SHOPS

⓹ MOMA DESIGN STORE

81 Spring Street
646-613-1367
momastore.org

The MoMA Design Store offers museum-approved furniture from the likes of Philippe Starck, Josef Albers and Charles and Ray Eames, plus gift-worthy art books, jewelry and accessories.

SINCE THE NEW MUSEUM OF CONTEMPORARY ART ANNOUNCED ITS MOVE TO THE BOWERY IN 2002, THE FORMERLY DOWN-AND-OUT AREA HAS BECOME MANHATTAN'S MOST EXCITING NEW ART DISTRICT. AD-HOC GALLERIES SHOWING EMERGING ARTISTS HAVE POPPED UP IN SMALL STOREFRONTS, BASEMENTS AND EVEN WALK-UP APARTMENTS. EVEN SOME BIG NAMES – INCLUDING THE CHELSEA BLUE CHIP LEHMANN MAUPIN AND THE UPPER EAST SIDE'S SALON 94 – HAVE SET UP OUTPOSTS HERE.

BOWERY ARTS DISTRICT

BOWERY ARTS DISTRICT

MUSEUM

1. New Museum

GALLERIES

2. ABC No Rio
3. Miguel Abreu Gallery
4. Abrons Art Center
5. Anastasia Photo
6. Anonymous Gallery
7. Art Since the Summer of '69
8. Asia Song Society
9. Charles Bank Gallery
10. Nicelle Beauchene Gallery
11. Jen Bekman Gallery
12. Blackston
13. Collette Blanchard Gallery
14. Bridge Gallery
15. Bureau
16. Canada
17. Lisa Cooley Fine Art
18. Cuchifritos
19. DCKT Contemporary
20. Dexter Sinister
21. DODGEgallery
22. Eleven Rivington
23. Forever & Today
24. Frosch & Portmann
25. James Fuentes LLC
26. FusionArts Museum
27. Gallery nine5
28. Gallery onetwentyeight
29. Laurel Gitlen
30. Half Gallery
31. Lesley Heller Workspace
32. Hendershot Gallery
33. Christopher Henry Gallery
34. Horton Gallery
35. Invisible-Exports
36. Allegra LaViola Gallery
37. Lehmann Maupin
38. LMAK Projects
39. Ludlow 38
40. NP Contemporary Arts Center
41. NY Studio Gallery
42. Number 35 Gallery
43. On Stellar Rays
44. Participant Inc.
45. Sperone Westwater
46. Simon Preston Gallery
47. Ramiken Crucible
48. Reena Spaulings Fine Art
49. Rooster Gallery
50. Salon 94 Freemans
51. Salon 94 Bowery
52. Scaramouche
53. Storefront for Art and Architecture
54. Sue Scott Gallery
55. Sloan Fine Art
56. Thierry Goldberg Projects
57. Rachel Uffner Gallery
58. White Box
59. Woodward Gallery

HISTORICAL

60. The Bunker
61. Jasper Johns Studio
62. Keith Haring Studio
63. Robert Indiana Studio
64. Roy Lichtenstein Studio

RESTAURANTS

65. Ballato
66. Gallery Bar

HOTEL

67. Thompson LES

SHOP

68. Clic Bookstore & Gallery

❶ NEW MUSEUM

235 Bowery
212-219-1222
newmuseum.org
Wed, Fri-Sun 11 a.m.-6 p.m.
Thursday 11 a.m.- 9 p.m.
$12

When Marcia Tucker founded the New Museum in 1977, even the visionary curator couldn't have imagined the influence her organization would have in promoting the cause of contemporary art. On the vanguard since its early days based in an abandoned TriBeCa office building, the organization transformed the art with a move to the Bowery just in time for its 30th anniversary. By the time the 60,000-square-foot, Sejima + Nishizawa/SANAA-designed building opened in 2007, galleries had begun sprouting up around the Lower East Side. Today, the museum is the gateway to one of New York's most exciting art districts. Throughout its history, the museum has championed under-represented artists from Carolee Schneemann to David Wojnarowicz, while supporting the next wave through exhibitions such as 2009's "generational" show "Younger Than Jesus," which featured 50 artists from 25 countries, all under the age of 33. The museum partnered with new media nonprofit Rhizome in 2003.

"There is an immediate element of surprise when you see the building, but one of the most surprising things is the transparency. You see art and people from the first instant through the floor to ceiling glass storefront. Then in a final flourish, SANAA clad the entire building in an expanded aluminum mesh that optically dematerializes the building and turns the entire structure into a play of light and reflection.

At the end of our 30th anniversary, we inaugurated our museum on November 30, 2007 with New York City's Mayor Bloomberg proclaiming that we had 'put the new back in New York'."

Lisa Phillips
Toby Devan Lewis Director
New Museum

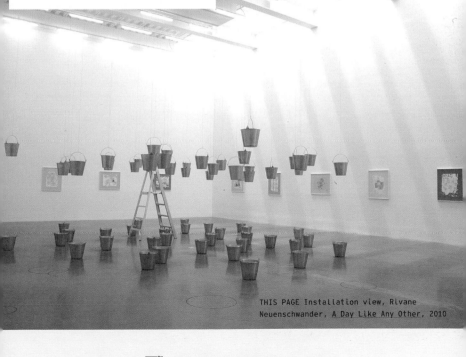

THIS PAGE Installation view, Rivane Neuenschwander, A Day Like Any Other, 2010

GALLERIES

❷ ABC NO RIO

156 Rivington Street
212-254-3697
abcnorio.org

ABC No Rio is a collective-run center for art and activism founded by a group of artists in 1980. Its name comes from the few letters left on its original storefront sign (Abogado Con Notario, lawyer and notary), and it's one of the few reminders of the area's gritty past. It's also a fully functioning counterculture space, home to a darkroom, print shop, computer center and 'zine library, as well as a regular slate of poetry readings, punk shows and art exhibits.

❸ MIGUEL ABREU GALLERY

36 Orchard Street
212-995-1774
miguelabreugallery.com
Wed-Sun 11 a.m.-6:30 p.m.

Filmmaker Miguel Abreu was an influential player on the SoHo scene before founding his gallery in 2006. Along with its regular slate of solo and group shows, the gallery hosts film screenings and talks with thinkers such as philosopher Slavoj Zizek and Kyong Park, an influential voice in architecture and urban planning.

❹ ABRONS ART CENTER

Henry Street Settlement
466 Grand Street
212-598-0400
henrystreet.org
Tues-Sat 9 a.m-10 p.m.
Sunday 10 a.m.-6 p.m.

The Abrons Art Center is the performing and visual arts arm of the Henry Street Settlement, a community center nestled on an unassuming stretch of Grand Street near the Williamsburg Bridge. Since 1975, Abrons has fostered artistic innovation on the Lower East Side through exhibitions, concerts, artist residencies and workshops. Its landmarked theater has hosted performances by such luminaries as John Cage, Dizzy Gillespie, Martha Graham and Laurie Anderson.

FEATURE INC.

131 Allen Street
212-675-7772
featureinc.com
Wed-Sat noon-6 p.m.
Sunday 1 p.m.-6 p.m.

As the Lower East Side transforms from artsy fringe to bona fide art hub, Hudson, director of Feature Inc., gave us his take on Manhattan's hottest cultural corridor.

What can people expect to see at Feature Inc.?

Feature opened in Chicago in 1984 and moved to NYC in 1988. The gallery exhibits a full range of contemporary art and tends to be content oriented with a preference for addressing trends, issues and aesthetics from more personal or individuated points of view. There is, as well, an interest in materials, skill and techniques. Feature is particularly noted for introducing the work of many artists who later have become quite famous, including: Richard Prince, Raymond Pettibon, Charles Ray, Jim Shaw, Tom Friedman and Takashi Murakami.

How would you describe the Lower East Side?

The L.E.S. is a thriving neighborhood that has more going on it than just art. It has a complex and varied history and has been a haven for the working class, lowlifers, intellectuals, and social, political and religious eccentrics.

There are terrific music venues, restaurants, boutiques for all kinds of things and many small cultural institutions. People who live, work and play here feel somewhat connected to each other.

The galleries on the LES mostly exhibit younger artists' work, or art that appears to be made by younger artist, but actually there is a wider range than is initially apparent. Often, the scene down here is described as edgy.

How does this scene compare to others in the city?

In comparison, Chelsea seems strictly business and quite cold. Its dense concentration of galleries is a bit exhausting. In feel, Brooklyn is similar to the L.E.S., however, it's more dispersed.

Any tips for someone looking to spend a day in the area?

If you are spending the day down on the L.E.S. be ready to wander around and be open to more than your agenda; you will enjoy your discoveries.

❺ ANASTASIA PHOTO

166 Orchard Street
212-677-9725
anastasia-photo.com
Wed-Sun 11 a.m.-7 p.m.

With a focus on photojournalism from around the world, Anastasia Photo showcases the images behind the news, with powerful photographs documenting everything from the conflicts in the Democratic Republic of Congo to China's rapidly developing trade routes to the lives of women in Afghanistan. The gallery also supports a number of charitable organizations.

❻ ANONYMOUS GALLERY

329 Broome Street
646-238-9069
anonymousgallery.com
Wed-Sun noon-7 p.m.

Since 2008, Anonymous Gallery has showcased a wide range of contemporary artists including Agathe Snow and Andy Warhol collaborator Ronnie Cutrone. The Anonymous mission extends beyond the space with exhibitions and events held extending to satellite locations and public spaces throughout the city.

❼ ART SINCE THE SUMMER OF '69

195 Chrystie Street #303
artsince69.com

Founded by artist and curator Hanne Mugaas, Art Since the Summer of '69 is a curatorial concept with a playful attitude and a teeny tiny gallery space. Past projects have included work inspired by lapdogs and a show of work by art-world interns.

❽ ASIA SONG SOCIETY

45 Canal Street
asiasongsociety.com

Asia Song Society is the home base of artist Terence Koh and dealer Javier Peres. The gallery keeps unusual hours, but events draw a fashionable crowd; check the website for upcoming events.

❾ CHARLES BANK GALLERY

196 Bowery
212-219-4095
charlesbankgallery.com
Wed-Sun noon-7 p.m.

This Bowery newcomer opened its slick space in 2010, with a slate of conceptually minded contemporary shows from international artists including Denmark's Kasper Sonne and Italian artist Mauro Bonacina.

OPPOSITE Construction Crisis by Kasper Sonne, part of the exhibition "Pure Colors" at Charles Bank Gallery, 2010.

❿ NICELLE BEAUCHENE GALLERY

21 Orchard Street
212-375-8043
nicellebeauchene.com
Wed-Sun noon-6 p.m.

Nicelle Beauchene, a veteran of Marianne Boesky and Perry Rubenstein galleries, showcases contemporary art ranging from the subtle geometric compositions of Sarah Crowner and Jim Lee to Valerie Hegarty's surreal renderings of ruined famous artwork.

⓫ JEN BEKMAN GALLERY

6 Spring Street
212-219-0166
jenbekman.com
Wed-Sat noon-6 p.m.

Since 2003 Jen Bekman Gallery has supported emerging artists and collectors. Along with the "Hey, Hot Shot!" competition of international photography, the gallery is also home of the 20x200 project, which offers limited edition prints at entry-level prices.

BOWERY ARTS DISTRICT

⑫ BLACKSTON

29C Ludlow Street
212-695-8201
blackstongallery.com
Wed-Sun 11 a.m.-6 p.m.

Founded as Bespoke Gallery
in 2004 and renamed in 2009,
Blackston exhibits emerging
contemporary artists working in
a range of disciplines including
Christina Hejtmanek's whistful
photographs and Pia Dehne's
hyperrealistic oil paintings.

⑬ COLLETTE BLANCHARD GALLERY

26 Clinton Street
917-639-3912
colletteblanchard.com
Wed-Sun 11 a.m.-6 p.m.

Collette Blanchard opened in 2008
with "Belle du Jour," a group show
featuring the female form as inter-
preted by female artists. Since then
programming has included solo
shows by gallery artists along with
"Brand New Heavies," an exhibi-
tion curated by artist Mickalene
Thomas featuring work by Deana
Lawson, Jessica Ann Peavy and
Lauren Kelley.

⑭ BRIDGE GALLERY

98 Orchard Street
212-674-6320
bridgegalleryny.com
Sun-Fri 11 a.m.-5 p.m.
Saturday 10 a.m.-5 p.m.

Exhibitions at Bridge Gallery have
featured furniture made of recycled
material, the Pop paintings of Marjorie
Strider and an installation based on
colors found in the surrounding neigh-
borhood created by SOFTlab.

⑮ BUREAU

127 Henry Street
212-227-2783
bureau-inc.com
Thus-Sun noon-6 p.m.

Former Swiss Institute curator Gabrielle
Giattino founded Bureau in 2010 with a
mission to support the development of a
select group of emerging artists.

⑯ CANADA

55 Chrystie Street
212-925-4631
canadanewyork.com
Wed-Sun noon-6 p.m.

Located in an office building near the
on-ramp of the Manhattan Bridge,
Canada was one of the area's first galler-
ies when it opened in 2002. The gallery's
exciting young roster includes painters
Katherine Bernhardt and Carrie Moyer,
who create fashion-model grotesques
and acrylic abstracts, respectively.

⑰ LISA COOLEY FINE ART

34 Orchard Street
212-680-0564
lisa-cooley.com
Wed-Sun 11 a.m.-6 p.m.

Artists with an intellectual
bent—Matt Sheridan Smith,
painter Alex Olson and textile
artist Josh Faught to name a
few—and creative curating that
pairs veteran artists with emerging
names make Lisa Cooley one of
the Lower East Side's most exciting
galleries.

⑱ CUCHIFRITOS

120 Essex Street
212-420-9202
aai-nyc.org/cuchifritos
Tues-Sat noon-5:30 p.m.

Located inside of the historic
Essex Street Market, Cuchifritos
is a project of the Artists Alliance,
which provides a forum for inde-
pendent curators to highlight the
work of underrepresented artists in
an unexpected setting.

⑲ DCKT CONTEMPORARY

195 Bowery
212-741-9955
dcktcontemporary.com
Tues-Fri 11 a.m.-6 p.m.
Saturday noon-6 p.m.
Sunday noon-5 p.m.

Founded in Chelsea in 2002, DCKT
moved to the Bowery in 2008 with
a roster that includes illustrator
Sophie Crumb and sculpture-based
performance artist Irvin Morazan.

⑳ DEXTER SINISTER

38 Ludlow Street
213-235-6296
destersinister.org
Saturday noon-6 p.m.

Dexter Sinister is equal parts
basement gallery, collaborative art
project, "occasional bookstore" and
the home of *Dot Dot Dot* magazine.

㉑ DODGEGALLERY

15 Rivington Street
212-228-5122
dodge-gallery.com
Tues-Sat 11 a.m.-6 p.m.

DODGEgallery highlights innova-
tive approaches in three-dimen-
sional work, such as Lorna Williams
layered mixed-media pieces.

BOWERY ARTS DISTRICT

㉒ ELEVEN RIVINGTON

11 Rivington Street
212-982-1930
elevenrivington.com
Wed-Sun noon-6 p.m.

This contemporary offshoot of Midtown's ritzy Greenberg Van Doren Gallery represents emerging and under-recognized established artists thanks, in part, to the influence of founder Ronald Greenberg's daughter Jeanne Greenberg Rohatyn, the gallerist behind the Salon 94 mini-empire.

㉓ FOREVER & TODAY

141 Division Street
foreverandtoday.org
Thurs-Sat noon-8 p.m.

This nonprofit commissions contemporary artists from around the world to create site-specific works, exhibitions and public programming in its 100-square-foot storefront.

㉔ FROSCH & PORTMANN

53 Stanton Street
646-266-5994
Wed-Sun, noon-6 p.m.
froschportmann.com

Frosch & Portmann is a partnership between Zurich-based curator hp Portmann and Eva Frosch, a former director of defunct Brooklyn favorite Jack the Pelican Presents, who has also worked with artist Peter Halley.

㉕ JAMES FUENTES LLC

55 Delancey Street
212-577-1201
jamesfuentes.com
Tues-Sun noon-6 p.m.

Since 2005, this hipster favorite has represented fashionable artists such as Lizzi Bougatsos, Jonas Mekas and Agathe Snow.

㉖ FUSIONARTS MUSEUM

57 Stanton Street
212-995-5290
fusionartsmuseum.org
Tues-Fri, Sunday noon-6 p.m.

Located behind an iconic sculpted gate, this nonprofit dedicated to multidisciplinary works has been a neighborhood fixture since 2000.

㉗ GALLERY NINE5

24 Spring Street
212-965-9995
gallerynine5.com
Mon-Sat 11 a.m.-7 p.m.
Sunday noon-7 p.m.

The gallery exhibits local and global contemporary artists, and also offers limited-edition prints for under $1,000.

㉘ GALLERY ONETWENTYEIGHT

128 Rivington Street
212-674-0244
galleryonetwentyeight.org
Wed-Sat 1 p.m.-7 p.m.
Sunday 1 p.m.-5 p.m.

Founded by sculptor Kazuko Miyamoto in 1986, Gallery ontwentyeight is a Lower East Side pioneer. Exhibitions range from Eric Ginsburg's quirky paintings of pets to group shows highlighting art from Japan.

㉙ LAUREL GITLEN

261 Broome Street
212-274-0761
laurelgitlen.com
Wed-Sun noon-6 p.m.

This gallery, formerly called Small A Projects, hosts exhibitions from the likes of Jessica Jackson Hutchins, who makes art from worn-in furniture and ceramics, and Allyson Vieira, who makes ghostly works in poured plaster, drywall and concrete.

㉚ HALF GALLERY

208 Forsyth Street
halfgallery.com
Mon-Fri 10 a.m.-6 p.m.

Run by author James Frey, designer Andy Spade and man-about-town Bill Powers, Half Gallery exhibits modish artists like Hanna Liden and Leo Fitzpatrick. Likewise, its openings are scene-y affairs, bringing out downtown's boldfaced names.

㉛ LESLEY HELLER WORKSPACE

54 Orchard Street
212-410-6120
lesleyheller.com
Wed-Sat 11a.m.-6 p.m.
Sunday noon-6 p.m.

Lesley Heller Workspace invites independent curators and artists to propose exhibitions, with a focus on emerging and underrepresented artists.

㉜ HENDERSHOT GALLERY

195 Chrystie Street
212-239-1210
hendershotgallery.com
Wed-Sun 11 a.m.-6 p.m.

Highlights at Hendershot include Catalin Petrisor's eerie oil paintings and the performative work of painter Miriam Cabessa, who represented Israel in the 1997 Venice Biennale.

The corner of Broome and Orchard streets on the Lower East Side.

③③ CHRISTOPHER HENRY GALLERY

127 Elizabeth Street
212-244-6004
christopherhenrygallery.com
Wed-Sun 11 a.m.-6 p.m.

Located in a former church on the edge of Chinatown, Christopher Henry hosts off-beat and thought-provoking exhibitions — including a satellite show of the 2010 London Biennial and the kooky crochet work of Olek, who created a knit-covered car on the street.

③④ HORTON GALLERY

237 Eldridge Street
212-253-0700
hortongallery.com
Thurs-Sun noon-6 p.m.

Originally opened as a one-day-a-week gallery called Sunday, Horton has expanded to a second location in Chelsea. Both locations specialize in presenting new work in all media, though there's a distinct leaning toward contemporary painting like Saul Becker's lyrical landscapes, Kirk Hayes' trompe-l'oeil painted collages and Daniel Rich's politically charged work in enamel.

③⑤ INVISIBLE-EXPORTS

14A Orchard Street
212-226-5447
invisible-exports.com
Wed-Sun 11 a.m.-6:30 p.m.

Just like its name implies, Invisible-Exports focuses on the intangible — as in contemporary work with a conceptual bent. Exhibitions include Mickey Smith's photographs of library collections and mixed media work by musician, performance artist and downtown legend Genesis Breyer P-Orridge.

③⑥ ALLEGRA LAVIOLA GALLERY

179 East Broadway
917-463-3901
allegralaviola.com
Wed-Sat noon-6 p.m.
Sunday 1 p.m.-6 p.m.

This bi-level contemporary gallery has a social feel, thanks to a series of artist talks and regular supper club performances. Exhibitions include Brian Montuori's dark visions and the outsized performance spectacles of Jennifer Catron and Paul Outlaw.

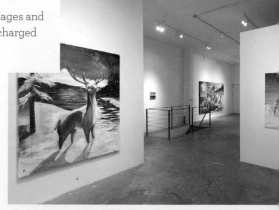

RIGHT Installation view of the Brian Montuori exhibit Cold Sweat at Allegra LaViola Gallery, 2010

㊲ LEHMANN MAUPIN

201 Chrystie Street
212-254-0054
lehmannmaupin.com
Wed-Sat 10 a.m.-6 p.m.
Sunday noon-6 p.m.

Lehmann Maupin was one of the
first Chelsea galleries to set up an
outpost on the Lower East Side,
and it remains one of the area's
finest. The space opened in 2007
with an architectural installation
created by Do-Ho Suh that filled
the entire gallery with gauzy fabric.
The gallery is a regular feature
on critics' must-see lists, with
exhibitions like the charged work
of Tracey Emin or Tony Oursler's
technological experiments.

㊳ LMAK PROJECTS

139 Eldridge Street
212-255-9707
lmakprojects.com
Wed-Sat 11 a.m.-6 p.m.
Sunday noon-6 p.m.

After time in Williamsburg and
Chelsea, LMAK moved to the L.E.S.
in 2008. The gallery focuses on inter-
national artists working in all media.

㊴ LUDLOW 38

38 Ludlow Street
212-228-6848
ludlow38.org
Fri-Sun 1 p.m.-6 p.m.

Ludlow 38 is the downtown satellite
of the Goethe-Institut New York.
Each year the organization partners
with a different German institution
for the year's programming.

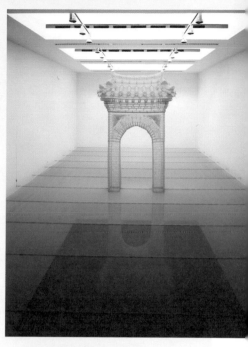

㊵ NP CONTEMPORARY ARTS CENTER

131 Chrystie Street
212-226-4552
npcac.org
Wed-Sun noon-6 p.m.

NP is a community-driven non-
profit organization that fosters
contemporary art through a range
of exhibition and performances.

ABOVE Do Ho Suh, Reflection, 2004.
Installation view, Lehmann Maupin
Gallery, 201 Chrystie Street

④ NY STUDIO GALLERY

154 Stanton Street
212-627-3276
nystudiogallery.com
Thu-Sat noon-6 p.m.

Along with regular exhibitions, NY Studio Gallery offers in-gallery studio space through its artist-in-residence program. During the summer six artists are chosen for the ARTcamp program.

④ NUMBER 35 GALLERY

141 Attorney Street
212-388-9311
numberthirtyfive.com
Wed-Sun noon-6 p.m.

Number 35 Gallery focuses on contemporary painting, sculpture and installations like Markus Linnenbrink's psychedelic multi-color abstractions.

④ ON STELLAR RAYS

133 Orchard Street
212-598-3012
onstellarrays.com
Wed-Sat 11 a.m.-6 p.m.
Sunday noon-6 p.m.

With a name that comes from an ancient Greek text on the physics of perception, On Stellar Rays presents adventurous art and experimentation in various media.

BELOW Sperone Westwater's Bowery gallery, designed by Norman Foster, Foster+Partners, and opened in 2010.

ⓧ PARTICIPANT INC.

253 East Houston Street
212-254-4334
participantinc.org
Wed-Sun noon-7 p.m.

Participant Inc. is an alternative space founded in 2001 with a focus on education. The gallery provides a forum for artists and curators to present challenging work and foster artistic exploration through its open submissions policy.

ⓧ SPERONE WESTWATER

257 Bowery
212-999-7337
speronewestwater.com
Tues-Sat 10 a.m.-6 p.m.

When this monolithic Norman Foster-designed gallery opened in 2010 it was a watershed moment in the Bowery's rise from skid row to art destination. The eight-story space serves as a gallery on the scale of a museum, with exhibitions by leading artists including Guillermo Kuitca, Bruce Nauman and Malcolm Morley. The gallery has been an important player on the international scene since it originally opened in SoHo in 1975 with a Carl Andre exhibition.

ⓧ SIMON PRESTON GALLERY

301 Broome Street
212-431-1105
simonprestongallery.com
Wed-Sun 11 a.m.-6 p.m.

Simon Preston represents emerging contemporary artists including Irish photographer John Gerrard and

Brazilian sculptor Carlos Bevilacqua. Group shows have included the work of established names such as feminist icon Mary Kelly.

ⓧ RAMIKEN CRUCIBLE

221 East Broadway
917-434-4245
ramikencrucible.com
Wed-Sun noon-6 p.m.

Ramiken Crucible features art with a dark edge in a raw, basement space. In addition to its regular programming, the gallery has hosted concerts, Art Handling Olympics and "Mouthful of Poison," a group show in a secret location featuring work by Rirkrit Tiravanija and art collective The Yes Men.

ⓧ REENA SPAULINGS FINE ART

165 East Broadway
212-477-5006
reenaspaulings.com
Thurs-Sun noon-6 p.m.

Reena Spaulings Fine Art is a gallery located above a Chinese restaurant, run by a fictional artist and dealer of the same name, and created by an international collective called the Bernadette Corporation. Gallery artists tend to be stylish and subversive, including photographer K8 Hardy and Sonic Youth's Kim Gordon.

BOWERY ARTS DISTRICT

⑳ ROOSTER GALLERY

190 Orchard Street
212-230-1370
roostergallery.com
Tues- Sun noon-10 p.m.

Rooster Gallery represents artists from the U.S. and abroad. The gallery occasionally invites guest curators to expand dialogue.

㊿ SALON 94 FREEMANS

1 Freeman Alley
212-529-7400
Tuesday 1 p.m.-6 p.m.
Wed-Sat 11 a.m.-6 p.m.

�51 SALON 94 BOWERY

243 Bowery
212-979-0001
Wed-Fri 11 a.m.-6 p.m.
Sat-Sun noon-6 p.m.
salon94.com

Salon 94 Freemans was the first downtown branch of Upper East Side gallery Salon 94. Like the original, Salon 94 Freemans and neighboring Salon 94 Bowery, which opened in 2010, boast an upscale lineup as well as special projects from the likes of Richard Prince.

�52 SCARAMOUCHE

52 Orchard Street
212-228-2229
scaramoucheart.com
Wed-Sat noon-6 p.m.
Sunday 1p.m.-5 p.m.

Scaramouche inaugurated its Orchard Street space in 2010 with an exhibition of monochrome paintings by Oliver Lutz that revealed appropriated images when viewed through infrared security cameras.

�53 STOREFRONT FOR ART AND ARCHITECTURE

97 Kenmare Street
212-431-5795
storefrontnews.org
Tues-Sat 11 a.m.-6 p.m.

Since 1982, this nonprofit has been dedicated to promoting innovation in architecture, art and design, showing the likes of Kiki Smith, Alfredo Jaar and Dan Graham. Its distinctive open façade featuring a dozen pivoting panels was designed by artist Vito Acconci and architect Steven Holl in 1993.

�54 SUE SCOTT GALLERY

1 Rivington Street, 2ⁿᵈ flooor
212-358-8767
suescottgallery.com
Tue-Sat 11 a.m.-6 p.m.

Founded by veteran curator and critic Sue Scott, this gallery presents emerging and established artists including Franklin Evans, an artist included in the 2010 edition of PS1's Greater New York for his installations made of paper, tape and other studio detritus.

⑤ SLOAN FINE ART

128 Rivington Street
212-477-1140
sloanfineart.com
Wed-Sun noon-6 p.m.

The gallery and project room at
Sloan Fine Art feature a range
of work including Elizabeth
McGrath's disturbing animal figu-
rines and Marion Peck's subver-
sively surreal oil paintings.

⑤ THIERRY GOLDBERG PROJECTS

5 Rivington Street
212-967-2260
thierrygoldberg.com
Wed-Sun 11 a.m.-6 p.m.

This small storefront space features
international and American talent,
including Khalif Kelly, a painter
whose stylized images of childhood
iconography earned him a residency
at the Studio Museum in Harlem.

⑤ RACHEL UFFNER GALLERY

47 Orchard Street
212-274-0064
racheluffnergallery.com
Wed-Sun 11 a.m.-6 p.m.

Opened by a veteran of both Chelsea
and Christie's in 2008, Rachel Uffner
Gallery is one of the most exciting of
the neighborhood's new wave. The
gallery opened with a roster of six
emerging artists — Josh Blackwell,
Barb Choit, Sara Greenberger
Rafferty, Hilary Harnischfeger, Pam
Lins and Roger White — as well as
group shows highlighting a wide
range of artistic voices.

⑤ WHITE BOX

329 Broome Street
212-714-2347
whiteboxny.org
Wed-Sun 11 a.m.-7 p.m.

This Lower East Side non-profit art
organization has a simple, storefront
exterior but the space is quite large.
With a worn, paint-splattered floor
in the front gallery and a large main
gallery, White Box's goal is to show
contemporary works in all media that
test and question the mainstream.

⑤⁹ WOODWARD GALLERY

133 Eldridge Street
212-966-3411
woodwardgallery.net
Tue-Sat 11 a.m.-6 p.m.
Sundays noon-5 p.m.

Originally opened in 1994, this two-story gallery represents a range of artists including street art icon Matt Siren. The gallery also offers multiples and prints by a wide range of artists including Jean-Michel Basquiat and Andy Warhol.

HISTORICAL

⁶⁰ THE BUNKER

222 Bowery

This landmarked building has been a hive of bohemian culture since the 1950s. The many artists who have lived and worked in the lofts here include Mark Rothko in the 1950s, as well as Fernand Leger, Brion Gysin and Lynda Benglis. Beat author William S. Burroughs lived here from 1974 until his death in 1997, and his apartment has been preserved by his friend, the poet John Giorno.

⁶¹ JASPER JOHNS STUDIO

225 East Houston

From 1967 to 1988 Jasper Johns based his studio in a fromer bank at the corner of Houston and Essex streets. It is here that he developed the iconic cross-hatching motif prominent in his work beginning in the mid-'70s.

⁶² KEITH HARING STUDIO

325 Broome Street

In the early 1980s a young Keith Haring lived and worked in this building, setting up the "Rat Studio" in the storefront basement where he collaborated with neighborhood graffiti artists.

⁶³ ROBERT INDIANA STUDIO

188 Bowery

In the mid 1960s artist Robert Indiana moved to the Bowery after losing his studio in the Coenties Slip building he shared with other pioneers of Pop.

⁶⁴ ROY LICHTENSTEIN STUDIO

190 Bowery

In 1965 Roy Lichtenstein moved to a fourth-floor studio in this former bank, which was also home to artist Adolph Gottlieb.

RESTAURANTS

⑥⑤ BALLATO

55 East Houston Street
212-274-8881

Located on the edge of Little Italy, casual Italian-American restaurant Ballato was a magnet for the artists of the '70s emerging SoHo art scene. Andy Warhol and his dog, Archie were regulars and the restaurant boast a photo of Warhol and an autographed artwork.

⑥⑥ GALLERY BAR

120 Orchard Street
212-529-2266
gallerybarnyc.com

Gallery Bar hosts a revolving slate of art exhibitions as well as the occasional performance to go along with your cocktail.

HOTEL

⑥⑦ THOMPSON LES

190 Allen Street
212-460-5300
thompsonles.com

This intimate, modern boutique hotel in the Lower East Side sports a tribute to Andy Warhol at the bottom of its third-floor terrace pool—three large stills of Warhol from Gerard Malanga's film, *Andy Warhol: Portraits of the Artist as a Young Man*. Other artwork is displayed throughout the industrial-chic hotel, including a Peter Halley installation of metallic rectangles in the restaurant and photographer Lee Friedlander's *Apples & Olives* series in lightboxes in the guestrooms.

STORE

⑥⑧ CLIC BOOKSTORE & GALLERY

255 Centre Street
212-966-2766
clicgallery.com

Clic offers an expert-curated selection of high-end art books in a gallery setting dedicated to contemporary photography.

The intersection of Spring Street and the Bowery, location of the former studios of Robert Indiana (left) and Roy Lichtenstein (right).

IN THE DAYS WHEN THE ABSTRACT EXPRESSIONISTS ARGUED OVER PINTS AT THE CEDAR TAVERN, GREENWICH VILLAGE WAS THE BOHEMIAN HEART OF NEW YORK CITY. IT'S CHANGED A LOT SINCE THEN, BUT THE NEIGHBORHOOD – HOME TO NEW YORK UNIVERSITY AND WASHINGTON SQUARE PARK – RETAINS SOME OF ITS ARTISTIC ENERGY.

GREENWICH VILLAGE

GREENWICH VILLAGE

22 GANSEVOORT STREET 6

29

11

14TH STREET

8TH AVENUE

7TH AVENUE

36

6TH AVENUE

30

W 11TH STREET

16

PERRY STREET

HUDSON STREET

33 15

21

WEST 10TH STREET

13

W 9TH STREET

5

CHRISTOPHER STREET

34

GREENWICH STREET

9

W 4TH STREET

10 28

BEDFORD STREET

17 37

35

4

2

26 WASHINGTON SQUARE S

7

14

W 3RD STREET

1

CARMINE STREET 31

12

24

BLEECKER STREET

8

HOUSTON STREET

32

GALLERIES

❶ 80 Washington Square East
❷ Gavin Brown's Enterprise
❸ Grey Art Gallery
❹ Maccarone Gallery
❺ West Street Gallery
❻ White Columns

PUBLIC ART

❼ Keith Haring, Carmine Street Mural, 1987
❽ Pablo Picasso and Carl Nesjär, Bust of Sylvette, 1967
❾ George Segal, Gay Liberation, 1980

HOTEL

❿ Washington Square Hotel

RESTAURANTS

⓫ Art Bar
⓬ Da Silvano
⓭ The Lion
⓮ Minetta Tavern

HISTORICAL

⓯ Marshall Chess Club
⓰ Diane Arbus Home
⓱ Diane Arbus Studio
⓲ The Artists' Club
⓳ Cedar Tavern
⓴ Chinese Chance
㉑ Marcel Duchamp Home
㉒ Florent
㉓ Keith Haring Studio
㉔ Keith Haring Home
㉕ Edward Hopper Home
㉖ Judson Memorial Church
㉗ The Locale
㉘ The New York Studio School of Drawing, Painting and Sculpture
㉙ Barnett Newman Studio
㉚ Palazzo Chupi
㉛ Jackson Pollock Home
㉜ Jackson Pollock Home
㉝ Tenth Street Studio
㉞ Waldorf Café
㉟ Washington Square Arch
㊱ Westbeth Artists Housing
㊲ Gertrude Vanderbilt Whitney Studio

GREENWICH VILLAGE

➊ 80 WSE / WASHINGTON SQUARE WINDOWS

80 Washington Square East
Washington Square Windows
Washington Square between West
Fourth Street & Washington Place
Broadway Windows
Northwest Corner of Broadway at
East 10th Street
212-998-5747
steinhardt.nyu.edu/80wse
Tues-Sat 10 a.m.-6 p.m.

Directed by pioneering video artist Peter Campus, the galleries of the Department of Art and Education at NYU Steinhart display exhibitions curated by faculty, students and alumni, as well as experimental projects by noted curators in a traditional gallery space and two 24-hour window galleries. Recent projects include "Stay in School," a site-specific installation by NYU alum Nate Lowman.

ABOVE Gavin Brown's Enterprise featuring the installation, Martin Creed, Work No. 300: the whole world + the work = the whole world, 2003
OPPOSITE (top) Installation view, Ann Craven, Flowers, May 1-June 26, 2010 at Maccarone Gallery.

➋ GAVIN BROWN'S ENTERPRISE

620 Greenwich Street
212-627-5258
gavinbrown.biz
Tues-Sat 10 a.m.-6 p.m.

Gavin Brown made his name in the '90s representing daring young talents like Elizabeth Peyton, Spencer Sweeney, Peter Doig, Rob Pruitt and Rirkrit Tiravanija— who have since gone on to major museum collections—as well as for the late-night antics of his club/gallery Passerby. The gallery recently doubled its space, expanding into the former warehouse of meat purveyor Pat LaFrieda.

➌ GREY ART GALLERY

100 Washington Square East
212-998-6780
nyu.edu/greyart
Tues, Thurs, Fri, 11 a.m.-6 p.m.
Wed 11 a.m.-8 p.m.
Sat 11 a.m.-5 p.m.
$3

Grey Art Gallery is home to the 6,000-piece New York University Art Collection, which specializes in late 19th and 20th century art, including leading post-war New York names such as Elaine de Kooning, Arshile Gorky and Ad Reinhardt, as well as Picasso's monumental *Bust of Sylvette*. Another of the gallery's strengths is the Downtown scene of the '60s, '70s and '80s; recent shows have included works by Robert Mapplethorpe, Andy Warhol, Nan Goldin and David Wojnarowicz.

❹ MACCARONE GALLERY

630 Greenwich Street
212-431-4977
maccarone.net
Tues-Sat, 10 a.m.-6 p.m.

Maccarone has a slight rough-around-the-edges feel, an easy-going vibe and a reputation for supporting young artists while allowing artistic freedom. Owner Michele Maccarone, a veteran of the Chelsea art scene, champions contemporary work; the gallery'a exposed wooden beams and raw floors are the backdrop for such varied artists as Elias Hansen, Carol Bove, Nate Lowman and Oscar Tuazon.

❺ WEST STREET GALLERY

395 West Street, Apt. 2
Saturdays 11 a.m.-6 p.m.
weststreet.info

The apartment gallery of Alex Gartenfeld and Matt Moravec showcases new art in a domestic setting. Additional shows in the Spare Room are organized by Joel Mesler.

❻ WHITE COLUMNS

320 West 13th Street
212-924-4212
whitecolumns.org
Tue-Sat, noon-6 p.m.

Founded in 1970 by Gordon Matta-Clark and Jeffrey Lew as the 112 Workshop, White Columns is New York's original alternative space. The non-profit remains one of the city's most exciting showcases, giving a platform to emerging artists and experimental projects.

PUBLIC ART

❼ KEITH HARING
CARMINE STREET MURAL, 1987

Tony Dapolito Recreation Center
3 Clarkson Street

Keith Haring's playful poolside mural features dolphins, fish and a figure wearing a crown made of the city skyline.

GREENWICH VILLAGE

❽ PABLO PICASSO AND CARL NESJÄR
BUST OF SYLVETTE, 1967

Silver Towers Courtyard, near
LaGuardia Place and Bleecker
Streets

The highlight of New York
University's art collection often
goes unnoticed, despite its monu-
mental size. Created in 1967, the
sculpture is an oversized version
of a sculpture created by Pablo
Picasso in 1957, situated by the
University's I.M. Pei-designed
Silver Towers.

HOTEL

❿ WASHINGTON SQUARE HOTEL

103 Waverly Place
212-777-9515
washingtonsquarehotel.com

Built in 1902, the Washington Square
Hotel has hosted its share of Village
writers and artists: Dylan Thomas and
Ernest Hemingway both stayed here
back when it was still called the Hotel
Earle and Bob Dylan lived in room 305.

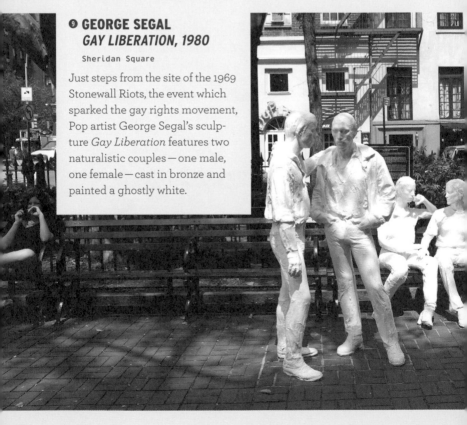

❾ GEORGE SEGAL
GAY LIBERATION, 1980

Sheridan Square

Just steps from the site of the 1969
Stonewall Riots, the event which
sparked the gay rights movement,
Pop artist George Segal's sculp-
ture *Gay Liberation* features two
naturalistic couples — one male,
one female — cast in bronze and
painted a ghostly white.

RESTAURANTS

⑪ ART BAR

52 Eighth Avenue
212-727-0244
artbar.com

The back room of this cozy West Village bar is a neighborhood institution, hosting rotating gallery shows by local artists.

⑫ DA SILVANO

260 Sixth Avenue
212-982-2343
dasilvano.com

Da Silvano has been a fashionable hangout for the art world elite for three decades. When it opened in 1975, the restaurant introduced the concept of the Tuscan trattoria to New York.

⑬ THE LION

62 West Ninth Street
212-353-8400
thelionnyc.com

Named after the '60s lounge where Barbra Streisand got her start, The Lion combines old-school New York charm with an art collection that's distinctly contemporary — highlights include works by Jean-Michel Basquiat and David LaChapelle.

⑭ MINETTA TAVERN

113 MacDougal Street
212-475-3850
minettatavernny.com

Since it first opened in 1937, the Minetta Tavern has served Village notables including Ernest Hemingway and artist Marisol Escobar as well as Jack Kerouac, Allen Ginsberg and the rest of the beats. The restaurant got a high-end makeover in 2008 from restauranteur Keith McNally, and now boasts some of the best — and most expensive — burgers in the city.

HISTORIC

⑮ MARSHALL CHESS CLUB

23 West 10th Street
212-477-3716
marshallchessclub.org

Throughout his career, Marcel Duchamp was a competitive chess player. In 1920 he joined the Marshall Chess Club, where he regularly played with Man Ray.

⑯ DIANE ARBUS HOME

131 1/2 Charles Street

After separating with her husband in 1959, Diane Arbus moved to a converted stable with her young daughters, where they lived until 1968.

GREENWICH VILLAGE

⑰ DIANE ARBUS STUDIO

71 Washington Place

In 1968, Diane Arbus established a photography studio near Washington Square Park where she worked for many years.

⑱ THE ARTISTS' CLUB

39 East Eighth Street

When the Waldorf chased them out, the Abstract Expressionists moved down the street. From the late '40s until 1955 the Club was where artists gathered to dance, debate and discuss art, creating the title Abstract Expressionism in 1952. Members included Willem de Kooning, Robert Motherwell, Philip Pavia, Ad Reinhardt and art dealer Leo Castelli, creating the basis for the landmark Ninth Street Show.

⑲ CEDAR TAVERN

24 University Place

In the later '40s and 1950s, the Cedar Tavern was the intellectual center of the New York School, the place where painters Willem de Kooning, Mark Rothko, Franz Kline and Robert Motherwell traded ideas alongside beat poets Allen Ginsberg and Jack Kerouac, It was also where Jackson Pollock was kicked out for kicking down a bathroom door. The bar moved up the street in the early 1960s and was demolished in 2006.

⑳ CHINESE CHANCE

1 University Place

Better known by its address, One University, this greasy spoon owned by Mickey Ruskin of Max's Kansas City fame, was a favorite of artists, musicians and filmmakers. Regular Mary Boone was dining at One U when cook Julian Schnabel asked her to visit his studio.

㉑ MARCEL DUCHAMP HOME

28 West 10th Street

In 1959, not long after he became a U.S. citizen, Marcel Duchamp and his wife moved from East 58th Street to the Village, where they remained until his death in 1968.

㉒ FLORENT

69 Gansevoort Street
restaurantflorent.com

From the time it opened in 1985 until it closed its doors in 2008, Florent Morellet's 24-hour diner was a favorite of Meatpacking District partiers, including the leather daddies and gender-benders of the club scene's early days and the fashion crowd that followed them. By day, Florent was also the second home to artists with nearby studios including Matthew Barney and Roy Lichtenstein. A map of Liechtenstein (the country), made by Morellet himself, famously hung in the booth where Lichtenstein (the artist) regularly sat.

㉓ KEITH HARING STUDIO

676 Broadway
haring.com

In 1986 Keith Haring stopped drawing in the subway and moved to a studio at 676 Broadway. The building now houses The Keith Haring Foundation, created shortly before his death to assist AIDS-related and children's charities.

㉔ KEITH HARING HOME

542 LaGuardia Place

Before his death in 1990, Keith Haring purchased an apartment just beyond the reaches of SoHo's Artist In Residence District.

㉕ EDWARD HOPPER HOME

1-3 Washington Square North

From 1913 until his death in 1967, Edward Hopper lived with his wife in a cold-water flat on the fourth floor of this Washington Square brownstone.

㉖ JUDSON MEMORIAL CHURCH

55 Washington Square South
212-477-0351

Village landmark Judson Memorial Church has provided a home for the avant-garde since it hosted an exhibition of then-unknowns Jim Dine, Claes Oldenburg and Robert Rauschenberg in 1957. The Judson also fostered combinations of art and dance pioneered by the likes of John Cage, Philip Glass, Merce Cunningham, Carolee Schneemann and Elaine Summers of the Judson Dance Theater.

㉗ THE LOCALE

Mercer Street at Waverly Place

At Mickey Ruskin's basement bar artist weren't just customers, they worked there, too: Sherrie Levine was a waitress, Julian Schnabel was the chef and David Salle was his sous-chef.

㉘ THE NEW YORK STUDIO SCHOOL OF DRAWING, PAINTING AND SCULPTURE

8 West Eighth Street
212-673-6466
nyss.org

The New York Studio School occupies the original home of the Whitney Museum of American Art, founded in 1929 by sculptor and heiress Gertrude Vanderbilt Whitney. Since 1963 it has offered students place to learn from leading artists including Philip Guston and Alex Katz.

㉙ BARNETT NEWMAN STUDIO

47 Horatio Street

From February through August of 1933, leading Color Field painter Barnett Newman rented a studio at 47 Horatio Street.

GREENWICH VILLAGE

㉚ PALAZZO CHUPI ▲
360 West 11th Street

The "Pompeii red" tower built by
Julian Schnabel over his home
and studio was originally scorned
by his West Village neighbors
when it was unveiled in 2007. All
units have since sold, although
for less than half the original $32
million (each) asking price. The
artist found the building after a tip
from Roy Lichtenstein in 1987, and
bought the property in 1997.

㉛ JACKSON POLLOCK HOME
46 Carmine Street

After a sojourn to Los Angeles in
1932, Jackson Pollock moved into
this studio with his brother, painter
Charles Pollock.

㉜ JACKSON POLLOCK HOME
76 West Houston Street

In 1934, Jackson Pollock and his
brother rented a small, unheated
apartment above a lumber-
yard while working as janitors.
According to the Museum of
Modern Art, here Pollock painted
a "vast, lewd mural in the style of
Orozco" directly on the walls.

㉝ TENTH STREET STUDIO
51 West 10th Street

When it was created in 1857, the
Tenth Street Studio was the first
facility dedicated to artists, and it
fostered leading members of the
Hudson River School as well as
William Merritt Chase. The build-
ing no longer exists.

㉞ WALDORF CAFÉ

390 Sixth Avenue

During WWII, the Waldorf Cafeteria was the place where artists such as Willem de Kooning and Arshile Gorky went to debate painting; these conversations would pave the way for Abstract Expressionism and the Cedar Tavern scene, though artists stopped coming when the price of coffee was raised to 10 cents.

㉟ WASHINGTON SQUARE ARCH

Fifth Avenue at Washington Square North

Built as a temporary structure in 1889, the Washington Square Arch is the enduring symbol of bohemian Greenwich Village. In 1917, a group of actors and artists led by Marcel Duchamp climbed atop the arch and declared Greenwich Village an independent nation.

㊱ WESTBETH ARTISTS HOUSING ▲

55 Bethune Street
212-989-4650
westbeth.org

Since 1970, Westbeth Artists Housing has provided affordable workspace and housing for artists, thanks to funding by the National Endowment for the Arts and the J.M. Kaplan Foundation. Along with its gallery space, Westbeth is also home to the Merce

Cunningham Dance Foundation, The New School for Drama and Brecht Forum. Among the artists who lived at Westbeth: conceptual artist Hans Haacke, painter Robert DeNiro, Sr., and photographer Diane Arbus, who took her own life here in 1971.

㊲ GERTRUDE VANDERBILT WHITNEY STUDIO

19 MacDougal Alley

Gertrude Vanderbilt Whitney was one of the first artists to convert a carriage house into a studio, setting up her sculpture workshop on MacDougal Alley in 1907.

IN THE 1950S THE EAST VILLAGE WAS HOME TO DOWN-AND-OUT ARTISTS INCLUDING JACKSON POLLOCK AND LEE KRASNER. THE LOW RENTS AND ARTISTIC EXCITEMENT LED TO A PROLIFERATION OF ARTIST-RUN GALLERIES AROUND TENTH STREET. IN THE EARLY 1980S, GALLERIES AGAIN BEGAN FLOCKING TOWARD THE NEIGHBORHOOD, THIS TIME SHOWING THE WORK OF JEAN-MICHEL BASQUIAT, KEITH HARING, FUTRA 2000 AND OTHER ARTISTS WHO WROTE GRAFFITI ON THE CITY'S BLIGHTED STREETS.

EAST VILLAGE

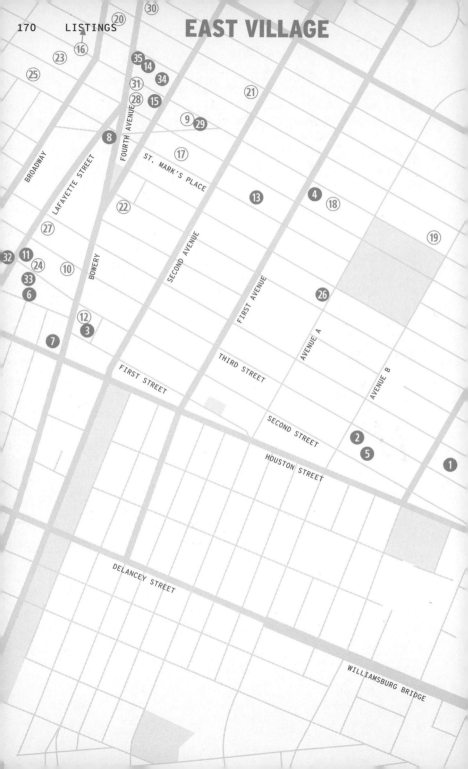

EAST VILLAGE

EAST VILLAGE

GALLERIES

1. A Gathering of Tribes
2. Kenkeleba House
3. La MaMa La Galleria
4. Performance Space 122
5. Wilmer Jennings Gallery
6. Zürcher Studio

PUBLIC ART

7. Houston Street Mural
8. Tony Rosenthal, Alamo, 1967

HISTORICAL

9. Diane Arbus Home
10. Jean-Michel Basquiat Studio
11. Chuck Close Studio
12. CBGB
13. Club 57
14. Willem de Kooning Studio
15. Willem de Kooning Studio
16. Willem de Kooning Studio
17. Exploding Plastic Inevitable
18. FUN Gallery
19. Gracie Mansion Gallery
20. Hansa Gallery
21. Peter Hujar and David Wojnarowicz Studios
22. Alex Katz Studio
23. Lee Krasner Studio
24. Robert Mapplethorpe Studio
25. Jackson Pollock Studio
26. Pyramid Club
27. Robert Rauschenberg Studio
28. Reuben Gallery
29. Saint Mark's Church in the Bowery
30. Tanger Gallery
31. Tenth Street Coffeehouse

STORES

32. Blick Art Materials
33. Dashwood Books
34. New York Central Art Supply
35. Utrecht

EAST VILLAGE

❶ A GATHERING OF TRIBES

285 East 3rd St, 2nd Floor
212-674-3778
tribes.org
Daily 10 a.m.-10 p.m.

In 1991, poet and playwright Steve
Cannon hosted a salon in his apart-
ment as a venue for underexposed
artists and a place for artists to
gather. Since then A Gathering
of Tribes has celebrated art in all
media through a series of exhibi-
tions, readings and the annual
Charlie Parker Festival.

❷ KENKELEBA HOUSE

214 East Second Street
212-674-3939
Wed-Sat 11 a.m.-6 p.m.

Established in the 1970s, pioneer-
ing alternative space Kenkeleba
House is dedicated to showcasing
the work of African-American,
Latino, Asian-American and Native
American artists, featuring histori-
cal and contemporary exhibitions.
Its namesake sculpture garden
stretches the width of a full block
between East Second and East
Third streets near Avenue B.

❸ LA MAMA LA GALLERIA

6 East First Street
212-505-2476
lamama.org
Thurs-Sun 1 p.m.-8 p.m.

Founded in 1984 as an extension
of the experimental La MaMa
Experimental Theatre Club, non-
profit La Galleria hosts instal-
lations, workshops, educational

projects and readings, all featuring
the legendary La MaMa inventive-
ness and curatorial eye for what's
next.

❹ PERFORMANCE SPACE 122 ▲

150 First Avenue
212-477-5829
ps122.org
Mon-Fri 9 a.m.-9 p.m.
Sat-Sun 10 a.m.-6 p.m.

In 1979, choreographer Charles
Moulton and performers Charles
Dennis, Tim Miller and Peter Rose
transformed an abandoned school
into non-profit arts center PS122,
an incubator for artistic expres-
sion across media. Today it is
home to two theaters and low-cost
rehearsal space.

❺ WILMER JENNINGS GALLERY

219 East Second Street
212-674-3939
Wed-Sat 11 a.m.-6 p.m.

Located across the street, sister gallery to Kenkeleba House features a similar programming and alternative Alphabet City vibe.

❻ ZÜRCHER STUDIO

33 Bleecker Street
212-777-0790
galeriezurcher.com
Tues-Sat noon-6 p.m.
Sunday 2 p.m.-6 p.m.

Zürcher Studio offers contemporary artists a place to exhibit and create new work. Working only in the primary market, the gallery fosters long-term relationships with its artists. The gallery is located in the former ground-floor studio of sculptor Joel Shapiro.

PUBLIC ART

❼ HOUSTON STREET MURAL

Bowery at East Houston Street

In 1982, Keith Haring painted a neon mural at the corner of the Bowery and East Houston Street. In honor of the artist's 50th birthday, Deitch Projects recreated the mural in 2008 and since then, the wall has featured murals by other major street artists including Brazil's Os Gemeos and Barry McGee. The project is now maintained by The Hole gallery.

❽ TONY ROSENTHAL
ALAMO, 1967

Astor Place

Fondly known by New Yorkers as the "Astor Place Cube" or simply "the Cube," *Alamo* was the first permanent contemporary outdoor sculpture. Originally part of the temporary Doris C. Freedman's "Sculpture in Environment" installation, residents of the Astor Place area petitioned to keep it. *Alamo* stands on one point and revolves around a pedestal. At nearly 1,800 pounds, moving the large sculpture is a trying task for one, but can easily be accomplished by a few people.

Installation view, Brian Belott, The Joy of File, Feb 26-April 3, 2010, Zürcher Studio.

HISTORICAL

⑨ DIANE ARBUS HOME
120 East 10th Street

In 1968, photographer Diane Arbus moved to idyllic Renwick Triangle where she lived until 1970.

⑩ JEAN-MICHEL BASQUIAT STUDIO
57 Great Jones Street

In 1983, Jean-Michel Basquiat moved his studio into a former carriage house loft owned by Andy Warhol. He would live and work here until his death from heroin overdose at the age of 27.

⓫ CHUCK CLOSE STUDIO ▲
20 Bond Street

Though he works mainly in the Hamptons, Chuck Close moved his Manhattan studio to his light-filled loft in a Bond Street artists' co-op in 1990. The artist landed in the center of a controversy in 2006 when developers tried to build on the lot next door, blocking his windows.

⑫ CBGB
315 Bowery

In 1973, Hilly Kristal opened a club featuring country, bluegrass and blues (the CBGB of the club's name). But it's the punk, hardcore and No Wave acts that played CBGB that came to define the space—The Ramones, Richard Hell, The Dictators, Blondie and Jean-Michel Basquiat's band Gray. The club closed in 2006 after a final performance by Patti Smith. Today it is a high-end men's boutique.

⑬ CLUB 57
57 Saint Mark's Place

This dingy, D.I.Y. basement club was a popular hangout and performance venue for members of the downtown scene from 1979 until 1983. Regulars included Keith Haring, Fab 5 Freddy, Kenny Scharf, John Sex and Klaus Nomi, who all performed at the club.

⑭ WILLEM DE KOONING STUDIO
85 Fourth Ave

Between 1946 and 1952, Willem de Kooning worked in an unheated second-floor studio. Here he developed black-and-white abstract sketches and embarked on his second *Woman* series.

OPPOSITE The wall at Bowery and East Houston Street features murals by leading graffiti artists, like this one by Barry McGee, 2010.

⑮ WILLEM DE KOONING STUDIO
88 East Tenth Street

In 1952, Willem de Kooning moved to a top-floor studio in the heart of the burgeoning Tenth Street art gallery scene. The artist was at the height of his creativity, and here he finished *Woman I*, a painting that he'd been working on for years, now at the Museum of Modern Art.

⑯ WILLEM DE KOONING STUDIO
831 Broadway

As his career took off financially, Willem de Kooning moved to a raw studio space in 1960, but he didn't work much at all, creating only two large-scale works that year. It would be his final Manhattan studio.

⑰ EXPLODING PLASTIC INEVITABLE
23 Saint Mark's Place

In 1966 Andy Warhol and Paul Morrissey hosted a series of Happenings at a former Polish dance hall they called The Dom (later known as the Electric Circus). The shows featured performances by house band the Velvet Underground and Nico.

⑱ FUN GALLERY
254 East Tenth Street

In 1981, Patti Astor opened FUN Gallery, the first of the 1980s East Village galleries. Fun popularized graffiti art, offering Lee Quinones, Fab 5 Freddy, Kenny Scharf, Jean-Michel Basquiat and Keith Haring early one-man exhibitions. Astor and many of her artists appears in 1983's cult-classic graffiti flick *Wild Style*. By the time the gallery closed in 1985, the art world was no longer interested in graffiti.

⑲ GRACIE MANSION GALLERY
337 East 10th Street

In the 1980s, art dealer Gracie Mansion's eponymous gallery was a Tompkins Square hotspot. The gallery closed in 1991, but Mansion still shows the work of downtown legends such as Keith Haring, David Wojnarowicz and May Wilson from her Second Avenue apartment by appointment.

⑳ HANSA GALLERY
70 East 12th Street

Hansa Gallery was founded in 1952 by Allan Kaprow, Jan Müller and a group of young artists who had studied under Hans Hofmann. Art dealer Ivan Karp would later work at the gallery when it moved to Central Park South. In 1954, the space became the James Gallery.

㉑ PETER HUJAR AND DAVID WOJNAROWICZ STUDIOS

189 Second Avenue

Peter Hujar lived in this East Village loft from 1970 until his death in 1987, and he used the studio to photograph his famous friends including David Wojnarowicz, Andy Warhol and John Cage. From 1980 until his death in 1992 downtown artist and activist Wojnarowicz lived and worked in the same building.

㉒ ALEX KATZ STUDIO

210 East Sixth Street

After art school Alex Katz moved to a cold-water flat on East Sixth Street where he lived from 1950 to 1953. After a few years of living frugally and working in a frame shop, the artist felt ready to become a painter.

BELOW: Last Address (2009) Director Ira Sachs' eight-minute elegy for the many artists who have lost their lives to AIDS in the past 30 years visits the final places each called home. The film can be viewed at lastaddress.org.

㉓ LEE KRASNER STUDIO

51 East Ninth Street

Lee Krasner lived and worked in the heart of the Village scene; her apartment was directly across the street from Franz Kline at 52 East Ninth Street. The building no longer exists.

㉔ ROBERT MAPPLETHORPE STUDIO

24 Bond Street

In the 1980s, Robert Mapplethorpe lived and worked at 24 Bond Street, his first studio, the place where the artist invited friends for drug- and sex-fuelled photo shoots. When he moved uptown to 23rd Street he retained the studio as his darkroom.

㉕ JACKSON POLLOCK STUDIO

46 East Eighth Street

In 1933, Jackson Pollock moved into the Eighth Street apartment of his brother Charles and his wife Elizabeth. They paid $35 a month for the entire floor, which Jackson also used as a studio. After trying to find a place of his own, Jackson returned in 1938 to live here with brother Sande. The building no longer exists.

Peter Hujar
David Wojnarowicz
189 2nd Ave.

㉗ ROBERT RAUSCHENBERG STUDIO

381 Lafayette Street

In 1963 Robert Rauschenberg bought a former Catholic orphanage and cathedral, which he transformed into a personal home and studio, as well as a place for staging performances and collaborative projects.

㉘ REUBEN GALLERY

61 Fourth Avenue

Opened in 1959, Anita Reuben's gallery was strictly anti-Abstract Expressionist. That same year the gallery hosted what some consider the first-ever Happening, Allan Kaprow's *Eighteen Happenings in Six Parts*, a combination of action painting with musical and performance techniques pioneered by John Cage.

㉖ PYRAMID CLUB

101 Avenue A
212-228-4888
thepyramidclub.com

The East Village has changed a lot since the Pyramid Club opened in 1979, but this gritty performance space remains a beacon for artists and weirdos of all persuasions. In its 1980s heyday, the club was a downtown alternative to glossy spaces such as Studio 54, a haven for the drag queen scene and the birthplace of Wigstock, an annual tradition that lives on today. The spaced also hosted early performances by Madonna and Nirvana, and even received the superstar treatment on the Andy Warhol's short-lived MTV show *Fifteen Minutes*.

㉙ SAINT MARK'S CHURCH IN THE BOWERY

131 East 10th Street
212-674-6377
stmarksbowery.org

This progressive church is home to The Incubator Arts Project (formerly Richard Foreman's Ontological-Hysteric Theater) as well as the Poetry Project and Danspace, an experimental dance project that has featured Merce Cunningham and Martha Graham. It was also the place where Andy Warhol screened his first films, and where Sam Shepherd put on his first two plays.

㉚ TANGER GALLERY

90 East Tenth Street

Tanger was one of the first cooperative galleries on Tenth Street. It counted Alex Katz and Tom Wesselmann among its members and was the premier gallery of the Tenth Street scene from 1952 until it closed in 1962. Other nearby galleries included Camino (92 East 10th Street) and The March (95 East 10th Street), two spaces promoted by Elaine de Kooning.

㉛ TENTH STREET COFFEEHOUSE

78 East Tenth Street

Opened by Mickey Ruskin in 1960 and located near a group of cooperative art galleries on Tenth Street and Fourth Avenue, The Tenth Street Coffeehouse was a popular hangout for the East Village artists, featuring nightly poetry readings.

STORES

㉜ BLICK ART MATERIALS

1-5 Bond Street
212-533-2444
dickblick.com

Located in a cast-iron building on a cobblestone street, Blick is a two-story art supply superstore in the home of the once-legendary Art Store.

㉝ DASHWOOD BOOKS

33 Bond Street
212-387-8520
dashwoodbooks.com

Founded by a veteran of Magnum Photos, this independent bookstore is dedicated to photography, bringing many international titles to the United States for the first time. Monographs run the gamut from the establishment to exciting young talent including Collier Schorr, Ryan McGinley and Hanna Liden.

㉞ NEW YORK CENTRAL ART SUPPLY

62 Third Avenue
212-473-7705
nycentralart.com

Since 1905, this old-school art shop has served Village artists, including Jackson Pollock. The store featuring a wide range of supplies, including high-end imported materials and a famous paper selection.

㉟ UTRECHT

111 Fourth Avenue
212-777-5353
utrechtart.com

In 1949, artist Norman Gulamerian began importing linen canvas from Europe. Now a successful chain, Utrecht creates its own paint and gesso in a Brooklyn factory. The store starred on the Bravo reality show *Work of Art: The Next Great Artist*.

DURING THE PEAK OF THE SOHO SCENE, THE WAREHOUSES ON THE WESTERN FRINGE OF MANHATTAN SEEMED AN UNLIKELY PLACE TO FIND ART. THE DIA ART FOUNDATION MOVED HERE IN THE 1980S, AND SO DID L.A. DEALER LARRY GAGOSIAN, BUT NOT MUCH MORE WAS HAPPENING. THAT IS, UNTIL SOHO STAPLES METRO PICTURES, BARBARA GALDSTONE AND PAULA COOPER MOVED TO THE NEIGHBORHOOD IN 1996. THAT SAME YEAR A NEW YORK MAGAZINE COVER DECLARED: CHELSEA! IT'S THE NEW SOHO!

WITH ITS INDUSTRIAL-STRENGTH GARAGES AND WAREHOUSES, THE NEW ART DESTINATION OFFERED GALLERIES THE ULTIMATE MANHATTAN LUXURY: OPEN SPACE TO SHOW LARGE WORK. IN THE DECADE THAT FOLLOWED, EVERYONE FROM MEGADEALERS TO ALTERNATIVE SPACES MOVED IN, MAKING CHELSEA NEW YORK'S OFFICIAL HOME OF CONTEMPORARY ART – FOR NOW, AT LEAST.

CHELSEA

CHELSEA

MUSEUMS
1 Dia:Chelsea
2 Rubin Museum of Art

PUBLIC ART
3 Joseph Beuys
4 Dan Flavin
5 Os Gemeos

AUCTION HOUSE
6 Phillips De Pury & Co.

GALLERIES
7 303 Gallery
8 Alexander & Bonin
9 Andrea Rosen Gallery
10 Andrew Edlin Gallery
11 Andrew Kreps Gallery
12 Anton Kern Gallery Inc
13 Aperture Foundation
14 Barbara Gladstone Gallery
15 Bortolami
16 Casey M Kaplan
17 Cheim & Read
18 D'Amelio-Terras
19 David Nolan Gallery
20 David Zwirner Gallery
21 Elizabeth Dee Gallery
22 Foxy Production
23 Friedrich Petzel Gallery
24 Galerie Lelong
25 Gagosian Gallery
26 Greene Naftali
27 Hasted Kraeutler
28 James Cohan Gallery
29 The Kitchen
30 Lehmann Maupin Gallery
31 Leo Koenig
32 Luhring Augustine
33 Marianne Boesky Gallery

34 Marlborough Chelsea
35 Mary Boone Gallery
36 Mary Ryan Gallery
37 Matthew Marks Gallery
38 Metro PIctures
39 Mitchell-Innes & Nash
40 Nyehaus
41 The Pace Gallery
42 Paul Kasmin Gallery
43 Paula Cooper Galleries
44 Perry Rubenstein Gallery
45 Peter Blum Chelsea
46 Phoenix Gallery
47 P.P.O.W.
48 Postmasters Gallery
49 Pratt Manhattan Gallery
50 Printed Matter
51 Robert Miller Gallery
52 Sean Kelly
53 Sikkema Jenkins & Co
54 Sonnabend Gallery
55 Tanya Bonakdar Gallery
56 Taxter & Spengeman
57 Tony Shafrazi Gallery
58 Wallspace
59 Yossi Milo
60 Yvon Lambert Gallery
61 Zach Feuer

HISTORICAL
62 Willem de Kooning Studio
63 Willem de Kooning Studio
64 Julian Schnabel Studio

RESTAURANT
65 Boutique Eat Shop

HOTEL
66 Hotel Chelsea

❶ DIA:CHELSEA ▲

535 West 22nd Street, 5th Floor
diaart.org

When it opened in 1987 at 548 West 22nd Street, the Dia Art Foundation was Chelsea's only artistic attraction, a place for large-scale single-artist installations including Jenny Holzer's *Laments* (1989) and Richard Serra's *Torqued Ellipses* (1997). That landmark space closed in 2004, but Dia remains an important part of the city's contemporary art scene. Not only does the foundation manage some of the New York's most important art installations — including Walter de Maria's *New York Earth Room* — it is also responsible for Dia:Beacon, an upstate museum that's home to long-term installations by Sol LeWitt, Dan Flavin and Donald Judd. Dia's Chelsea location is now home to a series of artists talks to readings of contemporary poetry. For more information on upcoming events visit diaart.org.

❷ RUBIN MUSEUM OF ART ▼

150 West 17th Street
212-620-5000
rmanyc.org
Mon, Thurs 11 a.m-5 p.m.
Wednesday 11 a.m.-7 p.m.
Friday 11 a.m.-10 p.m.
Sat-Sun 11 a.m.-6 p.m.
$10

Opened in 2004, the Rubin Museum of Art features more than 2,000 works of art from the Himalayan region, including Afghanistan, Burma, Tibet, Nepal, Mongolia and Bhutan, many from the personal collection of Donald Rubin.

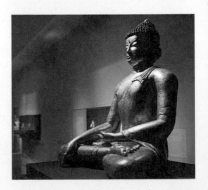

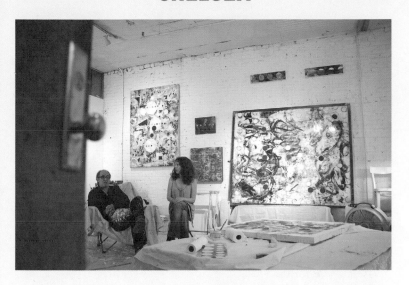

STUDIO VISIT: MARK WIENER AND LINDA DIGUSTA

551 West 21st Street, Studio 210
917-523-4280
Mon-Sat 10:30 a.m.-5 p.m. or by appointment

Amid the high-end galleries of Chelsea, it might be surprising to discover that art isn't just being sold here, it's also being made. At the end of 21st Street — one of the neighborhood's most densely populated gallery blocks — artists Mark Wiener and Linda DiGusta keep their studio open, offering art lovers a glimpse into the creative process.

Often, unsuspecting visitors stumble into the space and find the two artists working amid splattered paint and half-finished drawings. "We knew if people could touch art and smell it they would get more excited about it," said Wiener. "It gives art lovers an opportunity to experience something special."

After stopping in the studio, be sure to visit 571 Projects (571projects.com), a contemporary art space in the same building founded in 2009 by Sophie Bréchu-West.

For more information on the art of Mark Wiener and Linda DiGusta visit mwienerarts.com and lindadi.com.

CHELSEA

PUBLIC ART

❸ JOSEPH BEUYS *7000 OAKS*

West 22nd Street between Tenth
and Eleventh avenues

In 1988, Dia Art Foundation planted
five trees—gingko, linden, Bradford
pear, sycamore and oak—each
paired with a basalt column, as
part of German artist Joseph
Beuys' *7000 Oaks*, a sculptural
project begun six years earlier at
Documenta 7. In 1996, eighteen
new trees were added.

❹ DAN FLAVIN
UNTITLED, 1996

548 West 22nd Street

Located in the stairwells of the
former Dia Art Foundation build-
ing, Dan Flavin's final work in
florescent light casts a blue and
green glow visible from both inside
and outside the building. To view it
head to the north side of the street.

❺ OS GEMEOS AND
FUTURA 2000

320 West 21st Street

In 2010, Brazilian street art duo
Os Gemeos (The Twins) teamed
up with New York graffiti legend
Futura 2000 for a monumental
mural sponsored by creative studio
AKANYC and street art website
12ozProphet. The mural includes
the twins' famous yellow figure
decorated with international flags.

ABOVE: A mural collaboration by Os
Gemeos and Futura 2000 at P.S.11.
OPPOSITE: Alexander and Bonin
Gallery, featuring the 2009 exhibition
Rita McBride, "New Markers."

AUCTION HOUSE

❻ PHILLIPS DE PURY & COMPANY

450 West 15th Street
212-940-1200
phillipsdepury.com
Mon-Sat 10 a.m.-5 p.m.
Sunday noon-5 p.m.

Phillips was founded in London in 1796, and its current Meatpacking District incarnation dates back to 2003. Of the major auction houses, Phillips de Pury & Company corners the market on the hipper side of contemporary art and design. Once a season, Saturday@ Phillips offers an introductory-level auction aimed at young collectors, with low estimates on lots ranging from $500 to $20,000. If you prefer window-shopping to bidding, the downstairs gallery offers edgy exhibitions including the psychedelic installations of Assume Vivid Astro Focus and fashion photographers Guy Bourdin and Mario Testino.

GALLERIES

❼ 303 GALLERY

547 West 21st Street
212-255-1121
303gallery.com
Tues-Sat 10 a.m.-6 p.m.

It may get complaints for its cramped quarters, but 303 Gallery more than makes up for it with edgy programming that includes photographers Stephen Shore and Collier Schorr, and "Al-Qaeda Is the CIA," a retrospective of painter Sue Williams' work curated by artist Nate Lowman.

❽ ALEXANDER AND BONIN

132 Tenth Avenue
212-367-7474
alexanderandbonin.com
Tues-Sat 10 a.m.-6 p.m.

Carolyn Alexander and Ted Bonin showcase international contemporary artists, including painter Sean Scully and John Ahearn, an artist who got his start sculpting his South Bronx neighbors in the 1980s. Main shows take place on the first floor, with works on paper showcased on the second floor and a rotating selection on the third.

❾ ANDREA ROSEN GALLERY

525 West 24th Street
212-627-6000
andrearosengallery.com
Tues-Sat 10 a.m.-6 p.m.

This large gallery, with stark white walls and a ceiling featuring

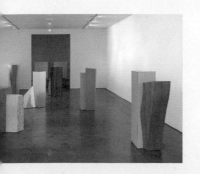

exposed steel beams and a skylight, has been a mainstay of the New York art scene since 1990. The gallery is divided into three parts, with larger exhibitions showcased in the main gallery and one-time exhibits by non-gallery artists in Gallery 2. The roster of artists includes painters Nigel Cooke and Rita Ackermann, as well as the estate of conceptual artist Felix Gonzalez-Torres.

⑩ ANDREW EDLIN ▲

134 Tenth Avenue
212-206-9723
edlingallery.com
Tues-Sat 11 a.m.-6 p.m.

Andrew Edlin represents so-called outsider artists, from the legendary Henry Darger to up-and-coming filmmaker Brent Green.

⑪ ANDREW KREPS

525 West 22nd Street
212-741-8849
andrewkreps.com
Tues-Sat 10 a.m.-6 p.m.

The artists at Andrew Kreps include photographer Roe Ethridge and performance artist Jamie Isenstein, singled out by *New York* magazine as one of the most promising artists to come out of the mid-aughts art boom.

⑫ ANTON KERN

532 West 20th Street
212-367-9663
antonkerngallery.com
Tues-Sat 10 a.m.-6 p.m.

The son of German painter Georg Baselitz, Anton Kern specializes in contemporary work including conceptual photographer Anne Collier and illustrator David Shrigley.

⑬ APERTURE FOUNDATION

547 West 27th Street, 4th Floor
212-505-5555
aperture.org
Mon-Sat 10 a.m.-6 p.m.

In 1952 photographers Ansel Adams, Dorothea Lange, Barbara Morgan and Minor White founded the not-for-profit Aperture Foundation. It remains dedicated to all things photographic, supporting photographers through gallery exhibitions, a quarterly magazine and the annual Portfolio Prize.

LEFT Henry Darger at Andrew Edlin Gallery, Sept 11-Oct 23, 2010. BELOW Carroll Dunham at Gladstone Gallery, New York, Oct 30-Dec 5, 2009. OPPOSITE Jack Pierson, Abstracts, 2009 at Cheim & Read.

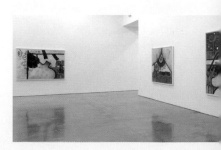

⑭ BARBARA GLADSTONE GALLERY

515 West 24th Street
212-206-9300
gladstonegallery.com
Mon-Fri 10 a.m.-6 p.m.

The venerable Gladstone Gallery is a maze of large spaces that can accommodate large-scale work, as well as smaller, closet-like rooms. The gallery's extensive list of artists include Sarah Lucas, who works with photography, collage and found objects, as well as Dada-inspired Huang Yong Ping, and filmmaker and pioneer perfor-mance artist Jack Smith.

⑮ BORTOLAMI GALLERY

520 West 20th Street
212-727-2050
bortolamigallery.com
Tues-Sat 10 a.m.-6 p.m.

The inaugural show at Bortolami's new 20th Street location included some of the scene's hottest names including Mika Rottenberg, Agathe Snow and Terence Koh alongside gallery artists Hope Atherton and Daniel Buren.

⑯ CASEY KAPLAN

525 West 21st Street
212-645-7335
caseykaplangallery.com
Tues-Sat 10 a.m.-6 p.m.

Casey Kaplan founded his gallery in 1995, and created the New York Gallery Week initiative in 2009.

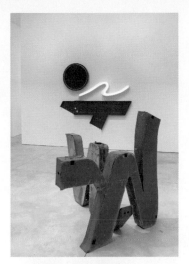

⑰ CHEIM & READ

547 West 25th Street
212-242-7727
cheimread.com
Tues-Sat 10 a.m.-6 p.m.

Founded in 1997 by John Cheim and Howard Read, the gallery focuses on contemporary international artists in the realms of painting, drawing, photography and sculpture includ-ing the ledendary sculptor Louise Bourgeois, pioneering color photog-rapher William Eggleston and Jenny Holzer, an artist best known for her text-based work.

⑱ D'AMELIO TERRAS

525 West 22nd Street
212-352-9460
damelioterras.com
Tues-Sat 10 a.m.-6 p.m.

D'Amelio Terras exhibits emerging and mid-career contemporary artists, including Polly Apfelbaum's textile installations.

CHELSEA

⑲ DAVID NOLAN ▼

527 West 29th Street
212-925-6190
davidnolangallery.com
Tues-Sat 10 a.m.-6 p.m.

A favorite gallery among gallerists, David Nolan specializes in works on paper from the likes of painter Carroll Dunham and sculptor Barry Le Va.

⑳ DAVID ZWIRNER ▼

519 West 19th Street
525 West 19th Street
533 West 19th Street
212-727-2070
davidzwirner.com
Tues-Sat 10 a.m.-6 p.m.

This high-end gallery has three locations on 19th Street, spanning an expansive 30,000 square feet. The gallery has the appearance of a small modern museum: skylights in almost every space, crisp white walls and high ceilings. Its blue-chip lineup leans toward artists with an intellectual bent, including a number of leading European painters, such as Daniel Richter, Luc Tuymans and Neo Rauch, who made his U.S. debut exhibition with the gallery. Zwirner also represents the estates of leading names from the Conceptual and Minimalist canons including Dan Flavin, Gordon Matta-Clark and Donald Judd, affirming the gallery's status as one of the art world's most important.

THIS PAGE (ABOVE) David Nolan Gallery. (RIGHT) Installation view of John McCracken, New Work in Bronze and Steel at David Zwirner, New York, Sept 16-Oct 23, 2010 OPPOSITE (TOP) Elizabeth Dee Gallery (BOTTOM) Friedrich Petzel Gallery

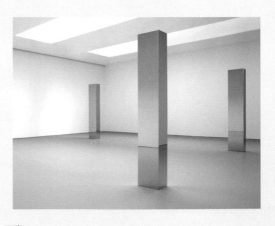

㉑ ELIZABETH DEE GALLERY ▲

545 West 20th Street
212-924-7545
elizabethdeegallery.com
Tues-Sat 10 a.m.-6 p.m.

Since 2002, the ambitious
program of international artists
at Elizabeth Dee has included
the debut of New Media pioneer
Ryan Trecartin and acclaimed
exhibitions by first-generation
Conceptual artist Adrian Piper.

㉒ FOXY PRODUCTION

623 West 27th Street
212-239-2758
foxyproduction.com
Tues-Sat 10 a.m.-6 p.m.

Foxy Production doesn't shy away
from provocative work, including
Sterling Ruby's videos of male
porn stars.

㉓ FRIEDRICH PETZEL GALLERY ▲

535 West 22nd Street
537 West 22nd Street
212-680-9467
petzel.com
Tues-Sat 10 a.m.-6 p.m.

Specializing in contemporary
work, Petzel's 537 West 22nd
Street location can accommodate
large-scale installations, such as
the colorful surfboards mounted
on the walls of the long hallway
leading to the main gallery for
the surf-themed group show
"Swell, Art 1950-2010." The second
space on the ground floor of 535
West 22nd Street is intimate and
dedicated to smaller exhibitions,
performances and artists' projects.

㉔ GALERIE LELONG

528 West 26th Street
212-315-0470
galerielelong.com
Tues-Sat 10 a.m.-6 p.m.

Galerie Lelong boasts locations
in Paris and Zurich, along with
a roster of established artists
including the estates of Hélio
Oiticica, a leader of the Brazilian
Tropicalismo movement, and
Cuban-born performance artist
Ana Mendieta.

㉕ GAGOSIAN GALLERY

```
555 West 24th Street
212-741-1111
522 West 21st Street
212-741-1717
gagosian.com
Tues-Sat 10 a.m.–6 p.m.
```

Installation views of Roy Lichtenstein, Still Lifes, May 8-Jul 30, 2010 at Gagosian Gallery, New York.

Since Larry Gagosian made the move from Los Angeles to New York in 1986, he has conquered the New York art scene. Gagosian's aggressive approach to the art trade is infamous, but it has only helped him reach the top of the international art world and establish a regular post as the top gallerist on *ArtReview* magazine's annual power list. Gagosian's contemporary talent runs deep: Damien Hirst, Jeff Koons, Richard Prince and Ed Rucha are just a few among many museum-calibur artists. Such a canonical roster lends the gallery an undeniable star-making power; Dan Colen's debut at the gallery was the most anticipated show of the 2010 season.

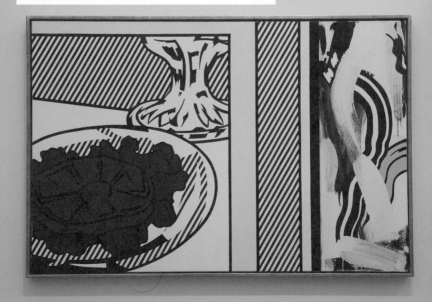

㉖ GREENE NAFTALI

508 West 26th Street, 8th Floor
212-463-7770
greenenaftaligallery.com
Tues-Sat 10 a.m.-6 p.m.

This early player on the Chelsea scene is home to wacky performance collective Gelitin and artist Paul Chan, who references literature in his politically poignant work, such as *Waiting for Godot in New Orleans*, a restaging of Samuel Beckett's play set in post-Katrina Louisiana.

㉘ JAMES COHAN GALLERY ▲

533 West 26th Street
212-714-9500
jamescohan.com
Tues-Sat 10 a.m.-6 p.m.

Imposing polished cherry-wood doors help the James Cohan Gallery stand out against the minimalist facades of its Chelsea neighbors. This large space — which seems even larger due in part to two well-placed skylights in the main gallery — specializes in contemporary work, such as Jesper Just's large-scale video installation, *A Vicious Undertow*, 2007. The gallery also represents video art pioneers Nam June Paik and Bill Viola and the estate of Robert Smithson.

㉗ HASTED KRAEUTLER ▲

537 West 24th Street
212-627-0006
hastedkraeutler.com
Tues-Sat 10 a.m.-6 p.m.

Contemporary photography gallery Hasted Kraeutler represents fashion photographer Jean-Paul Goude and Martin Schoeller, a photographer best known for his close-up portraits ranging from Bill Clinton to Angelina Jolie to female bodybuilders. The gallery also occasionally shows work by leading photographers Garry Winogrand, Lee Friedlander, Joel Sternfeld and William Eggleston.

(TOP) James Cohan Gallery
(BOTTOM) Installation View Martin Schoeller: Female Bodybuilders, July 1-Aug 20, 2010 Hasted Kraeutler.

㉙ THE KITCHEN

512 West 19th Street
212-255-5793
thekitchen.org
Tues-Fri noon-6 p.m.
Saturday 11 a.m.-6 p.m.

From the street, The Kitchen
has the appearance of a walk-up
apartment complex instead of a
legendary art institution. Visitors
gain access to the building by a
buzzer and ascend three narrow
flights of stairs to the gallery. Once
there, however, the large space
seems more like a well-lit stage
separated into three rooms instead
of a typical gallery space.

A leading alternative space
since it was founded as an artists'
collective in 1971, The Kitchen
embraces all aspects of the avant-
garde, from performance and
video art to music and literature
and champions emerging artists
as well as established names. The
nonprofit has helped to foster the
careers of leading artists such as
Vito Acconci and Laurie Anderson.
Recent performances include film-
maker Miranda July's 2007 *Things
We Don't Understand And Are
Definitely Not Going To Talk About*,
a piece that examined heartbreak
and obsession.

BELOW A performance from
the Dance and Process
series at the Kitchen.

OPPOSITE
Installation view, Jen-
nifer Steinkamp, Pre-
mature, 2010, Lehamann
Maupin Gallery, 540 West
26th Street

�30 LEHMANN MAUPIN

540 West 26th Street
212-255-2923
lehmannmaupin.com
Tues-Sat 10 a.m.-6 p.m.

Since 1996, Lehmann Maupin has boasted a stylish roster of talent including Turner Prize-nominated Brit artist Tracey Emin and painters Ashley Bickerton, Ross Bleckner and Hernan Bas.

�31 LEO KOENIG INC.

545 West 23rd Street
212-334-9255
leokoenig.com
Tues-Sat 10 a.m.-6 p.m.

Leo Koenig comes from art world royalty—his father is Museum Ludwig director Kasper König and his younger brother runs a successful Berlin gallery. In New York, Koenig represents a hot line-up of emerging artists such as Kelli Williams and Wendy White.

�32 LUHRING AUGUSTINE

531 West 24th Street
212-206-9100
luhringaugustine.com
Tues-Sat 10 a.m.-6 p.m.

Founded in 1985 and located on a prime 24th Street strip, Luhring Augustine represents an international roster of contemporary artists including video artist Pipilotti Rist, photographers Joel Sternfeld and Larry Clark (of *Kids* fame) and conceptual artist Glenn Ligon.

�33 MARIANNE BOESKY

509 West 24th Street
212-680-9889
marianneboeskygallery.com
Tues-Sat 10 a.m.-6 p.m.

Marianne Boesky opened in 1996 and moved in 2006 to its current Deborah Berke-designed space. The gallery represents video artist Sue de Beer, sculptor Rachel Feinstein and neo-Pop star Yoshitomo Nara.

�34 MARLBOROUGH CHELSEA

545 West 25th Street
212-463-8634
marlboroughgallery.com
Tues-Sat 10 a.m.-5:30 p.m.

With its airy two-story gallery and outdoor terrace, Marlborough Chelsea regularly features exhibitions of contemporary painting, photography and even monumental sculpture from heavyweight artists such as Fernando Botero, Claudio Bravo and Magdalena Abakanowicz.

CHELSEA

㉟ MARY BOONE GALLERY ▼

541 West 24th Street
212-752-2929
maryboonegallery.com
Tues-Fri 10 a.m.-6 p.m.
Saturday 10 a.m.-5 p.m.

The powerhouse behind the Neo-Expressionist boom of the 1980s, Mary Boone has been making waves since she opened in SoHo in 1977. Boone still represents some of the artists with whom she built her empire — Ross Bleckner, Francesco Clemente, Eric Fischl, Barbara Kruger and David Salle — as well as gallery newcomers including goth-mode provocateur Terence Koh and painter Will Cotton, whose candy-coated imagery was the inspiration for pop star Katy Perry's *California Gurls* video.

BELOW Installion view, David Salle, Some Pictures from the 80s, May 8-June 26, 2010 at Mary Boone Gallery, Chelsea

㊱ MARY RYAN GALLERY

527 West 26th Street
212-397-0669
maryryangallery.com
Tues-Sat 10 a.m.-6 p.m.

Established in 1981, Mary Ryan Gallery has been tucked away below street level in Chelsea for the past four years. The intimate space, with bright lighting and concrete floors, hosts a mix of contemporary art in all media. The gallery also specializes in early 20th-century American and British works on paper and prints.

㊲ MATTHEW MARKS

522 West 22nd Street
212-243-0200
matthewmarks.com
Tues-Sat 10 a.m.-6 p.m.

Matthew Marks Gallery showcases European and American artists in all media, including the ceramic works of Ken Price, wooden sculptures by the late Anne Truitt and Andreas Gursky's painting-like photos.

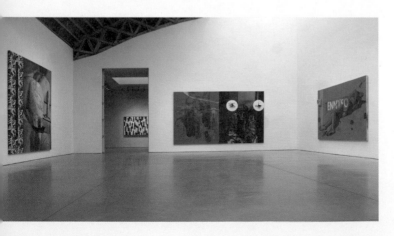

❸❽ METRO PICTURES

519 West 24th Street
212-206-7100
metropicturesgallery.com
Tues-Sat 10 a.m.-6 p.m.

In 1980, Artists Space veteran Helene Winer and Janelle Reiring of Castelli Gallery opened Metro Pictures with a group show featuring a young Cindy Sherman. The photographer remains with the gallery, which now also represents the likes of Olaf Breuning and Tony Oursler.

❸❾ MITCHELL-INNES & NASH

534 West 26th Street
212-744-7400
miandn.com
Tues-Sat 10 a.m.-6 p.m.

A leading figure in the secondary market, Mitchell-Innes & Nash represents modern and contemporary masters including Roy Lichtenstein and Martha Rosler.

❹❶ NYEHAUS

358 West 20th Street #2
212-366-4493
nyehaus.com
Tues-Sat 11 a.m.-6 p.m.

Formerly located in the National Arts Club, Nyehaus now occupies a Victorian townhouse in Chelsea. The gallery is run by collector/curator Tim Nye and presents exhibitions by leading mid-career artists, including Rirkrit Tiravanija and Sherrie Levine, as well as group shows such as a retrospective of Los Angeles' famous Ferus Gallery and a recreation of London's first experimental gallery, Indica.

❹❶ THE PACE GALLERY ▲

545 West 22nd Street
212-929-7000
545 West 22nd Street
212-989-4258
510 West 25th Street
212-255-4044
thepacegallery.com
Tues-Sat 10 a.m.-6 p.m.

Arne Glimcher opened The Pace Gallery in Boston in 1960 and moved it to New York in 1963. Since then, the blue-chip gallery's landmark shows have included early exhibitions of Pop and Op Art, as well as historical surveys of major names such as Pablo Picasso and Mark Rothko. The gallery's 50th anniversary exhibitions included a who's who of recent art history: Willem de Kooning, Donald Judd, Bridget Riley and James Rosenquist, plus many more. But Pace is still an active player in the contemporary scene — its roster of contemporary artists includes Chuck Close, Tim Hawkinson and Kiki Smith. The gallery recently expanded into the emerging Chinese market with a branch in Beijing.

CHELSEA

④ PAUL KASMIN GALLERY ▲

293 Tenth Avenue
212-563-4474
paulkasmingallery.com
Tues-Sat 10 a.m.-6 p.m.

Paul Kasmin Gallery is not averse to showcasing controversial work—such as provocative fashion photographer David LaChapelle's *American Jesus* show, which depicted images of Michael Jackson in religious poses.

④ PAULA COOPER GALLERY

534 West 21st Street
212-255-1105
paulacoopergallery.com
Tues-Sat 10 a.m.-6 p.m.

Since Paula Cooper opened in SoHo in 1968, the gallery has specialized in Conceptual and Minimal art. The space, with white walls and an attic-like ceiling, was large enough to accommodate Mark Di Suvero's 24-foot-high sculpture *Nova Albion*, made of steel and redwood logs. The gallery has occupied its current location since 1996 and a second space was added at 521 West 21st Street in 1999.

④ PERRY RUBENSTEIN

527 West 23rd Street
212-627-8000
perryrubenstein.com
Mon-Fri 10 a.m.-6 p.m.

The shows at Perry Rubenstien tend toward a colorful mix of performative artists including the late performance legend Leigh Bowery, street art duo FAILE and Bas Jan Alder, an artist who disappeared at sea during a 1975 performance.

④ PETER BLUM CHELSEA

526 West 29th Street
212-244-6055
peterblumgallery.com

Peter Blum co-founded the legendary arts magazine *Parkett* in 1984, and opened his second New York gallery in Chelsea in 2006 (the first, in SoHo, opened in 1993). Since then the gallery has hosted exhibitions of new work as well as historical surveys, including such important artists as Louise Bourgeois, Agnes Martin, Robert Ryman and Alex Katz.

④ PHOENIX GALLERY

210 Eleventh Avenue, Suite 902
212-226-8711
phoenix-gallery.com
Tues-Sat 11:30 a.m.-6 p.m.

The lone survivor of the 1950s Tenth Street scene, Phoenix Gallery has been a not-for-profit artists' collective for over 50 years.

ABOVE Installation view, Robert Indiana, Hard Edge, Sept 18 to Nov 1, 2008 at Paul Kasmin Gallery.

⁴⁷ P·P·O·W ▲

535 West 22nd Street, 3rd Floor
212-647-1044
ppowgallery.com
Tues-Sat 10 a.m.-6 p.m.

Founded in the East Village in 1983, P·P·O·W still has a little bit of the neighborhood's renegade bohemian spirit. The gallery represents edgy icons including Carolee Schneemann — one of the first artists to use the body as a medium for performance art, who more recently made waves for her images of victims of 9/11 — as well as the estate of 1980s downtown king David Wojnarowicz.

⁴⁸ POSTMASTERS

459 West 19th Street
212-727-3323
postmastersart.com
Tues-Sat 11 a.m.-6 p.m.

Postmasters has occupied its warehouse-style Chelsea space since 1998. The 25-year-old gallery, owned by Magdalena Sawon and Tamas Banovich, shows all media with an affinity towards conceptual art and new media. Past exhibits include "Defrosted: A Life of Walt Disney," with a remade version of *Steamboat Willy*, and video installations by Israeli artist Omer Fast that explore the line between fact and fiction.

⁴⁹ PRATT MANHATTAN GALLERY

144 West 14th Street, 2nd Floor
212-647-7778
pratt.edu/exhibitions
Tues-Sat 11 a.m.-6 p.m.

The Department of Exhibitions at Brooklyn's venerable Pratt Institute organizes shows of innovative art, design and architecture at the school's Manhattan outpost.

⁵⁰ PRINTED MATTER, INC. ▲

195 Tenth Avenue
212-925-0325
printedmatter.org
Tues-Wed 11 a.m.-6 p.m.
Thurs-Sat 11 a.m.-7 p.m.

A nonprofit founded in 1976 by a group of artists (including Carl Andre and Sol LeWitt) and art workers, Printed Matter is dedicated to "artwork for the page:" artists' books, posters, prints and zines. The public reading room offers 15,000 titles, featuring 5,000 artists, for viewing or purchase.

TOP Installation view Sarah
Oppenheimer, 554-5251, Sept 7-Oct 7,
2006 at P·P·O·W.
RIGHT Printed Matter

CHELSEA

⑤ ROBERT MILLER GALLERY

524 West 26th Street
212-366-4774
robertmillergallery.com
Tues-Sat 10 a.m.-6 p.m.

The artists represented by Robert Miller Gallery range from Abstract Expressionist painter Lee Krasner to photographer Diane Arbus and musician Patti Smith.

㊵ SEAN KELLY GALLERY

528 West 29th Street
212-239-1181
skny.com
Tues-Fri 11 a.m.-6 p.m.
Saturday 10 a.m.-6 p.m.

Founded in 1991, Sean Kelly represents a roster of leading contemporary artists including performance art pioneer Marina Abramović—the subject of a 2010 MoMA retrospective—musician/multimedia artist Laurie Anderson, painter Kehinde Wiley and the estate of photographer Robert Mapplethorpe.

㊳ SIKKEMA JENKINS & CO.

530 West 22nd Street
212-929-2262
sikkemajenkinsco.com
Tues-Sat 10 a.m.-6 p.m.

The contemporary line-up at Sikkema Jenkins includes conceptual photographer Vik Muniz, best known for his composition in chocolate, diamonds and other unusual media, and Kara Walker, whose paper silhouette installations have been exhibited at the Metropolitan Museum of Art and MoMA.

㊴ SONNABEND ▾

536 West 22nd Street
212-627-1018
Tues-Sat 10 a.m.-6 p.m.
artnet.com/sonnabend

In 1971, legendary dealer Ileana Sonnabend opened her gallery in the same 420 West Broadway building as her former husband, Leo Castelli, after a decade introducing American Pop art to European galleries. In New York, Sonnabend did not shy away from edgy shows, including Vito Acconci's 1972 performance *Seedbed*, in which the artist masturbated under the gallery floor for three weeks, and Jeff Koons' 1990 show *Made In Heaven*, a collection of erotic photographs, sculptures and paintings of the artist and his porn star wife, "la Cicciolina."

ABOVE Sonnabend Gallery
OPPOSITE (TOP) Installation view, Uta Barth: ...to walk without destination and to see only to see at Tanya Bonakdar Gallery, New York, 2010
(BOTTOM) Yossi Milo Gallery

Shafrazi opened his New York gallery he exhibited the leading graffiti artists of the 1980s, including Keith Haring, Futura 2000 and Jean-Michel Basquiat.

⑮ TANYA BONAKDAR ▲

521 West 21st Street
212-414-4144
tanyabonakdargallery.com
Tues-Sat 10 a.m.-6 p.m.

Tanya Bonakdar represents a top-tier line of artists including museum veterans Olafur Eliasson, who famously installed waterfalls in the East River, installation artist Sarah Sze and Rivane Neuenschwander, the subject of a solo show at the New Museum.

⑯ TAXTER & SPENGEMANN

459 West 18th Street
212-924-0212
taxterandspengemann.com
Tues-Sat 10 a.m.-6 p.m.

Taxter & Spengemann has a reputation for discovering and nurturing young talent, such as performance artist Xavier Cha.

⑰ TONY SHAFRAZI GALLERY

544 West 26th Street
212-274-9300
tonyshafrazigallery.com
Tues-Sat 10 a.m.-6 p.m.

Tony Shafrazi is one of the art world's most colorful characters — he famously vandalized Picasso's *Guernica* in 1974, scrawling the words "Kill Lies All" across in it spray paint. Fittingly, when

⑱ WALLSPACE

619 West 27 Street
212-594-9478
wallspacegallery.com
Tues-Sat 10 a.m.-6 p.m.

Wallspace opened in 2002 as a contemporary photography gallery, but has since moved into bigger space and expanded its programming to include work in all media.

⑲ YOSSI MILO ▲

525 West 25th Street
212-414-0370
yossimilo.com
Tues-Sat 10 a.m.-6 p.m.

Yossi Milo represents the cutting-edge of contemporary photography, including Pieter Hugo's images of the Nollywood film scene and Loretta Lux's haunting photographs of children.

CHELSEA

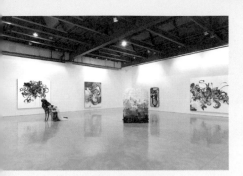

⑥⓪ YVON LAMBERT ▲

550 West 21st Street
212-242-3611
yvon-lambert.com
Tues-Sat 10 a.m.-6 p.m.

Yvon Lambert first opened in Paris in 1966, showing the pioneers of Minimal, Conceptual and Land Art. The gallery's New York branch opened in 2003 and has hosted the likes of AbEx-influenced painter Robert Ryman as well as photographer Andres Serrano's infamous "Shit" show.

⑥① ZACH FEUER

548 West 22nd Street
212-989-7700
zachfeuer.com
Tues-Sat 10 a.m.-6 p.m.

The critically acclaimed contemporary roster at Zach Feuer includes video artist Tamy Ben-Tor and Pheobe Washburn, an artist known for her delicate recycled-object installations.

HISTORICAL

⑥③ WILLEM DE KOONING STUDIO

145 West 21st Street

In 1934, Willem de Kooning moved to Chelsea with his model and lover Juliet Browner. Two years later, they moved to a nearby industrial space at 156 West 22nd Street.

⑥③ WILLEM DE KOONING STUDIO

156 West 22nd Street

In 1943, de Kooning moved to West 22nd Street and married artist Elaine Fried, beginning one of art history's most tumultuous relationships.

⑥④ JULIAN SCHNABEL STUDIO

521 West 23rd Street

In the 1980s, Julian Schnabel occupied a studio in a West Chelsea owned by artist Sandro Chia, the same building where dealer Larry Gagosian opened his first New York gallery.

RESTAURANT

⑥⑤ BOUTIQUE EAT SHOP

559 West 22nd Street
212-414-8700
boutiqueeatshop.com

Inspired by artist Gordon Matta-Clark's restaurant Food, hotspot B.E.S. caters to the Chelsea art crowd with an art-filled space featuring the work of artists such as

Thomas Beale and Paul Reynolds, as well as rotating installations curated by P.S.1's Tim Goossens. Like what you see? Bid on the restaurant's artwork on auction. If music is more your style, duo Andrew Andrew host a weekly Thursday-night party.

HOTEL

⑥⑥ HOTEL CHELSEA ▶

222 West 23rd Street
212-243-3700
hotelchelsea.com

The legendary Hotel Chelsea has more than earned its reputation as one of New York's most bohemian landmarks. The hotel's swingin' scene was captured in Andy Warhol's 1966 film *Chelsea Girls*, starring Factory Superstars Viva and Nico. Others in the long list of famous residents have included Bob Dylan (Room 211), Edie Sedgwick and roommates Robert Mapplethorpe and Patti Smith, as well as Sid Vicious, who may have murdered girlfriend Nancy Spungen in room 100. Spungen's isn't the only ghost who might haunt these hallowed halls; author Dylan Thomas died of alcohol poisoning here after a binge in 1953.

Along with history, the hotel is famously filled with art objects and decoration, including a mobile by Chelsea resident Arthur Weinstein that hangs in the stairwell. The art-filled lobby and downstairs restaurant El Quijote—opened in 1930—were both popular places for art-world rendezvous at the hotel's peak. New management took over in 2007, but quirky hotel rooms are still available.

MIDTOWN SOUTH

42ND STREET

②

③

10TH AVENUE

6TH AVENUE

9TH AVENUE

34TH STREET

Broadway

8TH AVENUE

7TH AVENUE

5TH AVENUE

⑰
⑯

①

⑪

8

MADISON AVENUE

⑫

⑮

⑤

23RD STREET

④

PARK AVENUE SOUTH

⑬

⑭

⑦

3RD AVENUE

2ND AVENUE

⑨ ⑩

⑥

14TH STREET

THE UPSCALE AREAS NORTH OF UNION SQUARE—INCLUDING GRAMERCY PARK AND MURRAY HILL TO THE EAST—HAVE BEEN HOME TO ARTISTS SINCE THE NATIONAL ARTS CLUB WAS FOUNDED IN 1898. MEANWHILE, MADISON SQUARE PARK'S RECENT REVIVAL HAS BRIGHTENED UP A ONCE-DREARY STRETCH OF THE CITY WITH PEDESTRIAN AREAS AND PUBLIC ART.

MIDTOWN SOUTH

MUSEUM
❶ The Morgan Library & Museum

GALLERY
❷ Exit Art

STUDIO
❸ Lower East Side Printshop

PUBLIC ART
❹ Madison Square Art

HISTORICAL
⑤ Roy Lichtenstein Studio
⑥ Max's Kansas City
❼ National Arts Club

⑧ Andy Warhol Apartment
⑨ The White Factory
⑩ Andy Warhol Studio
⑪ Andy Warhol's Final Factory

HOTELS
⑫ Ace Hotel
⑬ Carlton Arms Hotel
⑭ Gramercy Park Hotel
⑮ Gershwin Hotel

STORE
⑯ Macy's
⑰ Metropolitan Museum of Art Store

MIDTOWN SOUTH

MUSEUM

❶ THE MORGAN LIBRARY & MUSEUM

225 Madison Avenue
212-685-0008
themorgan.org
Tues-Thurs 10:30 a.m.-5 p.m.
Friday 10:30 a.m.-9 p.m.
Saturday 10 a.m.-6 p.m.
Sunday 11 a.m.-6 p.m.
$12

Formerly a private library, today the Morgan boasts a leading collection of manuscripts, drawings, rare books and music, as well as a new, expanded space designed by famed architect Renzo Piano and opened in 2006.

GALLERY

❷ EXIT ART

475 Tenth Ave
212-966-7745
exitart.org
Tues-Thurs 10 a.m.-6 p.m.
Friday 10 a.m.-8 p.m.
Saturday noon-6 p.m

Exit Art is an antidote to the overly commercial side of the Chelsea art scene. Its massive galleries favor exhibitions with political and social undertones, such as "Alternative Histories," which highlighted the history of alternative art spaces in New York City, as well as invitational group shows that provide a forum for new voices.

STUDIO

❸ LOWER EAST SIDE PRINTSHOP ▾

306 West 37th Street
6th Floor
212-673-5390
printshop.org

Founded in 1968, this not-for-profit studio offers printmaking classes for all levels, a resident artist program, 24-hour studio access and the spirit of an artists' collective. Printshop alumni include such major artists as Kiki Smith, Robert Longo and Barbara Kruger.

PUBLIC ART

❹ MADISON SQUARE ART

Madison Park, Fifth Avenue
at 23rd Street
madisonsquarepark.org

The outdoor gallery at Madison Square Park regularly hosts new work by major artists such as Roxy Paine, who installed twisting metal trees, and concrete sculptures by Sol LeWitt.

HISTORICAL

⑤ LICHTENSTEIN STUDIO

105 East 29th Street

Lichtenstein set up a factory-like studio in 1984, where he painted on a strict schedule—stopping for lunch daily at 1 p.m.

⑥ MAX'S KANSAS CITY

213 Park Avenue South

When it opened in 1965, Max's Kansas City immediately attracted a crowd of art world A-listers including artists Robert Rauschenberg, Richard Serra and Roy Lichtenstein and art dealer Leo Castelli. Andy Warhol was the reigning king of the scene, where his Factory entourage held court in the back room, partying through the night and well into the morning. The music crowd sat upstairs, while the artists took downstairs, paying their tabs with original artwork, and delighting when owner Mickey Ruskin threw live goldfish into the restaurant's famous piranha-filled fish tank. By the early '70s the place was out of fashion and, despite a remodeling in 1974, Max's closed in 1981.

⑦ NATIONAL ARTS CLUB

15 Gramercy Park South
212-475-3424
nationalartsclub.org

In 1898, *The New York Times* art critic Charles de Kay founded the National Arts Club as a place to "stimulate, foster and promote public interest in the arts and educate the American people in the fine arts." Early members included Robert Henri, Frederic Remington and William Merritt Chase. The invitation-only membership offers more than prestige—it also comes with a coveted key to Gramercy Park.

OPPOSITE Artist Arturo Herrera in the Lower East Side Printshop's studio with printers assisting him. THIS PAGE Max's Kansas City, 1976, by Bob Gruen.

MIDTOWN SOUTH

⑧ WARHOL APARTMENT

242 Lexington Avenue

In 1953, Andy Warhol and his mother moved to a modest two-story apartment above a dive bar called Florence's Pin-Up, where he lived until 1960.

⑨ THE WHITE FACTORY

33 Union Square West

In 1968 Warhol moved downtown to the Decker Building, where he set up his White Factory. A stark contrast to the anything-goes vibe of the Silver Factory, Warhol's Union Square studio was set up like an office. It was here that he was shot by Valerie Solanas in July 1968.

⑩ ANDY WARHOL STUDIO

860 Broadway

In 1974, Warhol moves to a nearby studio that came to be known as "the office." He stayed here until 1984.

⑪ ANDY WARHOL'S FINAL FACTORY

22 East 33rd Street

In 1984 Andy Warhol move the Factory and the offices of *Interview* to a converted Consolidated Edison building, where they remained until his death in 1987. The building no longer exists

HOTELS

⑫ ACE HOTEL

20 West 29th Street
212-679-2222
acehotel.com

This pet-friendly hotel—with a vintage-grunge look in the common areas complete with a street art-inspired sticker mural—is a good budget option near the Theater District. With a lively bar scene, the hotel is a hangout for both visitors and New Yorkers. DJs often play music in the lobby bar.

⑬ CARLTON ARMS HOTEL

160 East 25th Street
New York, New York 10010
212-679-0680
carltonarms.com

This quirky, budget-friendly hotel has a very storied history: from a modest shelter for visiting farmers and businessmen in the early 1900s, to a speak-easy and casino hangout during Prohibition, not to mention a haven for drug addicts, prostitutes and other unsavory characters from the '50s through the early '80s. Today, the hotel is a mecca for art enthusiasts. Artists come from all over the world to paint the walls of the guest-rooms, hallways and bathrooms. From colorful murals by graffiti artist Banksy to artwork by Gil Dominguez, this is a different take on the hotel experience.

⑭ GERSHWIN HOTEL

 7 East 27th Street
 212-545-8000
 gershwinhotel.com

This art-centric, economy hotel houses an extensive collection of modern art including prints by Lichtenstein and Warhol. Picasso-inspired wall murals abound, as well as modern furniture.

⑮ GRAMERCY PARK HOTEL

 2 Lexington Avenue
 212-920-3300
 gramercyparkhotel.com

Studio 54 co-founder turned celebrity hotelier Ian Schrager enlisted the help of Julian Schnabel when considering the aesthetic for this hotel. Almost like a live-in museum, the work of Andy Warhol, Jean-Michel Basquiat, Damien Hirst, Richard Prince, Keith Haring and Julian Schnabel are found throughout the hotel.

SHOPS

⑯ MACY'S

 151 West 34th Street
 212-695-4400
 macys.com

The world's largest department store has an unexpected artistic connection: Cindy Sherman got her first New York job at the store, but quit after just one day.

⑰ METROPOLITAN MUSEUM OF ART STORE

 151 West 34th Street
 212-268-7266
 store.metmuseum.org

The Macy's outpost of the Metropolitan Museum of Art gift shop offers the same artsy books, jewelry and gifts as the famed Fifth Avenue location.

MIDTOWN IS THE MODERNIST HEART OF MANHATTAN, HOME TO HIGH-END GALLERIES, RESTAURANTS AND THE CANONICAL MUSEUM OF MODERN ART. PERHAPS MOST SURPRISING, THOUGH, IS THE AREA'S CONCENTRATION OF PUBLIC ART – INCLUDING MODERN AND CONTEMPORARY MASTERPIECES TUCKED AWAY IN CORPORATE LOBBIES AND COURTYARDS.

MIDTOWN

MIDTOWN

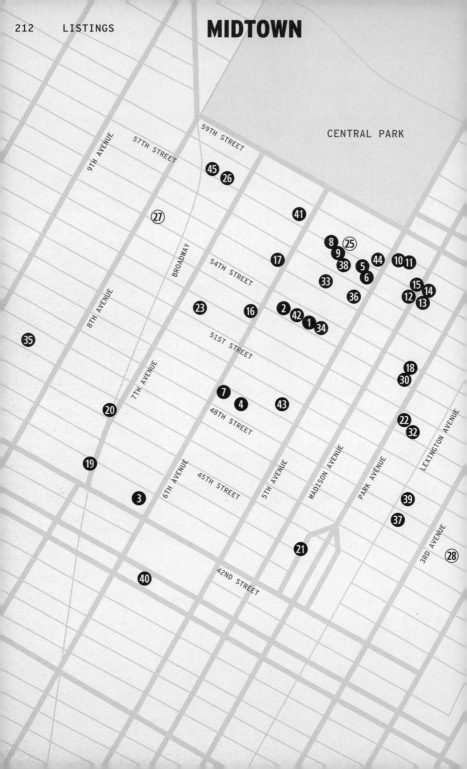

CENTRAL PARK

9TH AVENUE
57TH STREET
59TH STREET
8TH AVENUE
BROADWAY
54TH STREET
7TH AVENUE
51ST STREET
48TH STREET
6TH AVENUE
45TH STREET
5TH AVENUE
MADISON AVENUE
PARK AVENUE
LEXINGTON AVENUE
3RD AVENUE
42ND STREET

45 26
27
41
8 25
17 9
38 44 10 11
5 5
33 6
36
15 14
12 13
23 16 2 42 1 34
18 30
7 4 43
22 32
20 19 3 39 37
21 40 28 35

MUSEUMS

❶ Museum of Modern Art
❷ American Folk Art Museum
❸ International Center of Photography

AUCTION HOUSE

❹ Christie's

GALLERIES

❺ Gering & López
❻ Greenberg Van Doren
❼ Haunch of Venison
❽ Marlborough
❾ Marian Goodman Gallery
❿ Mary Boone
⓫ McKee Gallery
⓬ The Pace Gallery
⓭ Zabriskie

PUBLIC ART

⓮ 590 Madison Sculpture Garden
⓯ Alexander Calder, Saurien, 1975
⓰ Jim Dine, Looking Toward the Avenue, 1989
⓱ Robert Indiana, LOVE, 1992
⓲ Lever House Art Collection
⓳ Roy Lichtenstein, Times Square Mural, 1994
⓴ Max Neuhaus, Times Square, 2002
㉑ Julian Schnabel, Eight New Paintings, 2006
㉒ Seagram Building Lobby
㉓ Roy Lichtenstein, Mural with Blue Brushstroke, 1968
㉔ United Nations Art Collection

HISTORICAL

㉕ Art of this Century
㉖ Art Students League of New York
㉗ Studio 54
㉘ The Silver Factory
㉙ Home of Peggy Guggenheim and Max Ernst

RESTAURANTS

㉚ Casa Lever
㉛ Mr. Chow
㉜ The Four Seasons
㉝ Michael's Restaurant
㉞ The Modern
㉟ Barbetta

HOTELS

㊱ St. Regis
㊲ Roger Smith Hotel
㊳ Chambers Hotel
㊴ Marriott East Side
㊵ The Bryant Park Hotel
㊶ The Buckingham Hotel

STORES

㊷ MoMA Design Store
㊸ Metropolitan Museum of Art Stores
㊹ Tiffany & Co.
㊺ Lee's Art Shop

MIDTOWN

MIDTOWN

❶ MUSEUM OF MODERN ART

```
11 West 53rd Street
212-708-9400
moma.org
Mon, Wed-Thurs, Sat-Sun 10:30 a.m.-5:30 a.m.
Friday 10:30 a.m.-8:00 p.m.
$20
```

When it comes to Modernism, the Museum of Modern Art sets the canon. The museum was founded in 1929 by three visionary art patrons—Abby Aldrich Rockefeller, Lillie P. Bliss and Mary Quinn Sullivan—and its founding director, Alfred J. Barr, set his goal towards estabilishing "the greatest museum of modern art in the world." Under Barr, MoMA showcased important work of the 19th and 20th century, including a blockbuster show of Vincent Van Gogh in 1935. Now under director Glenn Lowry, the museum's collection includes more than 50,000 paintings, sculptures, drawings, prints, photographs, architectural models and drawings, and design objects. Highlights of the venerable collection include Van Gogh's *Starry Night* and Andy Warhol's *Campbell's Soup Cans*.

OPPOSITE The MoMA lobby featuring Takashi Murakami, 727, 1996, and Auguste Rodin, Monument to Balzac, 1898.
BELOW Kara Walker, Gone, An Historical Romance of a Civil War as it Occurred between the Dusky Thighs of One Young Negress and Her Heart, 1994. MoMA installation view, 2010.

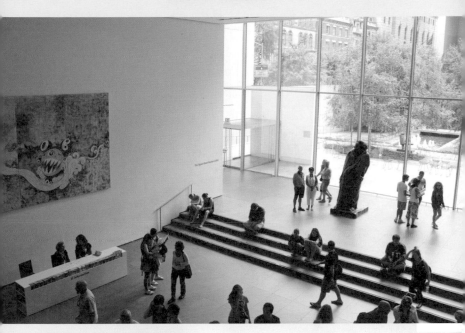

HIGHLIGHTS

Mark Rothko
No. 3/No. 13, 1949

Jackson Pollock
One: Number 31, 1950, 1950

Willem de Kooning
Woman, I, 1950-52

Robert Rauschenberg
Bed, 1955

Jasper Johns
Target with Four Faces, 1955

Andy Warhol
Gold Marilyn, 1962

Joseph Kosuth
One and Three Chairs, 1965

Dan Flavin
"Monument" for V. Tatlin 1, 1964

Donald Judd
Untitled (Stack), 1967

Cindy Sherman
Untitled Film Stills, 1977-1980

❷ AMERICAN FOLK ART MUSEUM

45 West 53rd Street
212-265-1040
folkartmuseum.org
Tues-Sun 10:30 a.m.-5:30 p.m.
Friday 10:30 a.m.-7:30 p.m.
$12

Founded in 1961, the American Folk Art Museum is a leader in the collection and study of crafts and outsider art. The collection features over 5,000 items, including 24 works by the legendary artist Henry Darger.

❸ INTERNATIONAL CENTER OF PHOTOGRAPHY ▾

1133 Avenue of the Americas
212-857-0000
Tues-Thurs 10 a.m.-6 p.m.
Fri 10 a.m.-8 p.m.
Sat-Sun 10 a.m.-6 p.m.
$12

The ICP collection features over 100,000 items, but its strongest holdings are documentary photographs from the 1930s through the '60s. Highlights include work by Henri Cartier-Bresson, Mitch Epstein, Stephen Shore and Louise Lawler. At the nearby school, professionals and hobbyists alike can learn everything from digital photography to darkroom practices from leading photographers including Mary Ellen Mark. Programs range from teen classes and continuing education to an MFA program in conjunction with Bard College.

GALLERIES

❺ GERING & LÓPEZ

730 Fifth Avenue, 6th Floor
646-336-7183
geringlopez.com
Tues-Sat 10 a.m.-6 p.m.

Located in the landmark Crown Building, this is a collaboration between two renowned gallerists: New York's Sandra Gering and Madrid's Javier López. The gallery represents a range of artists including graffiti writer KAWS and designer Karim Rashid.

❻ GREENBERG VAN DOREN

730 Fifth Avenue, 7th Floor
212-445-0444
gvdgallery.com
Tues-Sat 10 a.m.-6 p.m.

This upscale gallery focuses on postwar and contemporary art, with a roster that includes Jessica Craig-Martin and an inventory of work by such blue-chip artists as Ed Ruscha and Frank Stella.

AUCTION HOUSE

❹ CHRISTIE'S ▲

20 Rockefeller Plaza
212-636-2000
christies.com
Check website for viewing hours

Founded in London in the 18th century, Christie's is one of the world's leading auction houses, dealing in art from antiquity to today — including record-breaking sales by Andy Warhol ($71.7 million in 2007) and Pablo Picasso ($106.5 million in 2010). Pre-sale exhibitions and (most) auctions are open to the public, making a trip to Christie's some of the most expensive window-shopping in the world.

❼ HAUNCH OF VENISON

1230 Avenue of the Americas
20th Floor
212-259-0000
haunchofvenison.com
Tue-Sat 10 a.m.-6 p.m.

Haunch of Venison is Christie's foray into the contemporary gallery game. With locations in Zurich, Berlin and London, the gallery represents such major artists as Dan Flavin, Tom Wesselmann and Bill Viola.

MIDTOWN

⑧ MARLBOROUGH

40 West 57th Street
212-541-4900
marlboroughgallery.com
Mon-Fri 10 a.m.-5:30 p.m.

Since 1963, Marlborough New York has represented leading contemporary artists including Red Grooms and Claudio Bravo. The massive gallery and outdoor sculpture garden accommodates works from the likes of Fernando Botero and Tom Otterness.

⑨ MARIAN GOODMAN GALLERY

24 West 57th Street
212-977-7160
mariangoodman.com
Mon-Sat 10 a.m.-6 p.m.

Marian Goodman opened in 1977 with a show of Belgian conceptual artist Marcel Broodthaers, the first of many European names the gallery introduced to U.S. audiences. Goodman's roster boasts a wide range of top-tier talent including John Baldessari, Maurizio Cattelan, Lawrence Weiner and Julie Mehretu.

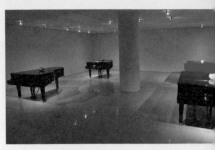

⑩ MARY BOONE ▲

745 Fifth Avenue
212-752-2929
maryboonegallery.com
Tues-Fri 10 a.m.-6 p.m.
Saturday 10 a.m.-5 p.m.

Mary Boone sent shockwaves through the art world when the gallery left SoHo in 1996, declaring the scene too commercial. Since it was founded in 1977, the gallery has been dedicated to cultivating young artists; David Salle and Julian Schnabel both came up within the gallery, which now represents emerging young talent Terence Koh.

⑪ MCKEE GALLERY

745 Fifth Ave
212-688-5951
mckeegallery.com
Tues-Sat 10 a.m.-6 p.m.

Established in 1974, McKee represents leading contemporary painters and sculptors including the wooden sculptures of Martin Puryear and Philip Guston's cartoonish canvases, which fall somewhere between Abstract Expressionism and Neo-Expressionism.

ABOVE Installation view, Sherrie Levine, May 6-June 26, 2010 at Mary Boone Gallery, New York. OPPOSITE Alexander Calder, Saurien, 1975

⑫ THE PACE GALLERY

32 East 57th Street, 2nd Floor
212-421-3292
Tues-Fri 9:30 a.m.-6 p.m.
Saturday 10 a.m.-6 p.m.

One of New York's leading galleries for half a century, Arne Glimcher's Pace Gallery was a key figure in Pop, Minimalism and Post-Modernism. The gallery broke the $1 million mark when it sold Jasper Johns' *Three Flags* to MoMA in 1980. Today it boasts an all-star line-up of modern masters including Mark Rothko, Donald Judd, Chuck Close and Louise Nevelson, as well as new names from China's emerging art scene. On other floors, the gallery also features master prints, primitive art and Pace/MacGill, which specializes in photography.

⑬ ZABRISKIE

40 East 57th Street, 4th Floor
212-752-1223
Tues-Sat 10 a.m.-5:30 p.m.
zabriskiegallery.com

Founded by Virginia Zabriskie in 1954, the gallery's dual locations in New York and Paris fueled international artistic dialogue throughout the 20th century. Now solely in New York, the gallery exhibits the work of photography pioneers Man Ray and Lisette Model and contemporary artists such as Tomoko Sawada.

PUBLIC ART

⑭ 590 MADISON SCULPTURE GARDEN

590 Madison Avenue

The midtown skyscraper formerly known as the IBM building features an indoor garden with rotating sculptural installations.

⑮ ALEXANDER CALDER ▲ SAURIEN, 1975

590 Madison Avenue

Alexander Calder's 1975 stabile adds a splash of bright-red color to an otherwise dark Midtown block.

⑯ JIM DINE LOOKING TOWARD THE AVENUE, 1989

1301 Avenue of the Americas

Jim Dine's monumental female figures reference the Venus de Milo, a theme the Pop artist worked with throughout his career.

MIDTOWN

⑰ ROBERT INDIANA
LOVE, 1966

Sixth Avenue and 55th Street

Originally conceived as a design for the Museum of Modern Art's Christmas card in 1964, *LOVE* is an instantly recognizable sculpture on Sixth Avenue and 55th Street in the heart of Midtown Manhattan. Robert Indiana's sculpture was placed in the middle of the busy sidewalk in 1992. The original *LOVE* sculpture is in Indianapolis and similar works by the artist can be found throughout the world.

⑱ LEVER HOUSE ART COLLECTION

390 Park Avenue
leverhouseartcollection.com

On the corner of Park Avenue and 54th Street, Lever House was constructed in the International Style architecture of Ludwig Mies van der Rohe. The lobby and plaza of the 24-story glass building, an otherwise typical office building, are dedicated to public art. Acclaimed artists Alexander Calder, Damien Hirst and Felix Gonzalez-Torres have all exhibited their work in and around the building.

⑲ ROY LICHTENSTEIN
TIMES SQUARE MURAL, 1994

Times Square-42nd Street
Subway Station

Roy Lichtenstein's comic-inspired figures and primary colors depict a futuristic New York City, with references to the 1939 and 1964 New York World's Fairs. Other references are given to the history of the station, with an image of the original 1904 plaque of the number 42, created by ceramics company Grueby Faience of Boston. Lichtenstein donated the piece to the city and, although it was finished in 1994, the piece sat in storage due to planned renovation of the subway station. The mural was finally installed in 2002.

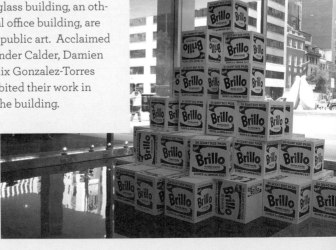

⑳ MAX NEUHAUS
TIMES SQUARE, 2002

Broadway between 45th
and 46th Streets
diaart.org

Max Neuhaus' invisible installation at Times Square consists of a block of sound emitted from the grating at the northern corner of a pedestrian island. The work was originally installed in 1977, then uninstalled in 1992. The work was reinstated in 2002 with help from Creative Time.

㉑ JULIAN SCHNABEL
EIGHT NEW PAINTINGS, 2006

200 Park Avenue
(enter on 45th Street)

Bombastic artist Julian Schnabel created eight canvases for one of Manhattan's most iconic landmarks, the MetLife Building. Look up in the lobby to see two canvases featuring the words Zeus and Duende, mythological figures that frequently appear in the artist's work.

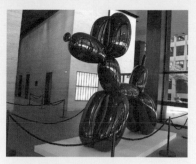

㉒ SEAGRAM LOBBY

375 Park Avenue

A modernist masterpiece in its own right, the Seagram Building also hosts high-end contemporary art: Jeff Koons' *Balloon Dog (Orange)* from the artist's Celebration Series.

㉓ ROY LICHTENSTEIN
MURAL WITH BLUE BRUSHSTROKE, 1968

787 Seventh Avenue

Located in the lobby of the AXA Center, Roy Lichtenstein's five-story mural measures 68 by 32 feet.

㉔ UNITED NATIONS ART COLLECTION

First Avenue at 46th Street
212-963-7539
un.org/events/unart

The United Nations headquarters boasts an impressive art collection, including a stained glass window designed by Marc Chagall in 1964 and *Non-Violence*, a sculpture by Carl Fredrik Reuterswärd. A gallery in the visitor's lobby features exhibitions promoting peace and social consciousness.

ABOVE Jeff Koons, Balloon Dog (Orange), 1994-2000. Installation view at the Segram Building, 2010. OPPOSITE Mike Bildo, Not Warhol (Brillo Boxes, 1964), 2005. Installation View, Lever House, 2010

MIDTOWN

HISTORICAL

㉕ ART OF THIS CENTURY

30 West 57th Street

Opened in 1942, Peggy Guggenheim's visionary gallery was among the first to show the artists of the New York School, including Jackson Pollock and Mark Rothko, though it also featured the work of European Surrealists. Its four galleries displayed art in untraditional ways: suspended in midair or in interactive displays. The gallery closed in 1947.

㉖ ART STUDENTS LEAGUE OF NEW YORK ▾

215 West 57th Street
212-247-4510
theartstudentsleague.org

Founded by artists for artists in 1875, the Art Students League offers a complete immersion in art making practices. The school has launched the careers of some of the 20th century's biggest names: Georgia O'Keeffe, Norman Rockwell and Louise Bourgeois,

as well as the pioneers of Abstract Expressionism Jackson Pollock, Mark Rothko and Cy Twombly.

㉗ STUDIO 54

254 West 54th Street

The glittering home of disco and decadence from 1977 to 1980, Studio 54 was the place were Andy Warhol and Mick Jagger mingled with the likes of Truman Capote and Liza Minnelli amid a hedonistic, cocaine-fueled crowd. The glamour ended when club owners Steve Rubell and Ian Schrager were sent to jail for skimming profits. It was briefly, but unsuccessfully, resurrected from 1981 to 1986 and, today, is the home of the Roundabout Theatre Company.

㉘ THE SILVER FACTORY

231 East 47th Street, Fifth Floor

Andy Warhol's famous studio from 1963 to 1968, The Factory, was covered top to bottom in silver foil by photographer Billy Name. A working studio, The Factory was where Warhol and his assistants produced silkscreen prints and shot the films that created the scene's Superstars. Its famous red couch became a favorite hangout for the likes of Edie Sedgwick, Anita Pallenberg, Candy Darling, Nico and Factory house band the Velvet Underground. The building no longer exists.

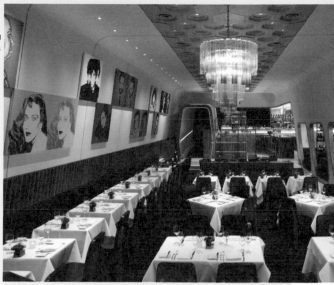

RIGHT The dining room at Casa Lever, featuring a selection of portraits by Andy Warhol.

㉙ HOME OF PEGGY GUGGENHEIM AND MAX ERNST

440 East 51st Street

After fleeing Europe during WWII, collector and gallerist Peggy Guggenheim and her husband, the Surrealist painter Max Ernst, moved to the Hale House in 1941.

RESTAURANTS

㉚ CASA LEVER

390 Park Avenue
212-888-2700
casalever.com

With a roomy atmosphere and Warhol portraits of everyone from Aretha Franklin to Sylvester Stallone mounted on the walls, Casa Lever — the restaurant attached to Lever House — boasts Italian cuisine and an extensive curated wine list.

㉛ MR. CHOW

324 East 57th Street
212-751-9030
mrchow.com

This Midtown Chinese restaurant — with another location at 121 Hudson Street in TriBeCa — was a major hangout for the New York art crowd in the 1980s (think Andy Warhol, Julian Schnabel, Keith Haring and Jean-Michel Basquiat). Artists used to trade their work for meals. Today the split-level restaurant caters to hip-hop musicians and music moguls, but its art history presence can still be felt.

MIDTOWN

㉜ THE FOUR SEASONS

99 East 52nd Street
212-754-9494
fourseasonsrestaurant.com

The Four Seasons opened in the Seagram Building in 1959, and since then it's been a power lunch spot for Manhattan's elite, who dine under a rotating selection of artwork from major galleries, including a recent group of work by Robert Rauschenberg, a series of glittering *Shadow* paintings by Andy Warhol and a permanently installed curtain designed by Pablo Picasso. Mark Rothko famously (and dramatically) turned down a commission to paint a series of murals for restaurant, keeping the canvases and returning his advance.

BELOW: The Grill Room at the Four Seasons Resaturant.

㉝ MICHAEL'S RESTAURANT

24 West 55th Street
212-767-0555
michaelsnewyork.com

Serving California cuisine, Michael's is a haven for modern art enthusiasts as well as those who fancy themselves wine aficionados—the restaurant boasts more than 800 bottles. The Garden Room, which can accommodate 20 to 400 people, features work by Frank Stella, Jasper Johns, David Hockney and Robert Graham.

㉞ THE MODERN

9 West 53rd Street
212-333-1220
themodernnyc.com

Specializing in French-American cuisine, this fine-dining restaurant at the Museum of Modern Art offers two dining options: the Dining Room, which looks out on the Abby Aldrich Rockefeller Sculpture Garden, and the more casual Bar Room for lighter fare. The Dining Room is closed on Sundays.

MIDTOWN

㉟ BARBETTA

321 West 46th Street
212-246-9171
barbettarestaurant.com

Located in the heart of the
Theater District on Restaurant
Row, Barbetta has been on the
New York dining scene for over
100 years. The classically upscale
Italian restaurant has lost some
of its sheen over the years, but
its lush courtyard and formal
dining room have hosted the
likes of Jacqueline Kennedy and
Elizabeth Taylor. The restaurant
was a favorite of Andy Warhol and
Jean-Michel Basquiat, who came
for the scene more than the food,
satisfying their expensive tastes
by ordering the priciest things on
the menu and not eating them.
The pair would sign autographs
and make sketches for the staff
and customers. The restaurant
appears in Julian Schnabel's 1996
film *Basquiat*.

HOTELS

㊱ ST. REGIS

2 East 55th Street
212-753-4500
stregisnewyok.com

Fifth Avenue's venerable St. Regis
hotel, which was declared a New
York City landmark in 1988, was
once a winter home to Salvador
Dali and his wife, Gala. The
couple's occupancy at the hotel
spanned more than a decade. The

eccentric artist's exploits are
the stuff of legend: He would
walk his pet ocelot — a type of
leopard — up and down the halls
and throw lavish — and occasion-
ally risqué — parties in the gallery
and second-floor salons. As a
teenager, Jeff Koons traveled
from his Pennsylvania home-
town, York, to see the artist while
he was a resident of the hotel.

㊲ ROGER SMITH HOTEL

501 Lexington Avenue
212-755-1400
rogersmith.com

The Roger Smith Hotel is a cozy,
art-filled alternative to Midtown's
mammoth hotels. Near Grand
Central Terminal, its ground floor
is bound to draw the attention
of passersby. On the corner of
Lexington Avenue and East 47th
Street, The Lab gallery is a con-
verted storefront where viewers
gaze in at the performances and
installations from the street — cre-
ating a fishbowl effect and bring-
ing experimental art onto the
streets of Midtown Manhattan.

MIDTOWN

⑱ CHAMBERS HOTEL

15 West 56th Street
212-974-5656
chambershotel.com

The Chambers Hotel, in the heart of Midtown, has 500 works of art displayed in the guestrooms and common areas. Each floor also boasts site-specific installations by such renowned artists as Patrick Brill — better known by his pseudonym Bob and Roberta Smith — readymade artist Sheila Pepe and painter John Newsome.

⑲ MARRIOTT EAST SIDE

525 Lexington Avenue
212-755-4000

In the 1920s painter Georgia O'Keeffe and her husband, photographer Alfred Steiglitz, moved into number 3003, the penthouse of the hotel, then called the Shelton Towers Hotel. The building and the view from O'Keeffe's home studio inspired several paintings, including a series from 1927-28 titled *East River from the Shelton*.

�40 ◂ BRYANT PARK HOTEL

40 East 40th Street
212-869-0100
bryantparkhotel.com

A hip hotel located in the
American Radiator Building,
a black-and-gold skyscraper
immortalized in Georgia
O'Keeffe's 1927 painting *Radiator
Building — Night, New York.*

�41 THE BUCKINGHAM HOTEL

101 West 57th Street
212-246-1500
buckinghamhotel.com

Just a short walk from the
Museum of Modern Art, The
Buckingham has been home
to some of art's biggest names,
including Marc Chagall and
Georgia O'Keeffe.

STORES

�42 MOMA DESIGN STORE

11 West 53rd Street
44 West 53rd Street
212-767-1050
momastore.org

With two locations, one in the
museum and one across the
street, the MoMA Design Store
offers high-end furniture, gifts,
jewelry and art books that run the
gamut from classically modern to
cutting-edge.

⓸ METROPOLITAN MUSEUM OF ART STORES

15 West 49th Street
212-332-1360
store.metmuseum.org

The Midtown outpost of the
Metropolitan Museum of Art gift
shop offers the same artsy books,
jewelry and gifts as the famed
Fifth Avenue location.

⓸ TIFFANY & CO.

727 Fifth Avenue
212-755-8000
tiffany.com

While struggling to make a living,
Robert Rauschenberg and Jasper
Johns designed windows for
Tiffany's Fifth Avenue flagship.

⓸ LEE'S ART SHOP

220 West 57th Street
212-247-0110

Located just across the street
from the Art Students League, the
massive Lee's Art Shop has been
serving artists for over 50 years.

THE POSH UPPER EAST SIDE IS HOME TO THE GLIMMERING CULTURAL CORRIDOR OF MUSEUM MILE, WHICH FEATURES SOME OF THE WORLD'S MOST FAMOUS – AND MOST FREQUENTED – MUSEUMS. THE AREA IS ALSO HOME TO A NUMBER OF UPSCALE ART DEALERS SPECIALIZING IN THE RESALE OF CONTEMPORARY AND MODERN MASTERS.

UPPER EAST SIDE

UES

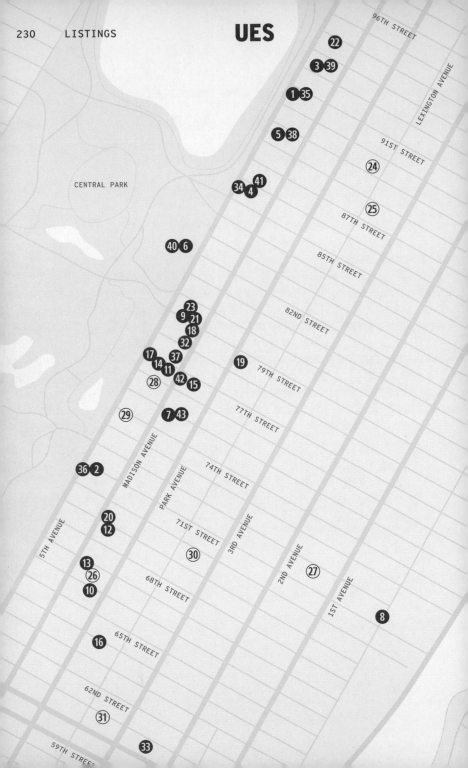

UES

MUSEUMS

1. Cooper-Hewitt, National Design Museum
2. Frick Collection
3. Jewish Museum
4. Neue Galerie
5. Solomon R. Guggenheim Museum
6. Metropolitan Museum of Art
7. Whitney Museum of American Art

AUCTION HOUSE

8. Sotheby's

GALLERIES

9. Acquavella Galleries
10. Adam Baumgold Gallery
11. Gagosian Gallery
12. Hauser & Wirth
13. James Graham & Sons
14. Castelli Gallery
15. Luxembourg & Dayan
16. Marianne Boesky
17. Michael Werner
18. Mitchell-Innes & Nash
19. Park Avenue Armory
20. Richard L. Feigen & Co.
21. Richard Gray
22. Salon 94
23. Skarstedt Gallery

HISTORICAL

24. Andy Warhol Townhouse
25. Andy Warhol Studio
26. Andy Warhol's Last Apartment
27. Diane Arbus Home
28. Les Pleiades
29. Marc Chagall Apartment
30. Mark Rothko Studio
31. Peggy Guggenheim Home

RESTAURANTS

32. Sant Ambroeus
33. Serendipity 3
34. Café Sabarsky

SHOPS

35. Cooper-Hewitt Shop
36. Frick Collection Shop
37. Gagosian Shop
38. Guggenheim Store
39. Jewish Museum Store
40. Metropolitan Museum of Art Shop
41. Neue Galerie Store
42. Ursus Books
43. Whitney Museum of American Art Store

UPPER EAST SIDE

UES

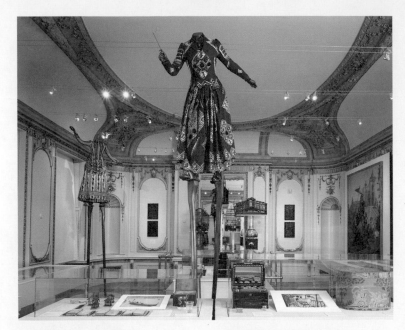

❶ COOPER-HEWITT, ▲ NATIONAL DESIGN MUSEUM

2 East 91st Street
212-849-8400
cooperhewitt.org
Mon-Fri 10 a.m.-5 p.m.
Saturday 10 a.m.-6 p.m.
Sunday 11 a.m.-6 p.m.
$15

Since 1897, Copper-Hewitt has been the nation's only museum dedicated to the history of design—from ancient Greek pottery to the latest fashions from Rodarte. Along with its historic collection, the museum's exhibitions focus on the cutting-edge, including socially conscious projects and the National Design Triennial. The museum is part of the Smithsonian Institute, and is located in the landmark Andrew Carnegie mansion, a setting as impressive as its collection.

❷ FRICK COLLECTION

1 East 70th Street
212-288-0700
frick.org
Tues-Sat 10 a.m.-6 p.m.
Sunday 11 a.m.-5 p.m.
$18

In the 19th century, Henry Clay Frick amassed an impressive collection of European masterpieces—including works by Goya, Turner, Degas and Velázquez—and decorative objects from around the world. Since 1935, the collection has been on display to the public in Frick's former Carrère and Hastings-designed manse.

ABOVE Installation view, Yinka Shonibare Selects: Works from the Permanent Collection, Cooper-Hewitt, National Design Museum

❸ JEWISH MUSEUM ▾

1109 Fifth Avenue
212-423-3200
thejewishmuseum.org
Sun-Tues 11 a.m.-5:45 p.m.
Thursday 11 a.m.-8 p.m.
Friday 11 a.m.-5:45 p.m.
Saturday 11 a.m.-5:45 p.m.
$12

The Jewish Museum is dedicated to the enjoyment, understanding and preservation of the artistic and cultural heritage of the Jewish people, but its reach is much further than one group. The Museum was the site of curator Kynaston McShine's landmark "Primary Structures", the 1966 show that defined Minimalism. In addition, the museum has hosted exhibitions of painter Alex Katz's portraits of his wife Ada, and Impressionist Camille Pissarro's landscapes, all in an elegant former residence on Museum Mile.

❹ NEUE GALERIE

1048 Fifth Avenue
212-628-6200
neuegalerie.org
Thurs-Mon 11 a.m.-6 p.m.
$15

Devoted to early 20th-century German and Austrian art and design, the Neue Galerie — German for "new gallery" — is a low-key gem next to its celebrated Museum Mile neighbors. Carrère and Hastings — the same architecture firm responsible for the New York Public Library and the building that houses the Frick Collection — designed the historic structure in 1914. New York City royalty, the likes of Mrs. Cornelius Vanderbilt III, have called the building home. Today, much of the Beaux-Arts-style building has been preserved and serves as the perfect backdrop for the work, much of which was created during the time of its construction. The second floor is devoted to Austrian decorative and fine arts, while the third floor showcases German works. Two of the museum's most notable pieces are Gustav Klimt's incandescent *Adele Bloch-Bauer I* from 1907 and Egon Schiele's 1917 work *Town Among Greenery (The Old City III)*. Recent exhibitions include the first solo museum exhibit of Otto Dix's work.

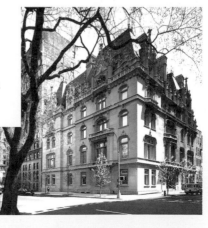

➎ SOLOMON R. GUGGENHEIM MUSEUM

1071 Fifth Avenue
212-423-3500
guggenheim.org
Sun-Wed, Fri 10 a.m.-5:45 p.m.
Saturday 10 a.m.-7:45 p.m.
$18

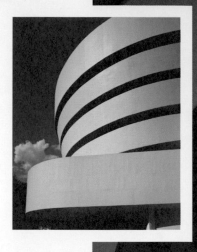

The Guggenheim is one of the most recognizable buildings in New York City. Originally conceived in 1943 as a larger space for collector Solomon Guggenheim's Museum of Non-Objective Painting, the museum was sixteen years in the making. A number of factors, chiefly numerous design plans and the rising cost of building materials following World War II, delayed architect Frank Lloyd Wright's vision. In October 1959—ten years after Guggenheim's death and six months after Wright's—the museum finally opened to visitors. The museum's interior mirrors its concrete, spiral façade. According to Wright's plan, visitors are meant to start on the top floor, leisurely walking down the ramp. Now, more than just a museum for non-objective painting, the museum includes photographs, sculpture and new media in its impressive collection. Meanwhile, its famous ramp hosts such notable single-artist exhibitions as Richard Prince's "Spiritual America" and Cai Guo-Qiang's "I Want to Believe."

HIGHLIGHTS

Marc Chagall
Paris Through the Window, 1913

Josef Albers
Homage to the Square: Apparition, 1959

Andy Warhol
Orange Disaster #5, 1963

Roy Lichtenstein
Grrrrrrrrrrr!!, 1965

Carl Andre
10 x 10 Altstadt Copper Square, 1967

Frank Stella
Harran II, 1967

Donald Judd
Untitled, December 23, 1969

Louise Bourgeois
Le Défi, 1991

Bill Viola
The Crossing, 1996

Matthew Barney
CREMASTER 3, 2002

RIGHT Installation view, Jenny Holzer, Untitled (Selections from Truisms, Inflammatory Essays, The Living Series, The Survival Series, Under a Rock, Laments and Child Text), 1989.

UES

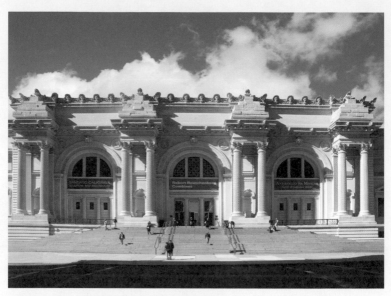

❻ METROPOLITAN MUSEUM OF ART

1000 Fifth Avenue
212-535-7710
metmuseum.org
Tues-Thur 9:30 a.m.-5:30 p.m.
Fri-Sat 9:30 a.m.-9 p.m.
Sunday 9:30 a.m.-5:30 p.m.
$20

The Metropolitan Museum of Art is the gold standard for encyclopedic museums, with a collection of more than 2 million works from around the world, representing every major period in the history of art. Its Beaux-Arts façade is a symbol of the city, welcoming nearly 5 million visitors every year. Highlights include the 15th century B.C. Egyptian Temple of Dendur and an impressive collection of European paintings ranging from Vermeer to Van Gogh to the $45-million Duccio masterpiece, *Madonna and Child*. While steeped in history, the museum is hardly static—in recent years the Met has made an aggressive effort to showcase contemporary art, including an installation by Kara Walker, a rooftop show of sculpture by Jeff Koons and a retrospective of the work of John Baldessari.

OPPOSITE (top) The Contemporary Art gallereis, featuring Andy Warhol, Skull (1977) and Chuck Close, Self-Portrait (1977). (bottom) View of the Leon Levy and Shelby White Court at The Metropolitan Museum of Art.

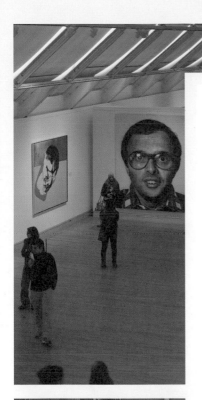

HIGHLIGHTS

Charles Demuth
The Figure 5 in Gold, 1928

Georgia O'Keeffe
Cow's Skull: Red, White, and Blue, 1931

Arshile Gorky
Water of the Flowery Mill, 1944

Jackson Pollock
Autumn Rhythm (Number 30), 1950

Jasper Johns
White Flag, 1955

Robert Rauschenberg
Winter Pool, 1959

Robert Motherwell
Elegy to the Spanish Republic, 70, 1961

Ellsworth Kelly
Blue Green Red, 1962-63

Philip Guston
The Street, 1977

Chuck Close
Lucas, 1986-87

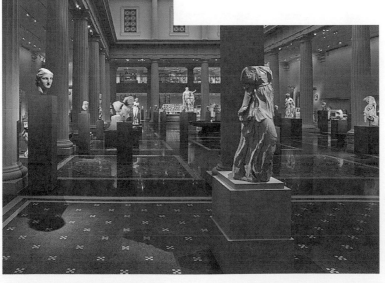

❼ WHITNEY MUSEUM OF AMERICAN ART

945 Madison Avenue
212-570-3600
whitney.org
Wed-Thur, Sat-Sun 11 a.m.-6 p.m.
Friday 1 p.m.-9 p.m.
$18

The Whitney Museum of American Art was originally opened by so-cialite, sculptor and patron Gertrude Vanderbilt Whitney in Greenwich Village in 1931. Since then it has become a premiere destination for cut-ting-edge contemporary art. The museum was the first to give retrospec-tives to Cindy Sherman and Jasper Johns, and was the first American museum to showcase Video Art. Located in a distinctive modernist concrete building designed by Marcel Breuer, the museum's collection includes works by Georgia O'Keeffe, Mark Rothko and Edward Hopper. But the Whitney's real strength is its rotating slate of special exhibitions, including the star-making Whitney Biennial, which helped launch the career of Jean-Michel Basquiat, and has recently featured Dash Snow, Dan Colen, Kori Newkirk, Tauba Auerbach and David Adamo. A down-town annex is scheduled to open in 2015.

HIGHLIGHTS

Edward Hopper
Early Sunday Morning, 1930

Lee Krasner
White Squares, c. 1948

Robert Rauschenberg
Satellite, 1955

Jasper Johns
Three Flags, 1958

Donald Judd
Untitled, 1968

Philip Guston
Cabal, 1977

Nan Goldin
The Ballad of Sexual Dependency, 1979–96

Jean-Michel Basquiat
Hollywood Africans, 1983

Matthew Barney
Drawing Restraint, 1993

Barbara Kruger ▶
Untitled (Thinking of You), 1999–2000

UES

AUCTION HOUSE

❽ SOTHEBY'S ▲

1334 York Avenue
212-606-7000
sothebys.com

This upscale auction house has
offices in 40 countries, but its New
York flagship has hosted some of
art's most exciting sales, including
the record-setting sale of Francis
Bacon's *Triptych*, which reached
$86.3 million . Auction items
are on public view in the weeks
leading up to sales, including the
major modern and contemporary
auctions, which happen in the
spring and fall.

GALLERIES

❾ ACQUAVELLA GALLERIES

18 East 79th Street
212-734-6300
acquavellagalleries.com
Mon-Sat 10 a.m.-5 p.m.

Located in a five-story French
neo-classical townhouse, the
Acquavella Galleries specialized
in the sale of major 19th- and
20th-century artwork, including
museum-quality works from Paul
Cézanne and Claude Monet to
Francis Bacon and Andy Warhol.

❿ ADAM BAUMGOLD

60 East 66th Street
212-861-7338
40 East 75th Street
212-861-7340
adambaumgoldgallery.com
Tues-Sat 11 a.m.-5:30 p.m.

Established in 1986, Adam
Baumgold showcases a mix of
modern masters — including
George Grosz, Alex Katz and *New
Yorker* artist Saul Steinberg — and
more idiosyncratic names such as
cartoonist Chris Ware in his two
Upper East Side spaces.

OPPOSITE Installation view Roy
Lichtenstein, <u>Mostly Men</u>, Castelli
Gallery, Sept 15-Oct 30, 2010.

⓫ GAGOSIAN GALLERY

980 Madison Avenue
212-744-2313
gagosian.com
Tues-Sat 10 a.m.-6 pm.

Art dealer Larry Gagosian has been called the most power-ful person in the art world, and his Upper East Side flagship is home to art's most revered — and expensive — names: Pablo Picasso, Jasper Johns, Roy Lichtenstein and Damien Hirst. Along with its acclaimed historical shows, Gagosian's Madison Avenue location has also hosted up-and-coming artists including Dash Snow and Dan Colen. Located in the Carlyle Galleries Building, the space is intimidating, but it is en-tirely open to the public — just take the elevator to the fifth floor.

⓬ HAUSER & WIRTH

32 East 69th Street
212-794-4970
hauserwirth.com
Tues-Sat 10 a.m.-6 p.m.

Europe's most respected dealer-ship opened its New York outpost in 2009 with a recreation of Allan Kaprow's *Yard*, a happen-ing consisting of a room filled with hundreds of tires (originally installed in the same space when it was Martha Jackson Gallery in 1961). Along with the Kaprow Estate, the gallery represents major players including Eva Hesse and Roni Horn.

⓭ JAMES GRAHAM & SONS

32 East 67th Street
212-535-5767
jamesgrahamandsons.com
Mon-Fri 9:30 a.m.-5:30 p.m.

James Graham & Sons is among America's oldest family-run gal-leries, exhibiting American and European painting, sculpture and ceramic, with a special interest in late-19th and 20th-century art.

⓮ CASTELLI GALLERY ▲

18 East 77th Street
212-249-4470
castelligallery.com
Tues-Sat 10 a.m.-6 p.m.

Leo Castelli was a leading figure in the art world from the early days of Abstract Expressionism through the 1980s heyday of Neo Expressionism, discovering such important artists as Andy Warhol, Robert Rauschenberg and Jasper Johns. The gallery continues to exhibit major names such as Roy Lichtenstein and Philip Guston.

UES

⑮ LUXEMBOURG & DAYAN

64 East 77th Street
212-452-4646
luxembourgdayan.com
Mon-Fri 11 a.m.-4 p.m.

Located in an Upper East Side townhouse, this private gallery features two curated exhibitions a year, including a restaging of Jeff Koons' infamous *Made in Heaven*, which featured intimate portraits of the artist and his porn-star wife.

⑯ MARIANNE BOESKY

118 East 64th Street
212-680-9889
marianneboeskygallery.com
Tues-Sat 10 a.m.-5:30 p.m.

Marianne Boesky opened her Upper East Side outpost in 2010 in an old-world town house, intending the space for historical exhibitions to support the up-and-coming and mid-career artists of the gallery's program.

⑰ MICHAEL WERNER

4 East 77th Street
212-988-1623
michaelwerner.com
Mon-Sat 10 a.m.-6 p.m.

Michael Werner represents important artists such as German Neo-Expressionist painters A.R. Penck, Georg Baselitz and Sigmar Polke.

⑱ MITCHELL-INNES & NASH

1018 Madison Avenue
212-744-7400
miandn.com
Mon-Fri 9 a.m.-5 p.m.

Before starting their gallery in 1996, Lucy Mitchell-Innes was the Director of Contemporary Art at Sotheby's, while her husband, David Nash, was the international head of Impressionism and Modern Art at the auction house.

BELOW The Drill Hall at the Park Avenue Armory

⑲ PARK AVENUE ARMORY

643 Park Avenue
212-616-3930
armoryonpark.org

The Park Avenue Armory has a
storied history as a military facility
and social club, but the block-sized
building has also become a hot
location for art installations since
Aaron Young's 2007 *Greeting
Card*, a massive "action painting"
which used motorcycles instead of
paint brushes.

⑳ RICHARD L. FEIGEN

34 East 69th Street
212-628-0700
rlfeigen.com
Mon-Fri 10 a.m.-6 p.m.

Founded in Chicago in 1957,
Richard L. Feigen & Co. handles
work by such important artists
as German Expressionist Max
Beckmann and Surrealist master
Henri Rousseau.

㉑ RICHARD GRAY

1018 Madison Avenue , 4th floor
212-472-8787
richardgraygallery.com
Tues-Sat 10 a.m.-5:30 p.m.

Founded in 1963, Richard Gray
Gallery represents Pop pioneers
Jim Dine and Alex Katz, while
also exhibiting such major
names as Josef Albers and Cy
Twombly.

㉒ SALON 94

12 East 94th Street
646-672-9212
salon94.com
By Appointment

Since 2002, gallerist Jeanne
Greenberg Rohatyn has present-
ed art and design in an experi-
mental venue modeled after the
grand European salons—the
living room of her posh Museum
Mile townhouse. While most
shows occupy the first-floor
gallery, with floor-to-ceiling
windows overlooking a garden,
the art extends to the living
spaces upstairs, blurring the
line between private and public
exhibition. The art itself tends
towards fashionable favorites
such as the high-gloss enamel
paintings of Marilyn Minter,
Andy Warhol's Polaroids or
furniture by haute-goth fashion
designer Rick Owens.

㉓ SKARSTEDT GALLERY

20 East 79th Street
212-737-2060
skarstedt.com
Tues-Fri 10 a.m.-6 p.m.
Saturday 10 a.m.-5 p.m.

Established in 1994, Skarstedt
Gallery focuses on historical
exhibitions of A-list 20th-century
American and European artists
including Andy Warhol, Cindy
Sherman, Jeff Koons, George
Condo and Mike Kelley.

HISTORIC

㉔ WARHOL TOWNHOUSE

1342 Lexington Avenue

In 1960, Andy Warhol acquired an Upper East Side townhouse to showcase his growing collection of art and furniture, purchased with the proceeds of his thriving career as a fashion illustrator.

㉕ WARHOL STUDIO ▲

159 East 87th Street

In 1963, Andy Warhol rented his first official studio, an old firehouse near his home.

㉖ ANDY WARHOL'S LAST APARTMENT

57 East 66th Street

In 1974, Warhol purchased a ritzy Upper East Side townhouse, where he lived until his death in 1987. Unlike The Factory, the artist's home was a private sanctuary.

㉗ DIANE ARBUS HOME

319 East 72nd Street

Before moving to the Village, photographer Diane Arbus lived on the Upper East Side from 1954 to 1958. The building no longer exists.

㉘ LES PLEIADES

20 East 76th Street

From 1971 to 1992, Les Pleiades was the place art world power brokers like Leo Castelli, Ileana Sonnabend and Irving Blum power lunched. Today it lives on as Bar Pleiades, Chef Daniel Boulud's bar in the Surrey Hotel.

㉙ CHAGALL APARTMENT

4 East 74th Street

Marc Chagall moved to New York in 1941 to escape WWII, living on the Upper East Side until the death of his beloved wife in 1944.

㉚ MARK ROTHKO STUDIO ▲

157 East 69th Street

Before his death in 1970, Mark Rothko spent his last years in his Upper East Side studio, using a pulley system to work on the giant canvases of his later work.

③ GUGGENHEIM HOME

155 East 61st Street

After her 1943 divorce from Max Ernst, Peggy Guggenheim moved to a 61st Street duplex featuring a mural painted by Guggenheim's newest discovery, the artist Jackson Pollock.

③ CAFÉ SABARSKY

1048 Fifth Avenue
212-628-6200
cafesabarsky.com

The Viennese-style café at the Neue Galerie is the perfect destination to take a coffee break on Museum Mile, or stop by for a little après-museum cabaret.

RESTAURANTS

② SANT AMBROEUS

1000 Madison Avenue
212-570-2211
santambroeus.com

A long-time haunt of wealthy European art types, this Milanese import still offers high prices, uptown appeal and its famous gelato. The restaurant was the site of an edible performance by artist Marina Abramović after the closing of her 2010 MoMA retrospective.

③ SERENDIPITY 3

225 East 60th Street
212-838-3531
serendipity3.com

Serendipity 3 was a favorite of both Marilyn Monroe and a pre-fame Andy Warhol, who paid his bills with drawings. The whimsical restaurant is known for its sweet treats, including the world-record $1,000 golden sundae and the signature Frrrozen Hot Chocolate.

SHOPS

③ COOPER-HEWITT SHOP ▲

2 East 91st Street
212-849-8355
cooperhewittshop.com

The Cooper-Hewitt Shop is as dedicated to good design as the museum that shares its name, offering a wide selection of fabulous and functional house wares and gifts.

③ FRICK COLLECTION SHOP

1 East 70th Street
212-547-6848
shopfrick.org

The shop at the Frick offers art supplies, prints, gifts and books inspired by the museum's collection of European masterpieces.

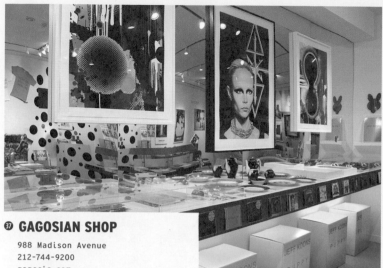

㊲ **GAGOSIAN SHOP**

988 Madison Avenue
212-744-9200
gagosia.com

The Gagosian shop is an art-lover's
paradise, featuring gifts and edi-
tions accessible for even entry-level
collectors: Jeff Koons' Puppy Vase,
a sewing kit designed by Cynthia
Rowley and furniture by Marc
Newson. Head downstairs for the
Other Criteria shop-within-a-shop,
featuring British artist Damien
Hirst's range of prints, wallpaper
and furniture. For those on a budget,
the reading room offers beautiful
monographs, signed books and
international magazines.

❸❽ GUGGENHEIM STORE

1071 Fifth Avenue
212-423-3615
guggenheim.org

Along with books and gifts, the
Guggenheim Store offers limited-
edition artwork from the likes of
James Rosenquist.

❸❾ JEWISH MUSEUM STORE

1109 Fifth Avenue
212-423-3200
thejewishmuseum.org

The Jewish Museum store offers
books, gifts and artsy takes on
Judaica ranging from Jonathan
Adler-designed menorahs to
high-design Seder plates.

❹⓪ METROPOLITAN MUSEUM OF ART SHOP

1000 Fifth Avenue
212-570-3894
metshop.org

Along with the usual books
and posters, the Met store
offers a surprising selection
of jewelry inspired by the
museum's collection.

❹❶ NEUE GALERIE STORE

1048 Fifth Avenue
212-628-6200
neuegalerie.org

The award-winning Design shop
at the Neue Galerie offers a range
of items—from jewelry to lipstick
to lighting—inspired by the col-
lection, as well as the Neue Haus
line of modern house wares.

❹❷ URSUS BOOKS ▲

981 Madison Avenue
212-772-8787
ursusbooks.com

For four decades Ursus Books
has specialized in fine art
books—from exhibition cata-
logs to reference titles and rare
books—as well as English and
European decorative works
on paper from the 16th to 19th
century.

❹❸ WHITNEY MUSEUM OF AMERICAN ART STORE

945 Madison Avenue
212-570-3614
whitney.org/MuseumStore

Located on the museum's lower
level, the Whitney Shop features
a range of books, gifts and
souvenirs.

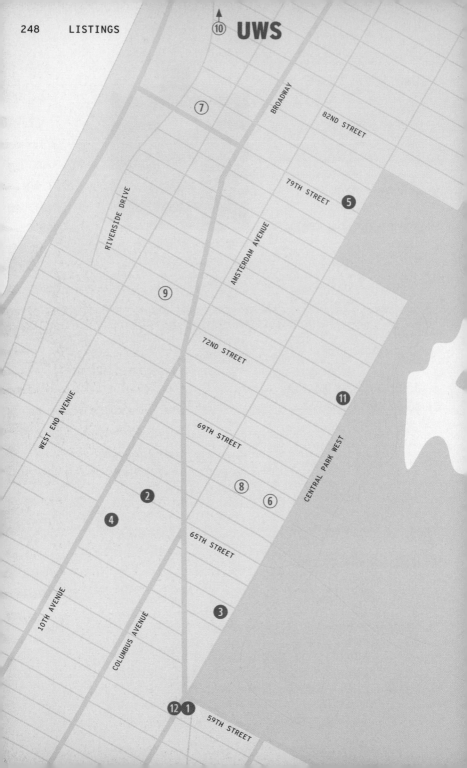

ARTISTS HAVE LONG BEEN PRICED OUT OF THE LIGHT-FILLED STUDIOS THAT ONCE LINED CENTRAL PARK, BUT THIS SCENIC RESIDENTIAL NEIGHBORHOOD IS A GREAT PLACE TO SEE WHERE MARCEL DUCHAMP TIPPED OVER A URINAL AND CREATED ONE OF HISTORY'S MOST FAMOUS ARTWORKS, THE READYMADE, *FOUNTAIN*.

UPPER WEST SIDE

MUSEUM
① Museum of Art and Design

PUBLIC ART
② Marc Chagall, The Triumph of Music and The Sources of Music

GALLERIES
③ 25CPW
④ Arnold and Marie Schwartz Gallery

HISTORICAL
⑤ Bag One Arts
⑥ Hotel des Artistes
⑦ Marc Chagall Apartment
⑧ Marcel Duchamp Studio
⑨ Marcel Duchamp Studio
⑩ Roy Lichtenstein Childhood Apartment
⑪ The Dakota

STORE
⑫ The Store at MAD

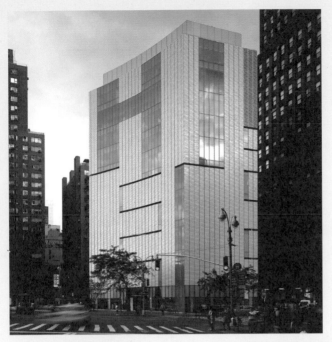

MUSEUM

PUBLIC ART

❶ MUSEUM OF ART AND DESIGN ▲

2 Columbus Circle
212-299-7777
madmuseum.org
Tues-Sun 11 a.m.-6 p.m.
Thursday 11 a.m.-9 p.m.
$15

Formerly the American Craft Museum, The Museum of Art and Design is a leader in collection and exhibition of contemporary objects created in media such as clay, glass, wood, metal and fiber. Exhibitions include both functional objects and art pieces created in fields such as craft, architecture, fashion, interior design, technology and the performing arts.

❷ MARC CHAGALL *THE TRIUMPH OF MUSIC* AND *THE SOURCES OF MUSIC*

Metropolitan Opera House
Lincoln Center
212-362-6000
metoperafamily.org

Commissioned by Lincoln Center in 1966, Marc Chagall's massive murals at the Metropolitan Opera House depicting the inspiration of music were recently valued at $20 million.

OPPOSTIE The Metropolitan Opera House ABOVE The Museum for Arts and Design's Chazen Building, designed by Allied Works Architecture.

GALLERIES

❸ 25CPW

25 Central Park West
25cpw.org
Tuesday 2 p.m.-5:30 p.m.
Thurs, Sat-Sun 2 p.m.-6 p.m.

Located in a vacant retail space, artist-run gallery 25CPW gives artists, curators, writers and educators a space to experiment and engage with the public, while also offering studio space rental.

❹ ARNOLD AND MARIE SCHWARTZ GALLERY MET ▾

Metropolitan Opera House
Lincoln Center
212-362-6000
metoperafamily.org
Mon-Fri 6 p.m.-last intermission
Saturday noon-last intermission

The Metropolitan Opera regularly invites leading artists to create new work inspired by its current seasons, and displayz them in the south lobby of the Opera House. Recent works have included Francesco Clemente's portraits of opera divas celebrating the Met's 25th season, Anselm Kiefer's paintings inspired by Wagner's *Ring Cycle* and a surreal version of *Hansel and Gretel*, which featured work by John Currin and William Wegman.

HISTORICAL

❺ BAG ONE ARTS

110 West 79th Street

In 1989, Yoko Ono opened Bag One Arts in a converted brownstone as a private gallery dedicated to the visual artwork of her late husband, John Lennon.

⑥ HOTEL DES ARTISTES

1 West 67th Street

This co-op studio building was once home to Norman Rockwell and Noël Coward, as well as the Café des Artistes — the romantic, Old World restaurant known for its Howard Chandler Christy

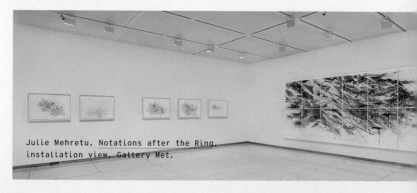

Julie Mehretu, <u>Notations after the Ring</u>, installation view, Gallery Met.

murals. The restaurant was opened in 1917 and closed in 2009.

⑦ CHAGALL APARTMENT

75 Riverside Drive

Following the sudden death of his wife in 1944, Russian-born artist Marc Chagall moved to the Upper West Side with his daughter. Depressed, the artist quit painting for months, and when he resumed much of his work dealt with the loss of his wife.

⑧ MARCEL DUCHAMP STUDIO

33 West 67th Street

When he first arrived in New York in 1915, Marcel Duchamp lived in a small studio apartment attached to the duplex of art patrons Walter and Louise Arensberg, founders of the Dada Salon. It's here that he first displayed his famous *Fountain* Readymade, a urinal upended and signed R. Mutt.

⑨ MARCEL DUCHAMP STUDIO

246 West 73rd Street

In 1920, Duchamp worked for several months on his *Rotary Glass Plates* in the basement studio on West 73rd Street.

⑩ ROY LICHTENSTEIN CHILDHOOD APARTMENT

West End Avenue and 106th Street

When Roy Lichtenstein was a child, his family moved to a home near

Straus Park, where they lived until worries about the Depression inspired them to move to a smaller apartment at 505 West End Avenue. The family would remain on the Upper West Side, throughout the artist's childhood.

⑪ THE DAKOTA

The Dakota
1 West 72nd Street

One of New York's most majestic apartment buildings, the Dakota has been home to Yoko Ono since she moved in with John Lennon in 1973. She continued to stay at the apartment following Lennon's murder in 1980, and has told press that she still feels his spirit in the home.

SHOP

⑫ THE STORE AT MAD

2 Columbus Circle
212-299-7700
madmuseum.org

The store at MAD features well-designed items from kitchenware to accessories.

HARLEM

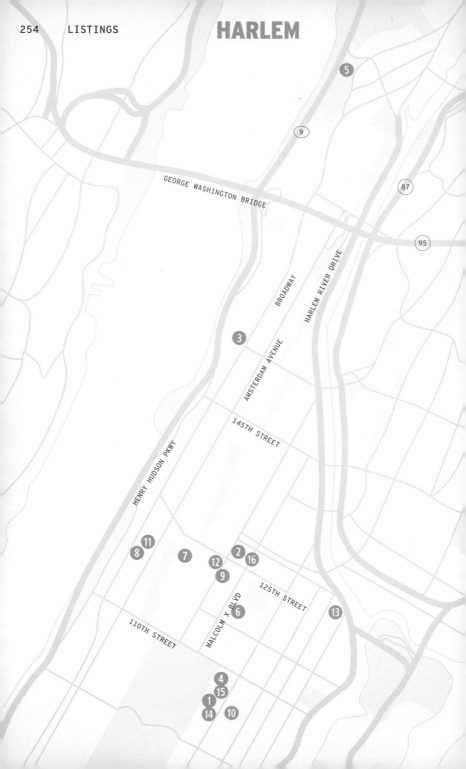

NORTH OF 106TH STREET, MANHATTAN IS HOME TO A VIBRANT MIX OF NEIGHBORHOODS INCLUDING HISTORIC HARLEM, THE BARRIO OF SPANISH HARLEM AND COLUMBIA UNIVERSITY.

MUSEUMS

❶ El Museo del Barrio

❷ Studio Museum in Harlem

❸ Hispanic Society of America

❹ Museum for African Art

❺ The Cloisters

GALLERIES

❻ Casa Frela

❼ Dwyer Cultural Center

❽ LeRoy Neiman Gallery

❾ Renaissance Fine Art

❿ Taller Boricua

⓫ Miriam and Ira D. Wallach Art Gallery

HISTORICAL

⓬ Romare Bearden Foundation

PUBLIC ART

⓭ Keith Haring, Crack is Wack, 1986

SHOPS

⓮ La Tienda

⓯ The Museum for African Art Shop

⓰ The Shop at The Studio Museum in Harlem

HARLEM & NORTH

MUSEUMS

❶ EL MUSEO DEL BARRIO

1230 Fifth Avenue
212-831-7272
elmuseo.org
Tues-Sun 11 a.m.-6 p.m.
$9

Since it was founded in 1969 by Raphael Montañez Ortiz and a group of artists, community activists and educators, El Museo has been dedicated to Puerto Rican artists the community of Spanish Harlem. Throughout the years El Museo's mission has expanded to include the art and culture of all of Latin America and the Caribbean, and today its collection includes more than 6,500 objects covering 800 years.

❷ STUDIO MUSEUM IN HARLEM

144 West 125th Street
212-864-4500
studiomuseum.org
Thurs-Fri noon-9 p.m.
Saturday 10 a.m.-6 p.m.
Sunday noon-6 p.m.
$7

Situated in the heart of Harlem since 1968, the Studio Museum in Harlem is a contemporary art museum that showcases artists of African descent and work that has been influenced by black culture. Its prestigious Artist-in-Residence program has supported some of the city's most exciting young artists including Kehinde Wiley, Julie Mehretu and Wangechi Mutu.

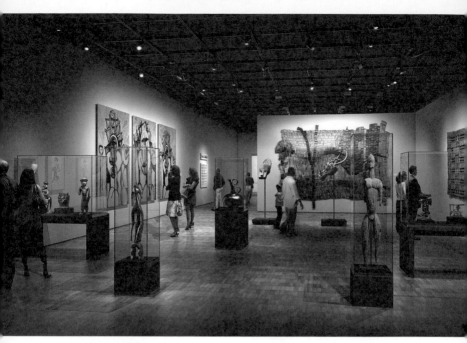

❹ HISPANIC SOCIETY OF AMERICA

Audubon Terrace, Broadway
between 155 and 156 Streets
212-926-2234
hispanicsociety.org
Tues-Sat 10 a.m.-4:30 p.m.
Sunday 10 a.m.-4 p.m.
FREE

Founded in 1904, the Hispanic Society of America is a museum and research center dedicated to the study of the art and culture of Spain, Portugal and Latin America. Highlights of the collection include Goya's famous pair of paintings of the *Duke* and *Dutchess of Alba* and an installation by contemporary artist Dominique Gonzalez-Foerster, sponsored by the Dia Art Foundation.

❺ MUSEUM FOR AFRICAN ART ▲

1280 Fifth Avenue
718-784-7700
africanart.org

As of 2011, The Museum for African Art calls Harlem its home in a new space on Museum Mile designed by Robert A.M. Stern Architects. Since it was founded in 1984, the museum has been dedicated to promoting understanding and appreciation of the art and culture of Africa, featuring exhibitions ranging from ancient crafts to contemporary art.

❻ THE CLOISTERS

```
99 Margaret Corbin Drive
212-923-3700
metmuseum.org
March-Oct
Tues-Sun 9:30 a.m.-5:15 p.m.
Nov-Feb
Tues-Sun 9:30 a.m.-4:45 p.m.
$20, or free with admission to
the Metropolitan Museum of Art
```

Located at the northernmost tip of Manhattan in beautiful Fort Tryon Park, the Cloisters is home to the Metropolitan Museum of Art's collection of medieval art, housed in a building combining pieces of five medieval French cloisters, a work of art in its own right.

GALLERIES

❼ CASA FRELA

```
47 West 119th Street
casafrela.com
```

Located in a historic Harlem townhouse, Casa Frela highlights artists from Harlem—as well as the Latino, African American and LGBT communities—through exhibitions and programs in various media.

❽ DWYER CULTURAL CENTER

```
258 Street Nicholas Avenue
212-222-3060
dwyercc.org
```

The multimedia Dwyer Cultural Center is dedicated to the culture, traditions and history of Harlem. Programming includes live theater, music and dance, as well as educational and community workshops.

❾ LEROY NEIMAN GALLERY

```
Columbia University School of
the Arts
310 Dodge Hall, MC 1806
2960 Broadway
212-854-7641
arts.columbia.edu
```

Columbia University's LeRoy Neiman Gallery features work curated and created by students in the school's prestigious MFA program.

❿ RENAISSANCE FINE ART

```
2075 Adam Clayton Powell, Jr.
Boulevard
212-866-1660
therfagallery.com
Wed-Sat 11 a.m.-7 p.m.
```

In the spirit of the Harlem Renaissance of the 1920s, Renaissance Fine Art displays the works of contemporary painters, sculptors and photographers in a welcoming neighborhood space.

⑪ TALLER BORICUA

1680 Lexington Avenue
212-831-4333
tallerboricua.org
Tues-Sat noon-6 p.m.

Founded in 1970, Taller Boricua/
The Puerto Rican Workshop Inc. is
one of New York's earliest alterna-
tive art spaces, an artist-run gallery
and cultural center dedicated to the
community of El Barrio.

⑫ MIRIAM AND IRA D. WALLACH ART GALLERY

826 Schermerhorn Hall, MC5517
1190 Amsterdam Avenue
212-854-7288
columbia.edu/cu/wallach
Wed-Sat 1 p.m.-5 p.m.

Part of the Department of Art
History and Archaeology, the
Wallach Art Gallery offers students
the opportunity to interact directly
with artwork while creating and
researching public exhibitions

HISTORICAL

⑬ ROMARE BEARDEN FOUNDATION

2090 Adam Clayton Powell, Jr.
Boulevard
212-665-9550
beardenfoundation.org

Established in 1990, the Romare
Bearden Foundation celebrates the
legacy of one of New York's most
original artists. Born in 1911, Bearden
moved to New York to study at NYU,
and later The Art Students League,
where he studied under George
Grosz. In the 1960s, he developed his
unique style of collage, elevating the
medium to fine-art status.

PUBLIC ART

⑭ KEITH HARING CRACK IS WACK, 1986

Crack is Wack Playground
East 127th Street between Second
Avenue and Harlem River Drive

Keith Haring's work often con-
veyed a social message, and his
famous mural in Harlem River
Park is no exception. Speaking out
against the crack epidemic and
its effect on New York City in the
1980s, Haring created this mural
on October 3, 1986 on both sides of
a handball court wall. The mural
is a mix of Haring's signature
frenzied, cartoon-like drawings
with the anti-drug message "Crack

is Wack" in prominent letters with a thick black outline. Haring did not have a permit to create the mural, but after its completion the piece was put under the protection and jurisdiction of the New York City Department of Parks and Recreation.

SHOPS

⑮ LA TIENDA

1230 Fifth Avenue
212-660-7191
elmuseo.org

The store at El Museo offers books, music and gift objects created by artists from all over Latin America, the Caribbean and New York City.

⑯ THE MUSEUM FOR AFRICAN ART SHOP

1280 Fifth Avenue
718-784-7700
africanart.org

The shop at the Museum for African Art features imported jewelry and crafts, including sculpted Baule figures from Ghana, jewelry from Mali and pottery from the Ivory Coast, as well as a library of art books and exhibition catalogues.

⑰ THE SHOP AT THE STUDIO MUSEUM IN HARLEM

144 West 125th Street
212-864-4500
studiomuseum.org

The Studio Museum in Harlem's shop features books and house wares, as well as limited-edition artwork from the likes of Khalif Kelly and Saya Woolfalk.

QUEENS

MUSEUMS

1. MoMA PS1
2. Fischer Landau Center For Art
3. Noguchi Museum
4. SculptureCenter

GALLERIES

5. The Chocolate Factory
6. Dorsky Gallery Curatorial Programs
7. Flux Factory
8. Local Project

PUBLIC ART

9. 5Pointz: The Institute of Higher Burnin'

36TH AVENUE

38TH AVENUE

40TH AVENUE

QUEENSBORO BRIDGE

10TH STREET

21ST STREET

NEW YORK 25A

QUEENS BLVD

VERNON BLVD

THOMSON AVENUE

JACKSON AVENUE

LONG ISLAND CITY IS A DIVERSE ENCLAVE OF ARTISTS' STUDIOS, ARTS CENTERS AND NONPROFITS DEDICATED TO INNOVATIVE AND EXPERIMENTAL ART JUST A STONE'S THROW FROM MANHATTAN. AT THE HEART OF THE NEIGHBORHOOD'S ARTISTIC SCENE IS THE GRANDDADDY OF ALTERNATIVE SPACES—THE PS1 CONTEMPORARY ART CENTER, NOW A PARTNER OF THE MUSEUM OF MODERN ART.

QUEENS

❶ MOMA PS1

22-25 Jackson Avenue
Long Island City
718-784-2084
ps1.org
Thurs-Mon noon-6 p.m.
$10 suggested admission

In 1971, curator Alanna Heiss founded the Institute for Art and Urban Resources Inc., an organization that staged exhibitions in underutilized and abandoned spaces throughout the city, including an abandoned school in Long Island City, Queens. Since then, PS1 has been one of the largest and oldest centers dedicated to contemporary art in the world. In 2000, PS1 became an affiliate of the Museum of Modern Art.

Housed in the former First Ward Primary School, long corridors, squeaky wooden floors, classroom-size spaces and an institutional feel make up this alternative, non-profit exhibition space. With an affinity toward the experimental, , PS1 showcases the works of contemporary artists in all forms of media. PS1's history of group exhibitions, such as 1981's "New York/ New Wave" show, has been showcased the work of emerging young artists, such as Jean-Michel Basquiat and Keith Haring. Today, the space still produces pertinent exhibits in its unique setting, such as Hank Willis Thomas' *Unbranded* series and Sharon Hayes' *Revolutionary Love: I Am Your Worst Fear, I Am Your Best Fantasy,* as part of the "Greater New York" exhibit in 2010.

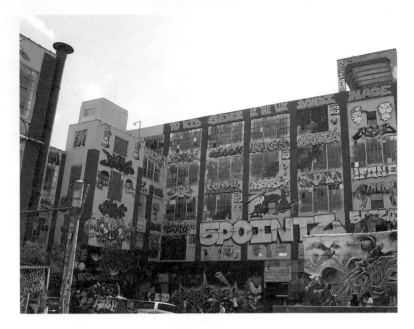

PUBLIC ART

❷ 5POINTZ: THE INSTITUTE OF HIGHER BURNIN'

45-46 Davis Street
Long Island City
317-219-2685
5ptz.com
Weekends noon-7 p.m.
Weekdays by appointment

A mecca for graffiti artists from around the globe, 5Pointz — an ornate five-story, 200,000-square-foot factory building near the elevated subway in Long Island City — is a permit-only place where graffiti artists can legally display their work. Film crews, DJs and the general public frequent the unique space on a daily basis to see the 350-plus murals featuring everything from colorful cartoon images and graffiti lettering, to realistic portraits of pop culture icons. Artists are always working on the constantly evolving façade, and permission needs to be granted before taking their pictures. Inside the building, artists rent studio space for under-market prices.

QUEENS

❸ FISCHER LANDAU CENTER FOR ART ▾

38-27 30th Street
Long Island City
718-937-0727
flcart.org
Thurs-Mon noon-5 p.m.
FREE

Established in 1991, The Fischer Landau Center is home to the collection of Emily Fisher Landau. At the core of the collection are 1,200 works of contemporary art from 1960 to today, including the work of major New York names spanning the 20th century: Andy Warhol, Jasper Johns, Donald Judd, Jenny Holzer, Agnes Martin, Cy Twombly, Robert Rauschenberg, Kiki Smith and Matthew Barney.

❹ NOGUCHI MUSEUM ▴

9-01 33rd Road
Long Island City
718-204-7088
noguchi.org
Wed-Fri 10 a.m.-5 p.m.
Sat-Sun 11 a.m.-6 p.m.
$10

Sculptor Isamu Noguchi founded his museum in 1985, three years before his death. Today the museum and sculpture garden serves as his legacy, featuring works in stone, metal, wood and clay, as well as models for public commissions.

❺ SCULPTURECENTER

44-19 Purves Street
Long Island City
718-361-1750
sculpture-center.org
Thurs-Mon 11 a.m.-6 p.m.
$5 suggested admission

SculptureCenter dates back to 1928 when sculptor Dorothea Denslow founded the Clay Club to promote and serve artists. Since then, the non-profit has grown, reflecting major changes in the art form throughout the century, including an early exhibition of sound sculpture in 1984 and the *In Practice* series of emerging artists.

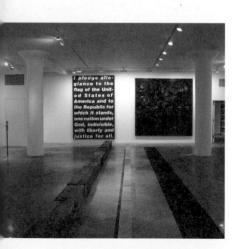

ABOVE Installation view from "Five Decades of Passion, Part Two: The Founding of the Center, 1989-1991," Fischer Landau Center.

GALLERIES

❻ THE CHOCOLATE FACTORY

5-49 49th Avenue
Long Island City
718-482-7069
chocolatefactorytheater.org

Multimedia arts space The Chocolate Factory is home to an Obie Award-winning theater, but its mission goes beyond performance. Its gallery and residency program fosters multi-disciplinary work combining dance, video, text and music.

❼ DORSKY GALLERY CURATORIAL PROGRAMS

11-03 45th Avenue
Long Island City
718-937-6317
dorsky.org
Thurs-Mon 11 a.m.-6 p.m.

The exhibitions at non-profit Dorsky Gallery Curatorial Programs emphasize the role of the curator. Through its application process, the gallery selects curatorial proposals that promote understanding and conversation about issues in contemporary art.

❽ FLUX FACTORY

39-31 29th Street
Long Island City
fluxfactory.org

Founded in Williamsburg in 1994, Flux Factory aims to foster artistic collaboration and innovation by giving artists a place to make and display their work, while connecting artists with opportunities at venues around the globe.

❾ LOCAL PROJECT ▲

45-10 Davis Street
Long Island City
localproject.org

Local Project is a non-profit that supports artists, providing a forum for artistic expression by granting space for work in all media. Local Project also offers workshops in everything from collage to creating an artistic statement.

THE WAREHOUSES AND GARAGES OF BROOKLYN HAVE BEEN A HAVEN FOR ARTISTS SINCE SOHO BECAME A HIGH-PRICED HOTSPOT IN THE 1970S AND '80S. WHILE WILLIAMSBURG BOASTS AN ESTABLISHED GALLERY SCENE, RISING RENTS IN THE AREA HAVE SENT ARTISTS LOOKING FOR SPACES IN NEIGHBORING BUSHWICK AND GREENPOINT. MEANWHILE, THE WATERFRONT DUMBO NEIGHBORHOOD IS HOME TO A CONCENTRATION OF GALLERIES, AND THE RAW SPACES OF SOUTH BROOKLYN'S GOWANUS AND RED HOOK NEIGHBORHOODS CONTINUE TO GIVE ARTISTS AMPLE SPACE TO WORK.

BROOKLYN

BROOKLYN

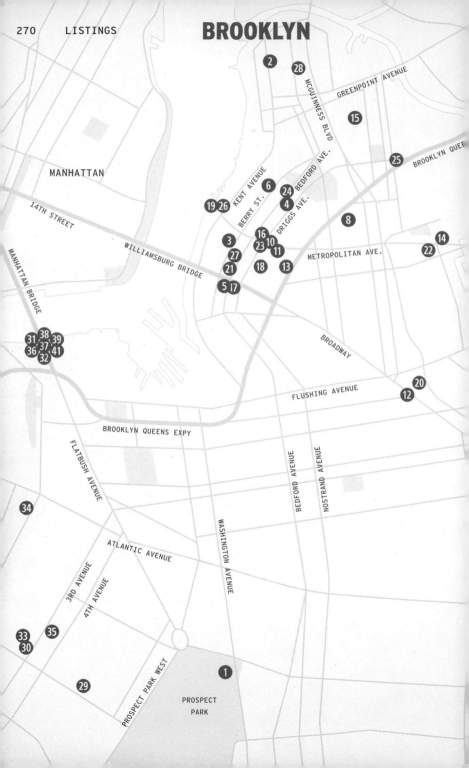

MUSEUMS

1 Brooklyn Museum

GALLERIES, NORTH BROOKLYN

2 Allan Nederpelt

3 Art 101

4 Black & White Gallery/
Project Space

5 Capricious Space

6 Causey Contemporary

7 English Kills

8 Eyelevel B.Q.E.

9 Factory Fresh

10 The Front Room

11 Gitana Rosa

12 Grace Exhibition Space

13 The Hogar Collection

14 International Studio
and Curatorial Program

15 Janet Kurnatowski Gallery

16 The Journal Gallery

17 K&K

18 Like The Spice

19 Live with Animals

20 Lumenhouse

21 Momenta Art

22 NUTUREart

23 Parker's Box

24 Pierogi

25 Real Fine Arts

26 Secret Project Robot

27 Sideshow Gallery

28 Yes Gallery

GALLERIES, SOUTH BROOKLYN

29 404 Gallery

30 Brooklyn Artists Gym

31 D.U.M.B.O. Arts Center

32 Front Street Galleries

33 Gowanus Studio Space

34 Invisible Dog Art Center

35 Issue Project Room

36 Kunsthalle Galapagos

37 Rabbit Hole Gallery

38 Smack Mellon

STORE

39 powerHouse Arena

BROOKLYN

❶ BROOKLYN MUSEUM

200 Eastern Parkway, Brooklyn
718-638-5000
brooklynmuseum.org
Wednesday 11 a.m.-6 p.m.
Thurs-Fri 11 a.m.-10 p.m.
Sat-Sun 11 a.m.-6 p.m.
$10

Opened in 1897, Brooklyn's encyclopedic museum is home to over a million objects spanning from its acclaimed collection of ancient Egypt artifacts to contemporary art. The museum houses a rich collection of eighteenth- and nineteenth-century American art, displayed in gilded frames on richly hued walls in the tradition of the European salon. But the museum's mission is far more than historic; it also features an impressive line-up of modern and contemporary art, including paintings by Georgia O'Keeffe and *The Dinner Party*, Judy Chicago's seminal feminist work of art.

The museum has also been known to cater to more populist tastes, a move that has drawn some criticism, with an exhibition on *Star Wars* and a solo show awarded to the winner of the Bravo television series *Work of Art: The Next Great Art Star.*

In 1999, the collector Charles Saatchi put together a show of London's hot young talent, including Damien Hirst, Tracey Emin and Chris Ofili. Called "Sensation," the show was just that, especially one work in particular: Ofili's *Blessed Virgin Mary*, a collaged painting featuring pornographic images and elephant dung. Mayor Rudolph Giuliani called the work "sick stuff" and attempted to withdraw the museum's funding, a move that was overturned in court after public outcry.

HIGHLIGHTS

Judy Chicago ▲
The Dinner Party, 1974-1979

Georgia O'Keeffe,
Brooklyn Bridge, 1949

Willem de Kooning
Woman, 1953-54

Louise Bourgeois
Decontractee, 1990

Andres Serrano
America (Snoop Dogg), 2002

Kiki Smith
Come Away from Her, 2003

Kehinde Wiley
Passing/Posing (Female Prophet Anne, Who
Observes the Presentation of Jesus on the
Temple), 2003

Ghada Amer
Heather's Degradé, 2006

Terence Koh
Untitled (Vitrines), 2006

Mickalene Thomas
A Little Taste Outside of Love, 2007

Nick Cave
Soundsuit, 2008

WILLIAMSBURG, GREENPOINT, BUSHWICK STARTING POINT: L TRAIN TO BEDFORD AVENUE

IN WILLIAMSBURG, WHAT WAS ONCE THE ART SCENE'S CUTTING EDGE HAS BECOME AN ESTABLISHED SCENE INVIGORATED BY A YOUNG AND ARTSY POPULATION. ON THE AREA'S FRINGE, EXPERIMENTAL SPACES CONTINUE TO THRIVE IN NEIGHBORHOODS LIKE BUSHWICK AND GREENPOINT.

❷ ALLAN NEDERPELT

60 Freeman Street, Brooklyn
allannederpelt.com
Sat-Sun 1 p.m.-6 p.m.

Greenpoint gallery Allan Nederpelt provides a forum for local and global contemporary artists. The gallery also offers a platform for curators to organize exhibitions, like Eva Schmidt's "Team Work," a show featuring 77 artists who work in the studio of artist Jeff Koons.

❸ ART 101

101 Grand Street, Brooklyn
718-302-2242
art101brooklyn.com
Fri-Sun 1 p.m.-6 p.m.

Founded by artist Ellen Rand—an artist and longtime Williamsburg resident who keeps a studio in the building's basement—Art 101 showcases artists at all stages of their career with a focus on local names. The gallery also serves as a meeting spot for the community, hosting poetry readings and live music.

❹ BLACK & WHITE GALLERY/PROJECT SPACE

483 Driggs Avenue
718-599-8775
blackandwhiteprojectspace.org
Fri-Sun noon-6 p.m.

Since 2002, this Williamsburg nonprofit has supported local artists, helping to produce and promote site-specific projects, even as development continues to threaten the area's art community.

Its gallery showcases emerging and established talent in its dual indoor/outdoor space.

❺ CAPRICIOUS SPACE

103 Broadway, Brooklyn
718-384-1208
becapricious.com
Wed-Sat noon-6 p.m.

Founded in 2008 as an offshoot of *Capricious* magazine by publisher/ editor Sophie Mörner, Capricious Space showcases photography with a whimsical side from artists like Brooklyn's own Skye Parrott.

❻ CAUSEY CONTEMPORARY

92 Wythe Avenue, Brooklyn
718-218-8939
causeycontemporary.com
Wed-Sat 11 a.m.-7 p.m.
Sunday 9 a.m.-5 p.m.

Williamsburg's Causey Contemporary represents artists at all stages of their careers, including Kevin Bourgeois, an artist whose pencil drawings explore the intersection of tradition and technology.

❼ ENGLISH KILLS

114 Forrest Street, Brooklyn
718-366-7323
englishkillsartgallery.com
Sat-Sun 1 p.m.-7 p.m.

Named for a heavily polluted nearby waterway, this Bushwick gallery focuses on solo shows by its stable of young, multimedia artists, as well as the annual Maximum Perception festival of performance art.

❽ EYELEVEL B.Q.E.

364 Leonard Street, Brooklyn
917-660-4650
eyelevelgallery.com
Sat-Sun noon-6 p.m.

The artist-run Eyelevel B.Q.E. provides a forum for innovative artists living and working in Brooklyn and Queens.

❾ FACTORY FRESH ▲

1053 Flushing Avenue, Brooklyn
917-682-6753
factoryfresh.net
Wed-Sun 1 p.m.-7 p.m.

Founded by two veterans of the Lower East Side gallery scene, this Bushwick space has its roots in street art, featuring art inspired by contemporary urban culture.

⑩ THE FRONT ROOM ▲

147 Roebling Street, Brooklyn
718-782-2556
frontroom.org
Fri-Sun 1 p.m.-6 p.m.

The Front Room is a center-piece of the Williamsburg scene, and not just because of its can't-miss painted façade. Gallery founder Daniel Aycock has been showcasing emerging and mid-career artists since 1999, and is the publisher of local gallery guide *wagmag*.

⑪ GITANA ROSA ▶

19 Hope Street, Brooklyn
718-387-0115
gitanarosa.com
Thurs-Fri 1 p.m.-7 p.m.
Saturday noon-6 p.m.

Williamsburg's first-ever green gallery exhibits a wide range of work with a positive mission — 10% of all proceeds go to charitable causes selected by the gallery and participating artists.

⑫ GRACE EXHIBITION SPACE

840 Broadway, 2nd Floor
646-578-3402
grace-exhibition-space.com

Since 2006, this Bushwick space has been dedicated to thought-provoking performance art.

⑬ THE HOGAR COLLECTION

362 Grand Street, Brooklyn
718-388-5022
hogarcollection.com
Fri-Sun 12:30 p.m.-7 p.m.

Since 2003, Williamsburg's Hogar Collection gallery has focused on the promotion of new art and dialogues by emerging and mid-career artists from the U.S. and abroad, including Sonic Youth guitarist Lee Ranaldo.

⑭ INTERNATIONAL STUDIO AND CURATORIAL PROGRAM

1040 Metropolitan Ave., Brooklyn
718-387-2900
iscp-nyc.org

Since 1994, ISCP has hosted over 1,000 artists in its residency program from more than 50 countries from France to Chile to New Zealand. In addition to its galleries, open studios and salon programs encourage dialogue between artists and viewers.

⑮ JANET KURNATOWSKI GALLERY

205 Norman Avenue, Brooklyn
718-383-9380
janetkurnatowskigallery.com
Fri-Sat 1 p.m.-7 p.m.
Sunday noon-6 p.m.

Greenpoint gallery Janet Kurnatowski specializes in abstract painting and sculpture.

⑯ THE JOURNAL GALLERY

168 North First Street, Brooklyn
718-218-7148
thejournalinc.com
Tues-Sun noon-6 p.m.

The art gallery of magazine *The Journal* presents the same fashionable artists found on the magazine's pages, including Gang Gang Dance front woman Lizzi Bougatsos, painter Rita Ackermann and director Harmony Korine.

RIGHT Rachel Beach: "Towers and Portals" installation at Like the Spice Gallery, 2009.

⑰ K&K

109 Broadway, Brooklyn
kkbroadway.com
Fri-Sun 1 p.m.-7 p.m.

Williamsburg's K&K is a photography gallery with a focus on young, emerging talent, located in a storefront space that does double duty as the gallerists' apartment.

⑱ LIKE THE SPICE ▾

224 Roebling Street, Brooklyn,
718-388-5388
likethespice.com
Wed-Sun noon-7 p.m.

As the president of the Williamsburg Gallery Association, Like the Spice founder and curator Marisa Sage is a leader in the Williamsburg art scene. Her gallery features work in traditional and digital media.

BROOKLYN

⑲ LIVE WITH ANIMALS

210 Kent Avenue, Brooklyn
livewithanimals.org
Sat-Sun 1 p.m.-6 p.m.

Live with Animals is an artist-run space in Williamsburg's Monster Island building. Founded by musicians Cameron Michel and Vashti Windish, the gallery features solo and group shows by emerging artists, including an exchange with Mexico City's Yautepec Gallery.

⑳ LUMENHOUSE

47 Beaver Street, Brooklyn
718-942-5395
lumenhouse.com

Bushwick's Lumenhouse offers low-cost professional photography studio access and also hosts a series of workshops, screenings, exhibitions and performances, as well as an artist-in-residence program. Check the website for hours and exhibition schedule.

㉑ MOMENTA ART

359 Bedford Avenue, Brooklyn
718-218-8058
momentaart.org
Thur-Mon noon-6 p.m.

Founded in Philadelphia in 1986, this artist-run organization has called Williamsburg home since 1995. Its mission is to promote emerging and underrepresented artists of all ages, races and ethnicities.

㉒ NURTUREART

910 Grand Street, Brooklyn
718-782-7755
nurtureart.org
Thur-Mon noon-6 p.m.

This Bushwick nonprofit lives up to its name by supporting emerging

artists and curators through six to eight annual shows of contemporary art. Proposals are selected by a guest panel of art world experts, and exhibitions feature artists from both inside and outside the NURTUREart artist registry.

㉓ PARKER'S BOX

193 Grand Street, Brooklyn
718-388-2882
parkersbox.com
Thur-Sun 1 p.m.-7 p.m.

For the last decade, Williamsburg gallery Parker's Box has given a platform for innovative artists from the U.S. and abroad.

㉔ PIEROGI

177 North Ninth Street, Brooklyn
718-599-2144
pierogi2000.com
Tues-Sun 11 a.m.-6 p.m.

Founded in 1994, artist-run gallery Pierogi was a pioneer on the Williamsburg scene. Since then it's expanded to include a second space, the Boiler, at 191 North 14th Street, for large-scale exhibitions. In addition, the Flat File archives—which can be seen at the gallery or online—include the work of over 700 artists.

㉕ REAL FINE ARTS

673 Meeker Avenue, Brooklyn
realfinearts.com
Thur-Sun noon-6 p.m.

This Greenpoint gallery focuses on contemporary art, including Alisha Kerlin's paintings of card games,

Asher Penn's conceptual collages and Antek Walczak's language- and technology-based work.

㉖ SECRET PROJECT ROBOT

210 Kent Avenue, Brooklyn
917-860-8282
secretprojectrobot.org
Sat-Sun 2 p.m.-7 p.m.

A gallery and performance space with a raw, D.I.Y. vibe, Williamsburg's Secret Project Robot is a non-profit space specializing in the edgy and experimental.

㉗ SIDESHOW GALLERY

319 Bedford Avenue, Brooklyn
718-486-8180
sideshowgallery.com
Thur-Sun noon-6 p.m.

Sideshow Gallery was founded in 1999 as a place for emerging artists to exhibit their work by Richard Timperio, an artist who moved to the neighborhood in 1979. Since then it has shown a variety of artists including Larry Poons and Jonas Mekas.

㉘ YES GALLERY

147 India Street, Brooklyn
917-593-9237
yesgalleryyes.com
Mon-Sun 11 a.m.-8 p.m.

This Greenpoint basement space features a variety of work, from Jared Spafford's lyrical landscape paintings to Hector Serna Jr.'s dark depictions of subculture and urban grit. The gallery has also served as a hub for the neighborhood's open studio program.

CLEOPATRA'S

110 Meserole Avenue, Brooklyn
cleopatras.us

Cleopatra's is an alternative art space founded in June 2008 by Bridget Donahue, Bridget Finn, Kate McNamara and Erin Somerville — four art-world professionals with a shared desire to create something in their Greenpoint neighborhood. Since then, Cleopatra's has collaborated with leading galleries and hosted a wide range of performances, exhibitions and events, all with an art-first philosophy that focuses on creativity rather than sales.

What is Cleopatra's mission?

Cleopatra's works collaboratively with artists, curators, writers, designers and musicians on projects that further connections between individual studios, institutions and galleries. These investigations are realized in our storefront space, as well as in the form of off-site, public programs, events and in print publications encompassing various fields and locales.

What can visitors expect here?

As a non-commercial art space and working archive, Cleopatra's looks to not only produce exhibitions and events in its physical space, but also publications, recordings, documentation and web based projects.

The space not only serves as a showroom, but also as a library that will house and make accessible such projects to the public.

How would you describe the Brooklyn art scene?

In many ways, Brooklyn is more accessible than the rest of NYC, especially when it comes to financing what ever it is you dream to do. Cleopatra's is a completely non-commercial space. The four of us who own and manage Cleo's also work jobs to support its livelihood. Being in Greenpoint means that our cumulative monthly costs are not paralyzing. We often speak about Cleopatra's as a curatorial studio space, a devoted place where the four of us are able to engage in conversations, conduct research, work with artists, curators, writers, designers and musicians. Cleopatra's is the incubator that allows its operators the ability to develop and

STUDIO VISIT: CAMEL ART SPACE

722 Metropolitan Avenue, Brooklyn
Second Floor
camelartspace.com
Sat-Sun noon-6 p.m.

Camel Art Space is a hybrid gallery and studio space with a mission to
support artists by offering opportunities to showcase new work. Founded in
2009 by artists Rob de Oude, James Isherwood, Enrico Gomez, Chris McGee,
Hilary Doyle and Reid Hitt, Camel opened at a time when many galleries
were closing due to economic pressure. As it got more difficult for artists
to get their work shown, Camel offered an alternative. Along with eight
light-filled studios, shared by about a dozen artists, Camel includes a com-
munal gallery space that hosts group shows featuring artists from the local
Williamsburg and Bushwick scenes as well as art from around the world.

And it's an exciting time to be in Brooklyn. "Fifteen years ago, you did
your own thing and then you brought it into the city," but now things have
changed, says Isherwood, a painter who works at Camel and lives on the
Lower East Side. "A lot of people are taking their futures and their friends'
futures into their own hands."

BROOKLYN

DISCOVER BROOKLYN

With so much ground to cover, navigating the Brooklyn art scene can be a daunting task. Thankfully, there are programs designed to help art lovers experience all that the borough has to offer.

ANNUAL GOWANUS ARTISTS STUDIO TOUR

Each autumn, the Brooklyn Art Council invites art lovers to step into the studio and meet artists face-to-face. Going steady for over 10 years, the Annual Gowanus Artists Studio Tour (A.G.A.S.T.) offers the public the unique opportunity to visit artists working in warehouses, brownstones and garages of South Brooklyn's Gowanus, Carroll Gardens, Cobble Hill, Boerum Hill and Park Slope neighborhoods.

For more information visit agastbrooklyn.com.

DUMBO ARTS WALK

The first Thursday of each month Dumbo's galleries stay open until 8 p.m. for the Dumbo Arts Walk. For a list of participating galleries visit dumboculture411.com or call 718-222-2500.

WILLIAMSBURG EVERY 2:ND ART AFTER HOURS

The second Friday of each month, the galleries of the Williamsburg Gallery Association stay open late for receptions and special events from 7 to 9 p.m. Visit wgabrooklyn.org for information on participating galleries.

STUDIO VISIT: 3RD WARD

195 Morgan Avenue
718-715-4961

In the middle of Brooklyn's thriving arts scene, 3rd Ward is a 20,000-square-foot member-based art and design center that offers a place for artists and artisans to create and exhibit their work. Varying degrees of membership range from dedicated workspace to discounted rentals on 3rd Ward's fully loaded facilities, including a digital media lab, jewelry workshop, photo studios and wood and metal shops. In addition, a wide selection of classes — over 100 options on everything from photography and print making to urban beekeeping — are available for members and non-members alike.

For more information on membership, classes and events visit 3rdward.com.

DUMBO, BOERUM HILL, COBBLE HILL, CARROLL GARDENS, GOWANUS, RED HOOK AND PARK SLOPE STARTING POINT: F TRAIN TO YORK STREET (DUMBO) F OR G TRAIN TO SMITH/ NINTH STREETS (GOWANUS)

ARTISTS HAVE STAKED THEIR CLAIMS ON BROOKLYN'S SUPERSIZED WAREHOUSES AND INDUSTRIAL SPACES ALL ALONG THE F TRAIN. DUMBO – SHORT FOR DOWN UNDER THE MANHATTAN BRIDGE OVERPASS – IS HOME TO ONE OF THE CITY'S MOST DYNAMIC COLLECTION OF GALLERIES AND PERFORMANCE SPACES, WHILE GRITTY GOWANUS AND RED HOOK ARE HOME TO STUDIOS AND EDGY ALTERNATIVE SPACES.

㉙ 404 GALLERY

404 Sixth Avenue, Brooklyn
718-499-3844
404gallery.com

This small, Park Slope storefront gallery is run by a collective of 13 artists working in a variety of media. The gallery encourages experimentation and occasionally invites guest curators for group shows, as well as artists' talks and readings.

㉚ BROOKLYN ARTISTS GYM

168 Seventh Street, 3rd Floor,
Brooklyn
718-858-9069
brooklynartistsgym.com

A combination of gallery and studio space, Brooklyn Artists Gym provides an affordable place for artists to create and showcase their work. Classes in techniques such as watercolor and printmaking are open to both members and non-members.

㉛ D.U.M.B.O. ARTS CENTER

30 Washington Street, Brooklyn
718-694-0831
dumboartscenter.org
Thurs-Sun noon-6 p.m.
$2 Suggested Donation

This 3,000-square-foot gallery focuses on innovative contemporary art, with exhibitions commissioned or selected by curators and open calls. In addition, DAC hosts the annual Art Under the Bridge Festival of experimental art, as well as programs for artists and high school students.

BROOKLYN

ⓛ FRONT STREET GALLERIES

111 Front Street, Brooklyn
safetgallery.com/FrontStreetGal-
leries

Located in the heart of Dumbo, 111 Front Street is home to 14 independent art galleries with specialties ranging from contemporary photography to Haitian art. Also at 111 Front Street is A.I.R. Gallery, the first artist-run, not-for-profit gallery for women artists in the U.S., which has served as an advocate for women in the arts since 1972.

ⓛ GOWANUS STUDIO SPACE

166 Seventh Street, Brooklyn
347-948-5753
gowanusstudio.org

Located in the heart of Gowanus, this studio provides a 2,000-square-foot workspace for artists, artisans and designers, including a woodshop and print studio.

ⓛ INVISIBLE DOG ART CENTER

51 Bergen Street, Brooklyn
347-560-3641
theinvisibledog.org
Thurs-Sat 1 p.m.-7 p.m.
Sunday 1p.m.-5 p.m.

Located in a converted factory in Boerum Hill, the Invisible Dog Art Center hosts a wide range of events including art exhibitions, dance and theater performances. The second floor hosts 29 artists' studios.

ⓛ ISSUE PROJECT ROOM

232 Third Street, 3rd Floor, Brooklyn
718-330-0313
issueprojectroom.com

Located in the historic Old American Can Factory, this Gowanus art space is dedicated to showing challenging work, with a focus on avant-garde performance, music, video and film.

㊱ KUNSTHALLE GALAPAGOS

16 Main Street, Brooklyn
718-222-8500
kunsthallegalapagos.com

This offshoot of Dumbo's Galapagos Art Space was founded in the fall of 2010 to provide a forum for large-scale art installations.

㊲ RABBIT HOLE GALLERY

33 Washington Street, Brooklyn
718-852-1500
rabbitholestudio.com
Tues-Sat noon-5:00 p.m.

Founded in 2005, Dumbo's Rabbit Hole Gallery fosters community involvement in the arts with a range of contemporary art programming and a bi-annual emerging artist group show featuring artists chosen by open call. A professional photo studio is also available for rentals.

㊳ SMACK MELLON

92 Plymouth Street, Brooklyn
718 834 - 8761
smackmellon.org
Wed-Sun noon-6 p.m.

Founded in 1995 to foster dialogue between artists and musicians, this Dumbo nonprofit includes a gallery and studio space with a mission to support emerging, under-represented and women artists.

SHOP

㊴ POWERHOUSE ARENA

37 Main Street, Brooklyn
718-666-3049
Mon-Fri 10 a.m.-7 p.m.
Sat-Sun 11 a.m.-7 p.m.

Equal parts bookstore, event space and indie publisher, powerHouse is the place to find top-notch books on art and culture, including a wide range of photography books and artist monographs. The soaring bookstore space also hosts a wide range of performances and exhibitions.

OPPOSITE: The Dumbo Arts Center
BELOW: Issue Project Room

EXTENDED TRAVEL

THANKS TO ITS SIGNATURE LIGHT, NATURAL BEAUTY AND LAIDBACK CHARM, NEW YORK'S LONG ISLAND HAS LONG DRAWN ARTISTS INCLUDING JACKSON POLLOCK, LEE KRASNER, WILLEM DE KOONING AND ANDY WARHOL. FROM SOUTHAMPTON ALL THE WAY TO MONTAUK, ART LOVERS WILL FIND MUCH TO DO ON EAST END.

ACCESS
The Hamptons are easily accessible from Manhattan. To avoid traffic, opt for public transportation.

LONG ISLAND RAIL ROAD
Trains leave from Pennsylvania Station on West 32nd Street. Eastbound trains stop in East Hampton, Bridgehampton, Southampton and Montauk. Travel time to Montauk is approximately three hours. Visit mta.info for fares and schedules.

HAMPTON JITNEY
Hampton Jitney coaches leave frequently from the East Side of Manhattan, making frequent stops along Long Island, including Watermill, East Hampton and Montauk. Travel time between the Upper East Side and Montauk is approximately 3-5 hours. Fares are $30 one-way or $55 roundtrip; for additional schedule and fare information visit hamptonjitney.com.

POLLOCK-KRASNER HOUSE AND STUDY CENTER

830 Springs-Fireplace Road
East Hampton, New York
631-324-4929
pkhouse.org

Open May-October on Thursdays,
Fridays and Saturdays

PEAK SEASON
June, July and August
1 p.m.-5 p.m.
$5 at the door
Guided tours leave at noon. $10.
Reservations required for tours.

OFF-PEAK
May, September and October
11 a.m.-4 p.m.
Admission is by guided tour only.
$10. Reservations must be made
in advance.

In 1945, just weeks after their wedding, Jackson Pollock and Lee Krasner moved to the tiny hamlet of Springs, located near East Hampton. Pollock's longtime patron Peggy Guggenheim lent the money for the down payment on a house where the artists could escape the pressures of city life and establish a country studio. Krasner worked in a small bedroom studio while Pollock worked in a nearby barn. It is here that Pollock developed the style for which he is best known today, radical all-over compositions of fluid liquid color. After Pollock's death in 1956, Krasner began working in the studio, which she continued until her death in 1984. The Pollock-Krasner House was created in Krasner's will, and the museum opened to the public in 1988. Today, the property is a National Historic Landmark, preserved by Stony Brook University. Visitors can see Pollock's studio much as it would have looked in his day, complete with art supplies and a paint-splattered floor that bares witness to his innovative approach to painting.

RIGHT Inside the
Pollock-Krasner studio,
the floor is a colorful
document of Pollock's
celebrated paint-
pouring technique. On
its surface are rem-
nants of some of his
most famous canvases,
including Blue Poles,
Convergence and Autumn
Rhythm.
OPPOSITE Watermill
Center

EXTENDED TRAVEL

ANDY WARHOL VISUAL ARTS PRESERVE

Montauk, New York
nature.org

In 1972, Andy Warhol took a trip to Montauk, on the far East End of Long Island. The artist had little interest in the aristocratic beach estates of East Hampton, but was mesmerized by Montauk and its quirky beach hotels — places like the Memory Motel and the Polynesian-inspired Ronjo Motel. In Montauk, Warhol purchased a sprawling compound called Eothen, where he hosted famous guests like Jackie Kennedy, Lee Radziwill and Liza Minnelli. In 1976, Warhol rented the estate to the Rolling Stones, who began rehearsals for the album that would become *Black and Blue*, which features a song named after the nearby Memory Motel.

In 1992, Warhol's ties to Montauk were celebrated with the founding of the Andy Warhol Visual Arts Nature Preserve, a project created by the Andy Warhol Foundation for the Visual Arts and the Nature Conservatory. Though not open to the public, the Preserve serves a dual mission — protecting the ecologically sensitive Montauk Moorlands and supporting the arts through programs for artists, as well as workshops and children's programming.

WATERMILL CENTER

39 Watermill Towd Road
Water Mill, New York
631-726-4628
watermillcenter.org

Founded by artist Robert Wilson in 1992, the Watermill Center is an artistic think tank, dedicated to fostering experimentation in the performance arts. Each fall, the organization's residency program invites groups of 12 to 15 artists — both established and emerging — to develop performance works from September through June, while the summer intensive brings up to 100 international artists to the center for a five-week program of workshops and artistic development. Works developed at the Watermill Center include *u*, the world's first Klingon opera. In addition, the Watermill art collection consists of nearly 8,000 pieces from the Stone Age to the present, including work by Donald Judd, Richard Serra and Agnes Martin. Check the website for a list of upcoming performances; most events are free.

PARRISH ART MUSEUM ▾

25 Jobs Lane
Southampton, New York
631-283-2118
parrishart.org

Summer Hours	Off-Season
Open Daily June-mid September	September-May
Mon-Sat 11 a.m.-5 p.m.	Monday, Thur-Sat 11 a.m.-5 p.m.
Sunday 1 p.m.-5 p.m.	Sunday 1 p.m.-5 p.m.
	CLOSED Tuesday and Wednesday

The Parrish Art Museum celebrates over 100 years of East End art history. Founded in 1897, the museum counts more than 2,600 works of art among its permanent collection. In addition to its leading collection of work by William Merritt Chase, the museum focuses on the work of artists who lived and worked in the area: Jackson Pollock, Lee Krasner, Willem de Kooning, Dan Flavin and Roy Lichtenstein, as well as contemporary artists active in the Hamptons, such as Chuck Close, Eric Fischl and Elizabeth Peyton. With the 2012 season the museum takes residence in a state-of-the-art 64,000-square-foot facility designed by renowned architects Herzog & de Meuron. Located in Water Mill, the new building was designed to host the museum's permanent collection in a hive-like arrangement of galleries that call to mind artists' studios.

EXTENDED TRAVEL

DIA:BEACON

3 Beekman Street	Summer Hours (April–October)
Beacon, New York	Fri–Mon 11 a.m.–6 p.m.
845-440-0100	Winter Hours (November–April)
diaart.org	Fri–Mon 11 a.m.–4 p.m.
$10	CLOSED Tuesday, Wednesday and Thursday

Since opening in 2003 as the official home of the Dia Art Foundation's permanent collection, Dia:Beacon has been a pilgrimage site for art lovers. The 300,000-square-foot museum—housed in a former Nabisco factory— is renowned for its dedication to the Dia mission of fostering large-scale and long-term exhibitions of leading names in contemporary art.

Located just about an hour north of New York City, Dia:Beacon, Riggio Galleries, is home to an impressive collection of contemporary artwork created from 1960 to the present. Much of the collection was established by Dia founders Philippa de Menil and Heiner Friedrich, specializing in the Minimalist, Conceptual and Post-Minimalist work of the 1960s and 1970s.

Each of the galleries at Dia:Beacon is designed to highlight the work of a single artist, including some of the most influential names of the past century. The collection includes Andy Warhol's *Shadows* paintings of 1978-79, 102 canvases installed edge-to-edge; On Kawara's *Today Series*, 36 of the artist's signature Date Paintings housed in a gallery filled with ionized, purified air; Richard Serra's monumental steel sculptures; and a group 15 of plywood boxes Donald Judd. Other highlights include more recent work, such as Bruce Nauman's multi-screen projection *Mapping the Studio I (Fat Chance John Cage)*, 2001, and German artist Gerhard Richter's installation *Six Gray Mirrors*, 2003.

In addition, the galleries continue the legacy of Dia:Chelsea by hosting temporary exhibitions by leading contemporary—and often challenging—artists including the likes of Tacita Dean, Sol LeWitt and Blinky Palermo.

ACCESS

Dia:Beacon is located about 60 miles north of New York City.
Metro-North Railroad trains run hourly on the Grand Central Terminal-to-Poughkeepsie Hudson Line; tickets cost $26 round trip during off-peak hours or $34.50 during peak hours. Dia:Beacon is about a five minute walk from the train station. Travel time by car is approximately 80 minutes.

ABOVE (top) Dia:Beacon, Riggio Galleries, 2003
(bottom) Andy Warhol, Shadows, 1978-79. Dia Art
Foundation, New York.

EXTENDED TRAVEL

STORM KING ART CENTER

Old Pleasant Hill Road
Mountainville,
New York
845-534-3115
stormking.org
$12

April 1-October 31
Wed-Sun 10 a.m.-5:30 p.m.
CLOSED Monday and Tuesday
November 1-November 14
Wed-Sun 10 a.m.-5 p.m.
CLOSED Monday and Tuesday
November 15-March 31
CLOSED TO THE PUBLIC

Storm King Art Center, which celebrated its 50th anniversary in 2010, was originally conceived as a museum for Hudson Valley painters. But when co-owner Ralph E. Ogden visited the Adirondacks home of the late sculptor David Smith in 1967, Ogden was impressed by the fluidity of the artist's sculptures set into the landscape around his home and studio, and a new vision for Storm King was born.

Today, Storm King Art Center is a 500-acre, open-air museum with an impressive collection of sculptures set within the rolling hills, woodlands and fields of the Hudson Valley. Fittingly, Smith's large welded steel sculptures are in abundance: The sculptor's thirteen works at Storm King range from the whimsical pink "drawing in space" *Study in Arcs*, 1957, to the simple and elegant stainless steel structure *Three Ovals Soar*, 1960. Other notable large-scale works include one of Alexander Calder's last "stabiles," *The Arch*, 1975; works by Richard Serra, Henry Moore and Louise Nevelson, plus the 2,278-foot-long *Storm King Wall* by Andy Goldsworthy and works by several other modern sculptors. In this outdoor museum, sculpture is beautiful in all weather conditions. Subtle changes in sun and shade and even rain cast each work in different light.

The French Normandy-style Museum Building houses nine exhibition galleries, a museum shop and offices.

ACCESS
Mountainville, New York, is located about 60 miles from New York City. Public Transportation from New York City is provided by Short Line Bus, which offers one-day tours departing from Port Authority Bus Terminal. Travel time is about 90 minutes; tickets cost $45.

RIGHT Mark di Suvero, <u>Mon Père, Mon Père</u> (1973-75) and <u>Mother Peace</u>, 1969-70.

INDEX

#

¼ Mile Piece 77
0-9 magzaine 30
3rd Ward 282
5Pointz 265
12ozProphet 186
25CPW 252
80 WSE 160
100 Coke Bottles 91
100 Dollar Bills 91
100 Soup Cans 91
100 untitled works in mill aluminum 101
101 Spring Street 98, 99, 101, 131
112 Chambers Street 19, 97, 98, 121
112 Workshop 131, 161
303 Gallery 187
404 Gallery 283
420 West Broadway 101, 200
7000 Oaks 186

A

Abakanowicz, Magdalena 195
ABC No Rio 140
Abramović, Marina 34, 200, 245
Abrons Art Center 140
Abstract Expressionism 8, 9, 10-13, 15,
 17, 21, 22, 23, 27, 46, 61, 62,
 64, 68, 72, 73, 77, 79, 81, 89,
 93, 99, 157, 164, 167, 178, 200,
 218, 222, 241
Acconci, Vito 33, 34, 118, 152, 194, 200
Ace Hotel 208
Ackermann, Rita 188, 277
Acquavella Galleries 240
Action Painting 11, 12
Adam Baumgold 240
Adamo, David 238
Adams, Ansel 188
A Gathering of Tribes 172
AG Gallery 19, 80
Ahearn, John 187
A.I.R. Gallery 284
Aitken, Doug 53
Alamo 173
Albers, Josef 17, 72, 133, 243
Alder, Bas Jan 198
Alexander and Bonin 187
Alexander, Carolyn 187
Allan Nederpelt 274
Allegra LaViola Gallery 148
American Folk Art Museum 216
Anastasia Photo 142
Anderson, Laurie 34, 128, 140, 194, 200
Andrea Rosen Gallery 187
Andre, Carl 25, 26, 35, 99, 101, 132,
 151, 199
Andrew Edlin 188
Andy Warhol Foundation 289
Anonymous Gallery 142
Anthology Film Archives 81
Antin, Eleanor 54, 129
Anton Kern 188
Aperture Foundation 188
Apex Art 118
Apfelbaum, Polly 189
Apollo Theater 80
Apple Shrine 49
Arbus, Diane 37-38, 163, 164, 167, 175,
 200, 244
Arcangel, Cory 55, 130
Art 101 274
Art and Language 30
Art Bar 163
Artforum 29, 30, 98, 104, 105, 109
Art in General 118

Art International Radio 118
Artist In Residence District 165
Artists Alliance 145
Artists' Club 11
Artists Space 41, 42, 104, 120, 126, 197
Artists' Union 67
ARTnews 13, 69
Art of This Century 8, 13, 61, 69, 222
ArtReview 192
Arts and Architecture magazine 70
Art Since the Summer of '69 143
Art Students League 22, 59, 67, 80, 222
Ashcan School 7
Asheville, North Carolina 17, 72
Asia Song Society 143
Assume Vivid Astro Focus 187
Astor, Patti 176
Atherton, Hope 189
Auerbach, Tauba 119, 238
Avant-Garde Festival 82
Avery, Milton 59
Avery, Sally 59
Aycock, Daniel 276

B

B-52s 121
Bacon, Francis 240
Bag One Arts 252
Baja California 100
Bakström, Fia 127
Baldessari, John 46, 104, 218, 236
Ballad of John and Yoko 81
Ballato 155
Balloon Dog (Orange) 221
Balloon Dog (Yellow) 111
Balloon Flower (Red) 111, 119
Banality 109
Banksy 208
Banovich, Tamas 199
Barbara Gladstone 189
Barbetta 225
Barney, Matthew 54, 164, 266
Barr, Alfred J. 65, 214
Baselitz, Georg 45, 188, 242
Bas, Hernan 195
Basquiat, Jean-Michel 46, 121, 129, 154,
 163, 169, 175, 176, 201, 209,
 223, 225, 238
Baumgold, Adam 240
Beale, Thomas 203
Beauchene, Nicelle 143
Becker, Saul 148
Beckett, Samuel 193
Beckmann, Max 243
Beer, Sue de 195
Bekman, Jen 143
Bellamy, Richard 97
Bellows, George 7
Ben-Day dot 21, 22, 79, 85
Benglis, Lynda 154
Benton, Thomas Hart 67
Ben-Tor, Tamy 202
Berke, Deborah 195
Berlin, Brigid 90
Bernadette Corporation 151
Bernhardt, Katherine 144
Bespoke Gallery 144
Betty Parsons Gallery 11, 81
Beuys, Joseph 33, 80, 186
Bevilacqua, Carlos 151
Bickerton, Ashley 43, 195
Black Mountain College 17, 33, 72
Blackston 144
Blackwell, Josh 153
Black & White Gallery 274

Bleckner, Ross 121, 195, 196
Blondie 121, 128, 175
Bochner, Mel 129
Boesky, Marianne 195, 242
Bolotowsky, Ilya 67
Bonacina, Mauro 143
Bonin, Ted 187
Bonnard, Peter 61
Boone, Mary 23, 44-47, 121, 132, 164,
 196, 218
Bortolami Gallery 189
Botero, Fernando 195, 218
Bougatsos, Lizzi 146, 277
Bourdin, Guy 187
Bourgeois, Kevin 275
Bourgeois, Louise 8, 50, 126, 128, 189,
 198, 222
Boutique Eat Shop 202
Bove, Carol 161
Bowery 38, 65, 89, 134-155
Bowery, Leigh 198
Brauntuch, Troy 41, 42
Bravo, Claudio 195, 218
Brecht, George 19, 80, 176
Breton, André 7, 12
Breuer, Marcel 238
Breuning, Olaf 197
Bridge Gallery 144
Brill, Patrick 227
Broken Kilometer, The 130
Broodthaers, Marcel 218
Brooklyn 268-285
Brooklyn Artists Gym 283
Brooklyn Museum 272
Browner, Juliet 202
Buffalo, New York 102, 103
Bureau 144
Buren, Daniel 189
Burgos, Ernesto 127
Burroughs, William S. 154
Bus Riders 103
Bust of Sylvette 160, 162
Byrne, David 107

C

Cabessa, Miriam 147
Café Sabarsky 245
Cage, John 15, 17, 19, 33, 73, 74, 80, 140,
 165, 177, 178
Calder, Alexander 219, 220, 292
California 62, 66
California Institute of the Arts 41, 46
Calle, Sophie 118
Camel Art Space 281
Camino Gallery 179
Campbell's Soup Cans 214
Campus, Peter 53, 54, 160
Canada 144
Canaday, John 16
Cannon, Steve 172
Capote, Truman 222
Capricious Space 275
Captiva Island, Florida 77
Carlebach Gallery 86
Carlton Arms Hotel 208
Carnegie, Andrew 232
Carnegie Hall 80, 100
Carnegie Institute of Technology 91
Cartier-Bresson, Henri 216
Casa Frela 259
Casa Lever 223
Casey Kaplan 189
Castelli Gallery 17, 23, 85, 132, 197, 241
Castelli, Leo 8, 13, 45-46, 74, 89, 120,
 121, 128, 132, 164, 200, 207,
 241, 244

Catron, Jennifer 148
Cattelan, Maurizio 218
Causey Contemporary 275
CBGB 175
Cedar Tavern 11, 15, 22, 63, 68, 121, 157, 164, 167
Celebration series 111
Celemente, Francesco 45
Centerfold series 105
Cézanne, Paul 89, 240
Chagall, Marc 221, 227, 244, 251, 253
Chamberlain, John 99, 100, 101
Chambers Hotel 227
Chan, Paul 193
Charles Bank Gallery 143
Charles Egan Gallery 87
Charlie Parker Festival 172
Chase, William Merritt 166, 207
Cha, Xavier 201
Cheim & Read 189
Chelsea 34, 180-203
Chelsea Girls 93, 203
Chia, Sandro 45, 202
Chicago, Judy 26, 272
Children's Art Project 126
Children's Museum of the Arts 126
Chinati Foundation 100, 101
Chinatown 148
Chinese Chance 164
Chocolate Factory 267
Choit, Barb 153
Christie's 153, 217
Christo and Jeanne-Claude 49
Christopher Henry 148
Cibo Matta 82
Clark, Larry 195
Clemente, Francesco 46, 196, 252
Cleopatra's 280
Clic Bookstore & Gallery 155
Clinton, Bill 193
Clocktower 118
Cloisters 259
Close, Chuck 175, 197, 219, 288
Club 57 175
Cody, Wyoming 66
Coenties Slip 98, 120, 154
Cohen, Ethan 118
Cohen, Ronny 109
Colacello, Bob 91
Cold War 42
Colen, Dan 192, 238, 241
Collier, Anne 188
Color Field 11, 25, 27, 165
Columbia University 97, 259
Combines 15, 17, 74
Conceptual Art 19, 23, 28-31, 33, 42, 132, 190, 191, 195, 198, 290
Condo, George 243
Conner, Bruce 16
Cooke, Nigel 188
Cooper-Hewitt 232, 245
Cooper, Paula 35, 100, 119, 132, 198
Cooper Square 67
Cortez, Diego 121
Cotton, Will 196
Coward, Noël 252
Craig-Martin, Jessica 217
Creative Time 31, 221
Cremaster Cycle 54
Crimp, Douglas 42, 126
Crossing, The 54
Crowner, Sarah 143
Crumb, Sophie 145
Cucchi, Enzo 45
Cuchifritos 145
Cunningham, Merce 15, 17, 33, 73-75, 165, 178

Cupping Room Café 132
Currin, John 252
Cut Piece 80
Cutrone, Ronnie 142

D

Dada 15, 16, 33, 189
Dali, Salvador 226
D'Amelio Terras 189
Danluck, Meredith 129
Danspace 178
Darger, Henry 188, 216
Darling, Candy 222
Dash, Damon 118
Dash Gallery 118
Dashwood Books 179
Da Silvano 163
Das Institut 127
David Nolan 190
David Zwirner 190
DCKT 145
Degas, Edgar 232
Dehne, Pia 144
Deitch Projects 127, 173
de Kay, Charles 207
de Kooning, Elaine 17, 160, 179
de Kooning, Willem 8, 10-13, 23, 68, 72, 73, 86, 164, 167, 175, 176, 197, 202, 286, 288
De Maria, Walter 50, 184
de Menil, Philippa de 290
DeNiro, Robert 167
Dennis, Charles 172
Denslow, Dorothea 266
Depression, Great 11
Dervaux, Isabelle 79, 80
Dexter Sinister 145
Dia Art Foundation 50, 100, 101, 130, 186, 258, 290
Dia:Beacon 290-291
Dictators, The 175
DiGusta, Linda 185
Dine, Jim 15-17, 33, 34, 81, 87, 88, 89, 165, 219, 243
Dirty: Jeff On Top 110
Di Suvero, Mark 198
Dix, Otto 233
Documenta 7 186
DODGEgallery 145
Doig, Peter 160
Dominguez, Gil 208
Dorsky Gallery 267
Double Fantasy 82
Douglass College 87
Dragset, Ingar 95
Drawing Center 126
Drowning Girl 86, 87, 89
Dubuffet, Jean 119
Duchamp, Marcel 9, 13, 15, 29, 69, 80, 109, 121, 163, 164, 167, 253
D.U.M.B.O. Arts Center 283
Dunham, Carroll 190
Dvinsk, Russian Empire 59
Dwyer Cultural Center 259
Dylan, Bob 162, 203

E

Ear Inn 132
East End 71
Easter and the Totem 70
East Hampton 69, 71
East Village 34, 43, 67, 81, 109, 168-179
Eggleston, William 37, 189, 193
Eighteen Happenings in Six Parts 34, 35, 178

Eleven Rivington 146
Eliasson, Olafur 201
Elizabeth Dee 191
Elmgreen, Michael 101
El Museo del Barrio 256, 261
El Quijote 203
Emergency Relief Bureau 67
Emin, Tracey 149, 272
English Kills 275
Epstein, Mitch 216
Equilibrium 109
Erased de Kooning 73
Ernst, Max 13, 80, 223, 245
Escobar, Marisol 163
Ethan Cohen Fine Art 118
Ethridge, Roe 188
Evans, Franklin 152
Evans, Walker 43
Exit Art 206
Experiments in Art and Technology 75
Expressionism 46
Eyelevel B.Q.E. 275

F

Fab 5 Freddy 175, 176
Factory Fresh 275
Factory, The 92, 91, 95, 222, 244
FAILE 198
Fanelli's Cafe 132
Fast, Omer 199
Faught, Josh 145
Federal Art Project 67, 68
Feinstein, Rachel 195
Fellig, Usher 38
Ferus Gallery 85, 197
Feuer, Zach 202
Fifteen Minutes 178
Filmmakers' Cinematheque 94
Fischer Landau Center 266
Fischer, Urs 160
Fischl, Eric 196, 288
Fitzpatrick, Leo 147
Five Words in Green Light 31
Flavin, Dan 24-28, 99, 100, 101, 132, 184, 186, 190, 217, 288
Florent 164
Flux Factory 267
Fluxfest 81
Fluxus 18-19, 33, 53, 54, 80, 88, 121, 132
Flynt, Henry 97
Following Piece 33
Food 99, 131, 202
Forbes 108
Foreman, Richard 178
Forever & Today 146
Fort Russell 100, 101
Fort Tryon Park 259
Foster, Norman 151
Fountain 9, 253
Four Seasons Restaurant 62, 224
Franco, James 118
Franklin, Aretha 223
Franklin School for Boys 86
Freedman, Doris C. 173
Freeman, Peter 129
Freire, José 130
Frey, James 147
Frick Collection 232, 233, 245
Frick, Henry Clay 232
Fried, Elaine 202
Friedlander, Lee 38, 155, 193
Friedrich, Heiner 100, 290
Friedrich Petzel 191
Frightened Girl 89
Fritz, Leslie 129
Front Room 276

Front Street Galleries 284
Frosch, Eva 146
Frosch & Portmann 146
Fuller, Buckminster 17
FUN Gallery 176
Futura 2000 169, 186, 201

G

Gagosian Gallery 111, 192, 241, 246
Gagosian, Larry 121, 192, 202
Galerie Lelong 191
Gallery ontwentyeight 146
Gao Brothers 118
Gartenfeld, Alex 161
Gavin Brown's Enterprise 160
Gay Liberation 162
Gelitin 193
Gering & López 217
German Expressionism 59
Gerrard, John 151
Gershwin Hotel 209
Giattino, Gabrielle 144
Gillespie, Dizzy 140
Ginsberg, Allen 163, 164
Ginsburg, Eric 146
Giorno, John 154
Girl With Ball 85, 89
Gitana Rosa 276
Giuliani, Rudolph 272
Glass, Philip 131, 165
Glimcher, Arne 197, 219
Gloub, Leon 129
Glueck, Grace 97
Goethe-Institut New York 149
Golden Lion Award 82
Goldin, Nan 39, 160
Goldstein, Jack 41, 42
Goldsworthy, Andy 292
Gonzalez-Foerster, Dominique 258
Gonzalez-Torres, Felix 51, 188, 220
Goodden, Carol 131
Goossens, Tim 203
Gorky, Arshile 12, 59, 61, 160, 167
Gottlieb, Adolph 60, 61, 154
Goude, Jean-Paul 193
Gowanus 283
Gowanus Studio Space 284
Goya, Francisco 232
Gracie Mansion Gallery 176
Graffiti 46, 132, 154, 265
Graham, Dan 31, 152
Graham, John 60
Graham, Martha 140, 178
Graham, Robert 224
Gramercy Park 207
Grand Central Terminal 82
Grapefruit 80
Gray 121, 175
Great Depression 11, 59, 60, 67, 86
Greater New York 152
Greenberg, Clement 27, 29
Greenberg, Ronald 146
Greenberg Van Doren Gallery 146, 217
Green, Brent 188
Greene, Gertrude 67
Greene Naftali 193
Green Gallery 97
Greenwich Village 7, 11, 35, 59, 156-167
Greeting, The 54
Grey Art Gallery 160
Grooms, Red 17, 33, 34, 218
Grossman, Sid 38
Grosz, George 240
Group of Four Trees 119
Guernica 201
Guerrilla Girls 35
Guggenheim Museum 131, 247
Guggenheim, Peggy 8, 13, 61, 69, 70, 80,
89, 222, 223, 245, 287

Guggenheim, Solomon R. 13
Gulamerian, Norman 179
Guo-Qiang, Cai 234
Gursky, Andreas 196
Guston, Philip 46, 165, 218, 241
Gysin, Brion 154

H

Haacke, Hans 167
Half Gallery 147
Halley, Peter 43, 109, 146, 155
Hamilton, Richard 21
Hamptons 286, 288
Hanging Heart 111
Hanley, Jack 119
Hanoi, Vietnam 79
Hansa Gallery 176
Hansen, Elias 161
Happening 17, 33-35, 80, 178
Hardy, K8 151
Haring, Keith 121, 129, 132, 154, 161,
165, 169, 173, 175, 176, 201,
209, 223
Harlem 38, 254-261
Harnischfeger, Hilary 153
Harris Lieberman 126
Harrison, Helen A. 68
Hasted Kraeutler 193
Haunch of Venison 217
Hawkinson, Tim 197
Hay, Alex 129
Hayes, Kirk 148
Hegarty, Valerie 143
Heiss, Alanna 118, 264
Hejtmanek, Christina 144
Hell, Richard 175
Hemingway, Ernest 7, 72, 162, 163
Hendershot Gallery 147
Hendricks, Jon 79-82
Henri, Robert 7, 207
Henry, Christopher 148
Henry Street Settlement 140
Herzka, Dorothy 78, 89
Herzog & de Meuron 288
Hess, Thomas 13
Hilton Kramer 26
Hirst, Damien 192, 209, 220, 241, 246, 272
Hispanic Society 258
Hockney, David 224
Hofmann, Hans 8, 12, 61, 176
Hogar Collection 276
Hole, The 173
Holiday, Billie 128
Holl, Steven 152
Holzer, Jenny 51, 184, 189, 266
Homes for America 31
Honda, Yuka 92
Hopper, Edward 7, 238
Horn, Roni 100, 241
Horton Gallery 148
Hotel Chelsea 203
Hotel des Artistes 252
Hotel Earle 71, 162
House With An Ocean View 34
Houston, Texas 62
Hudson River School 7, 166
Hugo, Pieter 201
Hujar, Peter 177
Hunt, Richard Morris 7
Hutchins, Jessica Jackson 147

I

Incubator Arts Project 178
Indiana, Robert 22, 23, 80, 120, 154
Indica Gallery 81, 197
International Center of Photography 216
International Studio 277
International with Monument 43, 109
Interview magazine 91, 208

Invisible Dog Art Center 285
Invisible-Exports 148
ISE Cultural Foundation 127
Isenstein, Jamie 188
Issue Project Room 285

J

Jaar, Alfredo 152
Jack Hanley 119
Jackson, Martha 16
Jackson, Michael 109, 129, 198
Jack the Pelican Presents 146
Jagger, Mick 222
James Cohan Gallery 193
James Gallery 176
James Graham & Sons 241
Janet Kurnatowski 277
Janis, Sidney 23, 87
Japan Society 80, 100
Jen Bekman Gallery 143
Jewell, Edward Alden 61
Jewish Museum 26, 96, 233, 247
J.M. Kaplan Foundation 167
Joannou, Dakis 109
Johns, Jasper 15, 16, 17, 23, 45, 72, 74,
80, 120, 154, 219, 224, 238,
241, 266
Johnson, Philip 62, 65, 85
Judd, Donald 25, 26, 29, 85, 96-101,
131, 132, 184, 190, 197, 219,
266, 288
Judd, Flavin 99, 100
Judd Foundation 99, 101, 131
Judd, Rainer 99, 100
Judson Gallery 33, 49
Judson Memorial Church 34, 80, 165
July, Miranda 194
Jung, Carl 11, 12
Just, Jesper 193

K

Kabakov, Ilya 101
Kaikai Kiki 43
Kaplan, Casey 189
Kaprow, Allan 17, 33, 34, 35, 49, 88, 176,
178, 241
Karp, Ivan 89, 128, 176
Kate Werble Gallery 127
Katz, Alex 23, 128, 165, 177, 179, 198, 233,
240, 243
Kawamura Memorial Museum 65
Kawara, On 30, 31
KAWS 217
Keith Haring Foundation 165
Kelley, Lauren 144
Kelley, Mike 243
Kelly, Ellsworth 26, 120
Kelly, Khalif 153, 261
Kelly, Mary 151
Kenkeleba House 172, 173
Kennedy, Jacqueline 225, 289
Kennedy, John F. 15, 76
Kern, Anton 188
Kerouac, Jack 62, 163, 164
Kiefer, Anselm 45, 252
Kimmelman, Michael 85, 110
Kirchner, Ernst Ludwig 59
Kitchen, The 194
K&K 277
Klein, Eli 126
Klein, Yves 33
Klimt, Gustav 233
Kline, Franz 8, 12, 68, 164, 177
Koenig, Leo 195
Koestenbaum, Wayne 91
Koh, Terence 127, 143, 189, 196, 218
König, Kasper 195

Koons, Jeff 43, 108-112, 119, 133, 192, 200, 221, 226, 236, 242, 243, 246, 274
Korine, Harmony 277
Kosuth, Joseph 9, 29, 30, 31
Kramer, Hilton 45
Krasner, Lee 8, 12, 61, 69, 70, 71, 169, 177, 200, 286, 287, 288
Kreps, Andrew 188
Kristal, Hilly 175
Kruger, Barbara 43, 196, 206
Kuitca, Guillermo 151
Kunsthalle Galapagos 285

L

Lab, The 220
LaChapelle, David 163, 198
La Cicciolina 110
LaFrieda, Pat 160
La MaMa Experimental Theatre Club 172
La MaMa La Galleria 172
Lane, Priscilla 89
Lange, Dorothea 188
Last Supper, The 131
Latvia 59
Laurel Gitlen 147
Lawler, Louise 216
Lawson, Deana 144
Led Zeppelin 120
Lee, Jim 143
Leger, Fernand 154
Lehmann Maupin 149, 195
Lennon, John 81, 82, 252
Lennon, Sean 82
Leo Koenig Inc. 195
LeRoy Neiman Gallery 259
Lesley Heller Workspace 147
Les Pleiades 244
Le Va, Barry 190
Lever House 220
Levine, Sherrie 41, 42, 43, 165, 197
LeWitt, Sol 26, 29, 30, 31, 126, 132, 184, 199, 206
Lew, Jeffrey 161
Lichtenstein, Roy 21-23, 84-89, 129, 154, 164, 166, 197, 207, 209, 220, 221, 241, 253, 288
Liden, Hanna 147
Life magazine 62, 66, 85
Ligon, Glenn 195
Like the Spice 277
Lincoln Center 251
Linnenbrink, Markus 150
Lins, Pam 153
Lion, The 163
Lisa Cooley Fine Art 145
Little Italy 155
Live with Animals 278
LMAK Projects 149
Locale, The 165
Local Project 267
Location One 128
London Biennial 148
London, England 81
Long Island 71
Longo, Robert 41, 42, 43, 102, 103, 206
Look Mickey 88
Los Angeles, California 67, 85, 106
LOVE 220
Lower East Side 134-155, 206
Lower Manhattan Ocean Club 120
Lowman, Nate 82, 127, 160, 161, 187
Lowry, Glenn 214
Lucas, Sarah 189
Ludlow 38 149
Luhring Augustine 195
Lumenhouse 278
Lutz, Oliver 152
Luxembourg & Dayan 242

Lux, Loretta 201

M

Maccarone 161
Maciunas, George 19, 80, 121, 132
Macy's 61, 209
Made In Heaven 110, 200
Madison Square Art 206
Madonna 178
Malanga, Gerard 155
Manhattan Bridge 144
Mapplethorpe, Robert 160, 177, 200, 203
Marfa, Texas 100, 101
Marianne Boesky 143, 242
Marilyn Diptych 91
Mark, Mary Ellen 37, 216
Marlborough Gallery 195, 218
Marshall Chess Club 163
Martha Jackson Gallery 16
Martin, Agnes 27, 120, 128, 198, 266, 288
Maryland Institute College of Art 108
Mary Ryan Gallery 196
Matisse, Henri 69
Matta-Clark, Gordon 99, 118, 131, 161, 190, 202
Matthew Marks Gallery 196
Max's Kansas City 120, 164, 207
McGee, Barry 173
McGinley, Ryan 39, 130, 179
McGrath, Elizabeth 153
McKee Gallery 218
McLaughlin, John 27
McMillen Gallery 69
McShine, Kynaston 26, 233
Meat Joy 34
Meatpacking District 164, 187
Medieta, Ana 34
Mehretu, Julie 218, 257
Mekas, Jonas 81, 146, 279
Mendieta, Ana 35, 191
Metro Pictures 104, 197
Metropolitan Museum of Art 42, 61, 104, 111, 200, 209, 236, 259
Metropolitan Opera 252
Meyerowitz, Joel 37
Michael's 224
Michel, Cameron 278
Miguel Abreu Gallery 140
Minetta Tavern 163
Minimalism 23, 24-27, 31, 43, 45, 97, 109, 120, 129, 130, 132, 190, 198, 219, 233, 290
Minnelli, Liza 222, 289
Minter, Marilyn 243
Mitchell-Innes & Nash 197, 242
Miyamoto, Kazuko 146
M. Knoedler 87
Model, Lisette 38, 219
Modernism 29
Modern, The 224
MoMA Design Store 227
Momenta Art 278
Monet, Claude 89, 240
Monogram 74
Monroe, Marilyn 245
Montauk, New York 289
Montuori, Brian 148
Moore, Henry 292
Moore, Thurston 82
Moorman, Charlotte 54
Moravec, Matt 161
Morazan, Irvin 145
Morellet, Florent 164
Morgan, Barbara 188
Morgan Library 85, 206
Morley, Malcolm 151
Mörner, Sophie 275
Morrison Hotel 128
Morris, Robert 25, 30, 79
Morrissey, Paul 90, 93, 176
Motherwell, Robert 13, 62, 164

Moulton, Charles 172
Mouthful of Poison 151
Moyer, Carrie 144
Mudd Club 121
Mugaas, Hanne 143
Müller, Jan 176
Muniz, Vik 200
Munroe, Alexandra 80
Murakami, Takashi 43, 82
Museum for African Art 258, 261
MoMA 8, 29, 38, 53, 67, 71, 78, 107, 109, 166, 176, 200, 214, 219, 220, 224, 264
Mutu, Wangechi 257
Myers, Frosty 120, 130

N

Name, Billy 91, 222
Namuth, Hans 71
Nara, Yoshitomo 195
National Arts Club 197
National Design Museum 232
National Endowment for the Arts 103, 167
Nauman, Bruce 30, 51, 118, 151
Neo-Dada 15, 17, 88
Neo-Expressionism 23, 44-47, 126, 196, 218, 241
Neo-Geo 43
Nesjär, Carl 162
Neue Galerie 233, 247
Neuenschwander, Rivane 201
Neuhaus, Max 221
Nevelson, Louise 119, 219, 292
Newkirk, Kori 238
Newman, Barnett 13, 62, 65, 73, 101, 165
New Media 16, 55, 130, 191
New Museum 35, 106, 109, 111, 120, 138, 201
New School 19, 59, 86, 167
Newsome, John 227
New York Cultural Center 30
New York Earth Room, The 50, 130
New York Gallery Week 189
New York/ New Wave 264
New York Public Library 233
New York School 10-13, 62, 164, 222
New York Studio School 165
New York University 101, 160, 162
Nicelle Beauchene 143
Nico 90, 93, 176, 203
Nine Jackies 92
Ninth Street Show 23, 164
Nirvana 178
No. 1 56, 61, 63
No. 3/No. 13 58
Noguchi, Isamu 120, 266
Noguchi Museum 266
Nolan, David 190
Nomi, Klaus 175
NP Contemporary Arts Center 149
Nude Descending a Staircase No. 2 9
Number 35 Gallery 150
NURTUREart 278
Nyehaus 197
NY Studio Gallery 150

O

Odeon, The 121
Ofili, Chris 272
Oiticica, Hélio 191
O'Keeffe, Georgia 222, 227, 238, 272
OK Harris 128, 133
Oldenburg, Claes 15, 17, 23, 33, 35, 81, 84, 88, 100, 165
Olson, Alex 145
One and Three Chairs 29
One: Number 31 68
Ono, Yoko 19, 78-83, 121, 252
On Stellar Rays 150

Ontological-Hysteric Theater 178
Opportunity Gallery 59, 61
Ortiz, Raphael Montañez 256
Os Gemeos 173, 186
Other Criteria 246
Otterness, Tom 218
Oursler, Tony 53, 149, 197
Owens, Rick 243

P

Pace Gallery, The 120, 197, 219
Paik, Nam June 53, 54, 98, 193
Paine, Roxy 206
Painting for the Wind 80
Painting to be Stepped On 79, 82, 121
Painting to Shake Hands 81
Palazzo Chupi 166
Pallenberg, Anita 222
Paragraphs on Conceptual Art 29, 30
Paris, Franec 7, 22
Parker's Box 279
Parkett 128, 198
Park, Kyong 140
Parrott, Skye 275
Parsons, Betty 70
Participant Inc. 151
Paula Cooper 119, 132, 198
Paul Kasmin Gallery 198
Pavia, Philip 164
Pearl Street 74, 80
Peavy, Jessica Ann 144
Peck, Marion 153
Pei, I.M. 162
Penck, A.R. 242
Pepe, Sheila 227
Peres, Javier 143
Performance Art 17, 19, 32, 172
Perry Rubenstein 143
Peter Blum Gallery 128
Peter Freeman 129
Petriso, Catalin 147
Petrisor, Catalin 147
Peyton, Elizabeth 160, 288
Phillips de Pury 187
Phoenix Gallery 198
Photo League, The 38
Piano Activities 19
Piano, Renzo 206
Picasso, Pablo 69, 89, 160, 162, 197, 201, 217, 224, 241
Pictures 41, 42, 43, 103, 126
Pierogi 279
Ping, Huang Yong 189
Piper, Adrian 30, 31, 191
Pissarro, Camille 233
Pittsburgh, Pennsylvania 91
Plastic Ono Band 100
Poetry Project 178
Polke, Sigmar 242
Pollock, Charles 67, 166
Pollock, Jackson 8, 11-13, 23, 32, 61, 62, 65, 66-71, 73, 164, 166, 169, 177, 179, 222, 245, 286, 287, 288
Pollock-Krasner House and Study Center 68, 287
Pollock, Sande 67
Poons, Larry 279
Pop Art 17, 20-23, 64, 76, 81, 84, 87, 109, 120, 129, 144, 154, 162, 195, 197, 200, 219, 243
Pop International 129
Pop Shop 132
P-Orridge, Genesis Breyer 148
Postmasters 199
Post-Modernism 41, 43, 219, 290
Post-Painterly Abstraction 27
Powers, Bill 147
P-P-O-W 199
Prada Marfa 101

Pratt Institute 199
Preston, Simon 151
Price, Ken 196
Primary Structures 25, 26, 29, 96
Prince, Richard 41, 43, 103, 109, 192, 209, 234
Princeton, New Jersey 89
Printed Matter 120, 199
Pruitt, Rob 160
PS1 152, 203, 264
Puryear, Martin 218
Putzel, Howard 9, 61
Pyramid Club 178

Q

Quinones, Lee 176

R

Rabbit 108
Rabbit Hole Gallery 285
Radziwill, Lee 289
Rafferty, Sara Greenberger 153
Ramiken Crucible 151
Ramones, The 175
Ranaldo, Lee 276
Rand, Ellen 274
Rashid, Karim 217
Rat Studio 154
Rauch, Neo 190
Rauschenberg, Christopher 74, 75, 76, 77
Rauschenberg, Robert 9, 15, 16-17, 21, 23, 33, 34, 72-77, 80, 120, 121, 131, 165, 178, 207, 224, 241, 266
Ray, Man 13, 163, 219
Read, Howard 189
Readymade 9, 15, 29, 253
Real Fine Arts 279
Red Cube 120
Reed, Lou 87
Reena Spaulings Fine Art 151
Reginald Marsh 86
Reinhardt, Ad 13, 160, 164
Reiring, Janelle 197
Remington, Frederic 207
Renaissance Fine Art 259
Renwick Gallery 129
Retroactive I 76
Reuben Gallery 34, 35
Reuterswärd, Carl Fredrik 221
Reynolds, Paul 203
Rhizome 138
Rice, John A. 17
Richard Gray Gallery 243
Richard L. Feigen & Co 243
Richardson, John 87
Richter, Daniel 190
Richter, Gerhard 126
Riley, Bridget 197
Rinehardt, Ad 13
Rist, Pipilotti 195
Rivers, Larry 15, 17
Robert Miller Gallery 200
Robert Rauschenberg 16, 131
ROCI 77
Rockefeller, Abby Aldrich 214
Rockefeller, David 119
Rockwell, Norman 222, 252
Rodarte 232
Roger Smith Hotel 226
Rohatyn, Jeanne Greenberg 146, 243
Rohe, Ludwig Mies van der 220
Rolling Stones, The 128, 289
Romare Bearden Foundation 260
Ronald Feldman Fine Arts 129
Rooster Gallery 152
Rose, Barbara 15
Rose, Charlie 72
Rosenberg, Harold 58

Rosenquist, James 21, 23, 80, 89, 120, 197
Rosenthal, Tony 173
Rosler, Martha 118, 128, 197
Rothko Chapel 62, 63
Rothko, Mark 8, 11-13, 23, 58-65, 154, 164, 197, 219, 222, 224, 238, 244
Rottenberg, Mika 189
Roundabout Theatre Company 222
Rousseau, Henri 243
Rowley, Cynthia 246

Rubenstien, Perry 198
Rubin Museum of Art 184
Ruby, Sterling 191
Ruscha, Ed 30, 192, 217
Ruskin, Mickey 120, 164, 165, 179, 207
Rutgers State University 87, 88
Ryman, Robert 128, 198

S

Saatchi, Charles 109
Sacred Heart 111
Saint Mark's Church in the Bowery 178
Salle, David 44, 46, 121, 165, 196, 218
Salon 94 146, 243
Saltz, Jerry 111
San Francisco, California 79
Sant Ambroeus 245
Sarah Lawrence College 79
Satellite 75
Sawada, Tomoko 219
Sawon, Magdalena 199
Scaramouche 152
Scarsdale, New York 79
Scharf, Kenny 175, 176
Schiele, Egon 233
Schjeldahl, Peter 30, 105
Schmidt, Aurel 127
Schnabel, Julian 23, 44-46, 120, 121, 164, 165, 166, 202, 209, 218, 221, 223, 225
Schneemann, Carolee 34, 35, 128, 138, 165, 199
Schoeller, Martin 193
Schorr, Collier 179, 187
Schrager, Ian 209, 222
Schwitters, Kurt 16
Scully, Sean 187
SculptureCenter 266
Seagram Building 62, 65, 221, 224
Sean Kelly Gallery 34, 200
Secret Project Robot 279
Sedgwick, Edie 84, 85, 203, 222
Seedbed 34, 200
Segal, George 23, 162
Sejima + Nishizawa 138
Self-Portrait 93
Semiotics of the Kitchen 54
Sentences on Conceptual Art 30
Serendipity 3 245
Serna, Hector 279
Serra, Richard 27, 98, 99, 121, 184, 207, 288, 292
Sex, John 175
Shafrazi, Tony 201
Shapiro, Joel 173
Shepherd, Sam 178
Sherman, Cindy 41, 43, 102-107, 126, 197, 209, 238, 243
Shore, Stephen 90, 94, 95, 187, 216
Shrigley, David 188
Sideshow Gallery 279
Sidney Janis Gallery 23
Sikkema Jenkins & Co. 200
Simmons, Laurie 43, 109
Simon Preston Gallery 151
Siqueiros, David Alfaro 67
Skarstedt Fine Art 105, 243
Sky Machine 81

Sloan Fine Art 153
Smack Mellon 285
Small A Projects 147
Smith, David 292
Smith, Jack 189
Smith, Kiki 152, 197, 206, 266
Smith, Matt Sheridan 127, 145
Smith, Patti 120, 128, 175, 200, 203
Smith, Philip 41, 42
Smithsonian Institute 232
Smithson, Robert 26, 49, 92, 193
Smoke Painting 97, 121
Snow, Agathe 142, 146, 189
Snow, Dash 238, 241
SOFTlab 144
SoHo 23, 35, 92, 104, 122-133, 155
SoHo Gallery Building 132
Soho Photo 119
Sokolowski, Tom 91, 94
Solomon R. Guggenheim Museum 234
Sonic Youth 100, 151, 276
Sonnabend Gallery 34, 109, 110, 132, 200
Sonnabend, Ileana 8, 23, 89, 121, 200, 244
Sonne, Kasper 143
Sony Portapak 53
Sotheby's 111, 240, 242
Southampton, New York 89
Space 122 172
Spade, Andy 147
Spafford, Jared 279
Sperone Westwater 151
Sprial Jetty 49
Springs, New York 71
Spungen, Nancy 203
Stable Gallery 85
Staller, Ilona 121
Stallone, Sylvester 223
Starck, Philippe 133
Starry Night 214
Steiglitz, Alfred 227
Stella, Frank 23, 35, 45, 65, 129, 217, 224
Step Piece 34
Sternfeld, Joel 37, 193, 195
Stern, Robert A.M. 258
Still, Clyfford 11, 13, 62
Stonewall 162
Stony Brook University 287
Storefront for Art and Architecture 152
Storm King Art Center 292
St. Regis 226
Streisand, Barbra 163
Studio 54 121, 178, 209, 222
Studio Museum in Harlem 257
Suh, Do-Ho 149
Sullivan, Mary Quinn 214
Summers, Elaine 165
Sunken Garden 120
Surrealism 7, 8, 12, 13, 16, 46, 59, 68, 85, 222, 223, 243
Sweeney, James Johnson 69
Sweeney, Spencer 160
Swiss Institute 129, 144
Szarkowski, John 38
Sze, Sarah 201

T

Talking Heads 120
Taller Boricua 260
Tanger Gallery 179
Tanya Bonakdar 201
Taxter & Spengemann 201
Taylor, Elizabeth 225
Team Gallery 130
Ten-Thirty Gallery 87
Tenth Street Coffeehouse 179
Tenth Street Studio 7, 166
Testino, Mario 187
The Journal Gallery 277

The New 109
The Syrian Bull 61
The Yes Men 151
Thomas, Dylan 162, 203
Thomas, Mickalene 144
Thompson LES 155
Three Transitions 54
Times Square 221
Timperio, Richard 279
Tiravanija, Rirkrit 127, 151, 160, 197
Today Series 31
Tokyo, Japan 79, 129
Tompkins Square 176
Tony Shafrazi Gallery 201
Toshi, Ichiyanagi 79
Transavantgarde 45, 46
Trecartin, Ryan 55, 191
TriBeCa 107, 120, 121, 138
Tropicalismo 191
Truitt, Anne 196
Tuazon, Oscar 161
Tucker, Marcia 138
Turner, J.M.W. 232
Turrell, James 50
Tuymans, Luc 190
Twombly, Cy 17, 23, 74, 222, 243, 266

U

Uffner, Rachel 153
Ultra Violet 84
United Nations 221
Untitled, 1968 99
Untitled, 1969 98
Untitled, 1981 105
Untitled, 2008 106
Untitled (Black on Gray) 64
Untitled (Blood Sign #2 / Body Tracks) 34
Untitled Film Stills 102, 104, 105, 107
Untitled (Subway) 59
Upper East Side 63, 228-247
Upper Wesr Side 248-253

V

Vaisman, Meyer 43
Vanderbilt, Gertrude 7
van der Rohe, Ludwig Mies 62, 65
Van Gogh, Vincent 214
Velvet Underground 93, 176, 222
Venice Beach, California 100
Venice Biennale 77, 100, 147
Vicious, Sid 203
Video Data Bank 55
Vieira, Allyson 147
Viola, Bill 53, 54, 131, 193, 217
Violette, Banks 130
Voice Piece for Soprano 78

W

Walker, Kara 200, 236
Wall Drawing 29, 126, 132
Wallspace 201
Ware, Chris 240
Warhol, Andy 21-23, 53, 77, 84, 89, 90-95, 108, 109, 121, 129, 131, 142, 154, 155, 160, 175, 176, 178, 203, 207, 208, 209, 217, 222, 223, 224, 225, 240, 241, 243, 244, 245, 266, 286, 289, 291
Warhol Museum 91
Washburn, Pheobe 202
Washing Machine 85
Washington Square Arch 167
Washington Square Hotel 71, 162
Washington Square Park 162, 164
Washington Square Windows 160
Watermill Center 288

Webster, Meg 100
Weegee 38
Wegman, William 252
Weil, Susan 72, 74
Weiner, Lawrence 29, 30, 31, 218
Weinstein, Arthur 203
Werble, Kate 127
Werner, Michael 242
Wesselmann, Tom 22, 23, 179, 217
West Street Gallery 161
Wheeler, Justine 110
White Box 153
White Columns 161
White Factory 208
White Flag 120
Whitehurst, Emilee Dawn 62, 63
White, Minor 188
White, Roger 153
White, Wendy 195
Whitney, Gertrude 165, 167, 238
Whitney Museum of American Art 7, 82, 100, 165, 238, 247
Wiener, Mark 185
Wigstock 178
Wild Style 176
Wiley, Kehinde 200, 257
Wilke, Hannah 129
Williamsburg Bridge 140
Williams, Kelli 195
Williams, Lorna 145
Williams, Sue 187
Wilmer Jennings 173
Wilson, Isabel 87
Wilson, May 176
Wilson, Robert 288
Windish, Vashti 278
Winer, Helene 104, 197
Winogrand, Garry 38, 193
Wojnarowicz, David 138, 160, 176, 177, 199
Woman I 10
Woman series 175
Wood, Sarah E. 127
Woodward Gallery 154
Woolfalk, Saya 261
Woolworth Building 102
Works Progress Administration 67, 126
World Trade Center 98
World War II 8, 11, 13, 60, 79, 81
Wright, Frank Lloyd 234
Wurm, Erwin 119

X

Xiaogang, Zhang 118

Y

Yau, John 97
Yes Gallery 82, 279
Yo La Tengo 82
Yossi Milo 201
Young, Aaron 243
Youngerman, Jack 120
Younger Than Jesus 138
Young, La Monte 19, 79, 121

Z

Zizek, Slavoj 140
Zürcher Studio 173
Zwirner, David 190

PHOTO CREDITS

MOVEMENTS

7: Edward Hopper, Early Sunday Morning, 1930. Oil on canvas, 35 3/16 × 60 1/4 in. (89.4 × 153 cm). Whitney Museum of American Art, New York; purchase with funds from Gertrude Vanderbilt Whitney 31.426 Photo: Misaki Matsui; 8: Marcel Duchamp, Bicycle Wheel. New York, 1951 (third version, after lost original of 1913). Metal wheel mounted on painted wood stool, 51 x 25 x 16 1/2" (129.5 x 63.5 x 41.9 cm). The Sidney and Harriet Janis Collection. © 2010 Artists Rights Society (ARS), New York / ADAGP, Paris / Estate of Marcel Duchamp Photo: Akira Chiba; 10: Willem de Kooning NY Woman I, 1950-52. Oil on canvas, 6' 3 7/8" x 58" (192.7 x 147.3 cm). Purchase. Location: The Museum of Modern Art, New York, NY, U.S.A. © 2010 The Willem de Kooning Foundation / Artists Rights Society (ARS), New York Photo: Akira Chiba; 12: ©ARS, Photo: Misaki Matsui; 14: Robert Rauschenberg, Bed, 1955. NY Oil and pencil on pillow, quilt, and sheet on wood supports, 6' 3 1/4" x 31 1/2" x 8" (191.1 x 80 x 20.3 cm). Gift of Leo Castelli in honor of Alfred H. Barr, Jr. © Estate of Robert Rauschenberg/Licensed by VAGA, New York, NY; 16: Jasper Johns b. 1930 Three Flags, 1958. Encaustic on canvas, Overall: 30 7/8 x 45 1/2 x 5in. (78.4 x 115.6 x 12.7cm) Framed: 32 x 46 3/4 x 5in. (81.3 x 118.7 x 12.7cm). Whitney Museum of American Art, New York; 50th Anniversary Gift of the Gilman Foundation, Inc., the Lauder Foundation, A. Alfred Taubman, Laura-Lee Whittier Woods, and purchase 80.32 Art © Jasper Johns/Licensed by VAGA, New York, NY Digital Image © The Museum of Modern Art/Licensed by SCALA / Art Resource, NY; 18: Yoko Ono, Smoke Painting, 1961. Published in Grapefruit, 1964. © Yoko Ono; Yoko Ono, Smoke Painting, 1961. Paintings and Drawings by Yoko Ono. AG Gallery, New York, July 16-30, 1961. Photograph by George Maciunas. Courtesy of Yoko Ono; 20: James Rosenquist, Marilyn Monroe I. 1962. Oil and spray enamel on canvas, 7' 9" x 6' 1/4". The Sidney and Harriet Janis Collection. The Museum of Modern Art, New York, NY, U.S.A. Art © James Rosenquist/ Licensed by VAGA, New York, NY Digital Image © The Museum of Modern Art/Licensed by SCALA / Art Resource, NY; 22: Robert Indiana, LOVE, 1970. © Robert Indiana/ Artists Rights Society (ARS), New York Photo: Akira Chiba ; 24: Flavin, Dan "Monument" for V. Tatlin 1.1964. Fluorescent lights and metal fixtures, 8' x 23 1/8" x 4 1/2" (243.8 x 58.7 x 10.8 cm). Gift of UBS. The Museum of Modern Art, New York, NY, U.S.A. © ARS, NY Digital Image © The Museum of Modern Art/Licensed by SCALA / Art Resource, NY; 26: Judy Gersowitz, Rainbow Picket; Peter Forakis, JFK; William Tucker, Meru I, Meru II, Meru III; Forrest Myers, Zigarat. (Primary Structures exhibit, 1966). The Jewish Museum, New York, NY, U.S.A. Credit : The Jewish Museum, NY / Art Resource, NY; 27: Frank Stella, Empress of India, 1965. Metallic powder in polymer emulsion paint on canvas, 6' 5" x 18' 8" (195.6 x 548.6 cm). Gift of S. I. Newhouse, Jr. Location :The Museum of Modern Art, New York, NY, U.S.A. © 2010 Frank Stella / Artists Rights Society (ARS), New York; 28: Joseph Kosuth, 'Titled (Art as Idea as Idea) [Water], 1966. Photostat, mounted on board 48 x 48 inches (121.9 x 121.9 cm) Solomon R. Guggenheim Museum, New York. Gift, Leo Castelli, New York 73.2066 © Joseph Kosuth / Artists Rights Society (ARS), New York; 31: Lawrence Weiner Cat. #151 (1970) EARTH TO EARTH ASHES TO ASHES DUST TO DUST, 1970. Language + the materials referred to, dimensions variable. Solomon R. Guggenheim Museum, New York, Panza Collection, Gift. 92.4184 92.4184. © 2010 Lawrence Weiner/Artists Rights Society (ARS), New York. Photo: David Heald; 32: Marina Abramovic, Rhythm 5, 1974. Gelatin silver print with inset letterpress panel. A.P., 1/3, edition of 16. Photograph: 22 7/8 x 31 5/8 inches (58.1 x 80.4 cm) Text panel: 9 ¾ x 6 ¾ inches (24.9 x 17.3 cm). Solomon R. Guggenheim Museum, New York. Gift, Willem Peppler. 98.5214 © 2009 Marina Abramovic. Courtesy of Sean Kelly Gallery / Artists Rights Society (ARS), New York; 34: Ana Medieta, Film still from Untitled (Blood Sign #2 / Body Tracks), 1974. Super-8 color, silent film. © The Estate of Ana Mendieta Collection. Courtesy of Galerie Lelong, New York; 36: Garry Winogrand, Central Park Zoo, New York City, 1967. © The Estate of Garry Winogrand. Courtesy of Fraenkel Gallery, San Francisco; 39: Nan Goldin, Trixie on the cot, NYC, 1979. Cibachrome Ed. 18/25 Image: 25 ¾ x 38 3/8 inches (65.4 x 97.5 cm), Sheet: 27 ½ x 40 inches (69.9 x 101.6 cm). Solomon R. Guggenheim Museum, New York. Purchased with funds contributed by the Photography Committee and with funds contributed by the International Director's Council and Executive Committee Members. 2002.61 © Nan Goldin / Courtesy Matthew Marks Gallery, New York; 40: Sherrie Levine, Untitled (President: 5), 1979, collage on paper. 24 x 18 in. © Sherrie Levine. Courtesy of Paula Cooper Gallery, New York. Collection of The Museum of Contemporary Art, Los Angeles, purchased with funds provided by Councilman Joel Wachs; 42: "Pictures," September 24-October 29, 1977, at Artists Space. Photo by D. James Dee; 43: Jeff Koons, Three Ball 50/50 Tank (Two Dr. J Silver Series, Wilson Supershot), 1985. glass, steel, distilled water, three basketballs, 60 1/2 x 48 3/4 x 13 1/4 inches 153.7 x 123.8 x 33.7 cm ©Jeff Koons; 44: David Salle, Gericault's Arm, 1985. Oil and synthetic polymer paint on canvas, 6' 5 7/8" x 8' 1/4" (197.8 x 244.5 cm). Gift of the Louis and Bessie Adler Foundation, Inc., Seymour M. Klein, President; Agnes Gund, Jerry I. Speyer Fund, and purchase. © David Salle / Licensed by VAGA, New York, Digital image © The Museum of Modern Art/Licensed by SCALA/Art Resource, NY; 45: David Salle, Muscular Paper, 1985. 98" by 187" acrylic, oil/canvas, fabric, wood. © David Salle / Licensed by VAGA, New York. Collection: The Museum of Modern Art, New York. Gift of Douglas S. Cramer Foundation. Courtesy: Mary Boone Gallery, New York; 47: Keith Haring, Untitled (Subway Drawing), 1983. Chalk on paper. © Keith Haring Foundation; Julian Schnabel, Installation: Mary Boone Gallery 420 West Broadway, New York. 10 February to 8 March 1979. Courtesy: Mary Boone Gallery, New York; Julian Schnabel, Installation: Mary Boone Gallery, 420 West Broadway, New York. 4 April to 7 May 1981. Courtesy: Mary Boone Gallery, New York; Left: David Salle / Julian Schnabel (painting collaboration) Right: Ross Bleckner. Installation: Mary Boone Gallery, 420 West Broadway, New York. 5 April to 1 May 1980. Courtesy: Mary Boone Gallery, New York; 48: Felix Gonzalez-Torres, "Untitled" (Public Opinion), 1991. Black rod licorice candies individually wrapped in cellophane, endless supply, ideal weight, 700 lbs. (317.5 kg) Dimensions variable. Solomon R. Guggenheim Museum, New York. Purchased with funds contributed by the Louis and Bessie Adler Foundation, Inc., and the National Endowment for the Arts Museum Purchase Program 91.3969 Photograph by David Heald © The Solomon R. Guggenheim Foundation, New York; 51: Gordon Matta-Clark, Conical Intersect, 1975. Silver dye bleach print. Sheet: 40 1/8 x 30 inches (101.9 x 76.2 cm) © Solomon R. Guggenheim Museum, New York. Purchased with funds contributed by the International Director's Council and Executive Committee Members, 1998. 98.5229 © 2010 Estate of Gordon Matta-Clark/Artists Rights Society (ARS), New York; 52: Bill Viola, The Crossing, 1996. Video/ sound installation 490 x 840 x 1740 cm. Two channels of color video projections from opposite sides of large dark gallery onto two large back-to-back screens suspended from ceiling and mounted to floor; four channels of amplified stereo sound, four speakers. Performer: Phil Esposito Production Still Photo: Kira Perov; 54: Nam June Paik, TV Garden, 1974 (2000 version). Video and audio installation with monitors and live plants, dimensions variable. Solomon R. Guggenheim Museum, New York. Purchased with funds contributed by the International Director's Council and Executive Committee Members and through prior gift of The Bohen Foundation 2001.6.; Aleksandra Domanovic, 19:30, 2010 (2 channel video, color, sound). Courtesy of Rhizome.

BIOS

56: American abstract artists, The Irascibles, including William Bazictes, James C. Brooks, Jimmy Ernst, Adolph Gottlieb, Hedda Sterne, Clyfford Still, Willem de Kooning, Bradley Walter Tomlin, Barnett Newman, Jackson Pollock, Theodoros Stamos, Richard Pousette-Dart, Robert Motherwell, Ad Reinhardt, and Mark Rothko. (Photo by Nina Leen//Time Life Pictures/Getty Images)

MARK ROTHKO

58: Mark Rothko (1903-1970) American painter, 1961. (Photo by Kate Rothko/Apic/Getty Images); 60: Mark Rothko, No. 3/No. 13, 1949. Oil on canvas, 7' 1 3/8" x 65" (216.5 x 164.8 cm). Museum of Modern Art, New York; Bequest of Mrs. Mark Rothko through The Mark Rothko Foundation, Inc. © 2010 Kate Rothko Prizel & Christopher Rothko / Artists Rights Society (ARS), New York; 63: Mark Rothko, No. 1, 1948. Oil on canvas, 8' 10 3/8" x 9' 9 1/4" (270.2 x 297.8 cm). Museum of Modern Art, New York; Gift of the artist. © 2010 Kate Rothko Prizel & Christopher Rothko / Artists Rights Society (ARS), New York; 64: Mark Rothko, Untitled (Black on Gray), 1969-70. Acrylic on canvas, 80 1/8 x 69 1/8 inches (203.3 x 175.5 cm). Solomon R. Guggenheim Museum, New York, Gift, The Mark Rothko Foundation, Inc., 86.3422. © 2010 Kate Rothko Prizel and Christopher Rothko/Artists Rights Society (ARS), New York; 65: Photos: Akira Chiba

JACKSON POLLOCK

66: © Rudolph Burckhardt/Sygma/Corbis; 68: Jackson Pollock, One: Number 31, 1950. Oil and enamel paint on canvas, 8' 10" x 17' 5 5/8" (269.5 x 530.8 cm). Museum of Modern Art, New York; Sidney and Harriet Janis Collection Fund (by exchange). © 2010

Pollock-Krasner Foundation / Artists Rights Society (ARS), New York; 69: Oil on canvas, 69" x 10' 5 1/2" (175.3 x 318.8 cm). Kay Sage Tanguy Fund. © 2010 Pollock-Krasner Foundation / Artists Rights Society (ARS), New York; 70: Jackson Pollock, Easter and the Totem 1953. Oil on canvas, 6' 10 1/8" x 58" (208.6 x 147.3 cm Museum of Modern Art, New York; Gift of Lee KrasnerLee Krasner in memory of Jackson Pollock. © 2010 Pollock-Krasner Foundation / Artists Rights Society (ARS), New York.

ROBERT RAUSCHENBERG

72: © Jacques Haillot/Sygma/Corbis; 75: Robert Rauschenberg. Satellite, 1955. Oil, fabric, paper and wood on canvas with stuffed pheasant, Overall: 79 3/8 x 43. 1/4 x 5 5/8in. (201.6 x 109.9 x 14.3cm) Whitney Museum of American Art, New York; gift of Claire B. Zeisler and purchase with funds from the Mrs. Percy Uris Purchase Fund 91.85 © Rauschenberg Estate / Licensed by VAGA, New York, NY Photograph by Sheldan C. Collins; 76: Robert Rauschenberg, Retroactive I. 1963. Oil and silkscreen ink on canvas. 84 x 60 in. Gift of Susan Morse Hilles. 1964.30 Wadsworth Atheneum Museum of Art, Hartford, Connecticut, U.S.A. Photo Credit : Wadsworth Atheneum Museum of Art / Art Resource, NY Art © Estate of Robert Rauschenberg/Licensed by VAGA, New York, NY

YOKO ONO

78: Yoko Ono, Voice Piece for Soprano, 1961 Published in Grapefruit, 1964 © Yoko Ono; Yoko Ono, Yoko Ono performing Voice Piece for Soprano, 1961, Courtesy of Yoko Ono; 81: Yoko Ono, Yoko Ono performing Cut Piece, March 21, 1965, Carnegie Recital Hall, New York, New York. Photo by Minoru Niizuma © Yoko Ono

ROY LICHTENSTEIN

84: © Bettmann/CORBIS Artwork ©Estate of Roy Lichtenstein; 86: Roy Lichtenstein, Whaam! 1963. Acrylic and oil on canvas, support: 1727 x 4064 mm frame: 1747 x 4084 x 60 mm. Tate Collection, London; 1966 purchase. © Estate of Roy Lichtenstein; 87: Roy Lichtenstein, Drowning Girl, 1963. Oil and synthetic polymer paint on canvas, 67 5/8 x 66 3/4" (171.6 x 169.5 cm). Museum of Modern Art, New York; Philip Johnson Fund (by exchange) and gift of Mr. and Mrs. Bagley Wright © Estate of Roy Lichtenstein; 88: Roy Lichtenstein, Girl with Ball, 1961. Oil and synthetic polymer paint on canvas, 60 1/4 x 36 1/4" (153 x 91.9 cm). Museum of Modern Art, New York; Gift of Philip Johnson 421.1981© Estate of Roy Lichtenstein.

ANDY WARHOL

90: Andy Warhol (center) with The Velvet Underground, Nico (bottom left), Paul Morrisey (far right) and Gerard Melanga (bottom right), c. 1966. Courtesy of the Everett Collection; 92: Andy Warhol 1928-1987, Nine Jackies, 1964. Synthetic polymer and silkscreen ink on canvas, Overall (Canvas): 59 1/2 x 48 1/4in. (151.1 x 122.6cm) Framed: 60 x 48 7/8 x 1 3/8in. (152.4 x 124.1 x 3.5cm). Whitney Museum of American Art, New York; gift of The American Contemporary Art Foundation, Inc., Leonard A. Lauder, President 2002.273 © Andy Warhol Foundation/Artists Rights Society (ARS) New York; 93: Andy Warhol, Self-Portrait, 1986. Silkscreened ink on synthetic polymer paint on canvas, 106 x 106 inches (269.24 x 269.24 cm). Solomon R. Guggenheim Museum, New York; Gift, Anne and Anthony d'Offay, 1992 92.4033 © Andy Warhol Foundation/Artists Rights Society (ARS) New York; 94: Andy Warhol, Mao, 1973. Acrylic and silkscreen on canvas, 176 1/2 x 136 1/2 in. (448.3 x 346.7cm). Metropolitan Museum of Art; Gift of Mr. and Mrs. Peter M. Brant, 1977. © Andy Warhol Foundation/Artists Rights Society (ARS) New York. Photo: Akira Chiba

DONALD JUDD

96: © Judd Foundation archive. Licensed by VAGA, NYC; 98: Donald Judd, Untitled, 1969. Copper, ten units with 9-inch intervals, 9 x 40 x 31 inches (22.9 x 101.6 x 78.7 cm) each; 180 x 40 x 31 inches (457.2 x 101.6 x 78.7 cm) overall . Solomon R. Guggenheim Museum, New York, Panza Collection © Judd Foundation. Licensed by VAGA, New York, NY; 99: Donald Judd 1928-1994. Untitled, 1968. Stainless steel and plexiglass, Overall: 33 x 68 x 48in. (83.8 x 172.7 x 121.9cm). Whitney Museum of American Art, New York; Purchase, with funds from the Howard and Jean Lipman Foundation, Inc. 68.36 © Donald Judd Foundation/Licensed by VAGA, New York, NY; 100: 101 Spring Street Donald Judd's SoHo home and studio with furniture by Judd Furniture and painting by Frank Stella. Judd Art/Works © Judd Foundation. Licensed by VAGA, NYC. Photo by Rainer Judd; 101: Donald

Judd, 100 untitled works in mill aluminum, 1982-1986 (detail) Permanent collection, the Chinati Foundation, Marfa, Texas, photograph by Douglas Tuck, 2009.

CINDY SHERMAN

102: Cindy Sherman, Untitled Film Still, 1978. Black and white photograph, 8 x 10 inches. Courtesy of the Artist and Metro Pictures; 105: Cindy Sherman, Untitled, 1981. Color photograph, 24 x 48 inches. Courtesy of the Artist and Metro Pictures; 106: Cindy Sherman, Untitled, 2008. Color photograph, 54.875 x 54 inches, 139.4 x 137.2 cm. Courtesy of the Artist and Metro Pictures

JEFF KOONS

108: Courtesy of Luc Castel; 110: Jeff Koons, Art Ad, 1988. lithographic print on paper, (portfolio of four color lithographs), 45 x 37 1/4 inches, 114.3 x 94.6 cm. © Jeff Koons; 111: Jeff Koons, Balloon Dog (Yellow), 1994-2000, Coloring Book, 1997-2005 and Sacred Heart, 1994-2007. © Jeff Koons Photo: Akira Chiba

LISTINGS

114: Akira Chiba; 118: Courtesy of Dash Gallery; 119: Jeff Koons, Balloon Flower, 1995-1999. © Jeff Koons. Photo: Misaki Matsui; 120: Isamu Noguchi, Red Cube, 1967. Photo: Akira Chiba; 121: (top) Akira Chiba; (bottom) Heather Corcoran; 122: Photo: Akira Chiba; 126: Photo by Daniel Pérez; Courtesy of Artists Space; 127: Courtesy of The Hole; 128 130: Photos. Akira Chiba, 131. Photo: Misaki Matsui; 132-134: Photos: Akira Chiba; 138-139: Photos: Misaki Matsui; 140: Photo: Akira Chiba; 141: Courtesy of Feature Inc.; 142: Courtesy of Charles Bank; 143: Courtesy of Jen Bekman; 144: Photo: Heather Corcoran; 145: Courtesy of Cuchifritos; 147: Photo: Akira Chiba; 148: Courtesy of Allegra LaViola; 149: Courtesy of the Artist and Lehmann Maupin Gallery, New York; 150: Courtesy of Nigel Young/Foster + Partners; 151: Photo Heather Corcoran; 152: Photo Misaki Matsui; 153: (left) Photo Heather Corcoran; (right) Courtesy White Box; 154-155, 156: Photo Akira Chiba; 160: Courtesy Gavin Brown's Enterprise; 161: (top) Courtesy of Maccarone Gallery; (bottom) Photo: Akira Chiba; 162: George Segal, Gay Liberation, 1980. © The George and Helen Segal Foundation/Licensed by VAGA, New York, NY Photo: Akira Chiba; 166: Photo Akira Chiba; 167, 168: Photo Misaki Matsui; 172: Photo: Akira Chiba; 173: Courtesy of the artist and Zurcher Studio; 174: Photo: Misaki Matsui; 175, 176: Photo Akira Chiba; 177: Film Still Courtesy of Ira Sachs; 178: Photo: Akira Chiba; 180: Photo: Akira Chiba; 184:(top) Akira Chiba; (bottom) Courtesy of Rubin Museum of Art, Photo: Evi Abeler; 185, 186: Photo: Misaki Matsui; 187: Courtesy of Alexander and Bonin; 188: (top) Courtesy of Andrew Edlin; (bottom) Photo by David Regen, © Carroll Dunham, Courtesy Gladstone Gallery, New York; 189: Courtesy Cheim & Read; 190: (top) Courtesy of David Nolan; (bottom) Courtesy David Zwirner, New York; 191: Photo: Akira Chiba; 192: © Estate of Roy Lichtenstein, Photos: Misaki Matsui; 193: (left) Courtesy of Hasted Hunt; (right) Photo: Liz Deschenes; 194: (top) Photo: Misaki Matsui (bottom) Courtesy of The Kitchen; 195: Courtesy of the Artist and Lehmann Maupin Gallery, New York; 196: Courtesy of Mary Boone, New York; 197: Courtesy of The Pace Gallery, New York; 198: Courtesy of Paul Kasmin Gallery, Photo Mark Markin; 199: (top) Courtesy of P.P.O.W. (bottom) Courtesy of Printed Matter; 200: Photo Akira Chiba; 201: (top) Photo: Jean Vong, Courtesy the artist and Tanya Bonakdar Gallery, New York (bottom) Akira Chiba; 202: Photograph by Kathryn Hillier; 203: Photo Akira Chiba; 206: Courtesy of The Lower East Side Printshop; 207: © Bob Gruen / www.bobgruen.com; 208: © Estate of Roy Lichtenstein; Photo by Akira Chiba; 214: Photo by Misaki Matsui, © Copyright: Kara Walker, Courtesy of Sikkema Jenkins & Co., New York; 215: Photo by Misaki Matsui, ©1996 Takashi Murakami/Kaikai Kiki Co., Ltd. All Rights Reserved.; 216: Credit: Nick Merrick ©Hedrich Blessing; 217: Courtesy of Christie's; 218: Photo Courtesy: Mary Boone Gallery, New York; 219, 220, 221, 222: Photo: Misaki Matsui; 223: Courtesy of Casa Lever; 224: Photo: Misaki Matsui; 225, 226: Photos: Akira Chiba; 227: Courtesy of the Metropolitan Museum of Art; 228: View of the Leon Levy and Shelby White Court at The Metropolitan Museum of Art. Photograph Courtesy The Metropolitan Museum of Art. © Brooks Walker 2008; 232: Photo: Andrew Garn; 233: Courtesy of the Jewish Museum; 234-235: Photograph by David Heald ©The Solomon R. Guggenheim Foundation, New York; 236: Photograph Courtesy The Metropolitan Museum of Art; 237: (top) Photo: Akira Chiba; (bottom) Photograph Courtesy The Metropolitan Museum of Art. © Brooks Walker 2008; 238: Photo: Misaki Matsui; 239: (top): Architect: Marcel Breuer and Hamilton Smith (1963-1966) Photograph by Jerry L. Thompson,

CONTRIBUTORS

Michael B. Dougherty is a New York City-based lifestyle writer and editor whose work has appeared in New York, Travel + Leisure and AOL.com. He once portrayed Jackson Pollock, cigarette in mouth and bottle in hand, as part of his undergraduate Art History studies.

Alex Gartenfeld is online editor for Interview and Art in America magazines. He has regular columns about contemporary art in the New York Observer and FANTOM. He is the co-curator of the inaugural exhibition at NJ MoCA, and organizes a project space called West Street Gallery.

Jordan Hruska is a Brooklyn-based writer and editor. His writing on art, design and travel appears in the New York Times, Art In America, The Economist and books from Rizzoli.

Maxwell Williams is a writer, curator, and vinyl junkie based in the Echo Park neighborhood of Los Angeles. He is the Editor of Flaunt magazine, and previously held an editorship at Tokion magazine. He has contributed to Interview, Heeb, Plastique, Intermission (DK), artinfo.co, and many other places.

ACKNOWLEDGEMENTS

Museyon would like to thank the many people and institutions who helped in the creation of this book:

Andy Warhol Foundation
Art Resource
Artists Space
Bill Viola Studio
Bob Gruen
Brooklyn Museum
Camel Arts Center
Castelli Gallery
Charlie Fish
Christopher Rauschenberg
Chinati Foundation
Cleopatra's
Dia Art Foundation
El Museo del Barrio
Feature Inc.
Fraenkle Gallery, San Francisco
Gagosian Gallery
Galerie Lelong
Helene Winer
Ira Sachs
Jeff Koons Studio
Jon Hendricks
Judd Foundation
Kawamura Museum
Keith Haring Foundation

Luc Castel
Mackenzie Allison
Mary Boone Gallery
Metro Pictures
Morgan Library
Metropolitan Museum of Art
Misaki Matsui
Museum of Modern Art
New Museum for Contemporary Art
Paula Cooper Gallery
Pollock-Krasner House and Study Center
PS 1 Contemporary Art Center
Rainer Judd
Rhizome
Roger Smith Hotel
Rothko Chapel
Roy Lichtenstein Estate
Shigeno Ichimura
Sikkema Jenkins & Co.
Solomon R. Guggenheim Museum
Stephen Shore
Storm King Art Center
Studio Museum in Harlem
The Four Seasons
The Pace Gallery
Warhol Museum
Whitney Museum of American Art
Yoko Ono

MUSEYON INC.

Publisher: Akira Chiba
Editor-in-Chief: Heather Corcoran
Media Editor: Jennifer Kellas
Sales and Marketing Manager: Laura Robinson
Design: CHIPS

Cover Design: Jose Antonio Contreras
Photographer: Misaki Matsui
Contributing Writer: Mackenzie Allison
Proofreader: Charlie Fish
Research: Shigeno Ichimura

MUSEYON GUIDES

Film + Travel Europe	9780982232002
Film + Travel Asia, Oceania, Africa	9780982232019
Film + Travel North America, South America	9780982232026
Music + Travel Worldwide	9780982232033
Art + Travel Europe	9780982232057
Chronicles of Old New York	9780982232064
City Style	9780982232071

Museyon Guides has made every effort to verify that all information in this guide is accurate and current as of our press date. All details are subject to change.

For more information visit www.**museyon**.com

ABOUT MUSEYON

Named after the Museion, the ancient Egyptian institute dedicated to the muses, Museyon Guides is an independent publisher that explores the world through the lens of cultural obsessions. Intended for frequent fliers and armchair travelers alike, our books are expert-curated and carefully researched, offering rich visuals, practical tips, and quality information.

Pick one up and follow your interests ... wherever they might go.